4/17

GUSTAV KLIMT

Art Nouveau Visionary

GUSTAV KLIMT

Art Nouveau Visionary

Eva di Stefano

STERLING

New York / London
www.sterlingpublishing.com

Translated from the Italian by Stephen Jackson.

STERLING and the distinctive Sterling logo are
registered trademarks of Sterling Publishing Co., Inc.

Library of Congress Cataloging-in-Publication Data
Di Stefano, Eva.
 Gustav Klimt : art nouveau visionary / Eva Di Stefano.
 p. cm.
 Translation of: Gustav Klimt: l'oro della seduzione.
 Includes bibliographical references and index.
 ISBN 978-1-4027-5920-8
 1. Klimt, Gustav, 1862-1918. 2. Artists—Austria—Biography. I. Klimt, Gustav, 1862-1918. II. Title.
 N6811.5.K55 D513
 759.36—dc22 [B] 2008008862

10 9 8

Originally published in Italian as *Gustav Klimt: L'Oro della Seduzione*
by Eva di Stefano @ 2006 by Giunti Editore S.p.A. in Florence, Italy

English translation published by Sterling Publishing Co., Inc.
387 Park Avenue South, New York, NY 10016
© 2008 by Sterling Publishing Co., Inc.
Distributed in Canada by Sterling Publishing
c/o Canadian Manda Group, 165 Dufferin Street
Toronto, Ontario, Canada M6K 3H6
Distributed in the United Kingdom by GMC Distribution Services
Castle Place, 166 High Street, Lewes, East Sussex, England BN7 1XU
Distributed in Australia by Capricorn Link (Australia) Pty. Ltd.
P.O. Box 704, Windsor, NSW 2756, Australia

Printed in China
All rights reserved

Sterling ISBN 978-1-4027-5920-8

For information about custom editions, special sales, premium and
corporate purchases, please contact Sterling Special Sales
Department at 800-805-5489 or specialsales@sterlingpublishing.com.

Original Italian book project manager, Claudio Pescio; editor, Augusta Tosone;
original graphics and layout, Elisabet Ribera; iconographical research, Claudia Hendel.

English co-edition edited and designed by Sterling.

CONTENTS

Fin-de-Siècle Vienna 6

Klimt's Beginnings 18

The Scandalous Paintings 40

The Secession Years 48

From *Ver Sacrum*
to the Wiener Werstätte
(Vienna Workshop) 64

Klimt's Artistic Creed 74

The Gold of Seduction 82

Judith and the Others 90

The Ambivalent Muses 100

Portraits of Ladies 120

The Erotic Sketches 134

The Women in His Life 146

The Landscapes 156

The Allegorical Friezes 174

The Kunstschau and
the Crisis in the Secession 200

The Florid Style 208

Appendix 234

 Bibliography 236

 Index of Names 238

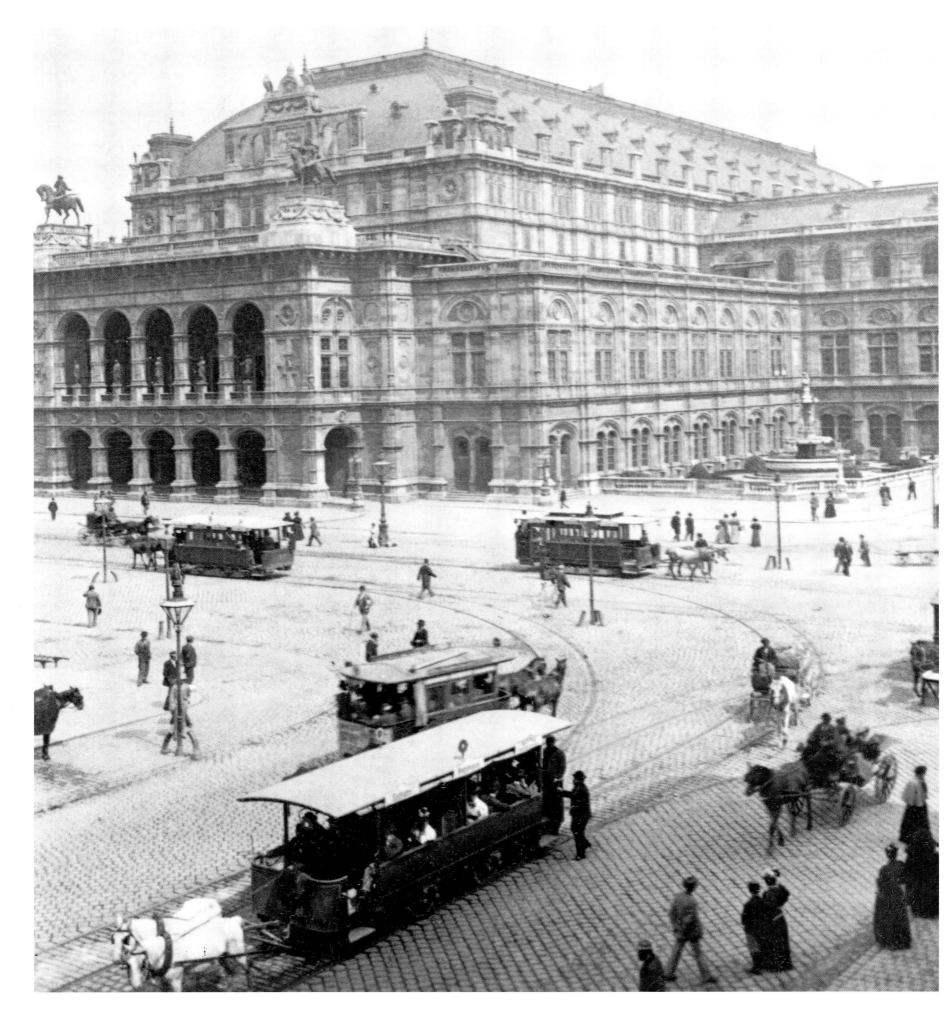

FIN-DE-SIÈCLE VIENNA

"This silence, this amiability, this splendor in *bourgeois modesty*, this is our Austrian Vienna," wrote Hermann Bahr in 1900 regarding the Klimt painting *Schubert at the Piano II*, recognizing the artist's ability to condense into one image the indefinable aura of the Viennese. Bahr points to a "Biedermeier" aspect coinciding with that comfortable middle-class decorum in which those melancholy destinies recounted by Arthur Schnitzler are consumed. This is one of the main ingredients in the cliché of fin-de-siècle Vienna, where what was called "the golden age of bourgeois security" slipped softly into its "gay apocalypse." The first of these two expressions was coined by the writer Stephan Zweig when nostalgically evoking his youth, the second by the sharp-tongued critic Hermann Broch; both define the climate between 1890 and the

First World War, years when the suspicion had began to insinuate itself into the peaceful splendor of Austro-Hungarian society.

The Hapsburg Empire dissolved in 1918 and with it the idea of a harmonious supranational state, a composite mosaic that, as Franz Werfel wrote, united "the alps of Tyrol, the lakes of Salzkammergut, the gentle landscapes of Bohemia, the wild Kras plateaus, the luxuriant regions of the Adriatic, the palaces of Vienna, the churches of Salzburg, the towers of Prague…the vast steppes of the Puszta…the high pastures of the Carpathians and the lowlands of the Danube, with all the wonders of its river basin." The old Emperor Franz Joseph began all his proclamations with "My Peoples!" expressing the supranational idea basic to the Danubian monarchy, about to be shattered by the

modern reawakening of national powers.

Even those like Robert Musil, who ironically expressed the imminence of this fall in *The Man Without Qualities*, contributed to shaping the subsequent myth: "There, in Kakanien—that unrecognized and now vanished nation that in so many things was never appreciated enough as a model—there was speed but not too much…There was luxury but not as refined as in France. There was sport, but not as keen as in England. Enormous sums were spent for the army, but only as much as needed to remain the penultimate of the great powers. Even the capital was a bit smaller than all the other world metropolises, although a bit larger than those that were not the usual great cities."

This civilization of good manners softened the thorny eruption of modernity and was essential to the charm of Viennese

Chapter Opening (p. 6):
The Vienna Opera House in a photograph from c. 1898.

Right:
Schubert at the Piano II,
1898–99, entire painting and details on following pages; destroyed.

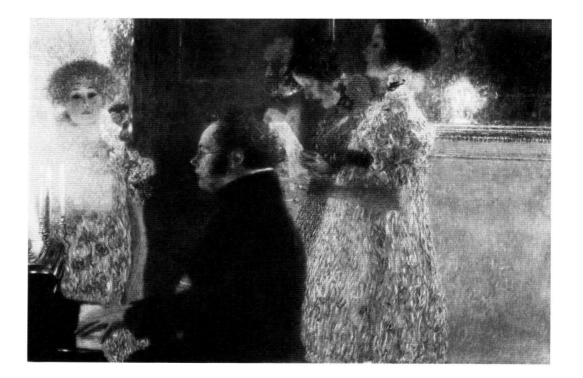

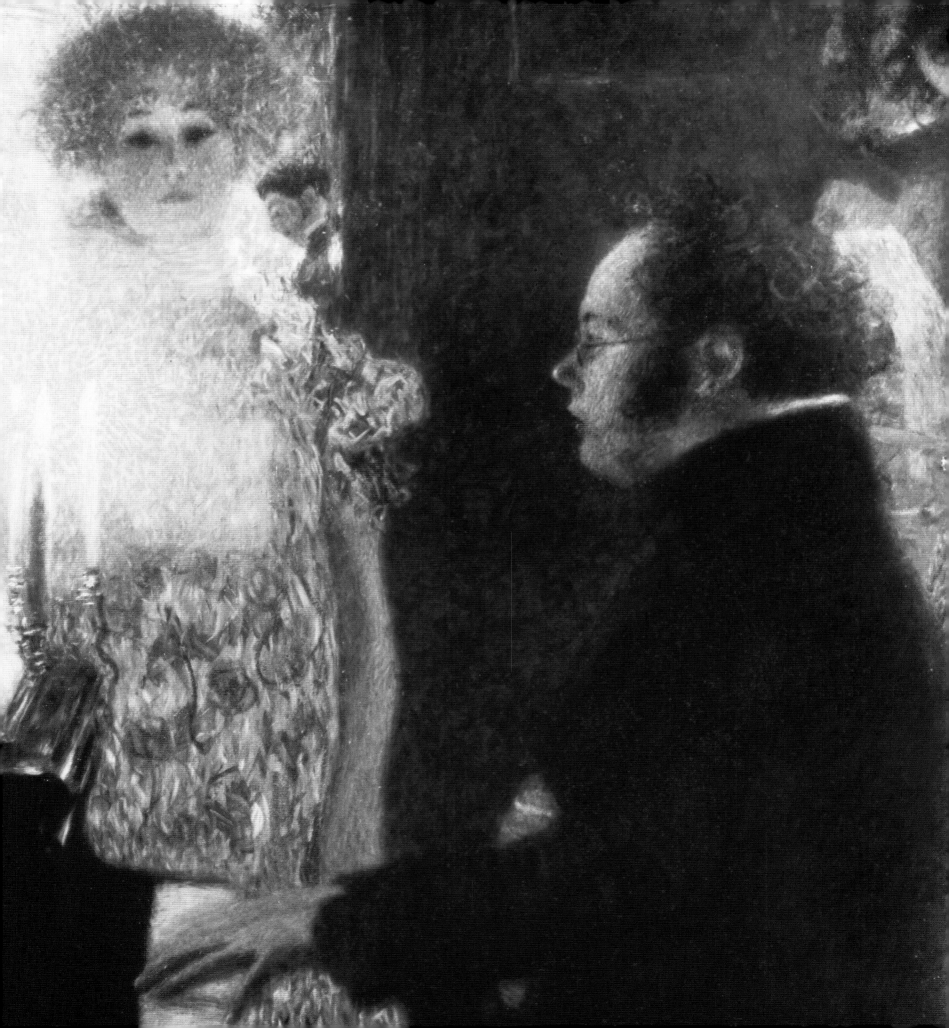

Above:
The Organ Player,
1885; Vienna, Österreichische,
Galerie Belvedere.

Right:
Study for "Schubert at the
Piano I," 1896.

Far right:
Sketch for "Schubert at
the Piano II," 1899.

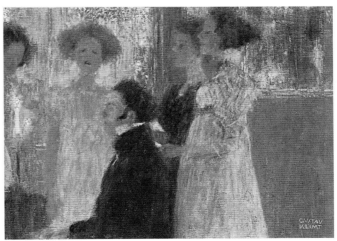

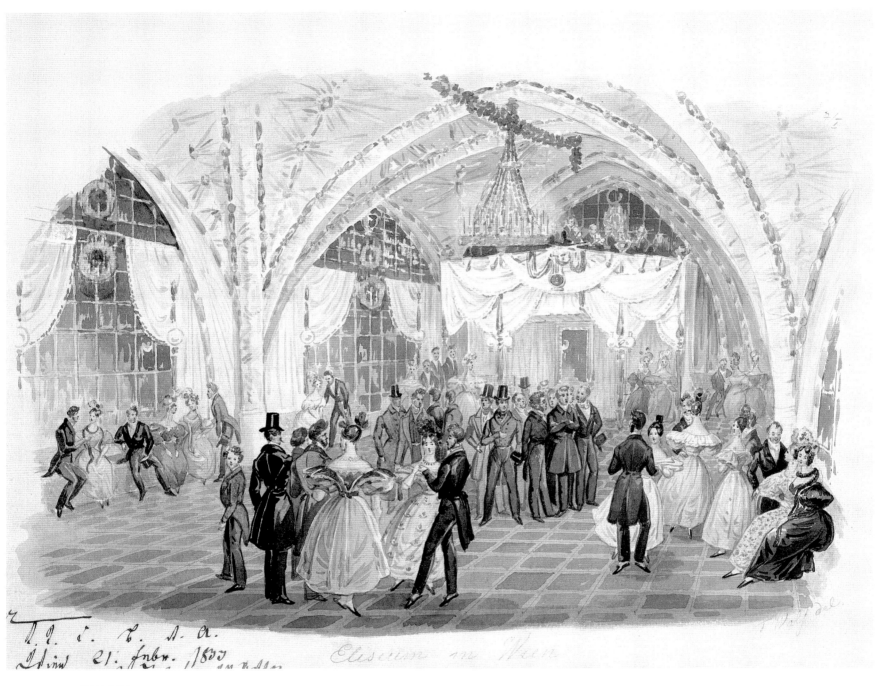

T. Wolfdel,
Dance Hall at the Eliseum in Vienna, 1899.

Ernst Klimt and Gustav Klimt,
Comic Actors Improvise a
Performance in Rothenburg,
c. 1884–92.

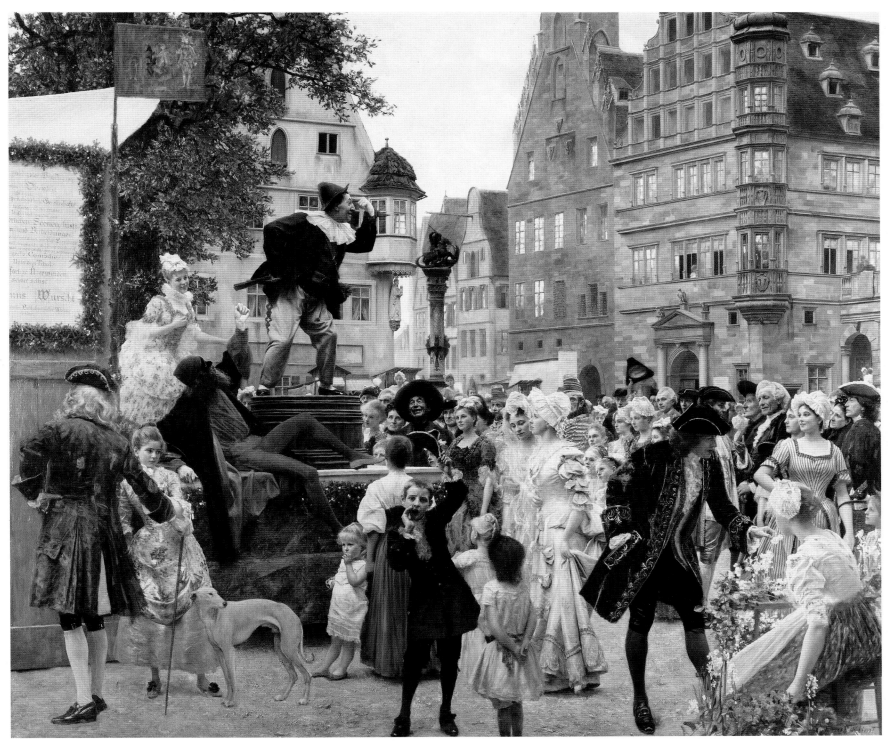

culture, whose wealth would anticipate problems that would arise completely only much later, problems which in that period coexisted and at times even coincided with exhausted melancholy, blasé hedonism, and aesthetic thrills.

Vienna was "the world of yesterday," the age of aristocratic elegance and captivating operetta melodies, but at the same time also the cradle of Zionism, anti-Semitism, Austrian Marxism, and neo-corporatism, as well as the extraordinary laboratory of an intellectual avant-garde committed to redefining modern subjectivity. Sigmund Freud, Ludwig Wittgenstein, and Ernst Mach all lived here, where for the first time the fragility of language and the power of repressed experiences in the psyche were recognized, where psychoanalysis was born, where Musil wrote one of the greatest novels of the nineteenth century, where Gustav Mahler composed his symphonies, and Arnold Schönberg created twelve-tone music, where the precision of Adolf Loos defined modern architecture, where a great moralist like Karl Kraus for forty years edited and published an anti-journal to fight against the ambiguous use of the language of power and the daily press.

This is the city where Hugo von Hofmannsthal described the dissolution of the ego and Schnitzler the apprehension implicit in bourgeois decorum, suggesting that within the progressive crisis of identity and narcissistic introversion lay the symptoms of a new anxiety, the unease of living in an era besieged by the process of cultural homogenization.

The entire artistic experience of the period seems marked by the awareness of living on a piece of land filled with fractures, in reality as well as language. Karl Kraus's sinister definition was, "The proving ground for the destruction of the world."

In his 1908 novel *The Other Side*, the disconcerting Austrian illustrator Alfred Kubin anticipated Franz Kafka when he wrote of the imaginary city of Perle, where splendid empty palaces have decaying foundations and rats flood the cellars of the city destined to collapse. The discovery of the unconscious coincides with its revolt as ancient powerful fears and new phantasms spring from the swamps of the conscience.

Oskar Kokoschka would later write, "People lived in security, nonetheless they were all full of fear. I perceived this through their refined manner of living, still derived from the baroque. I painted them in their anxiety and their panic." In *The Emperor's Tomb*, Joseph Roth wrote, "Above the ebullient glasses from which we drank, invisible Death was already crossing his bony hands…Alone and old, distant and omnipresent in the great and brilliant pattern of the Empire, lived and ruled the old Emperor, Franz Joseph. Perhaps in the hidden depths of our souls there slumbered that awareness which is called foreboding, the awareness above all that the old Emperor was dying, day by day with every day that he lived, and with him the Monarchy—not so much our Fatherland as our Empire; something greater, broader, more all-embracing than a Fatherland."

In this world that, according to Roth, loved anguish with the same lightness as pleasure, there also existed a divided and anxious erotic hedonism that acted itself out behind the irreproachable façade of daylight. This was the era of Anatol, the lead character in one of Schnitzler's plays and the sad, cynical characters in his *La Ronde*, puppets in a nihilistic, sleepwalking game of love. "Women, women,

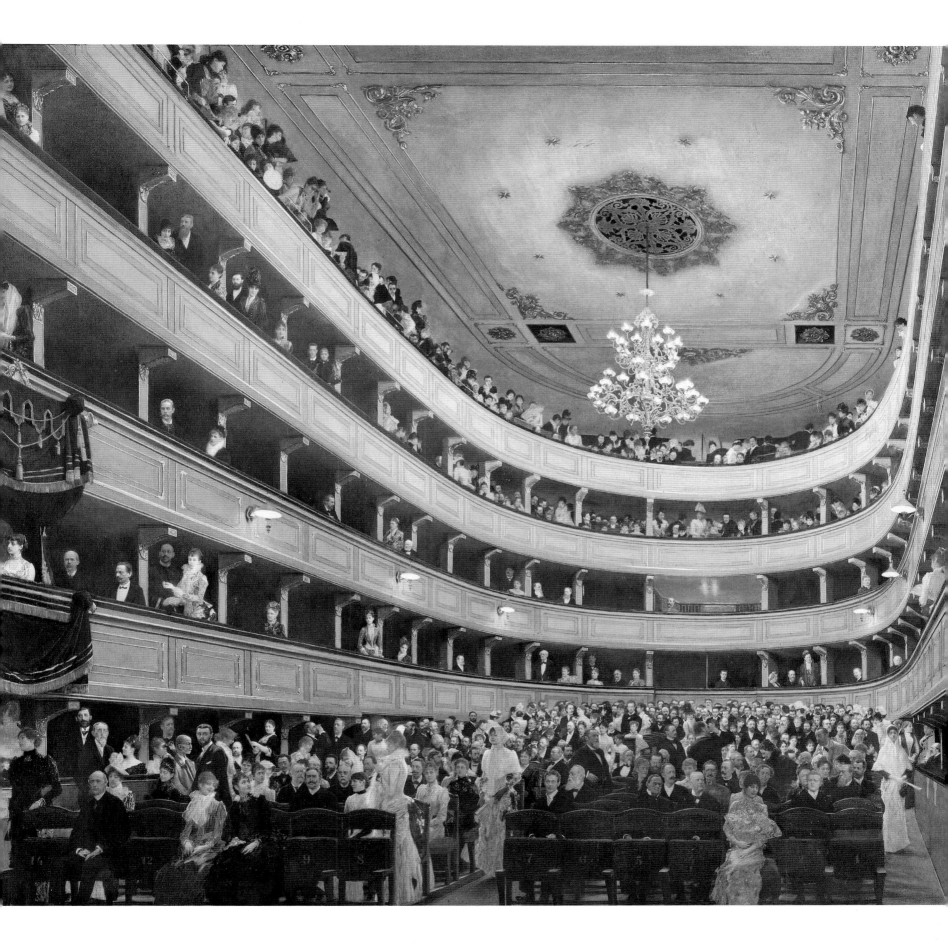

eternal…" insists the music of Franz Lehár. And that *cupio dissolvi*, or self-destruction, deeply identifying the period, seemed frequently to be easily and thoughtlessly translated into erotic obsession. Images of women increasingly assumed the features of a necessary yet deadly idol. The epoch had a sex phobia, and while Freud was developing his theory of the sexual origins of neuroses, a young Viennese Jew, Otto Weininger, wrote a rambling book called *Sex and Character* that pseudo-philosophically speculates about female inferiority.

Gustav Klimt, that golden artist of fin-de-siècle Viennese style, managed more than anyone else to give a face to the period's obsessions. The destructive power of Eros, the erotic superiority of women, and the idea of a metamorphic, elusive, eternal feminine are the central themes of his work. But Klimt seemed to overturn Weininger's misogynous assumptions.

Precisely the same things that attempted to justify contempt for the feminine in that book became the motifs of idolatry in Klimt's icons. Whether in allegorical representations or portraits of high-ranking women, the central character is always the same woman of myth, the "femme fatale" or the ancient maenad.

If this was a period when aesthetic values were taken to extremes, when art was considered the metaphysical ultimate, then the erotic and aesthetic come together in Klimt. In the *Beethoven Frieze*, the apotheosis of art occurs simultaneously with the apotheosis of Eros. More than a simple matter of subject choice, this was the development of a very personal decorative language where ornament was not an empty form, but instead became the structure of an image that developed through mosaic-like addition and interaction of the elements. So, just as the message from the unconscious, the decisive revelation, in psychoanalysis is concealed in an apparently superfluous discourse, so the message in his painting is entrusted to an ornamental microstructure.

From this point of view, any reading of Klimt's work as a simple, passive decorative cover for *Finis Austriae* appears limited. A subtler aspect complicates and gives more meaning to the nervous tenderness of his symbols and refined pictorial collages of his surfaces. This is the extreme effort to deeply reconcile the afflictions of the ego despite the opposing force of dire premonitions, the attempt to use painting to create a model of the symbolic transformation of the world with all its ambivalence and diversions.

Choir of Angels and Embracing Couple,
1902, detail from the *Beethoven Frieze*,
Vienna, Secession Building.

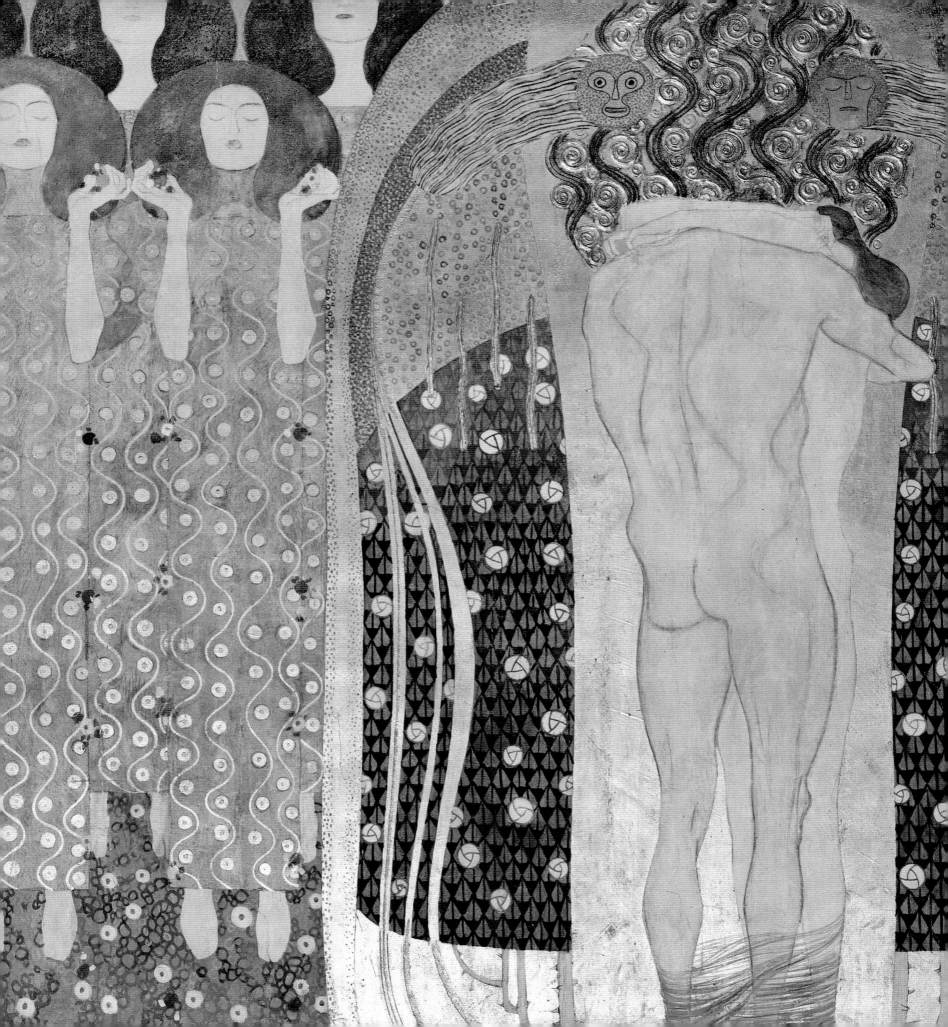

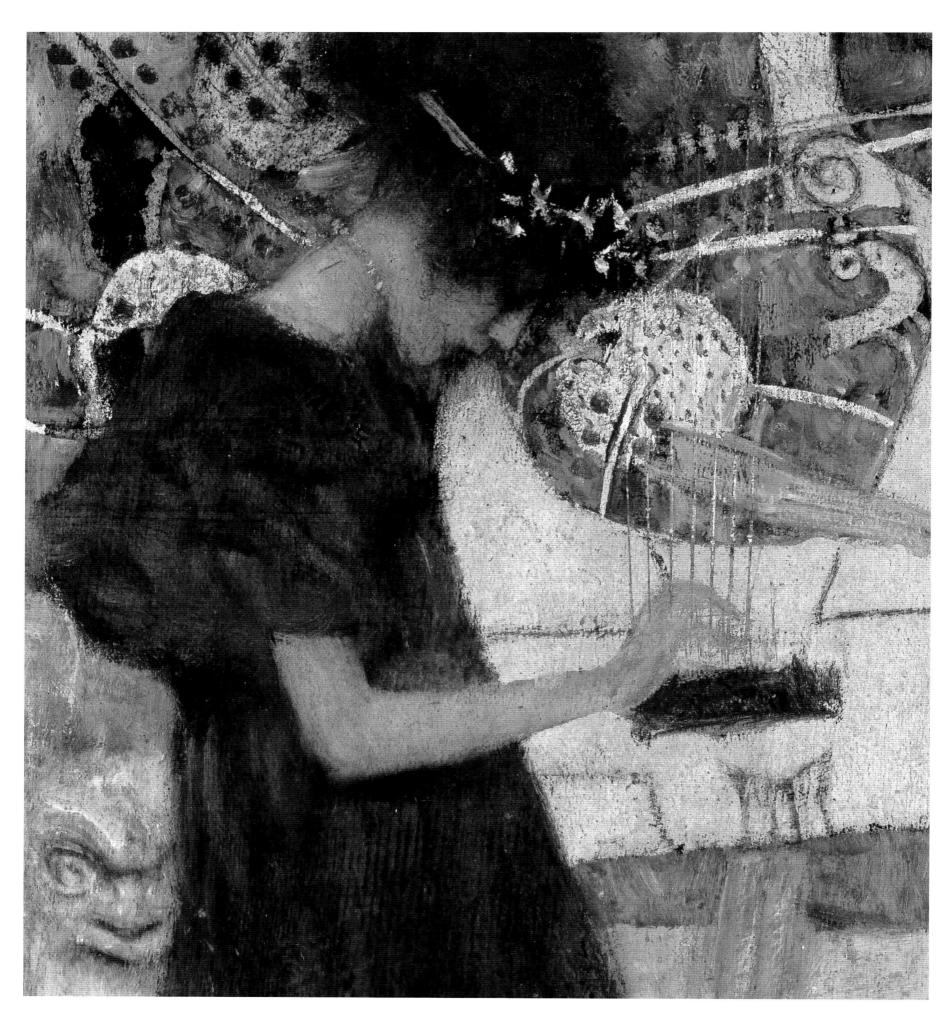

KLIMT'S BEGINNINGS

Chapter Opening (p. 18):
Allegory of Music I, 1895, detail;
Munich, Neue Pinakothek.

Below left:
Klimt's birthplace, on
Linzerstrasse in Vienna.

Below right:
Ferdinand Laufberger's painting class
in 1880 (front row from the left, Laufberger,
Gustav and Ernst Klimt; Franz Matsch is in
the third row to the right).

Gustav Klimt was born July 14, 1862, in a suburb of Vienna. His father, originally from Bohemia, was a gold engraver and the memory of his craftsman father would clearly influence the future development of his art. He inherited a powerful love for music from his mother, an unsuccessful opera singer. The second of seven children, Gustav and his large family lived in extremely modest conditions that would deteriorate further after 1873 because of the economic crisis following the failure of the Vienna International Exhibition.

In 1876, he was admitted to the School of Arts and Crafts at the Museum of Art and Industry, founded in 1864 and modeled after the Victoria and Albert Museum in London. He attended until 1883, where he learned various techniques, such as mosaics and metalworking, and absorbed a repertory of decorative motifs from many eras and cultures, from Greek ceramics to Egyptian and Assyrian reliefs, and Slavic folklore. Gustav also learned to prepare his own paints and chose to specialize in painting under the guidance

first of Ferdinand Laufberger, then Julius Victor Berger. This was the triumphal era of historicism, the conscious imitation of styles from the past. Thus the texts for Klimt's education would be the sumptuous and dazzling paintings of Hans Makart, idol of Viennese art lovers, and the virtuous academicism of a Jean-Léon Gérôme or Laurens Alma-Tadema. These influences would shape his early years of activity and he would free himself from them only very slowly.

In 1883, Gustav Klimt, his brother Ernst, slightly younger and destined for an early death, and schoolmate Franz Matsch would create a small artistic company that would share a studio and commissions that soon became fairly numerous.

There was no lack of work, since the Empire also spread its supranational message through the construction or renovation of theaters in its provinces. Using a "Makart style," these three artists decorated public buildings in Vienna, the royal castle in Pelesch, Transylvania, and the bedroom of the Hermesvilla (where the lunatic Empress "Sissi" would never

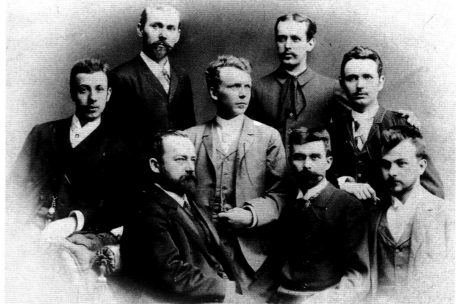

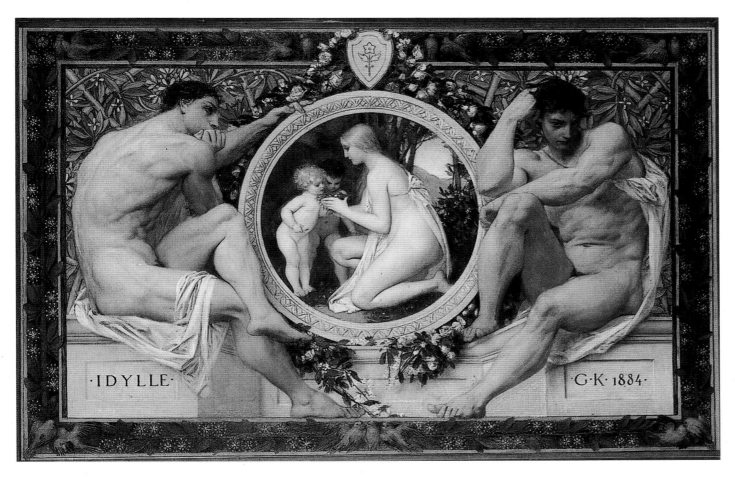

Left:
Idyll, 1884; Vienna,
Wien Museum Karlsplatz.

Below:
Hans Makart, *Venice Pays
Homage to Caterina Cornaro*,
1872; Vienna, Österreichische
Galerie Belvedere.

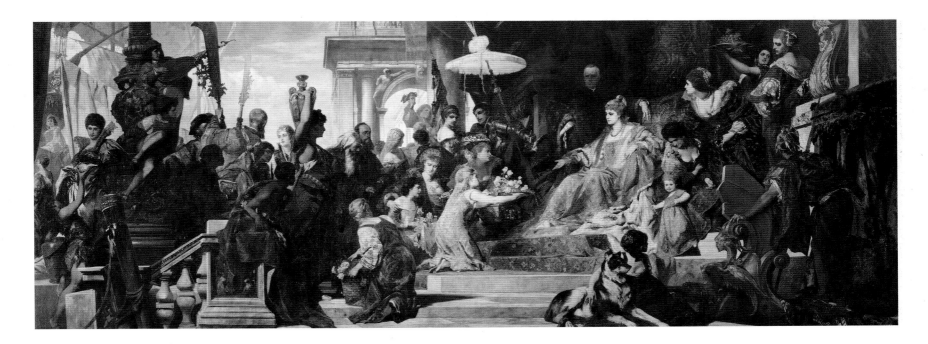

spend one night), and worked for theaters in Bucharest, Karlsbad, Rijeka, and Reichenberg.

Their first important commission (1886) was the decoration of an official site in Vienna, the new Burgtheater, designed by architects Gottfried Semper and Karl von Hasenauer to replace the old theater of Maria Theresa. Although the group had worked collectively up till now, this time their different efforts became clearly distinct. Stylistic differences and an internal hierarchy emerged. The work entailed illustrating the space of the entrance stairway with scenes from theater history. Ernst Klimt would do two of these and Matsch would do three, while Gustav took on the most difficult

task of decorating the two vaults of the entrance and three large sections of the central ceiling. The two altars of Apollo and Dionysus, the theater of Taormina, the carriage of Thespis, and the Shakespearian Globe Theater of London were chosen as subjects. His style here avoids neo-Baroque exultation. Historicism became "scientific" and the imaginative reconstructions of the past were inspired by faithful details. Members of Klimt's family served as models. The artist himself is featured in the audience of *Romeo and Juliet*. Separately, he dedicated an extraordinary painting to the interior of the old Burgtheater, then being demolished, precisely depicting 130 Viennese personalities in the boxes and house seats.

The musician Johannes Brahms, the great surgeon Billroth, politician Karl Lueger, and popular actor Alexander Girardi can all be recognized. This painting sparked great admiration for his virtuosity and won the artist the Emperor's prize of 400 gulden. Illusionism and faithfulness to physical appearance would always remain outstanding aspects of his style.

After the success of the Burgtheater, it came as no surprise that the "Company of Artists" would be assigned the decoration of the great entrance staircase of the new museum, the Kunsthistorisches designed by Semper and Hasenauer. Like other projects, this had originally been assigned to Markart, who died suddenly in 1884. This involved using allegorical

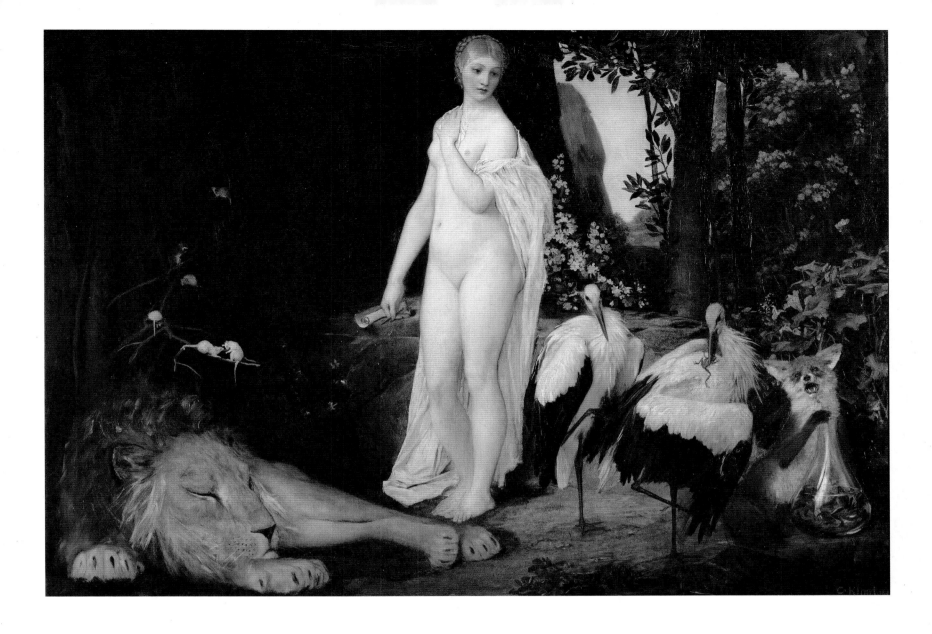

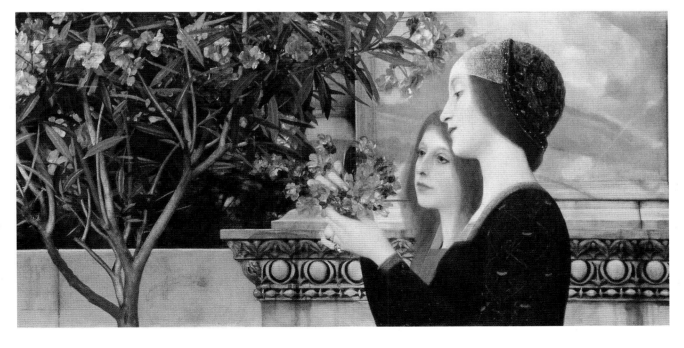

Above:
Fable, 1883; Vienna,
Wien Museum Karlsplatz.

Left:
Girl with Oleander, 1890–92.

Opposite page:
Laurens Alma-Tadema,
The Tepidarium, 1881.

Right:
The old Burgtheater
in Vienna in a photograph
from c. 1885.

Below:
Decorations for the entrance
vault and central ceiling
of the new Burgtheater
in Vienna.

Below left:
The Altar of Dionysus,
1886–88.

Below right:
The majestic staircase
with the ceiling fresco,
The Theater at Taormina, 1884,
detail on the following page.

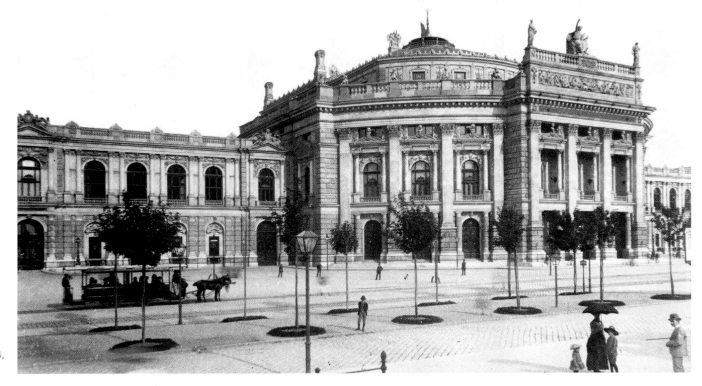

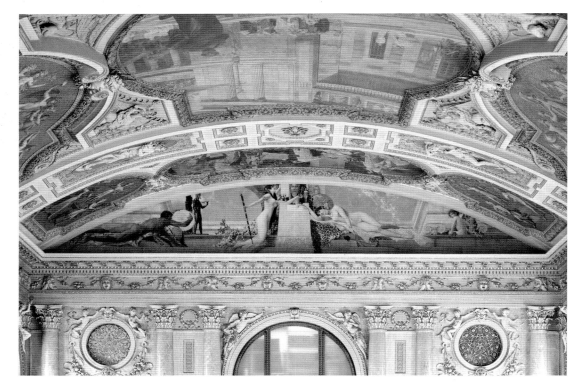

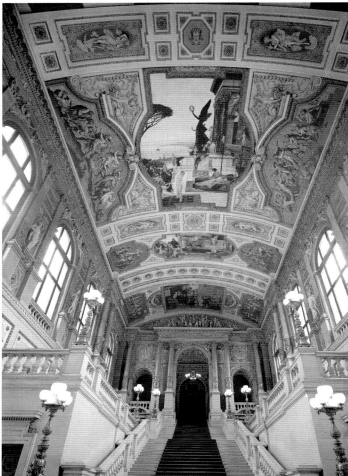

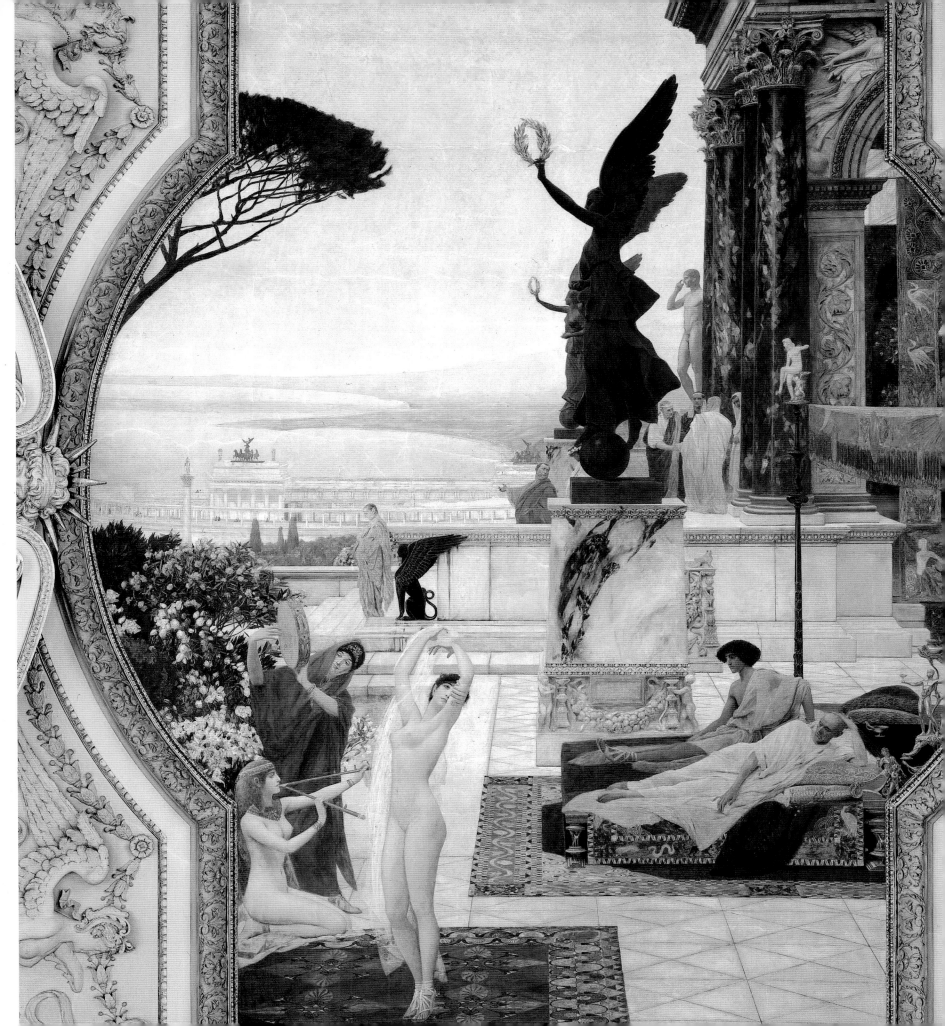

figurations to create a chronological journey through the history of art.

Klimt always emphasized this work's importance in the evolution of his style. Here he transfigured his own academicism into the search for new formal syntheses. He merged the illusionistic plasticity of the vaults with a sort of dimensional reduction so that the figures appear almost carved out of the solid base of the wall. At the same time, he put into play a mimetic eclecticism of styles, a surprising technical ability to quote from artists Jacopo Bellini to Melozzo da Forlì, Luca Della Robbia, Donatello, and Sandro

Botticelli. However, in this skillful *"Reader's Digest"* of art history, in these stylistic methods taken from tradition, he already inserts a singular Jugendstil (Art Nouveau) aura. Hidden among the others, the *Girl from Tanagra* represents Ancient Greece with her dress of stylized flowers, her pre-Raphaelite head of hair, and eyes circled in shadow. She is a languid, unsettling fin-de-siècle beauty in the manner of Symbolist Fernand Khnopff, as well as an early prototype of the femme fatale in future Klimtian epiphanies. With its uncommon style and relief in a floral motif, the painting *Two Girls with Oleander*

from this same period indicates the artist's openness toward Symbolist themes.

The formal characteristics that would mark his mature activity also begin to appear in portraits. Look, for example, at the Portrait of the Pianist Josef Pembaur (1890) with the powerful contrast between the extreme photographic realism of the face and flat background with the stylized lyre, a tension increased by the painted frame also covered in stylized, symbolic motifs.

The premature death of his brother Ernst, in 1892, planted a secret sadness in Gustav's heart. He painted very little for

Portrait of a Woman in a Gold Dress, 1886–87; painted in collaboration with his brother Ernst and Franz Matsch.

Opposite page:
Decorations of two ceiling panels at the Burgtheater in Vienna.

Top:
The Death of "Romeo and Juliet," 1884–87, in collaboration with his brother Ernst and Franz Matsch.

Bottom:
The Cart of Thespis, 1888, in collaboration with his brother Ernst.

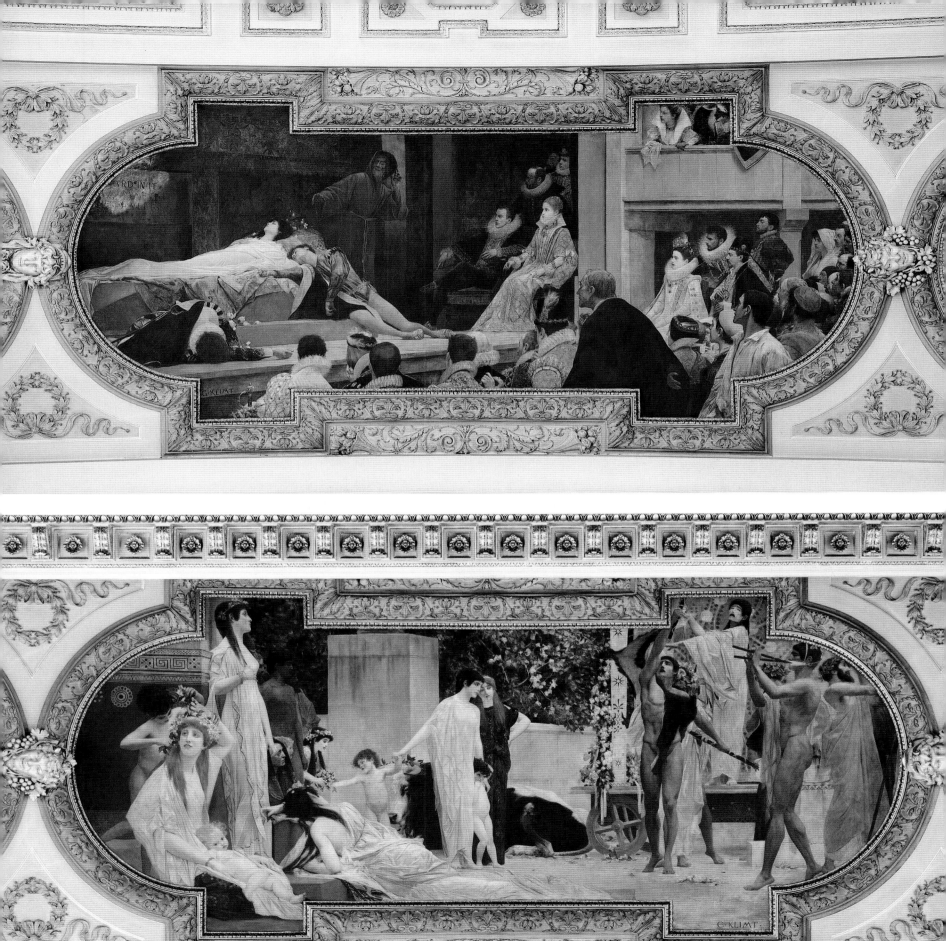

Right:
Greek Antiquity II and Egyptian Antiquity
(*on the left: Girl from Tanagra*)
1890–91, detail from the intercolumniation;
Vienna, Kunsthistorisches Museum.

Below:
Study for *"Greek Antiquity II,"* 1890–91,
detail; Vienna, Kunsthistorisches Museum.

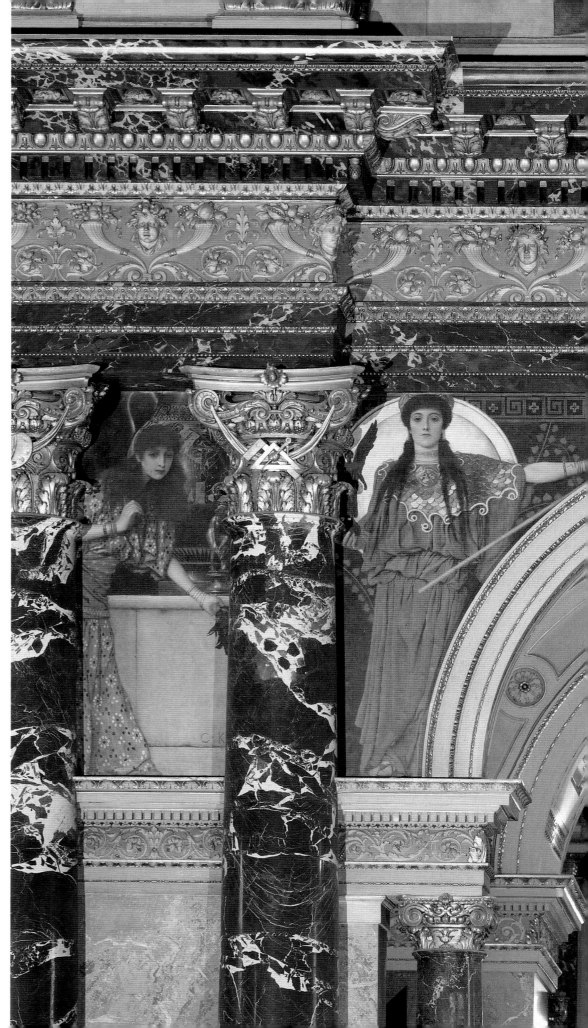

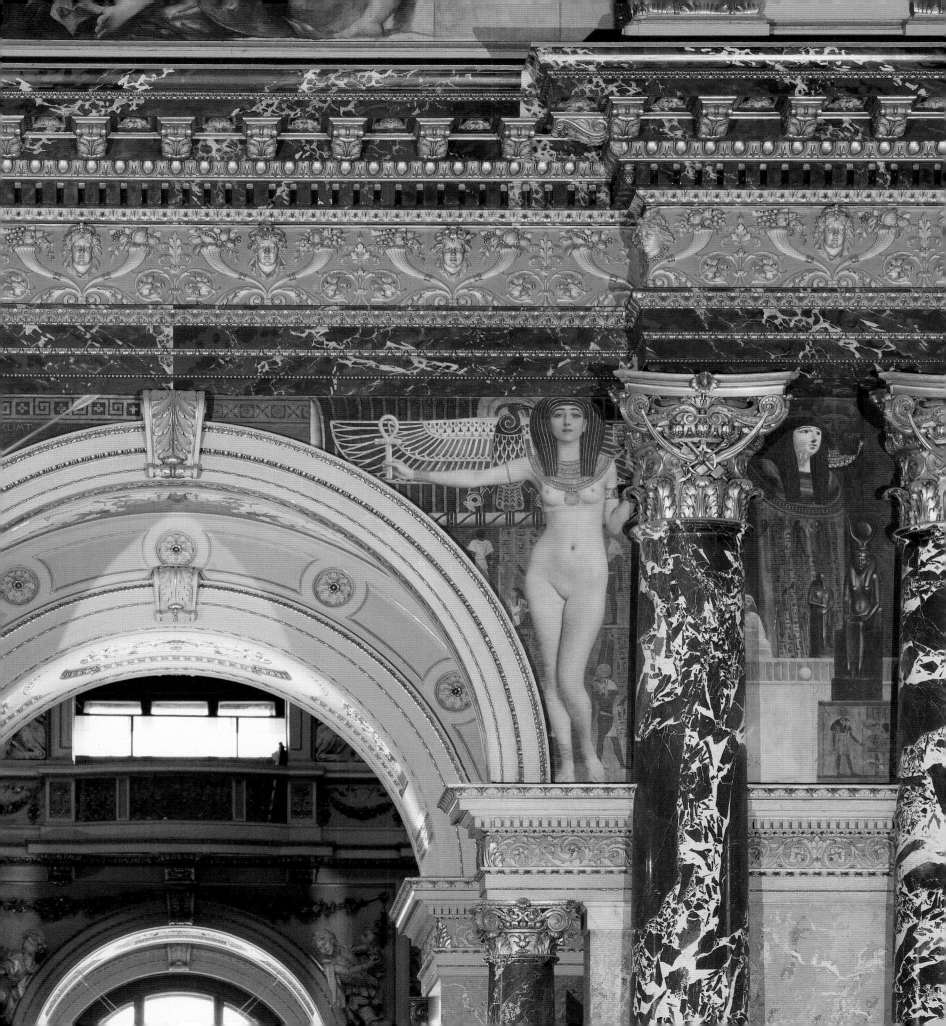

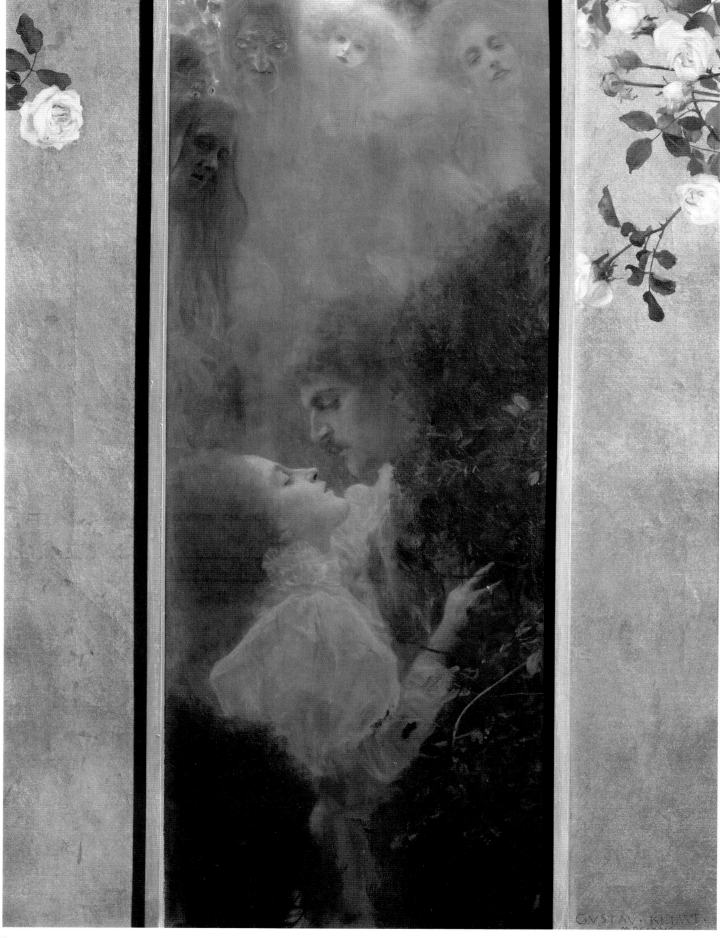

Right:
Love, 1895; Vienna,
Wien Museum Karlsplatz.

Opposite page:
*Portrait of the Pianist Josef
Pembaur,* 1890; Innsbruck,
Tiroler Landesmuseum
Ferdinandeum.

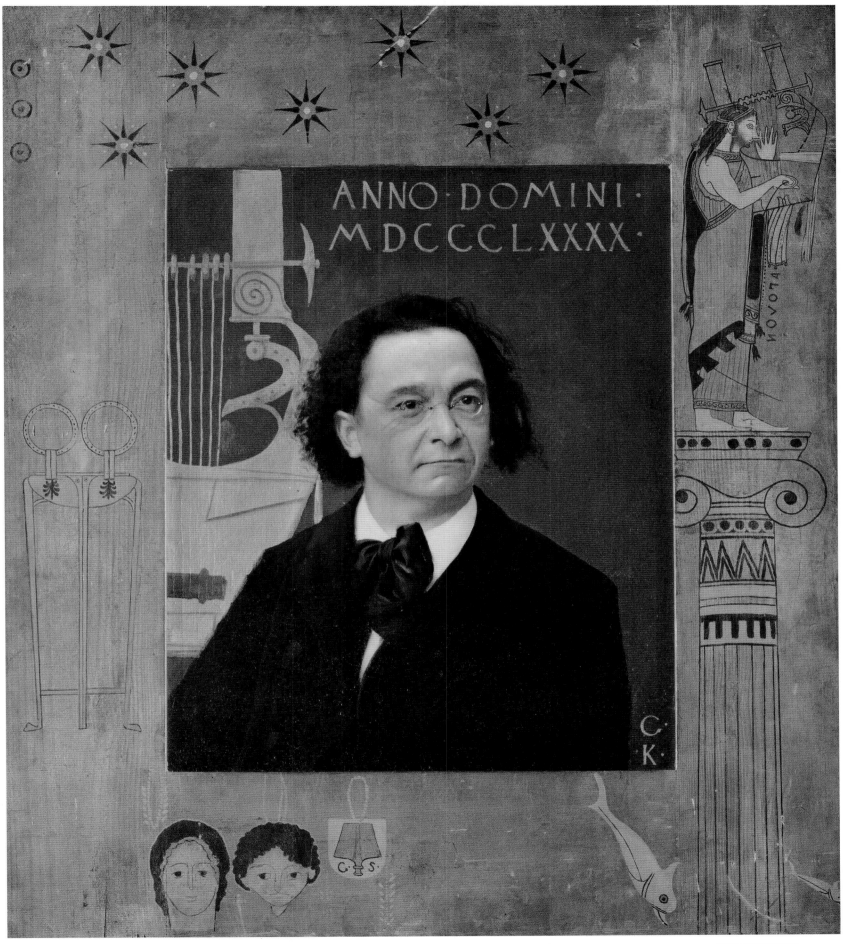

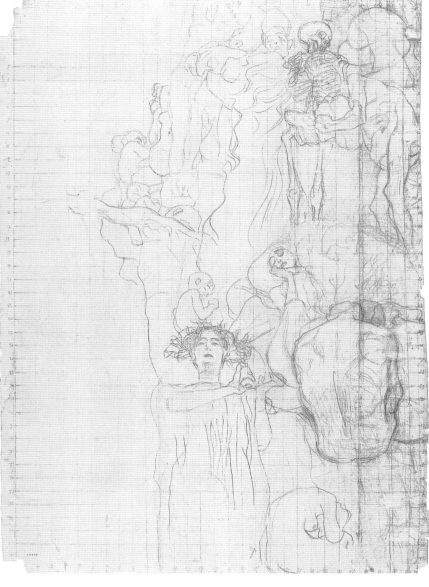

a few years and when he resumed, in 1895, he had by then completely entered his symbolist phase.

As a painter, Klimt traveled in the same imaginary landscapes as did decadent literary modernism, where the young Hofmannsthal was also undergoing his poetic apprenticeship, and was in search of a way to translate psychological concepts and ideas into figurative terms.

How to rediscover the lost symbol, and reformulate allegory in a modern key, was the question that now occupied him,

a question also driven by a commission. During this period, Gustav Klimt was working on the concept for the decorative panels in the great hall of the University of Vienna. He and his friend Matsch had been commissioned in 1894 by the Ministry for Culture and Education to create these panels representing the triumph of the light of knowledge over the darkness of ignorance.

Love, from 1895, is an example of this moment of research expressed in a vaporous, post-Impressionist painting.

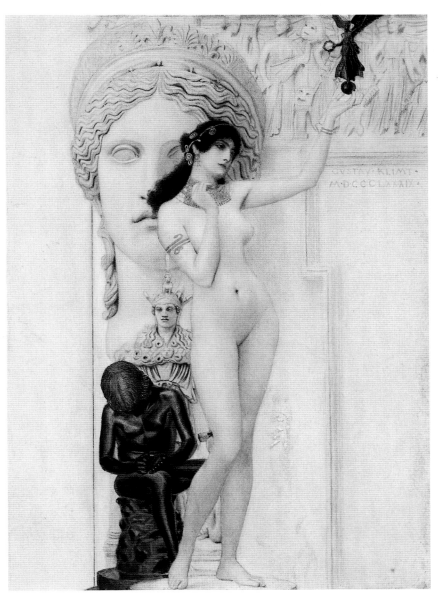

Allegory of Sculpture,
1889; Vienna, Österreichisches Museum
für Angewandte Kunst.

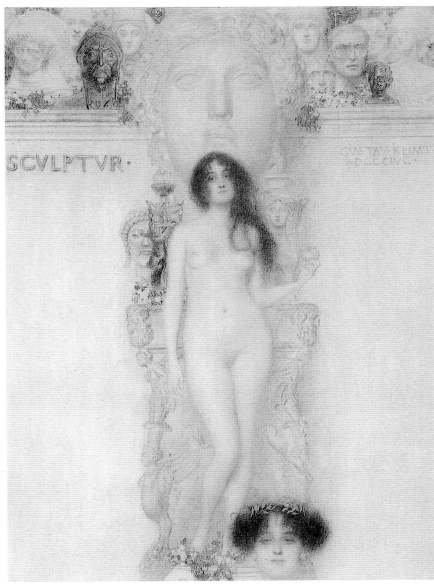

Study for "Allegory of Sculpture,"
1886; Vienna, Wien Museum Karlsplatz.

Wrapped in the fog of a dream, the couple is surrounded by hovering faces representing the tragic destiny from which the ecstatic lovers believe they can escape. Just barely seen above are the terrifying faces of the crowd, Sickness and Death, as well as a child, a woman, and an old woman, signifying the unstoppable decay that the flow of time brings with it, while rose branches on the lateral bands of gold show beauty's eternal fragility.

The first design for the ceiling was presented to the Minister in 1896: a large, central painting, the triumph of light, surrounded by four panels representing respectively Theology, Philosophy,

Medicine, and Jurisprudence. Franz Matsch assumed the job of painting the central section and Theology. The other three would be the work of Klimt.

Comparison between two designs done in that period for the portfolio *Allegories and Emblems,* produced by Viennese publishers Gerlach & Schenk for whom the artist had worked earlier, between 1883 and 1884, help us follow the development of Klimt's investigations into allegory. While the *Allegory of Sculpture* displays a repertory of sculpted busts with a historicist and academic flavor, despite the fact that the mysterious head below hints at the new seduction of modernity, the

design of *Tragedy* (1897) has a more essential allegorical language and, in the surrounding strip that acts as a frame, fades into a curvilinear Jugendstil arabesque, temporarily borrowed from the Dutch painter Jan Theodore Toorop.

Even the cultural climate becomes precise and thick. Here the vision of the ancient is clearly not Apollonian, but rather appears inspired by the ideas of Friedrich Nietzsche in *The Birth of Tragedy.* Here demonic sexuality dominates in the guise of a girl with a dark, fixed gaze, dressed in black but adorned with jewels, holding a mask in her hands. To the lower right, the branch with heart-shaped leaves

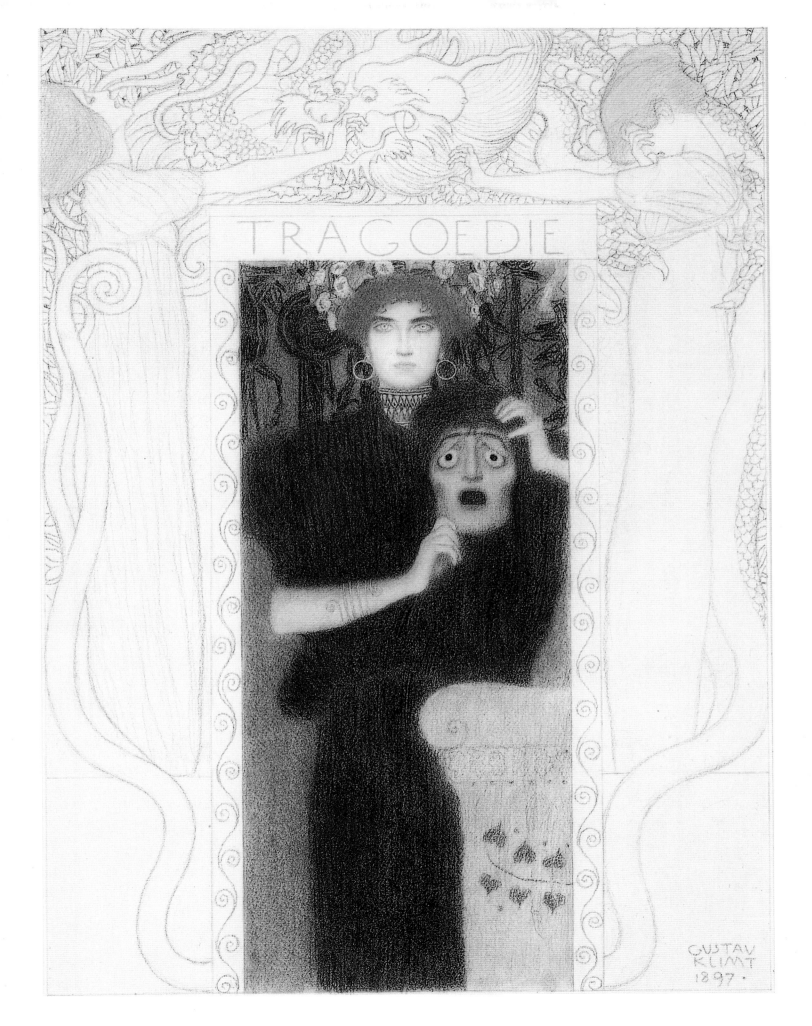

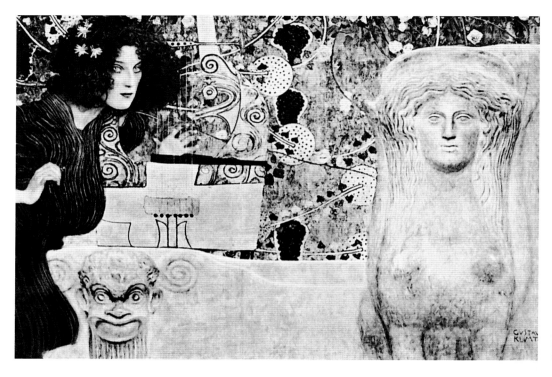

Above left:
Allegory of Music II,
1898; destroyed.

Above right:
Music, Ver Sacrum, 1901.

symbolizes Eros and returns in a painting that is the apotheosis of Eros, *The Kiss,* from 1907.

This same mix of historicism and Jugendstil, with a special predilection for the Empire style, would dominate the furnishings for the Dumba Palace Music Room for which Klimt was commissioned in 1898: mahogany, gilded bronze, marble walls, a white ceiling decorated with stars and serpentine lines, a head of Medusa over the fireplace, a fire screen with motifs of flames and musical notes, and a general eclecticism rich with symbolic meanings similar to the refined atmosphere of the contemporary Villa Stuck in Munich.

For the Music Room, Klimt painted two panels to go over the doors that represented a key point, *Schubert at the Piano I* and *Allegory of Music I*, unfortunately now lost.

Allegory of Music II is the second version of a theme already tackled

in 1895. Although still crowded with naturalistic details, the ornate background and predominant linearity of this painting show how the allegorical theme begins to correspond to a more stylized, intellectual method of painting. The unsettling female figure recalls the attitude of *The Girl from Tanagra* in the museum frescoes, and the presence of the sphinx and faun–like mask reveals the Dionysian secret (for Klimt) of music.

Like *Sonja Knips* (1898), the first of the great portraits in a square format, the two early sketches done in 1898 for the university still remain fluidly atmospheric. The Vienna Secession (Union of Austrian Artists), an artistic rebellion, debuted the same year and was prepared to overturn the Viennese aesthetic derived from the building designed by Joseph M. Olbrich. Despite his shy temperament, Klimt was by then an authoritative figure and driving force for renewal.

Allegory of Music I,
1895; Munich, Neue Pinakothek.

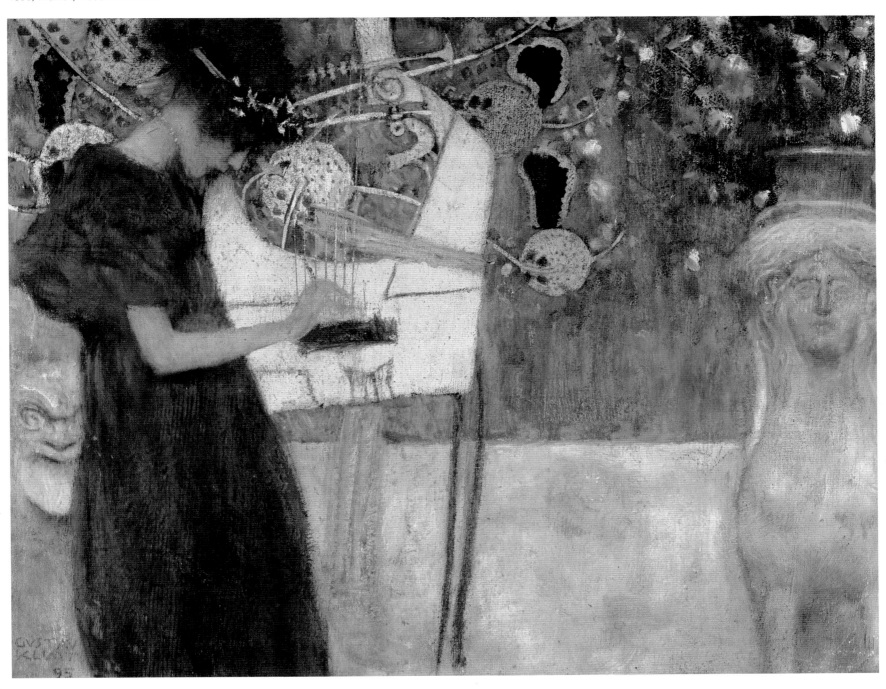

Above:
Head of a Girl, 1898.

Right:
Portrait of Serena Lederer,
1899; New York, Metropolitan
Museum of Art.

Opposite page:
Portrait of a Woman, 1898–99;
Vienna, Österreichische
Galerie Belvedere.

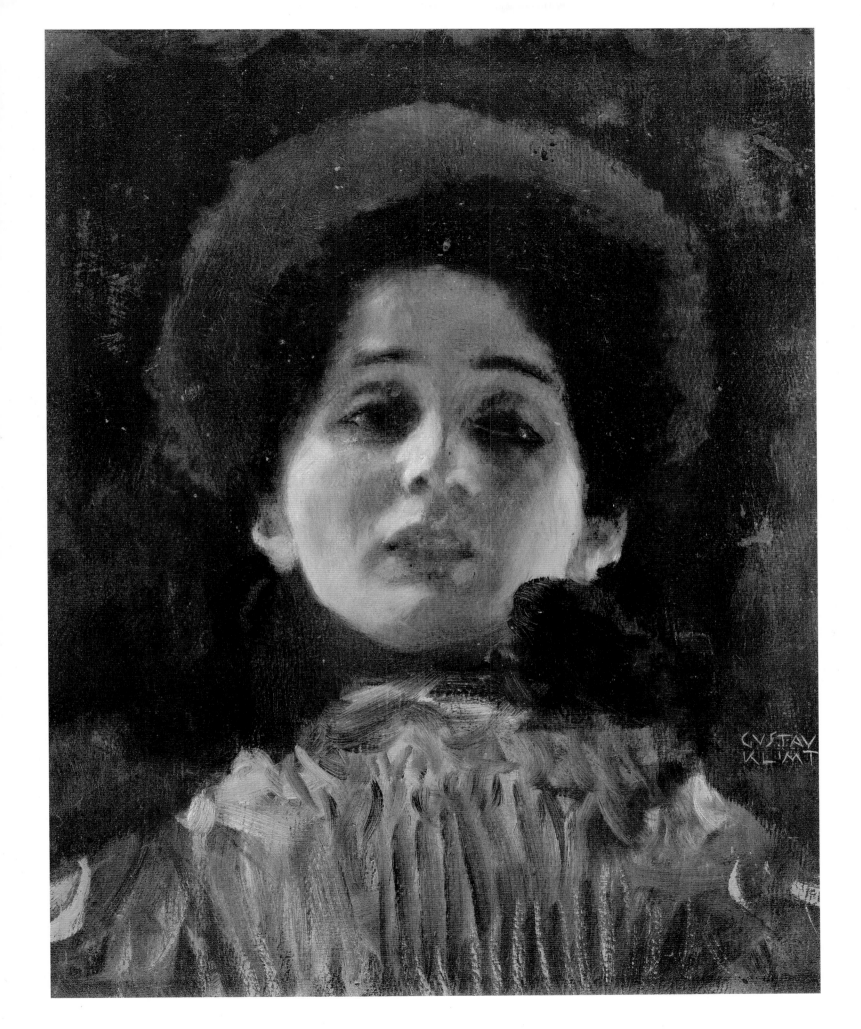

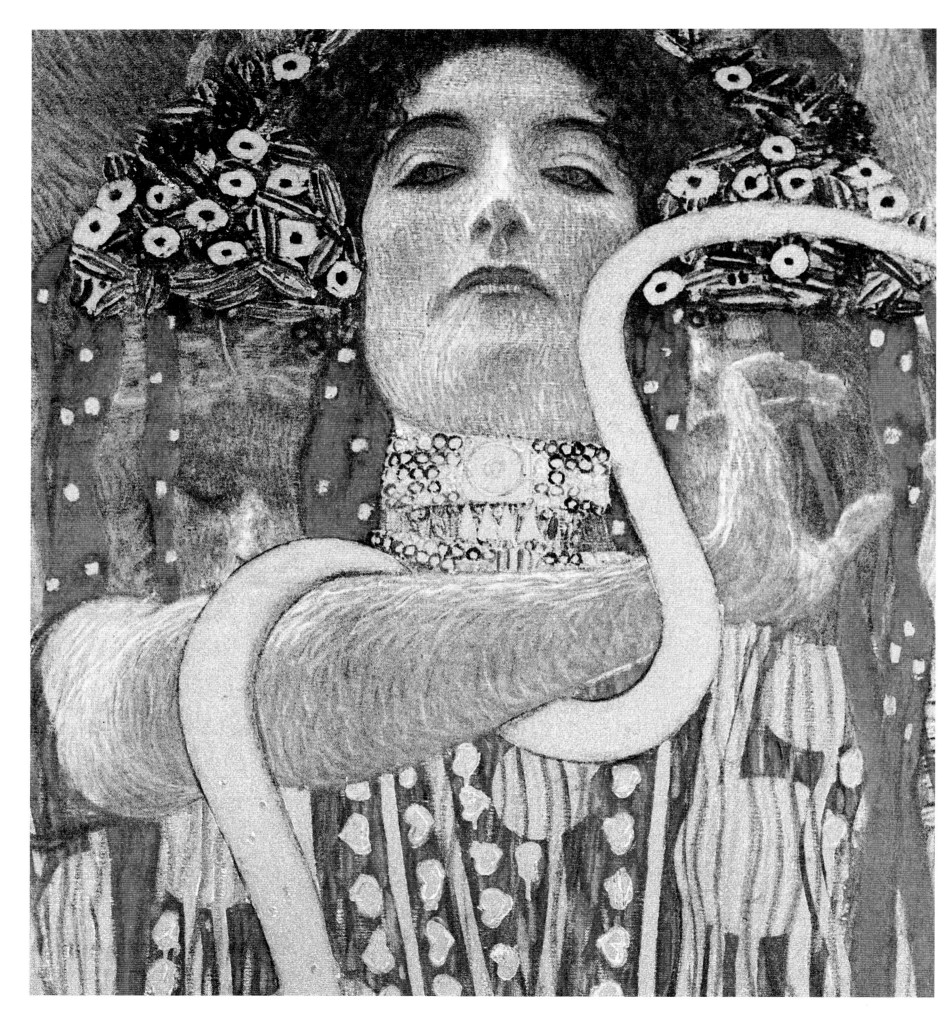

THE SCANDALOUS
PAINTINGS

The difficult affair of the panels for the great hall of the University occurred during the same period when the Secession took center stage in the artistic life of the Viennese, establishing a radical change in the flavor and evolution of Klimt's style. Aware of the fact he would no longer enjoy the general consensus of taste of his academic period, the artist chose a path of poetic truth that annoyed his clients yet at the same time helped develop the unmistakable mark of his decorative symbolism.

As early as 1898, his sketches had been the objects of criticism by the Ministerial Commission. But the controversy exploded in 1900 when the viewing of the first painting, *Philosophy*, sparked the protest of 87 university professors who, in an indignant letter to the Ministry, urged the Commission to reexamine the matter. As the press broadcast the scandal, the controversy became heated and involved the entire Viennese intelligentsia. One of the signatories, the liberal Friedrich Jodl, declared, "We are fighting neither against the nude nor artistic free-dom, but against ugly art." Art historian Franz Wickhoff, aligned with the minority defending Klimt, answered on May 9, 1900, with a conference entitled "What is Ugly?" At the conference, he exposed the critics' defense against the threatening truth expressed by the work examining the notion of ugliness.

During this first phase, the Ministry seemed to protest little and sent *Philosophy* to the Paris Exposition, where it received a gold medal. But the second work, *Medicine*, presented in 1901, heated up the debate even further, provoked by the figure of a pregnant woman accompanied by a column of entangled bodies floating in a void. The painting was accused of being merely a senseless anatomical orgy. Yet 38,000 spectators would flock to see it, attracted by the accusations of immorality. Authorities would even temporarily confiscate the sixth edition of *Ver Sacrum*, the Secession magazine that contained several of Klimt's preparatory designs.

Despite the fact that this controversy was linked to the debate surrounding the Heinze legislation in nearby Germany (against immorality in art that had provoked heated opposition in artistic and liberal circles the same year), even the progressive Kraus would come out against the subject matter of the panels. The various different opinions, collected and published in a small volume by Hermann Bahr in 1903, constitute an interesting documentation of the reception, prejudices, and ideologies of the era, even revealing hints of anti-Semitism.

All this rage provoked a parliamentary interrogation and, when *Jurisprudence* was finished in 1903, the Ministerial Commission judged the works unsuitable for the great hall and proposed instead to exhibit them at the recently established Gallery of Modern Art. Klimt refused the proposal of a different site and reacquired his works from the government in 1905.

This scandal marked the break between the artist and the institutional world and caused his nomination for professor at the academy to be dropped. Klimt declared, "I cannot depend on someone I must struggle against," and from then on would

Reconstruction of the planned location of three paintings (shown in red) by Klimt, commissioned to decorate the ceiling of the Great Hall at the University of Vienna.

Chapter Opening (p. 40):
Medicine, 1901; detail, destroyed.

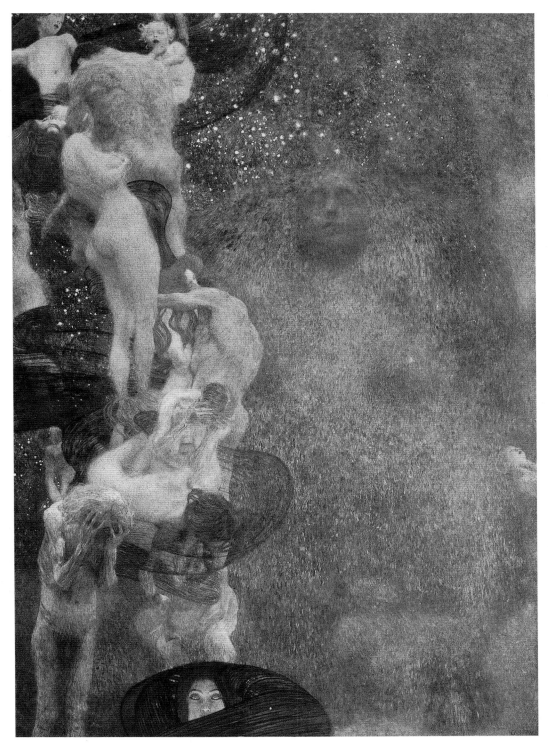

Left:
Philosophy, 1900; destroyed.

Below:
Study [2] for "Medicine,"
1900–01; Vienna, Albertina.

rely solely on the economic support of a cultural elite who collected his works and commissioned portraits. He became an even more charismatic figure in Viennese circles, president of the Secession and surrounded by the enthusiasm of the rich, cultured, Jewish middle class. Yet he found himself forced to renounce what had been his ambition and creed as an artist, the creation of large public commissions that, as he stated in his inaugural speech at the Kunstschau in 1908, he saw as containing the potential for a nonelitist art, an integration between painting and architecture, and a reversal of the logic of a painting as a merchandised object.

He remained obsessed with the three panels. Not just because of the scandal they provoked, but also on account of the clear, formal lack of homogeneity between the first two and the last caused by, as mentioned earlier, the fact that his personal style had matured over the course of their production. He continued working on them, changing details and adding decorative elements, until 1907, when the paintings were

exhibited in private galleries in Berlin and Vienna.

The works were later acquired by one of his major collectors, industrialist August Lederer, but were lost in a fire in 1945. Today, only black-and-white photographic documentation remains except for a color reproduction of the figure of *Hygieia*, a description of the colors in news articles from the period, and a single sketch of *Medicine*.

But what was the cause of all this polemical fervor? As Wickhoff surmised, behind the aversion to the erotic charge of the paintings, the accusations of obscenity concealed the rejection of the ideology that had been turned into image. "The triumph of light over the darkness of ignorance" planned by the Ministry and Academy had been actually overturned in a burst of visionary pessimism imprinted by the philosophy of Schopenhauer and Nietzsche, and filtered through Symbolist culture.

Instead of celebrating the resolving power of science, it illustrated the latter's tragic impotence to liberate humanity from pain. The paintings declared that

philosophy could not help man understand his destiny, medical progress could not conquer death, and law was no more than the legitimization of violence that could defend itself neither from injustice nor from the Furies, the goddesses of vengeance and guilt. Suffering humanity and the cosmic void were at the center of Klimt's representations; science remained in the margins as a divinity and sphinx; and the same concept of space, fluidity, and centerlessness in *Philosophy* and *Medicine*, broken into segments in *Jurisprudence*, announced the crisis in rationalistic values and positivist confidence.

An apparition with blurred outlines emerges from the nebulous firmament of *Philosophy*, as if the blue-green void had condensed into an immense female body and the lunar face of the Sphinx. "The image of the world and its enigma," according to the comments in the catalogue from the Seventh Secession Exhibition, dominates with sublime indifference the floating procession of humanity adrift. Below a head appears as Truth, veiled yet radiating light; it is another feminine representation, more a figure of

Studies for the compositions "Hygeia" and "Couple" for "Medicine," two pages from the four published by the Viennese magazine *Ver Sacrum* (IV, 1901, no. 6) dedicated to the preparatory sketches for the painting shown at the Tenth Secession Exhibition, March 15, 1901.

Gustav Klimt designed the numerals for the sixteen pages.

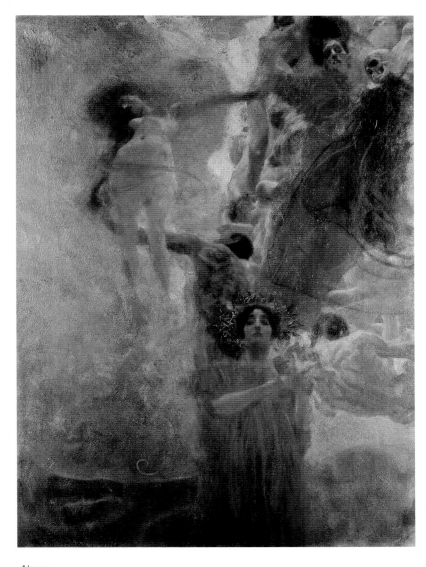

Above:
Sketch for "Medicine," 1897–98.

Right:
Medicine, 1901; destroyed in
the 1945 fire at Immendorf Castle.

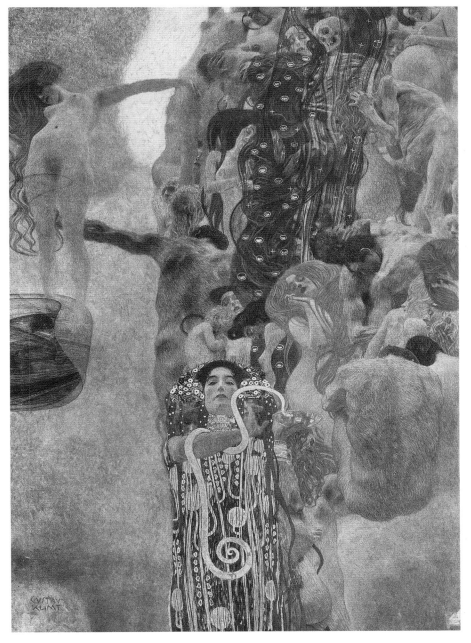

Sibyl and prophetess than an image of rationality triumphant in the cosmic drama.

In *Jurisprudence*, the fluid, existential space of the first two paintings has been petrified, fixed in black and gold, and is now a cage with no escape. The amniotic floating of an inert crowd is replaced by the figure of the victim set into the surface as if trapped inside his own guilt. In the upper section, far away, abstract and cold in their geometric parameters, Truth, Justice, and Law supervise the scene as if mounted in a Byzantine mosaic. Their doubles are the three demoniacal creatures, protagonists in the scene below, who represent the Furies, goddesses of vengeance, remorse, and guilt. As if in a Kafkaesque nightmare, the man being judged with his head bowed awaits the verdict already reached in the octopus-uterus trap that envelopes him. His punishment takes on the semblance of a sinister dream of castration, "a disturbing, fantastic sexual vision," as Carl Schorske would write.

Thus, Klimt not only unmasked the ephemeral nature of the realm of law and order but also displayed the supremacy of dark forces over reason in the cosmology of the other two panels. He gave the face of a woman to these profound psychic energies. While in *Philosophy* and *Medicine* the figures of the Sphinx/Isis, Truth/Sibyl, and the priestess Hygieia proclaim the sovereignty of the feminine, *Jurisprudence* explodes with anguish over the negative power of the matriarchal principle.

The theme of the bipolarity of the feminine myth, embedding the ambivalence of Eros between instinct and socio-cultural foundations, would dominate all Klimt's work. Like Freud and Nietzsche, he would bring back the instinctive, subterranean forces of Ancient Greece in order to give a meaning and face to the values and angst of contemporary life.

Therefore, these three panels represent a fundamental stage in his artistic evolution. Over the course of the slow progress of their completion, between 1898 and 1903, not only did his per-sonal poetics and pan-sexual vision take shape, but also his particular abstract-decorative style. *Jurisprudence* announced the definitive abandonment of those pictorial-atmospheric values that still permeated *Philosophy* and *Medicine*. It showed the use of anti-Impressionist color and a choice of linear stylization, and the dominance of the surface with a collage of ornamental motifs within which is set the extreme naturalism of the figure. In fact, *Jurisprudence* is constructed of the contrast between a rigid, flattened spatiality, linked decoratively to mosaic methods, and the shortened perspective of the powerfully three-dimensional body. Here, the scenic, illustrative machine of allegory has been reduced to an interlocking fabric, an ambiguous, obsessive puzzle. The ornament becomes structure and message. "Depth must hide. Where? On the surface," wrote the poet Hofmannsthal during this period, thus reflecting Nietzsche's imperative in *The Gay Science* (1882) "to be, as the Greeks, superficial because of being profound."

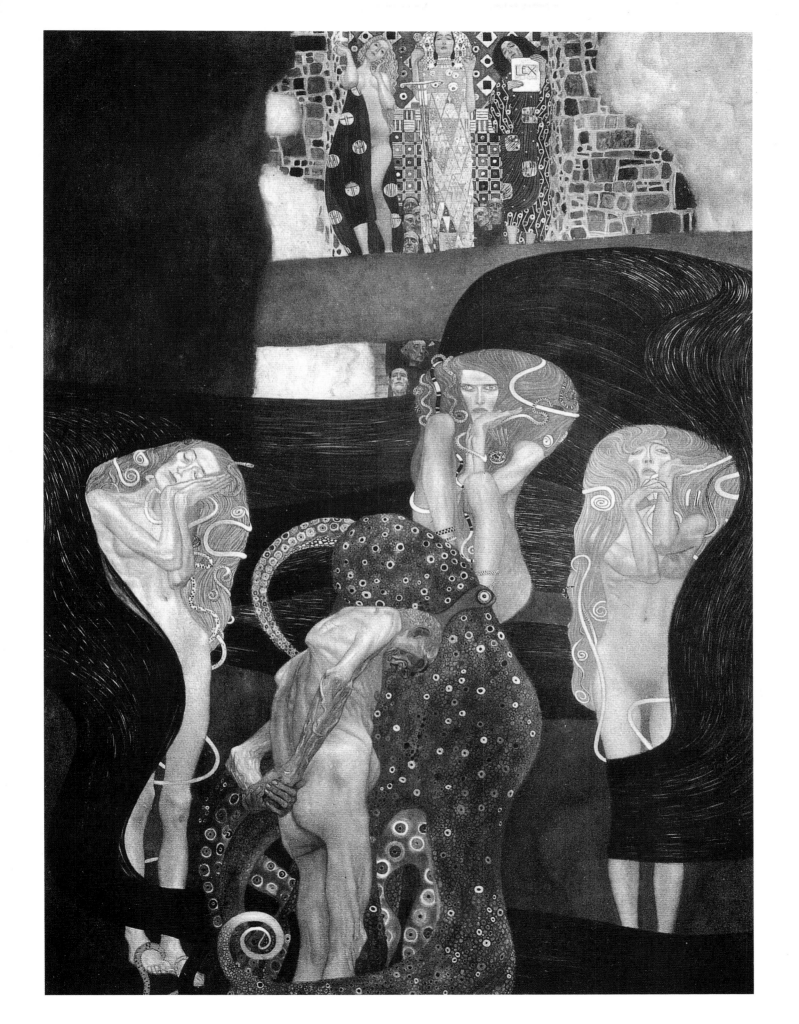

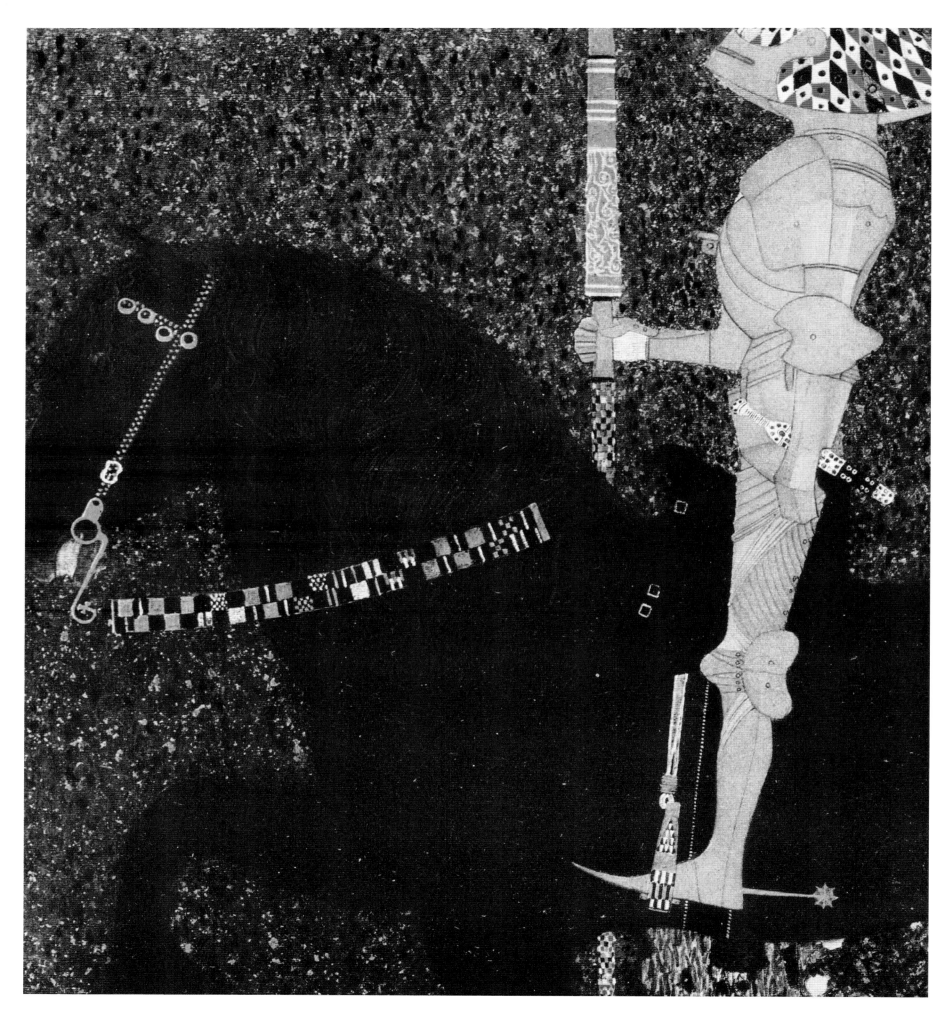

THE SECESSION YEARS

At the center of controversy, yet president of the Secession at the same time, Klimt had meanwhile become the major player in the rebirth of the artistic scene. It was Klimt who, on April 3, 1897, sent a letter to the management of the Künstlerhaus (the Artist's House that directed the association of Viennese artists and the official organization of exhibitions) informing them the Secession had been founded in order to "bring Viennese artistic life into a vital relationship with developments in foreign art and present exhibitions with a pure artistic character, free from any market requirements."

This was discussed in the salon of the writer Berta Zuckerkandl, at the Mahler house, Caffè Sperl and Caffè Griensteidl, with the art critic Ludwig Hevesi, writer Hermann Bahr, and the progressive director of the Burgtheater, Max Burckhard. Klimt had already developed an early plan in 1896 together with the painters Josef Engelhart and Carl Moll. Their initial intention was simply to create an internal committee within the Viennese Artists' Association. But after the group was

founded, the rigid attitude of the conservatives led to a complete break in just a month and a half, making it the Secession not only in word but in deed.

The model and the name recalled the ancient Roman *secessio plebis*; it was also derived from the Munich Secession, founded in 1892 by Franz von Struck. Their 1894 exhibition in Vienna had fed the growing current inside the institution that controlled local artistic life, rebuked by younger artists for not opening up to the spirit of the times that was also identified with Symbolist art. This cultural need was widespread. In 1898, a similar secession was also inaugurated in Berlin. But while other European secessions remained simply names of artistic associations, the Viennese Secession quickly became synonymous with modernism and a stylistic trademark. This was definitely attributable to the quality of the personalities involved and the special intellectual climate in Austria at the time.

In Vienna, the Secessionists' critical targets were historical painting and sketched realism, but above all, the eclectic,

historicist decoration of the architecture along the Ringstrasse, the broad ring road that had replaced the ancient walls surrounding the old city center. Between 1858 and 1888, the opulent new seats of power were built there, the theaters, museums, and palaces of the wealthy new bourgeoisie. This monumental project of urban planning had rendered the face of the capital majestic, where Gothic, Renaissance, and Baroque revival followed each other with grandiose grace.

The demands of modernity would inform the Secessionist motto, "to every age its art and to art its freedom," and coincided with the need to leave the era of artistic revivals, now judged a traditionalist travesty. Not coincidentally, three architects were among the organizers of the Secession: the old and eminent Otto Wagner, and two young men, Josef Hoffmann and Joseph Olbrich, moved by the desire to re-create architectural culture. "Modern man needs to be shown his true face," wrote Wagner. In *Modern Architecture* in 1895, he defined the Vienna of the Ringstrasse as "a city by Potemkin,"

Right:
Franz von Stuck, *Poster for the First International Art Exhibition of the Munich Secession,* 1893; Munich, Münchner Stadtmuseum.

Far right:
Franz von Stuck, *The Sin,* 1893.

Chapter Opening (p. 48):
Life Is a Struggle (or *The Golden Knight*), 1903, detail; Nagoya, Aichi Prefectural Museum of Art.

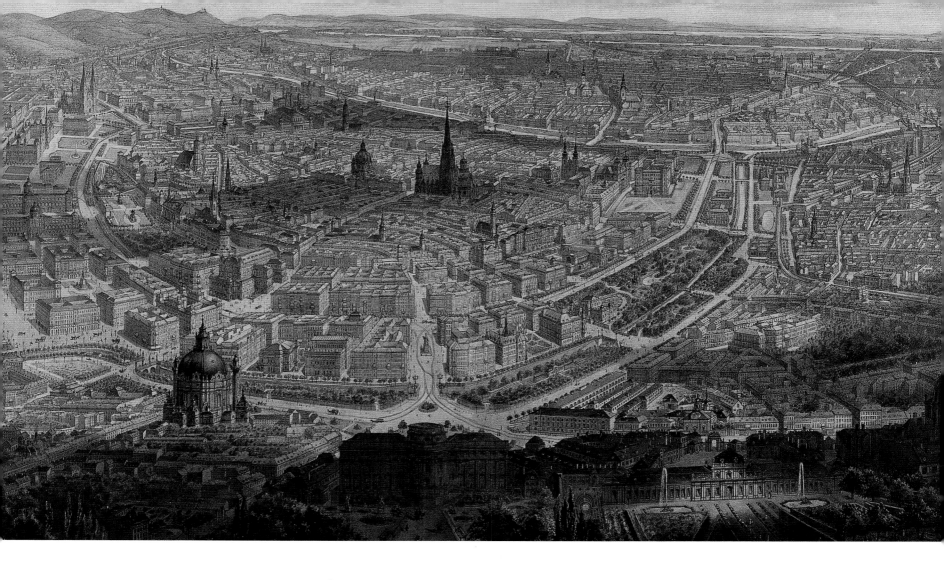

Left:
Two designs for the new
Karlsplatz plan with two
views of the construction
of the Stadtmuseum, 1909.

Above:
Gustav Veith, *Vienna Viewed
from the South with the
Ringstrasse, the Year of the 1873
World Exposition,* detail; Vienna,
Wien Museum Karlsplatz.

Otto Wagner, *Canalization of the Danube with a view of the Neue Aspern and Ferdinand bridges,* 1897; Vienna, Wien Museum Karlsplatz.

the Czarina's favorite general, who erected fake façades as screens to hide the squalor and emptiness in districts he knew Catherine II would pass through.

Initially, the Secession's agenda avoided formulating any real manifesto for the movement and was generic from the ideological point of view, although very concrete on the practical level. In fact, plans were immediately made for a magazine called *Ver Sacrum*, the construction of an exhibition pavilion, and the organization of exhibitions. The movement's vagueness was inevitable, since the group that had given birth to the association, gathered around the notion of modernity, was fairly heterogeneous and brought together naturalists, late-Impressionists, and sentimental sketch artists. But in reality, the movement's leading personalities (Klimt, the architects Otto Wagner, Joseph Olbrich, and Josef Hoffmann, and painters Carl Moll, Koloman Moser, Maximilian Kurzweil, and Alfred Roller) had a clearly defined orientation, and the existence of an unmistakable "Secessionist" style was quickly evident to everyone. This

would later provoke a series of internal conflicts and finally forced the sensational departure of Klimt's group in 1905. Although the association would continue to exist after that, it would lose its initial impetus.

Basic to the immediate success of the ambitious Secessionist projects was the support, financial and otherwise, of the Jewish cultural elite and sons of the bureaucratic upper-middle class that had become established as the managerial class after the 1848 revolution. These were, paradoxically, the inhabitants of the "Potemkin City." In other words, the birth of the new style was supported by those who had wealthy homes along the Ringstrasse.

The municipal political situation was also favorable at the time, since Christian Social Party forces led by the demagogue Karl Lueger, who feared compromising his confirmation as mayor in April 1897, would consider it opportune not to obstruct the project and voted to grant a plot of land for the construction of the Secessionist pavilion. This area was fairly central, adjacent to the great square

in front of the baroque church of Saint Charles where Wagner was building one of the metro stations. Olbrich immediately began to design the new building, inaugurated in November 1898 with the second group exhibition.

In the meantime, the opening of the First Secession Exhibition on March 23, 1898, in the pavilion of the Horticultural Society, was grand, very official, and even honored by the presence of the old emperor Franz Joseph who, although he had never nurtured any strong aesthetic passions, still considered it one of his duties to patronize art and encourage new developments, as long as they remained within the limits of propriety. But then again, even though they were revolting against academic power, these young Viennese artists were definitely neither *maudits* (outcasts) nor "bohemians," nor did they cultivate irritating anti-bourgeois habits. On the contrary, they respected convention. The old emperor could have only been surprised, although certainly secretly pleased, when he saw the young artists were led by an 80-year-old painter,

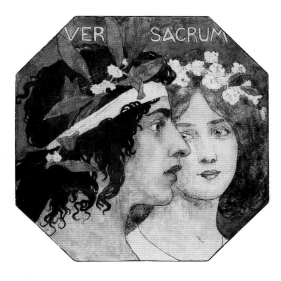

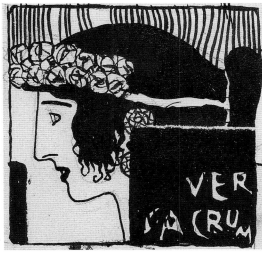

Left:
Gustav Klimt, *Drawing for* Ver Sacrum, 1898; Vienna, Albertina.

Below:
Façade of a building in Vienna with decorative elements from the Secession, designed (1898–99) by the architect Otto Wagner.

Above:
Johann Viktor Krämer, *Watercolor for* Ver Sacrum, 1897; Vienna, Albertina.

Below:
Joseph Maria Olbrich, *Poster for the Second Secession Exhibition,* 1898; Vienna, Wien Museum Karlsplatz.

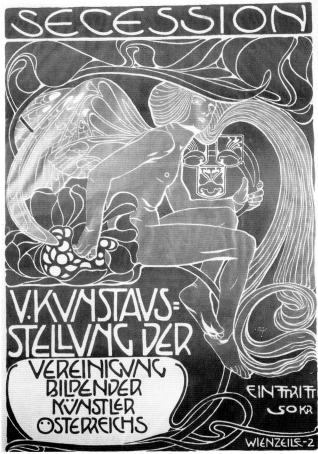

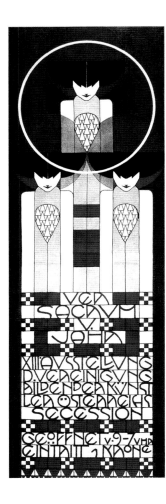

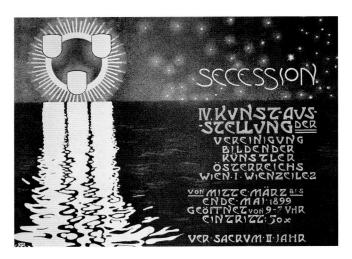

Rudolf von Alt, who, as honorary president, paid homage to all those present. "I am truly very old, Your Majesty, but I feel young enough to start over again from the beginning."

Reported in the news of the time and illustrated with a drawing by Secessionist painter Rudolf Bacher, who depicted Klimt in a tailcoat to the left of the emperor, respectful but firm in his resolve, this anecdote bears perfect witness to the peculiar atmosphere in fin-de-siècle Vienna, where crisis and the replacement of values appeared to progress smoothly, where apparently the old emperor seemed able to absorb and defuse intemperance, and even intellectual "revolts" seemed to shrink from extremes and barricades.

The first Secession exhibition closed with a total of 57,000 visitors and 218 works sold, an unprecedented success. Viennese artistic life seemed suddenly to shake off its torpor. Along with the zeppelin, streetcars, electric lights, the tele-phone, and the typewriter, the winds of modern art had arrived in the Danube capital, especially the idea that this art had inescapable international features.

In autumn of the same year, at the edge of the baroque Karlsplatz where the first metro stations designed by Wagner had been recently inaugurated, the second exhibition opened the doors to the new pavilion. This expressive, symbolic building had suddenly given life to the Secessionist idea and application of the new style, distinguishing itself quickly from the heterogeneous, scenographic landscape of historicist architecture because of its candid smoothness and geometric measure, crowned by an open-work dome of laurel leaves in brass-plated wrought iron. Conceived by Joseph M. Olbrich as a "temple to art that bestows on the art lover a quiet, elegant refuge…white, shining walls, chaste and pure…simple dignity, like the unfinished temple of Segesta, in front of which I lingered alone, unmoving, while a shudder ran through me." The construction suggests solemnity without imposition, while the neutrality of the white walls, in contrast with the neo-Renaissance of museums from the period, is functional in giving central place to the works exhibited.

Olbrich's design created the basis for a new language and at the same time was a declaration of poetics: a temple for art, a place of initiation where such an attitude of aestheticism could be manifested along with that cult of art that would become ever more evident among Secessionists in subsequent years and was peculiar to Viennese culture at the time. Consider the decadence of a man of letters like Hermann Bahr, one of the most passionate supporters of Klimt and Secessionism, and the circle of writers and poets who gathered around him, or the poet Hugo von Hofmannsthal who wrote in his *Antigone*, "Only in works of art is there Truth, all the rest is nothing more than a game of mirrors."

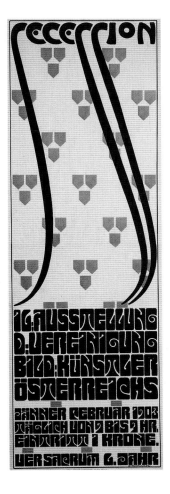

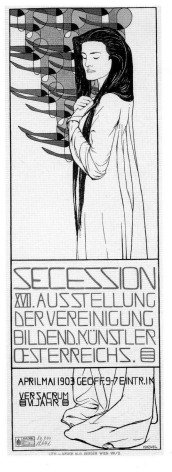

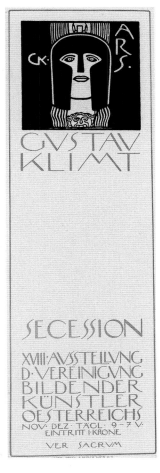

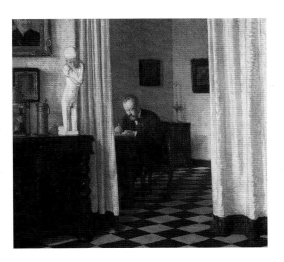

Nietzsche had already expressed this idea in *The Birth of Tragedy* (1872)— "Being in the world is legitimate only as an aesthetic phenomenon"—and this cultural theme became widespread in the twilight of old Europe, permeating even the symbolic universe of an artist like Klimt. This could not be otherwise.

In his role as catalyzing element and president of the Secession, Klimt was actively involved in designing the building. A couple of his sketches testify to his role as advisor to Olbrich. It seems legitimate to consider as his idea the naked, smooth whiteness of the two walls flanking the entrance, where in an earlier phase he considered instead creating mural decorations. Clearly he inspired the masks of the three Gorgons placed above the entrance, the designs traceable to one of the surviving sketches, as well as other insertions on the lateral façades such as the three owls, the birds of Athena, and other zoomorphic presences that make

up the intentional symbolic representation of a nocturnal, female realm of the imagination, a central theme in Klimt's work.

One new feature in this modern architecture was the transformable interior space, totally neutral and available, of the building designed by Olbrich. The contribution of the Secession to the modern concept of exhibition design is fundamental. The idea also was to create innovative exhibitions from the point of view of presentation.

They were no longer interested in simply hanging paintings on the walls but in developing a global model where interior architecture and the applied arts would come together in creating a unique environment adapted to each single exhibition. From the first exhibition in 1898, two criteria were used that appeared radically new for the exhibition culture of the period and coincided with the disordered confusion and model of the Salon: the paintings were actually

hung at eye level and grouped by artist. Beginning with the second exhibition, the mobile walls of the Secession pavilion made it possible to create constantly new arrangements and spatial harmonies.

This new concept foresaw the design phase entrusted to an architect and equally as important as the phase of choosing the works to be exhibited. This reached its peak at the fourth exhibition designed by Olbrich in 1899, the ninth exhibition designed by Alfred Roller in 1901, and finally the fourteenth exhibition in April 1902, dedicated to Ludwig von Beethoven and designed by Josef Hoffmann.

In the case of the Beethoven exhibition, the increasing trend toward a complete aesthetic harmony among concept, exhibited object, interior decoration, and furnishings represents the most important attempt in European art to create a total artwork. In any case, these principles continued to be developed and act on the contemporary concept of the museum.

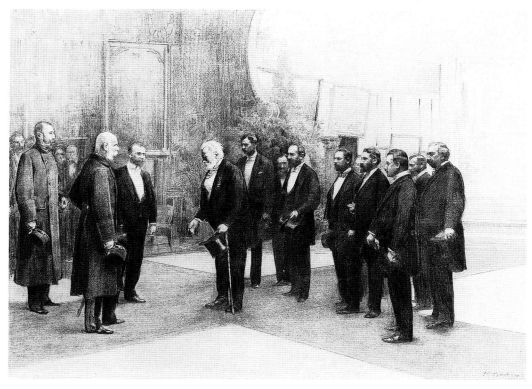

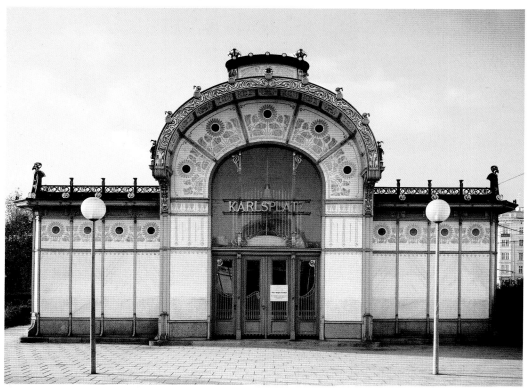

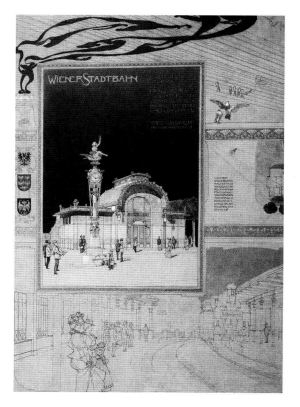

Left:
Rudolf Bacher,
Emperor Franz Joseph at the First Secession Exhibition, 1898; Vienna, Wien Museum Karlsplatz.

Below left:
The Karlsplatz station of the Vienna metro, designed by the architect Otto Wagner, 1898.

Below right:
Otto Wagner, *Prospective Drawing of the Vienna Metro, Karlsplatz Station,* 1898; Vienna, Wien Museum Karlsplatz.

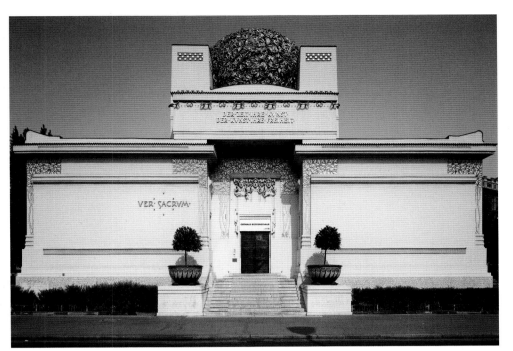

Below:
Sketch [1] of the Secession Building, 1898,
detail; Vienna, Wien Museum Karlsplatz.
This was drawn on the back of a letter to
Klimt signed by Alfred Roller.

Above:
Sketch [2] of the Secession Building,
1897, detail; Vienna, Wien Museum
Karlsplatz.

Above right:
Main façade of the Secession
Building designed by Joseph
Maria Olbrich, 1897–98.

Below:
Detail of stuccowork on the
walls of the entrance, with
masks of the three Gorgons
representing Painting,
Architecture, and Sculpture.
The phrase above the door-
way reads: "To every age its
art and to art its freedom."

The Secession also stimulated public efforts in contemporary art, giving rise to a policy of institutional acquisitions to which the association itself contributed by dedicating a third of its profits from sales. Among others, they acquired works by Vincent van Gogh, Giovanni Segantini, and Auguste Rodin, and assembled the first public collection of modern art in Vienna. Ratified by Emperor Franz Joseph I in 1902, the gallery was inaugurated the following year. Between 1898 and 1905, the Secession organized 23 exhibitions, many of which would remain memorable. During this period, artists usually present included Franz von Stuck and Arnold Böcklin, Max Klinger and George Minne, Edvard Munch and Henri de Toulouse-Lautrec, Auguste Rodin, Giovanni Segantini, Ferdinand Hodler, Eugène Carrière, Eugène Grasset, Alphonse Mucha, Walter Crane, Jan Toorop, Fernand Khnopff, and Charles Mackintosh.

In January 1900, the Sixth Secession Exhibition celebrated Japanese graphic art, recognizing it as an influence on the development of European art. This was when the idea was first mentioned openly in Vienna of a "Style," conceived as a powerfully two-dimensional figurative language, aimed at joining organic lines and geometric shapes, and creating a decorative, structural rhythm instead of a representation.

Although similar to the aesthetic universalism of Art Nouveau and the German Jugendstil, the emerging trend within the Secession broke away from this by giving priority to square shapes and the play of angles in antithesis to the typical fluidity of Art Nouveau, a choice that reveals an intellectual-rationalist character tinged with ornamental abundance, the need for a clear, economical structure, for an element of balance where the forces in opposition or subjected to gravity are anchored and cancel one

another out. The checkerboard planes that break up spaces and surfaces also suggest the nostalgia for a calm, peaceful state outside time and the world's condition expressed in the conflict with the power of gravity. So the geometric module contained and condensed the dual spirit of Viennese culture: the need for discipline and the necessity for refuge.

The aesthetic climax came in 1902. As already mentioned, the fourteenth exhibition was a shrine to Beethoven, prototype of the artistic genius. The harmony among the arts was celebrated and the doors to the Secessionist temple were opened to the chorus from the *Ninth Symphony* conducted by Mahler, followed by the cultish dances of Isadora Duncan.

The first historicization of modernity and the "Style" was attempted in 1903. The Sixteenth Secession Exhibition in fact recognized Impressionism as the forerunner of the modern, and among its

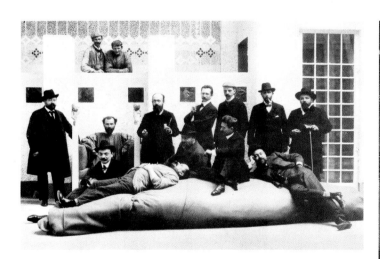

Group of artists from the Fourteenth Secession Exhibition (1902) in a photograph by Moritz Nahr. Klimt is seated in the second row with Koloman Moser in front of him. Carl Moll is reclining on the right.

Opposite page:
Gnawing Grief, 1902, detail from the second wall of the *Beethoven Frieze;* Vienna, the Secession Building.

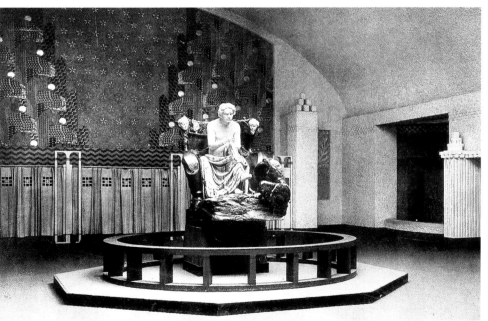

The main hall of the Fourteenth Secession Exhibition (1902) with the Beethoven statue sculpted by Max Klinger, now in Leipzig, Museum der Bildenden Künste.

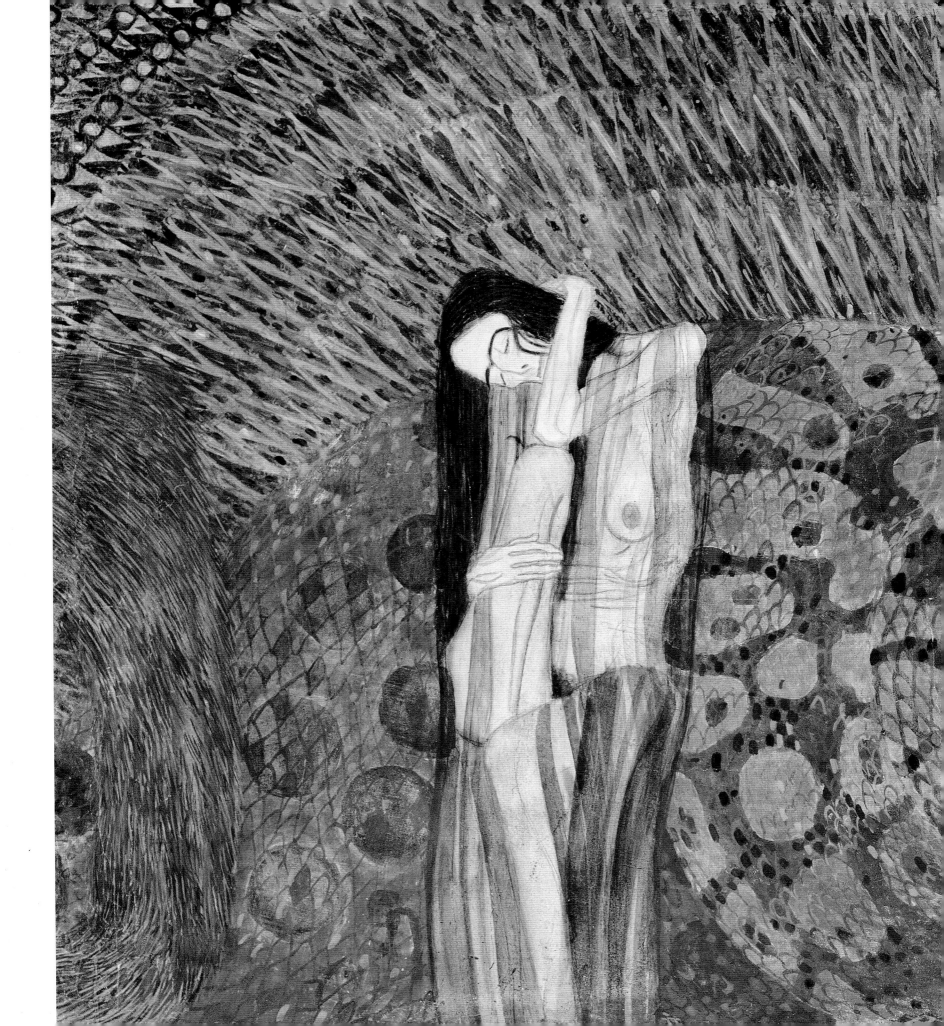

Left:
Gnawing Grief, 1902,
detail from the second wall
of the *Beethoven Frieze;*
Vienna, the Secession
Building.

The spirals of an interminable
serpent's tail make up the
background for the mournful
figure of Woe.

Top right:
Katsushika Hokusai,
*Illustrated Book of
Musashi Province,* 1836;
London, British Museum.

Below:
Jan Toorop, *The Dreamer,*
1897; Vienna, Albertina.

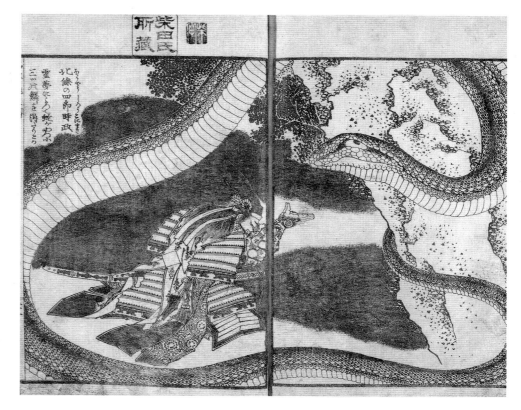

Above:
Fernand Khnopff, *Portrait of a Girl with Long Hair*, 1895; Vienna, Albertina.

Right:
Fernand Khnopff, *Study for "L'Offrande,"* 1891; Vienna, Albertina.

prophets traced El Greco, Velázquez, Goya, Corot, Delacroix, Constable, and Turner. This look backward traces a path toward the progressive fading of representation and the emancipation of content. This vision of art history would play a crucial role in the formulation of a historiography of contemporaneity and attribute the key turning point to Georges Seurat, demonstrate the role of Japanese print-making, and identify as fundamental moments of transition toward the "Style"— in other words the central role of surfaces—works by van Gogh, Gauguin, Toulouse-Lautrec, Bonnard, Denis, Redon, Vallotton, Vigeland, and Vuillard.

This historic awareness, clearly tracing the suppositions and genesis of their own expressive morphology, corresponded to an assumption of responsibility. In the Secessionist creed, ethics and aesthetics coincide; form is also and above all an existential orientation.

That year, 1903, the movement was at its peak and the Eighteenth Secession Exhibition, designed by Koloman Moser, would be a solo exhibition for Klimt,

surrounded by the admiration of his collectors and at the center of the scandal sparked by the university panels.

The 48 paintings exhibited expressed the quintessence of the Secessionist style and, like *Jurisprudence*, declared the abandonment of pictorial-atmospheric values and the choice of a rigid, flattened spatiality, of compositions joined together from naturalistic elements, ornamental motifs, and precious materials, of a search for refinement and harmony that instead of relaxing tension, concentrated it, fixing it in a setting like a jewel.

This was his golden period, coinciding with the full bloom of his creative maturity. Klimtian Vienna became a new Byzantium where the metallization of his scenes heightens sensuality, deifies beauty, and compresses all the ambivalent seduction of life into the inaccessible, ecstatic face of a woman.

In the meantime, despite the controversies raging around its president, government support of the Secession remained strong. Its artists received commissions for not only important

buildings, but the design of stamps and money as well.

The scholar Carl Schorske's hypothesis is that a tacit agreement existed in some way between the Secessionists' cosmopolitan spirit and the supranational statutes of a government occupied in keeping various nationalist movements at bay. It should be remembered that in 1898, the same year the Secession opened and contemporaneity gracefully occupied a square in Vienna, the assassination of the intolerant, vagabond Empress Elisabeth in Geneva suggested the solidity of the empire. Its institutions may have been in essence illusory, and signaled the turbulence of the rising new century, foreshadowing that day in June 1914, when several shots from a pistol would kill the Hapsburg world, and with it, the old Europe.

Below:
Kitagawa Utamaro, *Husband and Wife Caught in an Evening Shower,* c. 1800; Vienna, Albertina.

Right:
Alfred Roller, *Poster for the Fourteenth Secession Exhibition,* 1902.

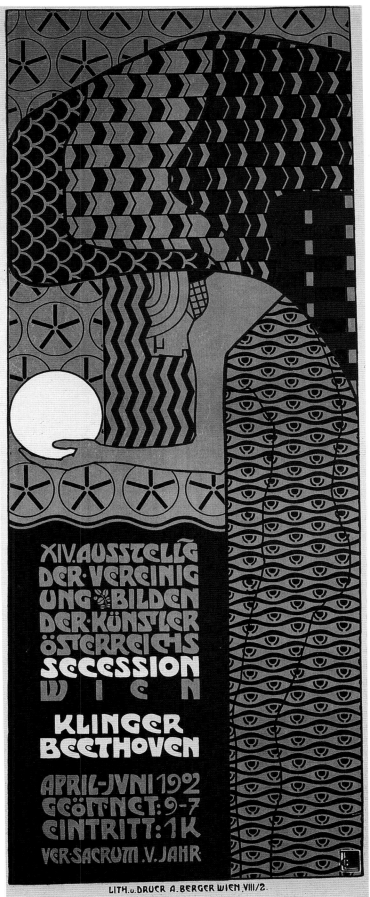

FROM *VER SACRUM* TO THE WIENER WERKSTÄTTE
(VIENNA WORKSHOP)

Chapter Opening (p. 64):
The Blood of Fish, 1898.

Below left:
Serenade, drawing by Gustav Klimt
for the magazine *Jugend*, 1882;
Vienna, Wien Museum Karlsplatz.

Below right:
Josef Hoffmann, *Moravian Country House*,
1900, title page of Hoffmann's contribution
to the Viennese magazine *Ver Sacrum*.

"I firmly insist every edition of *Ver Sacrum* be a small exhibition and the entire *Ver Sacrum* a large one," wrote Alfred Roller in a letter to Gustav Klimt from 1898. And each one of the 96 editions of the magazine, published between 1898 and 1903 in printings that ran from 400 to 600 copies, was presented as a complete, coherent work of art, just as each of the 55 lithographs or 216 woodcuts published seems like the membership card of an organic whole born out of collective labor.

Sacred Spring, the title taken from a line by the Romantic German poet Ludwig Uhland, joins the need for rebirth with the sublime concept of art the Secessionists wished to make coexist with the need for its democratization. In fact, the editorial in the first edition reads, "To reawaken, stimulate, and spread the artistic sensibility of our time…We know no difference between great art and small art, between art for the rich and art for the poor. Art is a collective good."

Magazines played a fundamental role in spreading new aesthetic principles during this period. The trend was started in 1893 by the English publication *The Studio*, widely read in Vienna; *Pan*, started in Berlin in 1895; and *Jugend*, founded in Munich in 1896. But *Ver Sacrum* was something more than an organ for propagating international modernism. Secessionist artists used it as a field for experimentation and allowed themselves greater freedom in graphics than they dared take in their painting which, with the exception of Klimt's, would remain a step behind.

On the open territory of the square page, absent from contrast and conflict with the rules of painting, the new "Style"—the linearism that combined abstract and figurative forms on the same plane, the sensitivity for the rhythm of surfaces—flourished freely. Though in the beginning Secessionist artists dealt more with illustrating or framing written articles, they developed a new relationship of

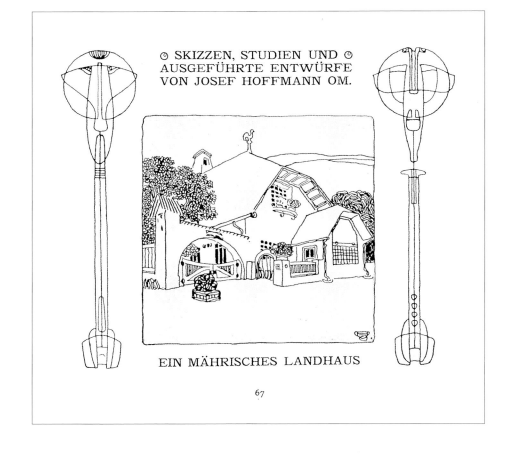

SKIZZEN, STUDIEN UND
AUSGEFÜHRTE ENTWÜRFE
VON JOSEF HOFFMANN OM.

EIN MÄHRISCHES LANDHAUS

67

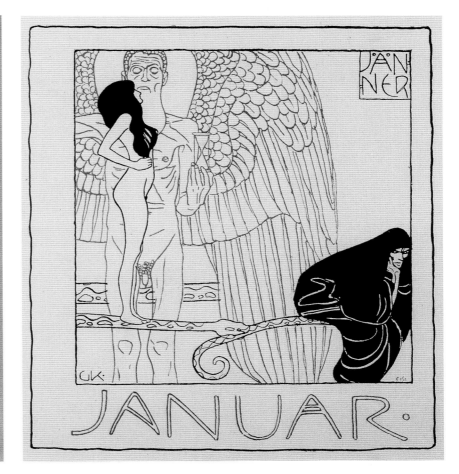

Above left:
Cover, initialed A. D., of the
magazine *Jugend* (no. 2,
January 8, 1900), with the
Allegory of Fortune;
Munich, Münchner Stadtmuseum.

Above right:
Gustav Klimt, illustration for the
month of January 1901, page of
a calendar attached to a special
edition of the magazine *Ver
Sacrum* (IV, 1901, p. 2).

Left:
Cover, signed H. Weiss,
of the magazine *Jugend*
(no. 50, December 12, 1896),
with *The Birth of Modernity*;
Munich, Münchner Stadtmuseum.

harmony between work and image. This involved absorbing the "vibrations" of the text in order to translate them into allegories of line and color that led to the intermingling of writing and decoration until the typographic character itself became part of a harmonic whole. This profound reinvention of book art was mostly due to the graphic genius of Koloman Moser. The page layouts for articles by Bahr, Loos, Khnopff, and Segantini; texts by Hugo von Hofmannsthal, Emile Verhaeren, and Maurice Maeterlinck; and poetry by Arno Holz and Rainer Maria Rilke, gave birth to the decorative modules Josef Hoffmann would later transfer to the walls of his interiors.

Klimt was especially involved the first year, 1898, with several graphic decorations and some original designs (including *Nuda Veritas, The Blood of Fish*, and *Envy*). He also collaborated, though infrequently, in 1900 and 1901. As already mentioned, the sixth edition of the magazine in 1901 contained several reproductions of the scandalous preparatory designs for *Medicine* and was confiscated even though the court would later authorize its circulation as a specialist journal.

In 1903, the affirmation of the new "Style," and the growing number of commissions, suggested creating the studios of the Wiener Werkstätte, in the spirit of the Arts and Crafts movement of William Morris, to help realize the long-awaited joining of arts and crafts and to carry out the overarching aesthetic plans advanced by Secessionism. The periodical now appeared superfluous and, in the final editorial, the artists declared the first cycle of their activity closed, satisfied at having achieved the initial dual purpose of spreading European art in Austria and Austrian art in Europe. Internal disagreements between the "naturalists" and the smaller yet dominant group of the "stylists" may have contributed to accelerating the magazine's closing. This conflict became clearer the following year when it led to canceling Secessionist participation at the Saint Louis International Exposition and finally their breakup in 1905.

Active until 1932, despite continuous financial problems, the Wiener Werkstätte was the Secession's longest lasting creation and the instrument which best equipped the association to realize its aspirations for the total work, the rule of absolute harmony between building and detail, painting, furnishings, and lifestyle.

"The period animated by the foundation of the Viennese Secession, which wrote on its flag the motto 'To the Age its Art' and loved to occupy itself with problems that sprang from daily life, awakened in Moser and me the powerful desire to make anew all the things from everyday life," later wrote Hoffmann. Thanks to financial support from the industrialist Fritz Waerndorfer, he and Moser founded the Arts and Crafts studios. Architecture

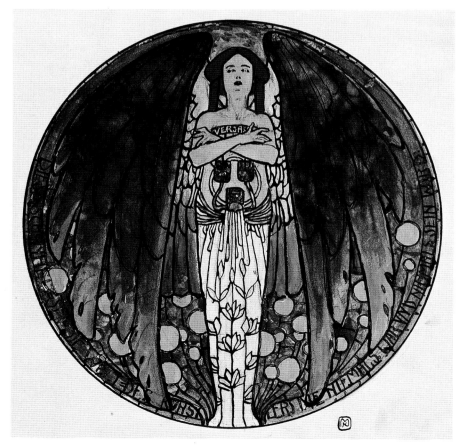

Koloman Moser, *Angel Viewed from the Front,* 1897–98, stained glass window design; Vienna, Österreichisches Museum für Angewandte Kunst.

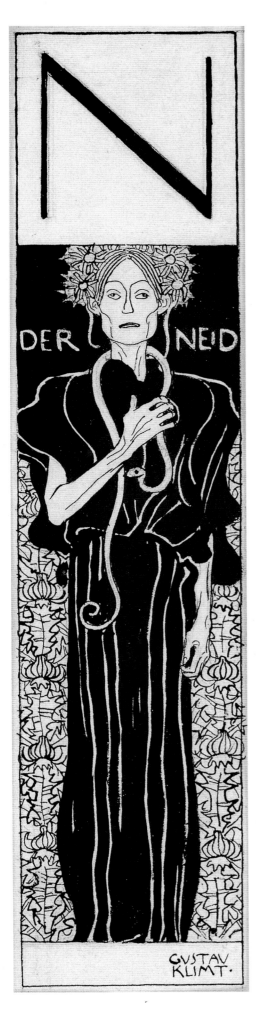

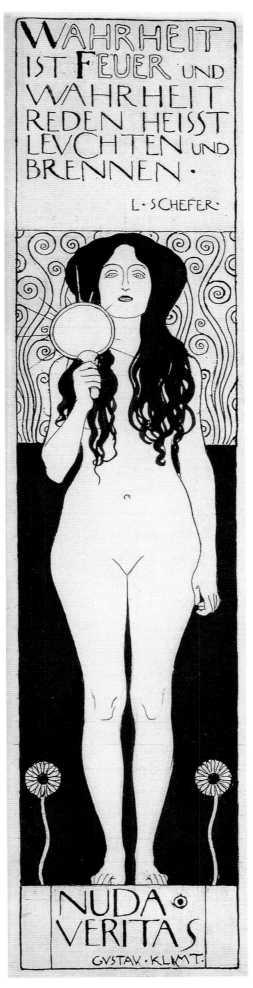

Far left:
Envy, 1898, illustration for the magazine *Ver Sacrum.*

Left:
Nuda Veritas, 1898, drawing for the March edition of *Ver Sacrum.*

At the top is the quote by L. Schefer: "Truth is fire, and to speak the truth means to illuminate and burn."

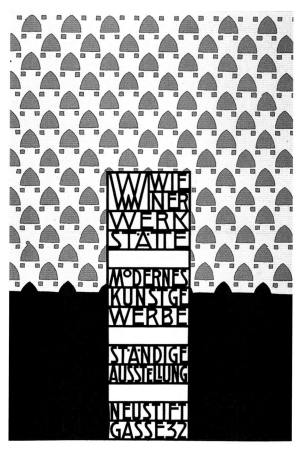

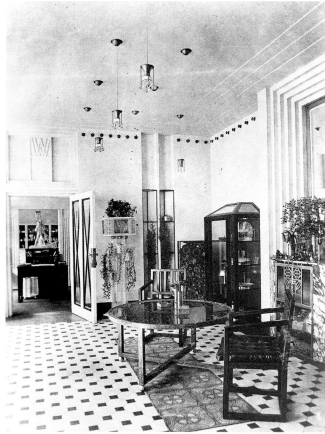

Left:
Josef Hoffmann,
Poster for the Wiener Werkstätte, c. 1908, with the logo of the Viennese Workshop Association founded by Hoffmann in 1903 in the spirit of the London "Arts and Crafts" movement started by William Morris in 1851.

Far left:
Interior of the Wiener Werkstätte headquarters.

had finally conquered the dimension of the applied arts, measured in small-scale projects and details, and the ever-growing consecration of art was accompanied by the need to make everyday life aesthetic, to enter into homes and ennoble useful objects, to transform even teatime into an artistic event. This totalizing concept of art was also joined by the need to purify, considering the architectural façades and interiors of middle-class residences, furnished with the eclectic overabundance of nineteenth-century well-being and infested with knick-knacks like "inkstands shaped like powder horns and cigarette holders shaped like doghouses."

The unrealistic motto of "An art for everyone" corresponded with an elite, costly production. But although this may have thwarted their developing utopia and revealed the absence of an ideological structure capable of considering the imminence of a new social subject, mass society, it nevertheless failed to tarnish

new and original products from a broad variety of fields (ceramics, glass, metal, paper, cloth, furniture, and jewelry). With the exception of the work of Scotsman Charles Rennie Mackintosh, who exerted notable influence on Secessionist crafts and on Hoffmann in particular, this production immediately distinguished itself in contrast to the European Jugendstil (Art Nouveau) in its preference of straight lines rather than curves and the geometric over the organic aspect, from decorative as well as structural points of view. The square became the basic form and trademark; simple elements and clear black-and-white contrasts were predominant and the invention of elementary objects made with metal grillwork walls constituted one of the more pure and functional results destined to be frequently imitated.

Aside from furnishing a large number of stores and apartments, the Wiener Werkstätte created Cabaret Fledermaus,

a small underground theater in the heart of Vienna designed entirely by Hoffmann. The walls of the colorful bar were covered in a jigsaw puzzle of 7,000 majolica tiles, with figures and decorations, and made a lively prologue to the linear elegance of the black-and-white hall where notes of color came exclusively from the performances; sets and costumes were designed by the Wiener Werkstätte for the entire period the cabaret was active, between 1907 and 1913.

Based on the fame of the studios, and Hoffmann himself, two large building projects were completed: the Sanatorium in Purkersdorf (1904–05) and Palais Stoclet in Brussels (1905–11). Both of these materialized as the basic concept of Secessionism: the work of art as a collective outcome and the rule of harmony among building and detail, space, furnishings, and lifestyle. But a disparity lies between these two constructions that reveals the dual nature of the Secession:

Below:
Josef Hoffmann and Koloman Moser, Wiener Werkstätte logo reproduced on wrapping paper and letterhead stationary, 1903–1910.

Right:
Tile panel designed by William Morris in 1876 to decorate the floor of Membland Hall in Devon; destroyed in 1928.

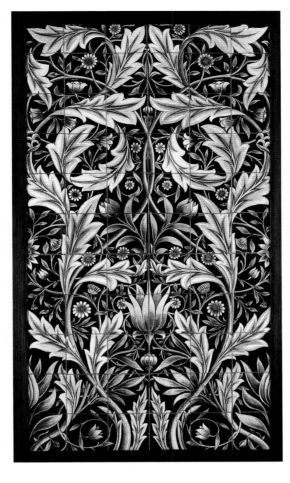

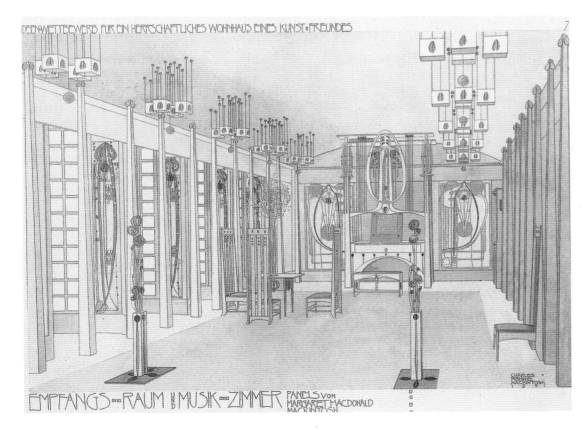

Above right:
William Morris, original black-and-white design for *St. James's wallpaper, 126,* 1880; London, William Morris Gallery.

Left:
Charles Rennie Mackintosh, *Reception and Music Hall,* 1901; interior design for the competition "Haus eines Kunstfreundes" (House of an Art Lover).

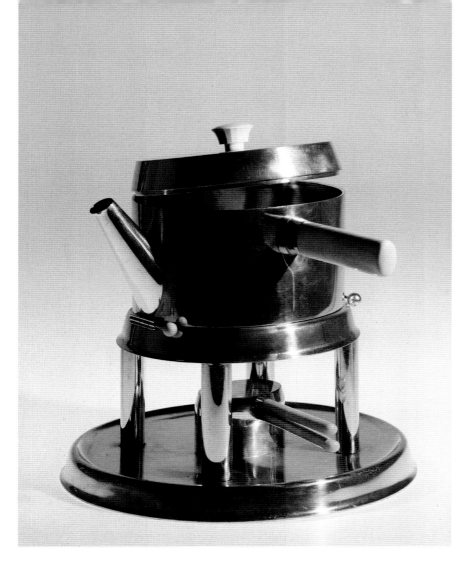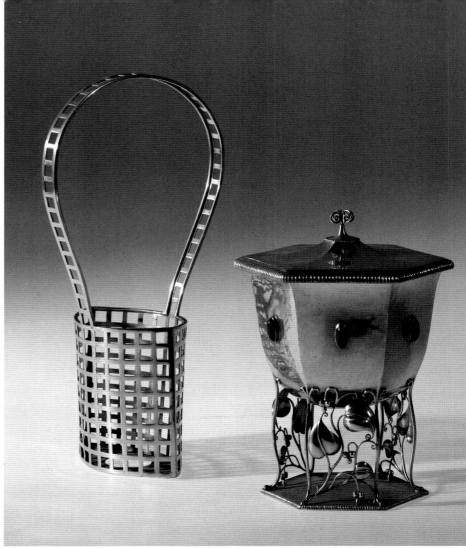

the difficulty in balancing the tension toward the "necessary form" and the aspiration toward "sublime totality," and finally the prevalence of ornamental exquisiteness over functional objectivity, luxury over simplicity. The white, square Purkersdorf Sanatorium was the concretization of Hoffmann's geometric, functional, and democratic dream, but unfortunately has not retained the original structure and furnishings. Palais Stoclet was designed by the same architect as the private residence of a multimillionaire and involved many artists from the Wiener Werkstätte studios. (Klimt created a large symbolic-decorative frieze for the dining room.) Still intact today, in the refined simplicity of its structure, obsessive attention to detail, preciousness of ornamentation, and architectural harmony, the building stands out as an ivory tower of beauty and the ultimate elitist stylization of the bourgeois lifestyle.

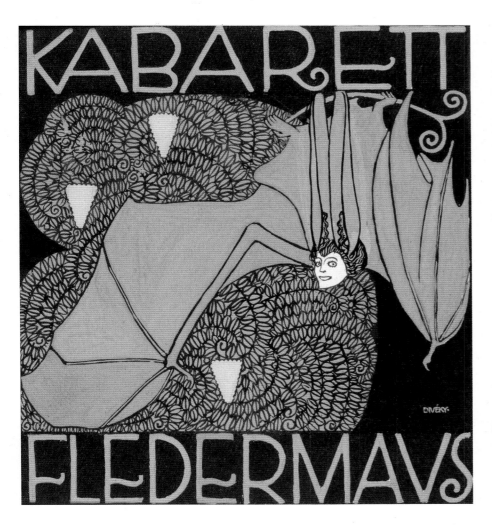

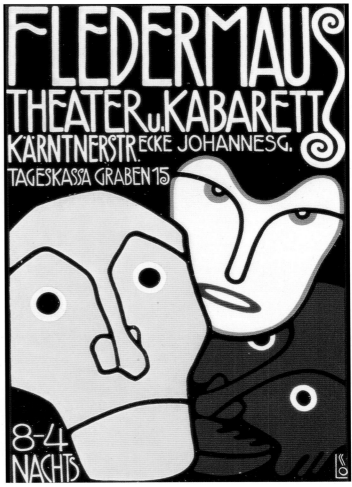

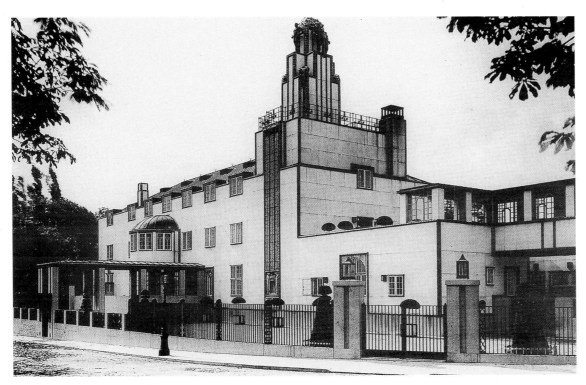

Above left:
Josef von Diveky, *Poster for Cabaret Fledermaus*, 1907.

Above right:
Bertold Lôffler, *Poster for Cabaret Fledermaus*, 1907.

Left:
The Stoclet Palace in Brussels was designed by Josef Hoffmann as the private residence of an industrialist and constructed between 1905 and 1911; Photographic Archives of the National Association of Art and Antique Assessors.

KLIMT'S ARTISTIC CREED

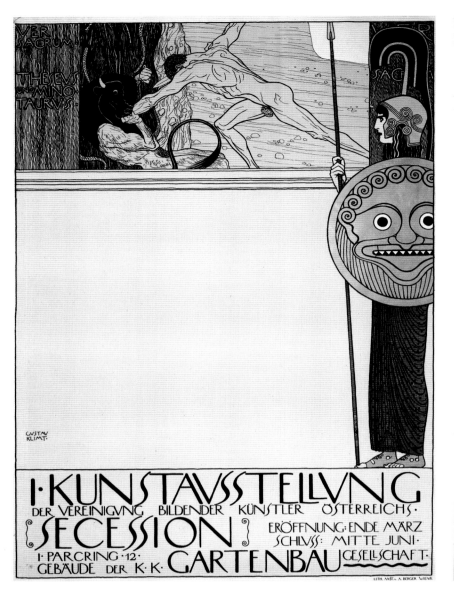

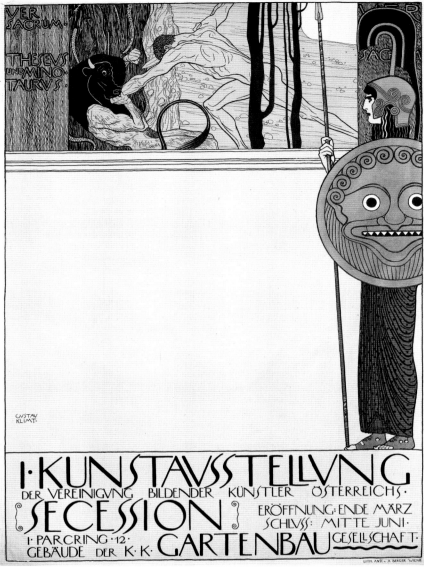

Theseus and the Minotaur.
Poster for the First Secession Exhibition,
1898, in the original version (left) and
censored version (right); Vienna,
Wien Museum Karlsplatz.

Chapter Opening (p. 74):
Pallas Athena, 1898, detail;
Vienna, Wien Museum Karlsplatz.

The medal worn on the armor of
golden scales portrays the
grotesque effigy of the Gorgon.
The hand of Athena squeezes
between her fingers a nude woman
with red hair and pubic hair.

Klimt designed the poster for the First Secession Exhibition in 1898, and once again there was such controversy that the artist was forced to censor it and supply a second version with a tree trunk to cover the nudity of Theseus who kills the Minotaur under Athena's vigilant gaze. The hero who freed Athenian youth appeared to Klimt as the most appropriate image for illustrating the generational revolt aimed at liberating art from duty to convention.

But even the stylized figure of Athena, virgin warrior goddess, inspiration for the arts and spiritual combat, proposed by the artist as a graphic motif in the magazine and other publications, became a sort of Secessionist symbol. This was in keeping with its presence in the poster by Franz von Stuck (1893) of the First Munich Secession Exhibition, and the motif Kandinsky used again in the poster for the Munich Secessionist association Phalanx (1901).

Shown at the Second Secession Exhibition, the painting *Pallas Athena* (1898) created no lack of dissension. The brilliant critic and chronicler of that period Ludwig Hevesi wrote at the time, "The public is accustomed to Athenas where you clearly see in reality they are painted marble statues. Klimt has represented his Athena openly as a Secessionist of today, a goddess or demon of the Secession with pale, clear blue coloring, great, clear, celestial eyes, and fine red hair that falls on both sides."

Again in this case, Klimt appropriated the frontal position of the goddess within

the square format from a work by Franz von Stuck, but attributed the ineffable and slightly vampirish expression to the heroines of Khnopff, and in the background painted a wrestling scene between Heracles and Triton taken from an ancient Greek vase. His *Pallas Athena* has the same unapproachable frontality of the stately Hygeia, who dominates suffering humanity in the *Medicine* panel, and oblivious Judith who, in a subsequent painting, holds a man in her fist. On her breastplate of golden scales, she carries the medallion with the ancient, grotesque effigy of the Gorgon, harkening back to an ancestral emasculating power. Not coincidentally, this disturbing detail specifically aroused the most criticism. More than just a symbol of the freedom of the arts, this is also the first appearance of the Klimtian model of the femme fatale.

In place of the traditional statuette of Nike, the goddess holds in her hand a small female nude, a "living sculpture" with fiery red hair and pubic hair, colors of the apocalyptic Whore of Babylon, and arms outstretched in the same gesture of self-offering as made by the ancient priestesses of Astarte. In the spirit of the Secessionist motto, Athena presents Living Art, a sensual, ecstatic creature who appears as the vestal of what will become from that moment on Klimt's purpose: painting as a place for the celebration of Eros and woman as the powerful priestess of her universe.

With these same attributes—the delicate nudity, the hair color, the reflecting mirror in her hand, the light blue veil that rises up like a wave around her feet—along with an added serpent, the small figure would become the protagonist in a painting the following year: *Nuda Veritas*,

a modern Aphrodite and allegory for a truth that matches the most secret desires, those removed by daytime morality and social norms.

The work was painted the following year for the study of the writer Hermann Bahr, *Apostle of the Secession*, as a pictorial version of a drawing that had already appeared in the March 1898 edition of *Ver Sacrum*. The inscription above was changed and the quote from Jean Louis Schefer in the drawing ("Truth is fire, truth means to illuminate and burn") was substituted in the painting, with a clear sense of controversy, by a phrase from Friedrich von Schiller, "If you cannot please many with your actions and art, please few. Pleasing many is bad."

Enclosed between two gilded boards, the dominant note is the light blue of the veil that floats behind Naked Truth and evokes the movement of water with its waving.

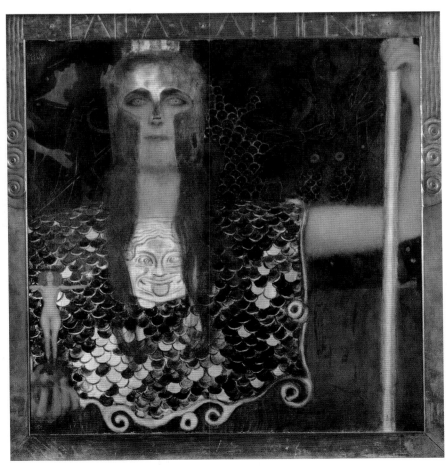

Far left:
Ex Libris, c. 1900, for the Seventh Secession Exhibition.

Left:
Pallas Athena, 1898; Vienna, Wien Museum Karlsplatz.

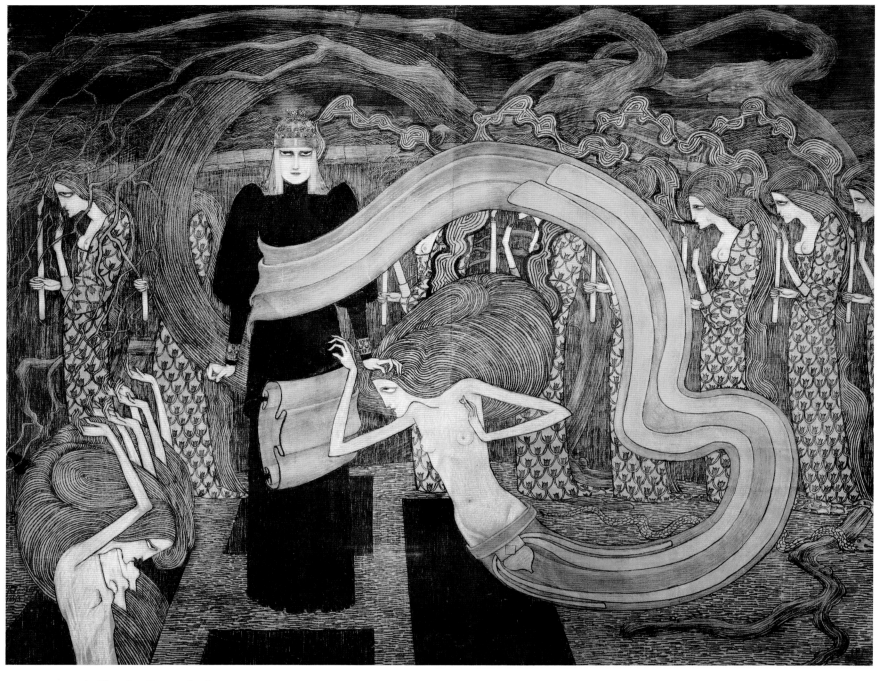

Jan Theodore Toorop, *Fatality*,
1893; Otterlo, Rijksmuseum
Kroller-Muller.

Opposite page:
Pallas Athena, 1898, detail;
Vienna, Wien Museum Karlsplatz.

The background portrays an
ancient scene from the struggle
between Heracles and Triton.

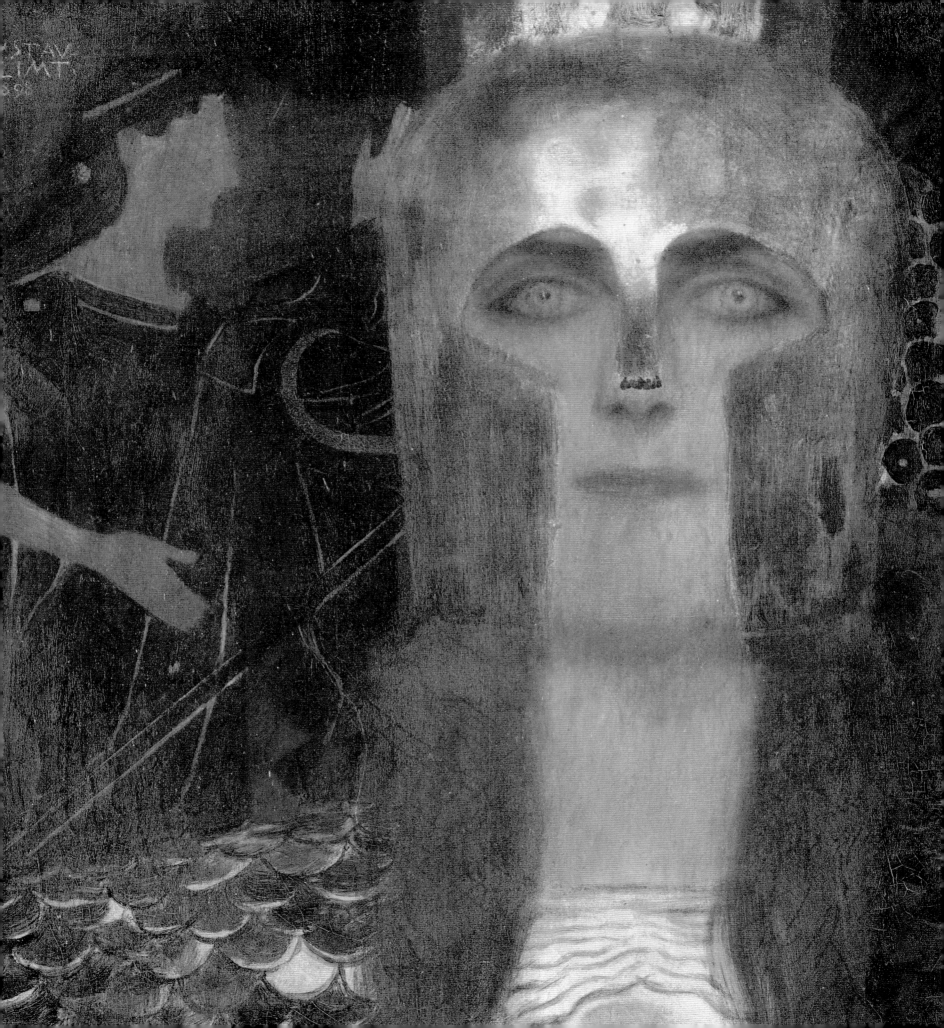

Nuda Veritas, 1899, entire
painting far right and detail
on the opposite page;
Vienna, Österreichisches
Theatermuseum.

Right:
Max Klinger, *The Serpent*,
1880, from the series
Eve and the Future.

Below:
Ferdinand Khnopff,
Head of a Woman, 1899.

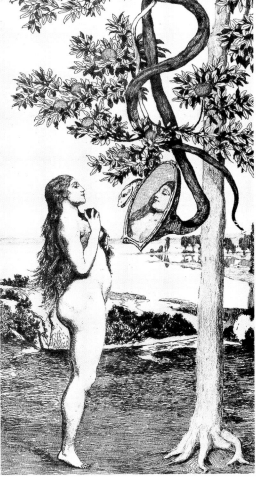

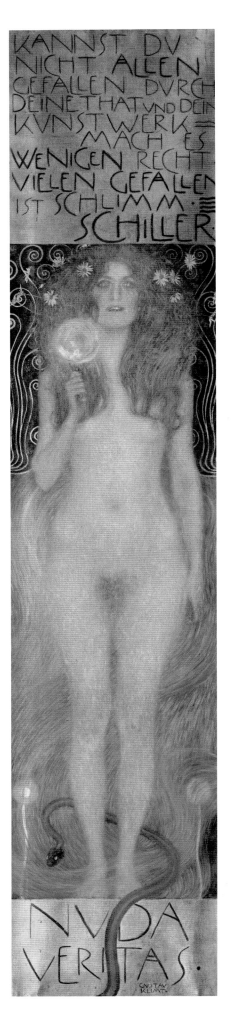

The two flowers below are dandelions. Their downy blowballs scatter everywhere at the slightest breeze and symbolize the rapid spread of new ideas. In iconographic tradition, the mirror and serpent are symbols of Prudence when they appear together. But in an etching from 1880 by Max Klinger, an artist dear to the Secessionists, they instead represent the two instruments of the sin of Eve. On the other hand, the mirror is also one of the key themes in fin-de-siècle symbolism, where the motif of Narcissus is superimposed by the motif of Dorian Gray. Like the portrait of Dorian in the Oscar Wilde novel, the mirror contains and reveals the secret ego; watching one's reflection is equal to throwing away the social mask in order to recognize the most intimate truth within oneself. So if the serpent is simultaneously a symbol of wisdom and libido, then the mirror-torch Truth held menacingly aimed at the public is at the same time Pandora's box and Psyche's lamp, perilous temptation as well as scandalous revelation of the most secret contents of the consciousness.

Although that may make it unpopular, as Schiller noted (pleasing few rather than many), so-called True Art is inhabited by phantasms of desire and unafraid of expressing what social norms repress.

In *Nuda Veritas*, Klimt turns to his reflections on the function of art and gives a face to his erotic-aesthetic ideology. Sketched while working on the university panels, this pan-sexual vision is in some ways similar to the theories developed by Sigmund Freud. The cardinal text of Freudian psychoanalysis, *The Interpretation of Dreams*, would be published the following year, 1900.

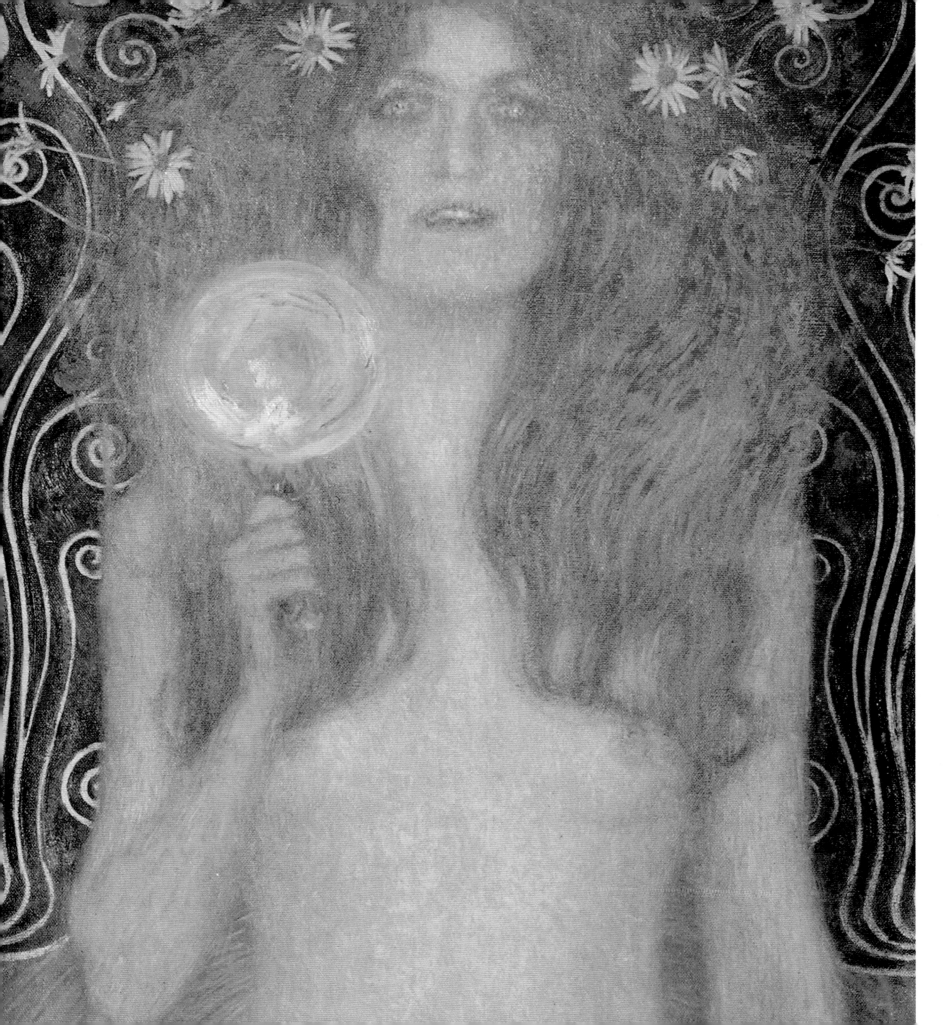

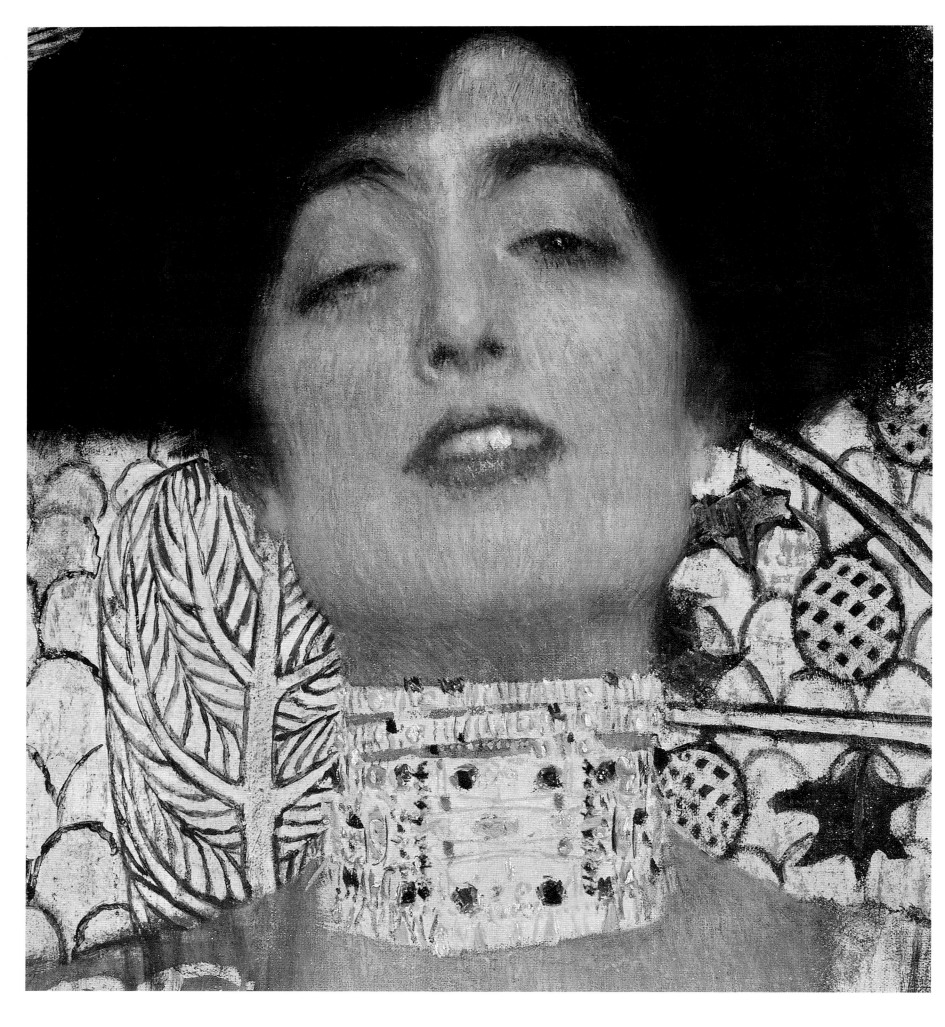

THE GOLD OF SEDUCTION

Klimt's women are covered in gold, supreme creatures mounted into precious surfaces like jewels and icons of a new religion. But this "gyneolatry" also contains within itself its own downfall and the fear of its own capitulation. *Judith I* from 1901 celebrates the femme fatale and at the same time marks the beginning of Klimt's "golden style," which reached its peak in the second, different version, *Judith II*, in 1909.

For the artist, son of a goldsmith, gold was the shining memory of his childhood as well as the timeless material of regal seduction. Perhaps he discovered the potential of the color gold with a decorative function in the painting *Modern Amoretti* (1868) by Hans Makart, his first pictorial reference. He began to use it first in frame panels such as *Love* and the *Portrait of Josef Lewinsky* from 1895, then as an ornamental background element in the two versions of *Allegory of Music* (1895 and 1898), until finally gold became his dominant compositional material.

The peculiarity of Klimt's "golden style" lies not only in the massive use of pure gold leaf and gilded paper, but above all in the structural role this assumes in the painting. In fact, while Klimtian gold seeks to transfigure reality as in Byzantine mosaics, i.e., fix the image in a sublime eternal transcendence by freezing it in the metal's distance and perfection, the artist's use of it recalls mainly the technique of Gentile da Fabriano.

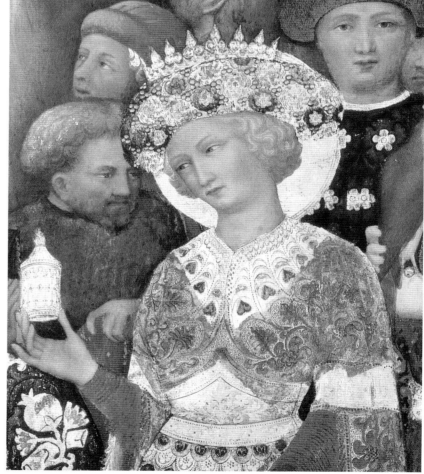

Above right:
The Empress Theodora and Her Court, c. 540, detail; Ravenna, Basilica of San Vitale (southern side).

Right:
Gentile da Fabriano, *Adoration of the Magi* (Pala Strozzi), 1420–23, detail of *Balthazar;* Florence, Uffizi Gallery.

Opposite page:
Judith, 1895, detail; Vienna, Österreichische Galerie Belvedere.

Chapter Opening (p. 82):
Judith I, 1901, detail; Vienna, Österreichische Galerie Belvedere.

Opposite page:
Love, 1895, detail; Vienna,
Wien Museum Karlsplatz.

Left:
*Portrait of the Actor Josef
Lewinsky*, 1895; Vienna,
Österreichische Galerie
Belvedere.

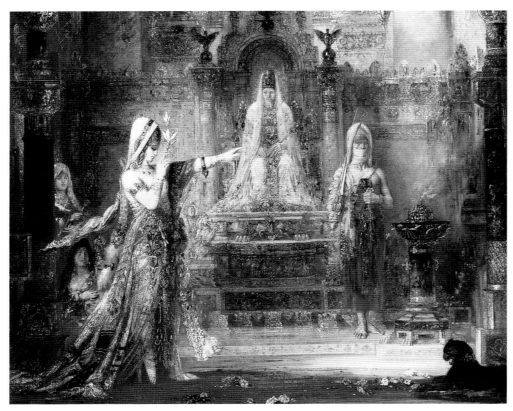

Gold is never a simple background but, in its two qualities of brightness and opaqueness, modulates the relationship between the flat and plastic sections of the surfaces.

The artist visited Ravenna twice in 1903 to study mosaic technique in depth and in person. This exciting encounter drove him eventually to experiment with the potential of this precious metal, as well as additive mosaic composition, in *Jurisprudence*, his project at the time. When he exhibited the painting the same year, 1903, the critic Hevesi, running counter to the general rejection, recognized in the luminescence of gold the remote echo of medieval mosaics. "I took a look at his painting, immersed in the semi-darkness of a church choir where the sparks glittered from golden objects and moved me greatly. The color was still color, but resting on it was a veil of evening air, and the gold shone even more golden. Suddenly, one thing was clear to me. I had returned from Sicily just four days earlier and still retained all the thrill of the mosaics ... the ancient world of medieval gold backgrounds, bright and glittering, on which was now also spread the smile of the gold of the mystic golden rose ... this came to mind while I was facing Klimt's painting. He gave me a luminous encounter with his gold. A new style conquered through combat, after all the pictorial orgies of the past decade, a more solemn and religious form and color."

In *Judith I*, with the rosy body like an orchid boxed among jewels, the gold exalts the ageless depth of a seductive and deadly female archetype that governs the decadent fantasies of the era just as it obstructs the imagination of Klimt. An image that comes from far away, that before history was Pandora, Lilith, Medusa, Circe, Helen, Medea, Isis, or Astarte, and who now, in the age of industry and great cities, in the world of speed and transformation, has become a cliché

like the tempting assassin's dance of Salomé in paintings by Gustave Moreau, in the pages of Joris-Karl Huysmans, in the sinuous lines of Aubrey Beardsley's designs, and the music of Richard Strauss. "Ancient fantasy" and "modern idea," the power of feminine seduction outflanks positivist pride, thwarts virile activity in the world, and draws one back into the region dominated by needs and the body's fragility. Gold, which celebrates and imprisons the bejeweled phantasm of the era's misogyny, suggests the return of a remote and inescapable memory.

Above left:
Aubrey Beardsley, *The Climax*, 1894; illustration for the English edition of *Salomé* by Oscar Wilde.

Above right:
Aubrey Beardsley, *The Dancer's Reward*, 1894; illustration for the English edition of *Salomé* by Oscar Wilde.

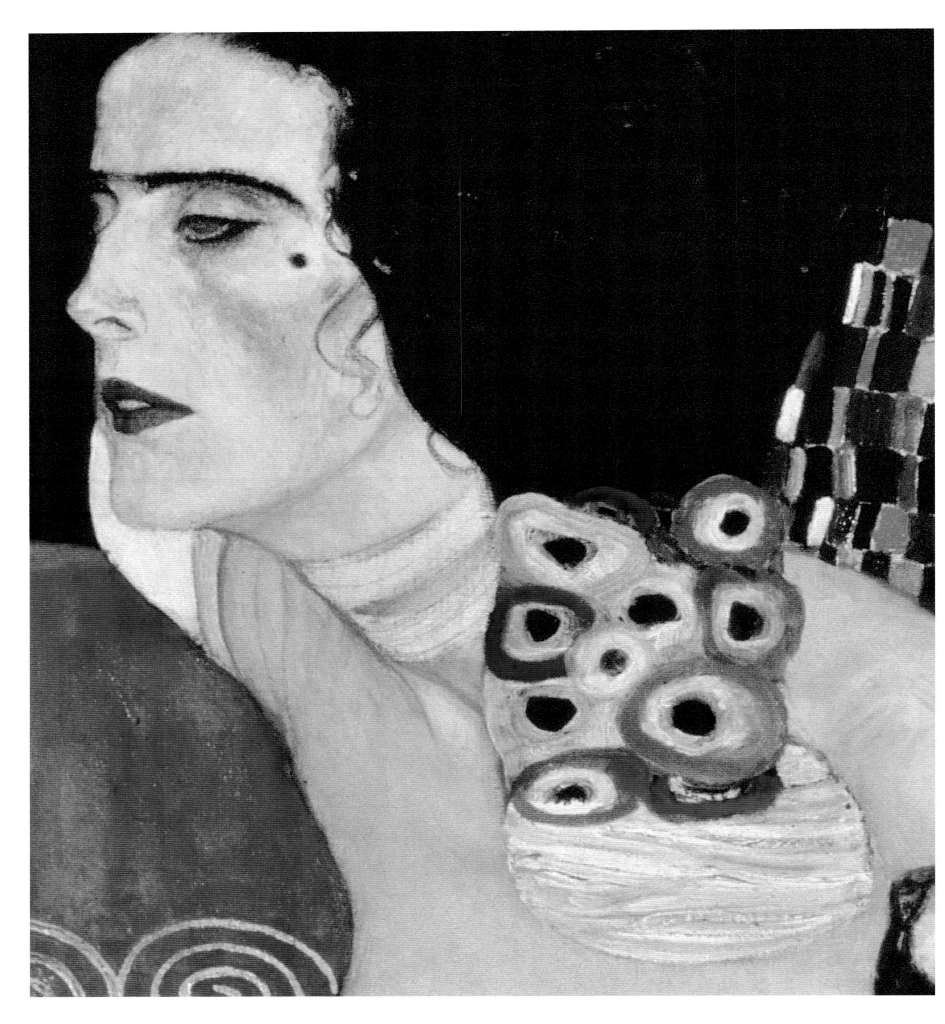

JUDITH AND THE OTHERS

"While reading the Book of Judith, I envied the ferocious hero, Holofernes, because of the regal woman who decapitated him with a sword; I envied him that lovely, bloody end," declared Severin, protagonist of *Venus in Furs* (1870) by Leopold von Sacher-Masoch, the author whose surname would survive to describe a perversion tinged with the pathology of desire that invaded culture at the turn of the century.

When Klimt painted his first *Judith* in 1901, he did not have in mind the noble cause of the biblical heroine, but something closer to what the female decapitator exercised on Sacher-Masoch. Before moving on to celebrate the deadly dance of that other vicarious decapitator, Salomé, artists in vogue like Franz von Stuck and Carl Strathmann painted their Judiths in triumphal contemplation of the man's severed head.

Although the adolescent dancer would prevail in the imagination of the time after the runaway success of Oscar Wilde's stage play (1892), the two biblical figures were superimposed to such an extent that this same painting by Klimt would frequently be cited with the title *Salomé* despite the inscription on the frame. For example, the magazine *Die Kunst* reproduced it under this name in 1911. The moon-like and lunatic creature with the golden, debauched eyes, who yearns for the kiss of the bloody head, although evoked by Wilde, has her precedent in the ferocious, painted gaze of she who replaced the mother in *Herodias* (1877) by Gustave Flaubert. She had already been magnificently celebrated by the painter Gustave Moreau who, having exhibited at the Salon of 1876 two paintings dedicated to Salomé that fascinated Huysmans, would continue to draw and redraw the features of the seductive princess right up till the day before his death, when he announced to a friend that he had found still another suit of jeweled armor for his Salomé and

had traced the outlines on the sheet. On the other hand, even before the biblical dancer began filling his imagination, Moreau had already given form to the intriguing vision of a lovers' dialogue between a young woman and a severed head in *Thracian Girl Carrying the Head of Orpheus* (1865). "Can a woman lust after the head of a man she does not love?" The Romantic poet Heinrich Heine had already asked himself this (*Atta Troll*, 1842) and, under the banner of erotic masochism, the castration fantasies permeating this image took the upper hand at the end of the nineteenth century. In the pages of the novel *Against the Grain* (1884), Huysmans describes the contemplative obsession of his main character, Des Esseintes, for the "evil beauty" of Moreau's Salomé, "divine symbol of Lewdness, goddess of the immortal Hysteria." These examples clearly represent a model for subsequently evoking the wanton virgin, in a constant

Right:
Gustave Moreau,
Salomé in the Garden, 1878.

Far right:
Gustave Moreau,
Thracian Girl Carrying the Head of Orpheus, 1865.

Chapter Opening (p. 90):
Judith II, 1909, detail; Venice, Galleria Internazionale d'Arte Moderna Ca' Pesaro.

play of interference between literature and visual art.

Beardsley broke away and, when illustrating Wilde's text in 1894, removed the bejeweled frills from the virgin and, with a razor-sharp stroke of the lash, wrapped the silhouette in a cloak that in the illustration recalls the peacock's tail sewn onto the shoulders of *Salomé* (1887) by the poet Jules Laforgue. From the beginning, Wilde continued to have the Byzantine Moreau in mind and failed to recognize in the hysterical tension of those sharp drawings his own enchanting creature, born to be interpreted on the Parisian stage by the divine Sarah Bernhardt, who also played the femme fatale in real life. In 1880, she even sculpted her own bronze, vampiresque self-portrait in the shape of a bat with a woman's face. Contemporaries described her as a creation of Moreau.

The ecstatic Claude Lorrain wrote, "The enigmatic Sarah is the child of Gustave Moreau, sister to the muses who bring her the decapitated heads of Orpheus and Salomé, the lean, bloodstained Salomé from the famous watercolor."

Wilde's play, set to music by Richard Strauss, was first performed in Dresden in 1905 and brought success to the composer. In the meantime, the repertory of Salomé grew out of all proportion. Max Klinger sculpted a marble sphinx with unfathomable amber eyes, a pitiless dominatrix that gathered the heads of her victims among the folds of her dress (*The New Salomé*, 1893). She was "as eternal as the eternal earth" in lines from decadent poets such as Albert Samain (1893) and Theodor Wratislaw (1894). The writer Marcel Schwob, in *The Book of Monelle* (1894), tells of a Morgana in search of her own grail who becomes a charming assassin after entering the palace of Salomé and finding the copper plate carrying the head of the Baptist encrusted with blood and still intact after centuries. In his *Herodias* (1896), Stéphane Mallarmé chose to sing of her virginity of "cruel

Above left:
Gustave Moreau, *The Apparition*, 1876; Paris, Musée du Louvre, Département des Arts Graphiques.

Above center:
Félicien Rops, *Diaboli Virtus in Lombis*, 1888, illustration for the title page of *L'Initiation Sentimentale* by Joseph Péladan; Paris, Musée du Louvre, Cabinet des Dessins.

Above right:
Aubrey Beardsley, *The Peacock Skirt*, 1894; illustration for the English edition of *Salomé* by Oscar Wilde.

snow" while his English translator, Arthur Symons (1897), was the author of several verses in which he describes her thirst for blood: "Her perverse malevolent eyes / see, instead of wine / in a frenetic vision, blood." These verses bring back a vision of the avid malevolence of the figure drawn by Beardsley. In contrast, the painter Georges de Feure attempts an unprejudiced version of her in contemporary clothes with his *Salomé* (1900), a fashionable lady confidently carrying her bloody trophy for a walk as if it were a recent purchase. Different once again, the passionate kiss of the soft *Salomé* (1896) by Lévy Dhurmer contains all the passion and perilous sweetness of a classic possession.

Between 1880 and 1890, the mocking Félicien Rops introduced his satanic female headhunters, Judiths like Valkyries armed with swords or skeletal, sneering women holding up their macabre loot. Another artist obsessed with the theme, Edvard Munch placed her in a contem-porary, autobiographical setting in a large number of works. At times, as in *The Salomé Paraphrase* (1903), feminine locks of hair hold the man's suspended severed head like hooks. After the premiere of the Strauss opera, Franz von Stuck painted his *Salomé* (1906) as a gypsy belly dancer amid the sensations of the Orient.

Like Moreau, for Klimt the Orient meant Byzantium. Like his *Empress Theodora* at the beginning of his mature style, his regal decapitator set in gold is the cult icon of the femme fatale, the phantasm of a culture that expressed its own decline in its refinement. Now the time was coming when angst would refuse all legendary disguise and horror would coagulate in the threatening masks and hard, multiple gaze of Picasso's *Les Demoiselles d'Avignon*, presenting the bare wall of their unattainable, angular nudity.

Why did Klimt choose the name Judith for his lovely assassin instead of the predom-inant Salomé? The artist clearly wanted to celebrate the grown woman and not the adolescent girl whose presence causes the king to abdicate his power and con-cede. Judith is herself actually the pow-er, she who never asks but decides, who uses her own hands to commit the crime the dancer performs by proxy, and per-haps with unconscious cynicism, if only on her mother's account. Clearly, Judith is the queen of her own desire.

In the painting, based on the contrast between the naturalism of the face and gesture and the absence of depth on the radiant decorative planes, the woman has her face slightly leaned back as if in a trance, her languid eye barely unclosed and mouth half open in a wandering smile-non-smile of satisfied rapture, while the hand holds and simultaneously caresses the head of Holofernes. The heavy collar of gold and precious stones chains her to the background, as well as visually sep-arating her head from her torso almost as if to reintroduce and vindicate symbol-ically the decapitation/castration that

Right:
Franz von Stuck,
Dancing Salomé, 1906;
Munich, Städtische Galerie
im Lenbachhaus.

Far right:
Max Klinger, *Salomé,*
1893; Leipzig, Museum
der Bildenden Künste.

The actress Sarah Bernhardt in
a photograph by Nadar, c. 1863;
Paris, Bibliothèque Nationale.

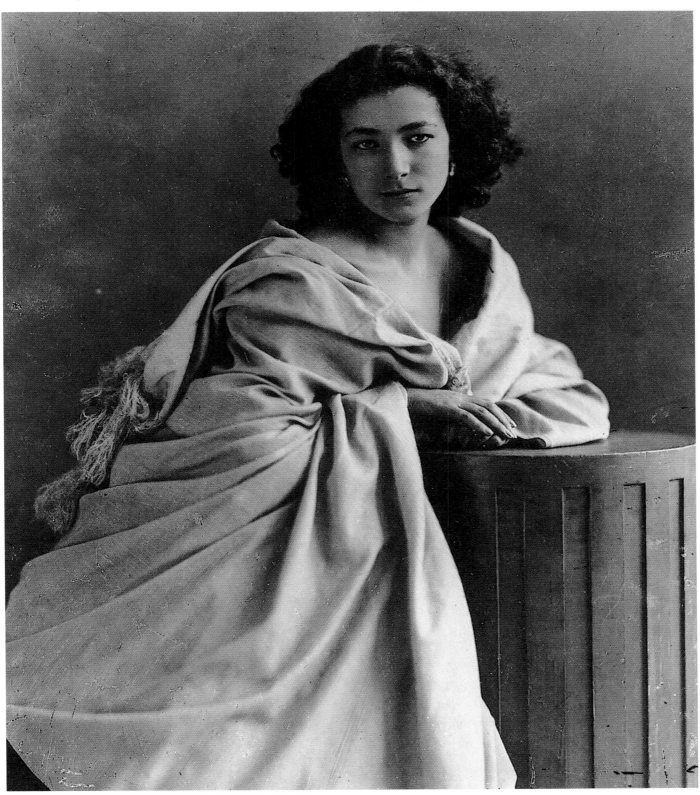

Right:
*Fragment of an Assyrian
Relief with Battle Scenes,*
mid-seventh century BC,
originally from Quyunjiq,
Northern Palace, Throne
Room, detail; Paris,
Musée du Louvre.

The narration is set in a hilly
landscape and occurs on two
levels. Above, infantry with
round shields and Assyrian
horsemen; below, slingsmen,
archers, and horsemen.

Opposite page:
Judith II, 1901, entire
painting and detail; Vienna,
Österreichische Galerie
Belvedere.

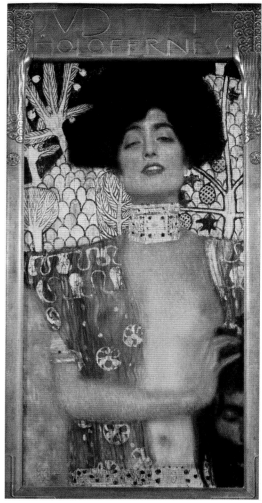

drives her oblivious pleasure. The frontal pose and cutoff at the height of the pelvis puts the accent on the belly, something Munch had already done in his orgasmic *Madonna* (1893–94), and works to bring the figure closer, as if the point of view were that of a sexual partner, a closeness Judith at the same time negates with her arm bent and placed before her body like a crossbar.

"Ancient Fantasy"—An ancient landscape is featured in the background with trees, mountains, and vines reproducing an Assyrian relief from Sennacherib's Palace in Nineveh, an archeological quote to indicate the distant past that presides over this vision, just as gold evokes the original depth of the earth that preserves light in its womb.

"Modern Idea"—But in that face, that hairstyle, that silky skin and near-photographic illusionism of the represen-

tation, are found the stigmata of the present. Contemporaries recognized the Viennese lady of the epoch, one of the many who frequented the Demel pastry shop or fashion designers' studios in Graben.

As inaccessible as an idol, yet as sensual as a flower of live flesh, more than any other image from the era, Judith represents the longing, nostalgia, and fear that shaped the male erotic imagination of the time, a masterpiece in the Klimtian itinerary, already foreseen by other apparitions of femmes fatales. The critic Hevesi defined the painting at the time as "Concentrated poison like that which was once set inside precious antiquities."

On the threshold of abandoning the "golden style," the theme of Judith would return only as a nervous inlay, with no satisfaction or abandon. The 1909 version

is manneristic in the lengthening of the vertical format and extreme decorativism. Gold is found only in the light spiral decoration at the bottom. The painting is dominated by the colored puzzle of cloth and ornaments. The woman is turned three-quarters and advances toward the left, her expression tense, her beautiful feverish hands clinging to the gown while they hold by the hair the decapitated head that seems to sink into the multicolored cloth as if into a pool.

Lacking the disturbing sweetness of the voluptuousness that suffused the first Judith, this one has twisting hands that reveal the hysteria that consumes her. She advances solemnly, removing herself from any direct relationship with the observer, captured in the weave of her own tapestry like a caged exotic bird.

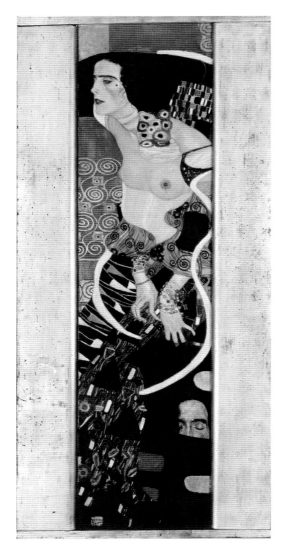

Judith II, 1909, entire painting and details;
Venice, Galleria Internazionale d'Arte
Moderna Ca' Pesaro.

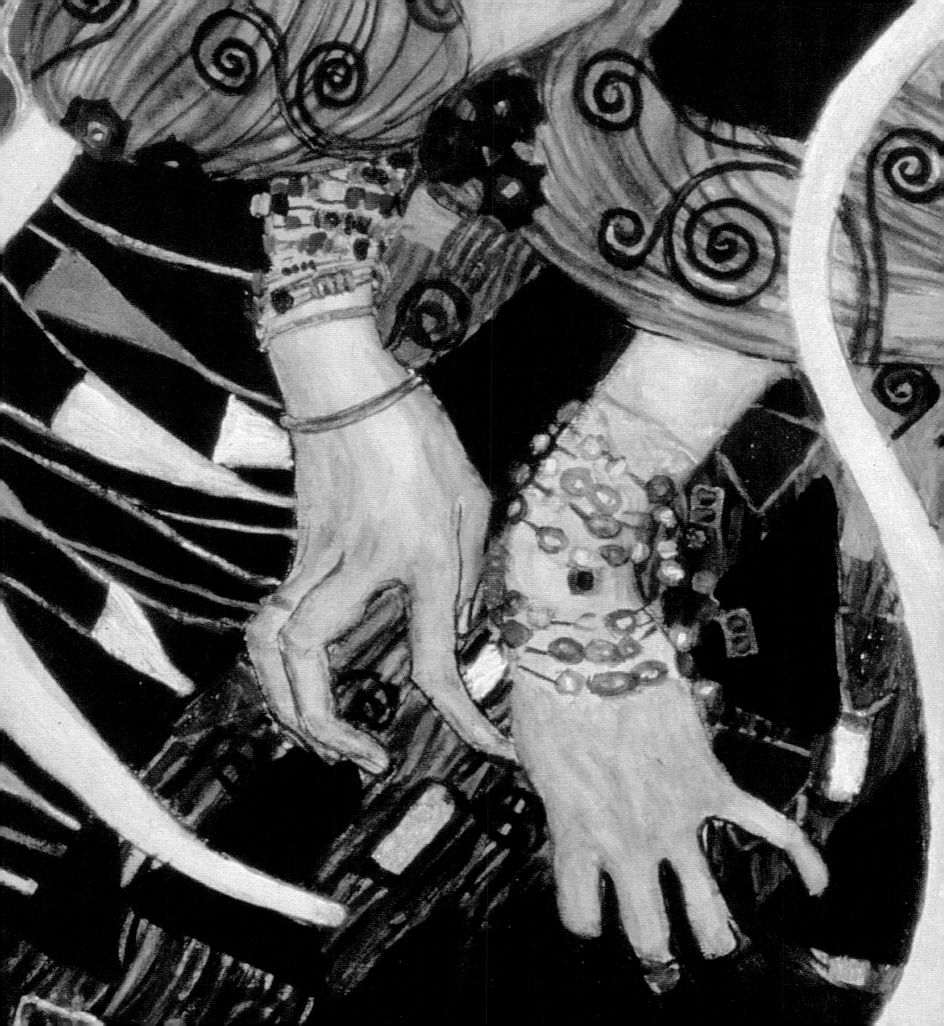

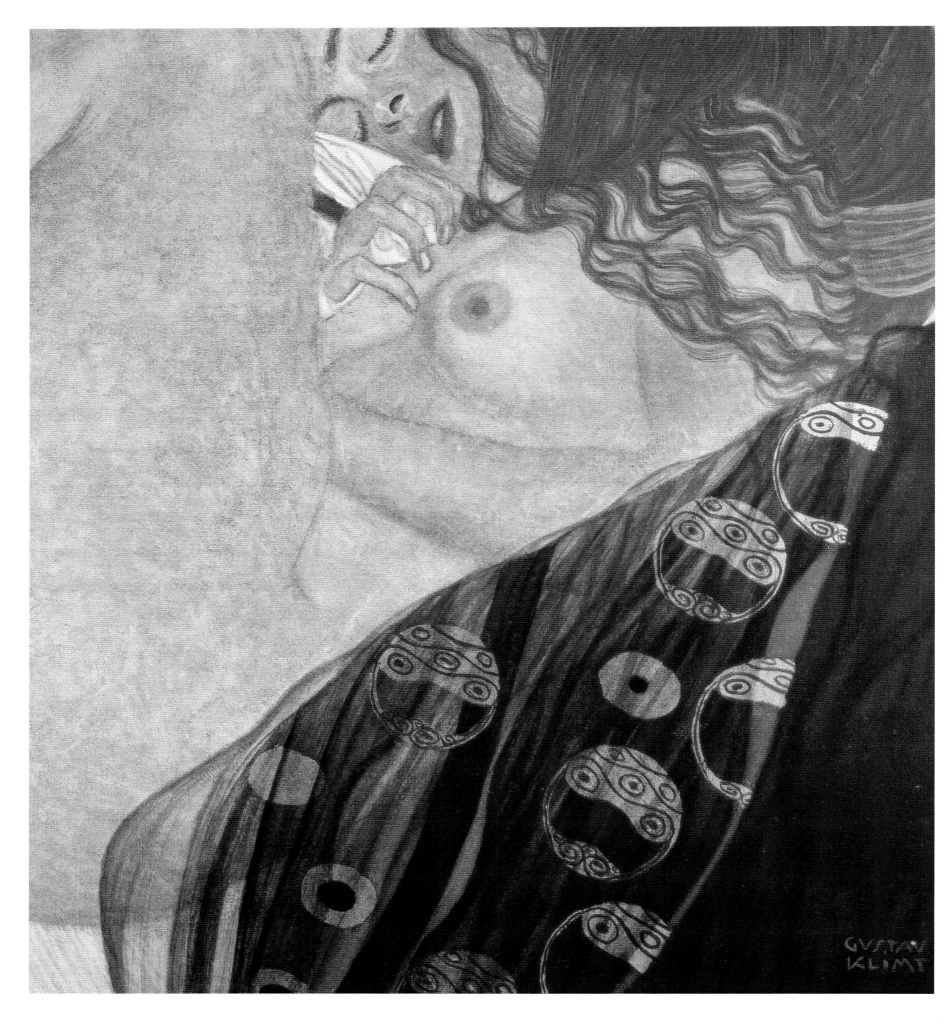

THE AMBIVALENT MUSES

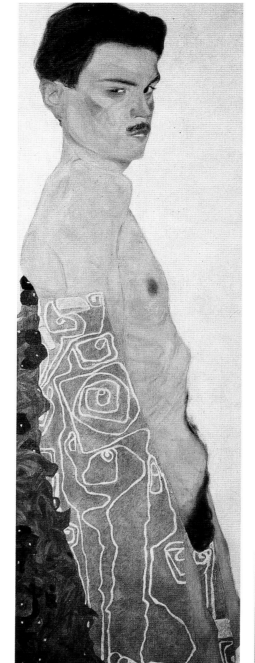

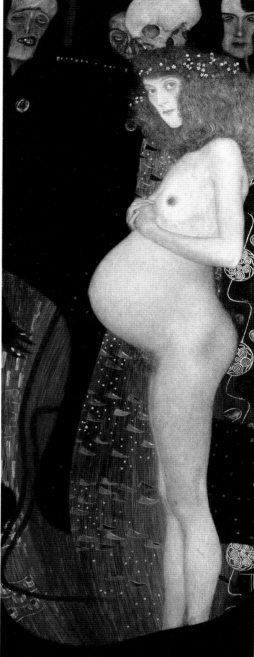

In Vienna, where even opera emphatically celebrated the inescapability of the feminine ("Women, women, eternal goddesses!" or "Without women, the 'thing' won't go!"), misogyny and gyneolatry confused their ideas even more than in other places stricken with the same lunatic possession, reflecting the twilight of the old Europe and its virile certainties.

In his iridescent surfaces, Klimt expressed this hotbed of ambivalence while con-tinuing the search for a reconciliation that would remain foreign to his successors, Egon Schiele and Oskar Kokoschka, when, on the eve of the First World War, nothing would be left of that great obsession that had so distressed the bourgeois intelligentsia but horror. But for Klimt, once again, the only possible utopia was the hope cum menace of the "maternal" dream. The artist painted women as if in perennial homage to the superiority of the female principle. Men remained rare in his repertory, for the most part represented from behind, never principal actors, only simple costars. But the ambivalence and negative forces connected to his system of feminine symbols appear more than once in his work. The scandalous painting *Hope I* (1903) shows a nude pregnant woman with a realism unprecedented in the history of painting and reflects the double face of maternity as well as the duplicity of the psyche, where each affection also has its destructive, consuming side.

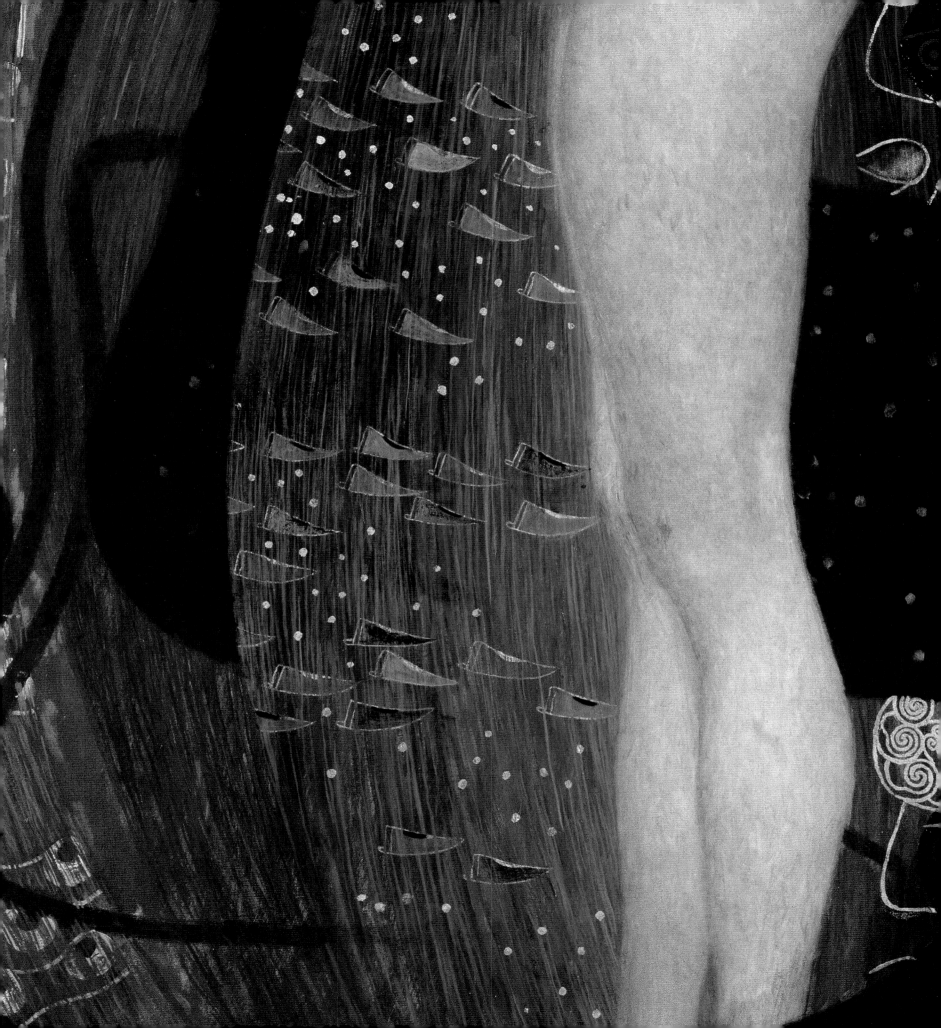

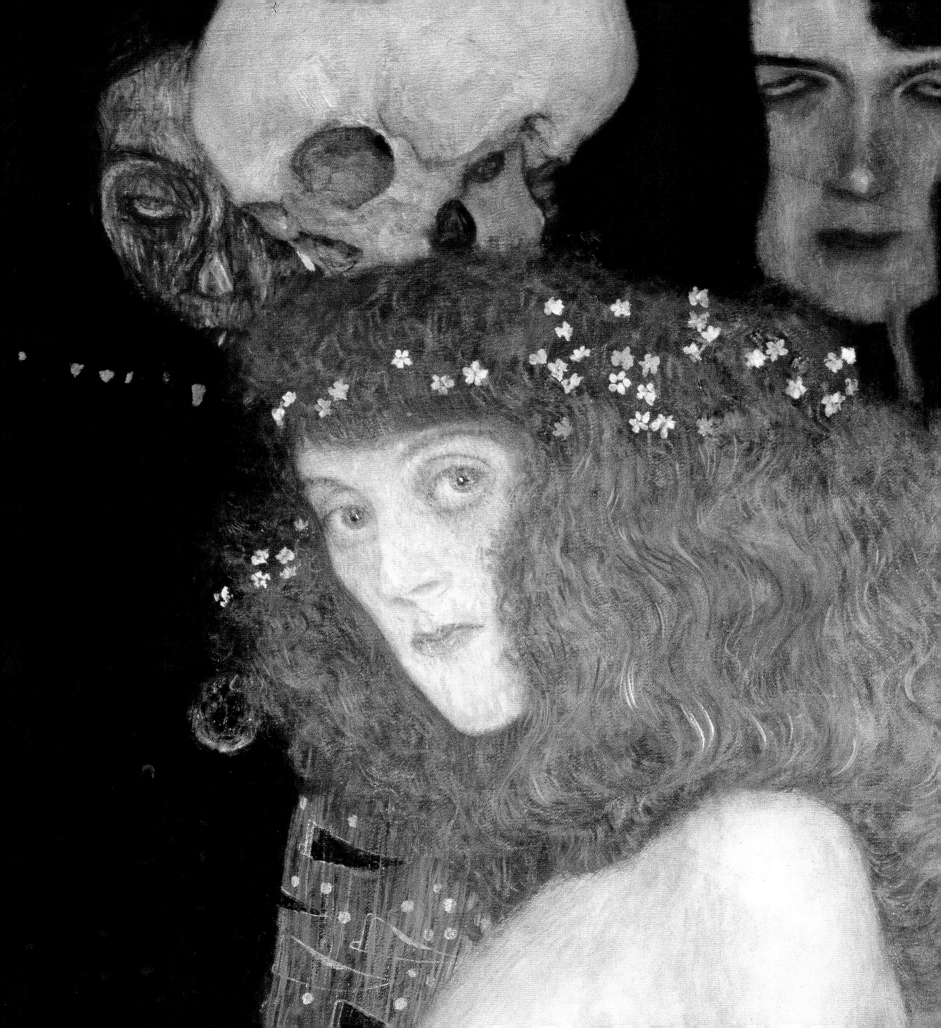

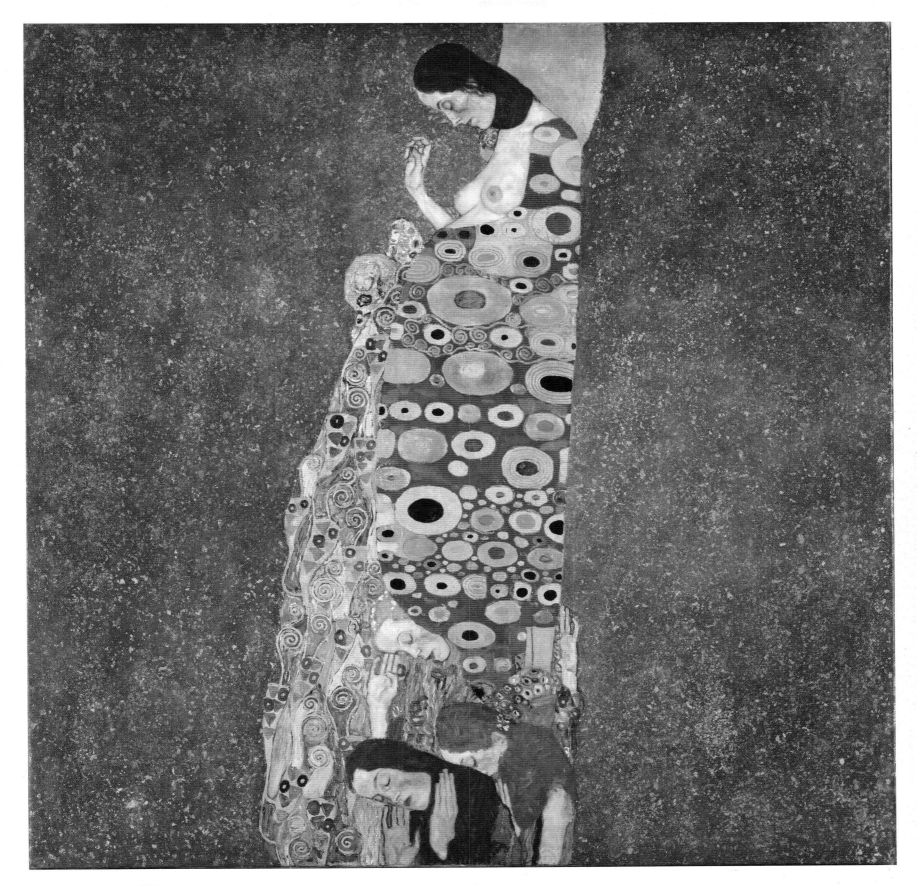

Hope II, 1907–08; New York,
Museum of Modern Art (MoMA).

Giovanni Segantini,
The Source of Evil
(or *La Vanità*), 1897.

This painting has been interpreted in various ways. Ludwig Hevesi, the critic closest to Klimt and someone who definitely expressed his thoughts, at least in part, felt it represented the menace of the world awaiting the unaware creature still protected by the maternal body.

Johannes Dobai, editor of the general catalogue of Klimt's work, read this as a protest against Victorian society and its double morality. Klimt celebrated maternity outside any social restraints, and the monsters represented the dangers of puritanical philistinism and its stupidity.

Censored at the 1903 exposition and considered obscene, the painting was acquired by the collector and patron of the Secession Fritz Waerndorfer, who kept it in a wall enclosure, designed by Moser, and opened the doors only for a few close friends. It features an elongated format and the usual mosaic structure of stylized elements and decorative surfaces, in contrast to the naturalism of the figure. The inter-

esting presence of a mask-face in the upper left shows an expressionistic deformation, which would impress the young Schiele, and reflects a knowledge of African sculpture of which Klimt owned several examples at the time, an early demonstration of the interest in non-Western cultures that would later captivate the major players in the historic Parisian avant-garde. His eye was omnivorous and could recognize the expressive quality wherever it was manifested. Many years later, in 1914, on visiting a museum in Brussels, he wrote to his friend Emilie Flöge: "The most beautiful things are these sculptures by these Negroes from the Congo. They are superb, magnificent, and we should be ashamed that in their own way they are more capable than we are. I was absolutely dazzled."

In the painting, the mother, red-haired like the *Nuda Veritas*, is accosted by a monstrous, serpent-shaped creature, a dragon that, in Jungian psychology,

actually symbolizes the evil mother who devours her children. The artist took inspiration for this image from a drawing by Beardsley for *The Gold of Reno*. The crown of flowers that adorns the woman's hair, and seems to continue on to the head of the monster, alludes to an important identity between the two figures. The blue veil behind the pregnant body and the red stripe behind the dragoness recall the water and blood connected at birth; while in the upper band, a specter and other demoniacal creatures, the three Fates, intone their silent chorus of death. In fact, "if the world, life, nature, and the psyche have been created as the Feminine that generates and nourishes, protects and warms" wrote the psychoanalyst Erich Neumann in his study of the symbolic reality of the Great Mother, "their opposites also become perceived in the image of the Feminine: death and destruction, danger and need, hunger and lack of protection are experienced

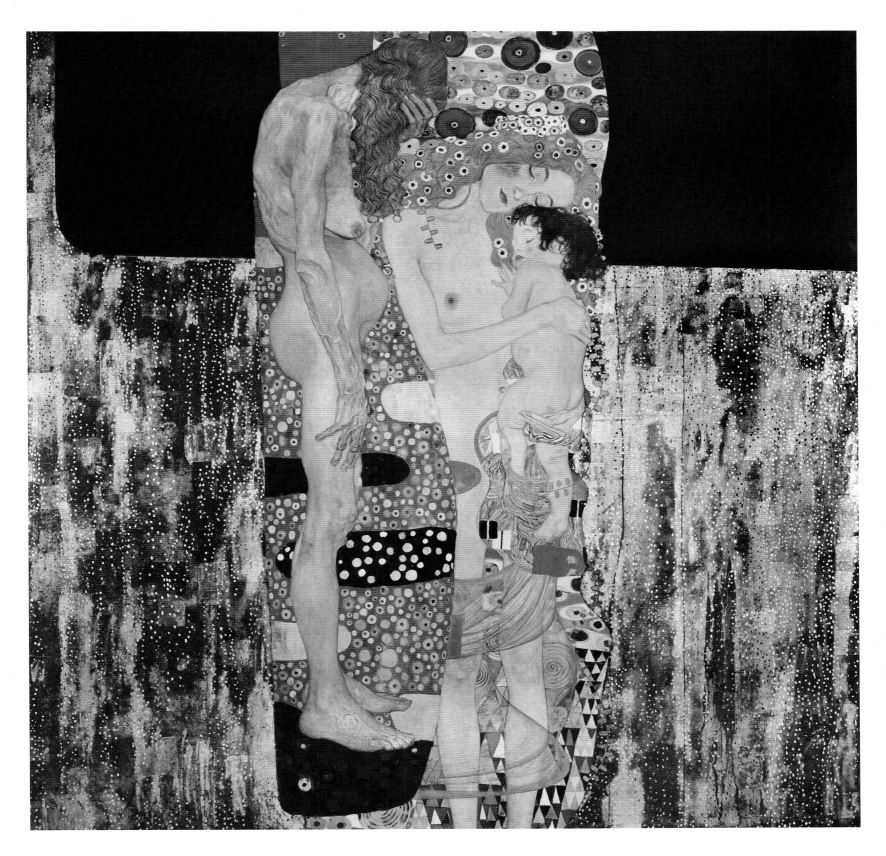

The Three Ages of Woman, 1905;
Rome, Galleria Nazionale d'Arte Moderna.

The Three Ages of Woman, 1905, detail;
Rome, Galleria Nazionale d'Arte Moderna.

by humanity as subjugation to the dark and terrible mother."

The work by Segantini, *The Source of Evil* or *La Vanitá* (1897), an allegory of vanity that was part of the Wittgenstein collection in Vienna and therefore known to Klimt, who frequented their home, had already established the mirror-like correspondence between a young woman with Titian locks and the horrible dragon springing from the water. With different results, the theme of the deep connection between birth and death inspired many artists, such as Edvard Munch in his *Madonna* (1893–94), Alfred Kubin in *Fecundity* (1900–03), and Cuno Amiet who, in the lateral sections of a triptych also entitled *Hope* (1902), placed two sneering specters in the central section to menace the woman and child.

In 1907–08, Klimt returned to the theme in *Hope II* and dedicated various works to the precariousness of life and beauty, works like *The Three Ages of Woman* (1905), where the figure of the mother with child is the moving poetry of humanity threatened by time, and the raw naturalism of the old nude is similar to the disconcerting nudity in *Hope I*. An excess of sentimentality renders the work fragile, but the solitude of the background, with its shades of gray and brown illuminated by a white dust, seems like a wall with crumbling plaster, while the black band in the upper section is interrupted on the lefthand border, opening onto a sort of empty abyss, a dark chasm of nothingness.

The positive bond of maternity is also shown in a bare painting with dark tones that belongs to the brief phase of crisis after his "golden style," when the artist distanced himself from his usual decorative methods. In *Mother with Children* (1909–10), the two children, wrapped in the mother's cloak, brown as an earthen womb, seem to barely emerge from the uterine depths.

The angular face and flame-red hair of *Hope I* bring together the ambivalence of the mother's image, just as he concentrated the ambivalence of the lover in *Judith I*. Another dominant theme in his repertoire of fatal figures is feminine erotic self-sufficiency, i.e., the idea of an irreducible otherness that escapes all comprehension as well as all possession, the enigma of a difference that escapes capture like running water. This aspect of the mythology of the feminine finds its perfect representation in the motif of the water dweller, the undine or siren.

This originally Romantic motif abounded in the art and literature of the Symbolist era. (Among the poets who dedicated verses to the water nymphs, we recall Stefan George and Rainer Maria Rilke, among composers Claude Debussy, among painters Edward Burne-Jones, Arnold Böcklin, and Hans von Hofmann, among sculptors Auguste Rodin and Aristide Maillol, and among illustrators Hans Christiansen and Heinrich Vogeler.) This came from combining the idea of woman as a more elementary being, tied to nature,

with the unfortunate and perilous aspect of her seductive charm. The undine is, in fact, like plants and animals, a creature without a soul that participates in the most secret movements of nature in its aquatic chamber, and generally has a malevolent character since it represents the traitorous side of rivers and lakes. Moreover, the visual similarity and opportunity for infinite poetic metaphors comparing the waves in a woman's hair with the movement of water made this motif particularly dear to the linear graphics of the Jugendstil.

In repeated variations on this theme, Klimt shifted the accent to a different aspect: in *Moving Water* (1898), the young women slipping across the surface of the water show the fusion of femininity, nature, and unbridled abandonment to the physical sensation; in *Silverfish* (1899), the subtle gaze and tubular, snake-like bodies bring out the demoniacal quality of the water dwellers; in *Goldfish* (1901–02), which Klimt ironically dedicated to his critics after the controversy over the university paintings, the erotic echo is more direct, and the sirens, here provocative instead of deadly, flash a malicious, tempting gaze toward the observer; in *Water Snakes I* (1904–07), a masterpiece of the Klimtian style and one of the most significant works from the entire Jugendstil movement, the two entwined female bodies meld and mingle with the close-knit decorative weave, making any other presence superfluous; in *Water Snakes II* (1904–07), the enchanting creatures let themselves flow in the same direction, abandoning themselves to their element, each one enclosed in a cocoon defined by a streak of color, suggesting the seduction and inaccessibility of a supreme, solitary eroticism. This liquid, self-sufficient universe is like a secret Sapphic bedroom, a "boudoir" that excludes the presence of any and all men, who retain only the role of victim or voyeur.

Water Snakes I, the most suggestive version of the theme of the undine, has the features of a refined miniature. Created on parchment with various techniques including tempera, watercolor, and applications of gold and silver leaf, it is contained in a frame of engraved silver, the work of Klimt's brother Georg, who worked with metals. This small painting brings together fragility and passion in the combination of the two heads with golden hair and the embrace of the two thin ivory bodies, and is filled with the idea of metamorphosis—the analogy of human and plant forms.

Above:
Moving Water, 1898.

Opposite page, far left:
François-Auguste-René Rodin,
Reclining Female Nude Stretching,
c. 1885; Paris, Musée Rodin.

Opposite page, right:
Arnold Böcklin, *Naiads at Play*,
1886; Basil, Kunstmuseum.

Silver Fish (or *Undines*), 1899;
Vienna, Zentralsparkasse.

Fantastic floating serpentine creatures completely
meld into their element, as though algae among algae,
flowers among flowers. Sinuous and mysterious, they
recall the character of the siren enchantress or evil
undine, the latter considered soulless and treacherous
like the water in which it swims.

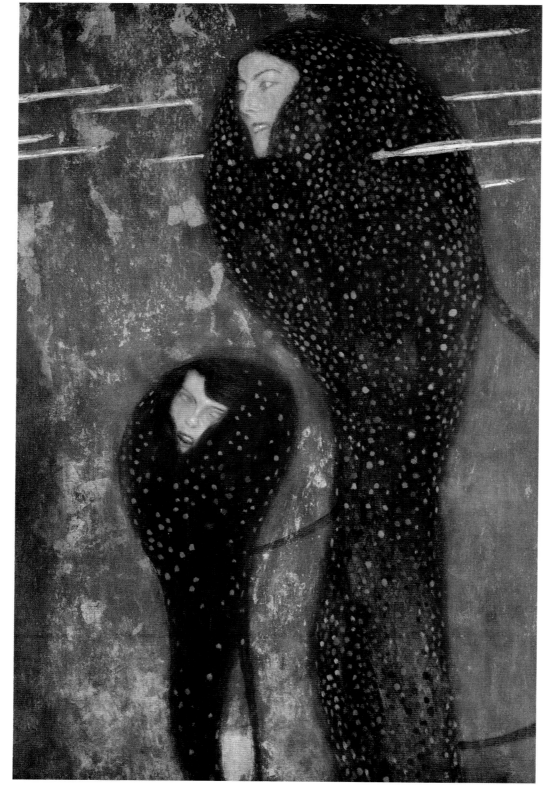

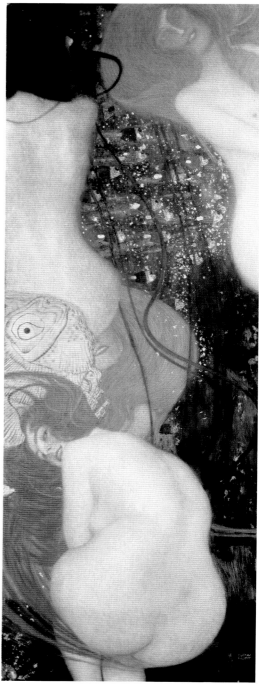

Above:
Goldfish (or *Undines*),
1901–02, entire painting and
detail on opposite page;
Solothurn, Kunstmuseum,
Dübi-Müller Foundation.

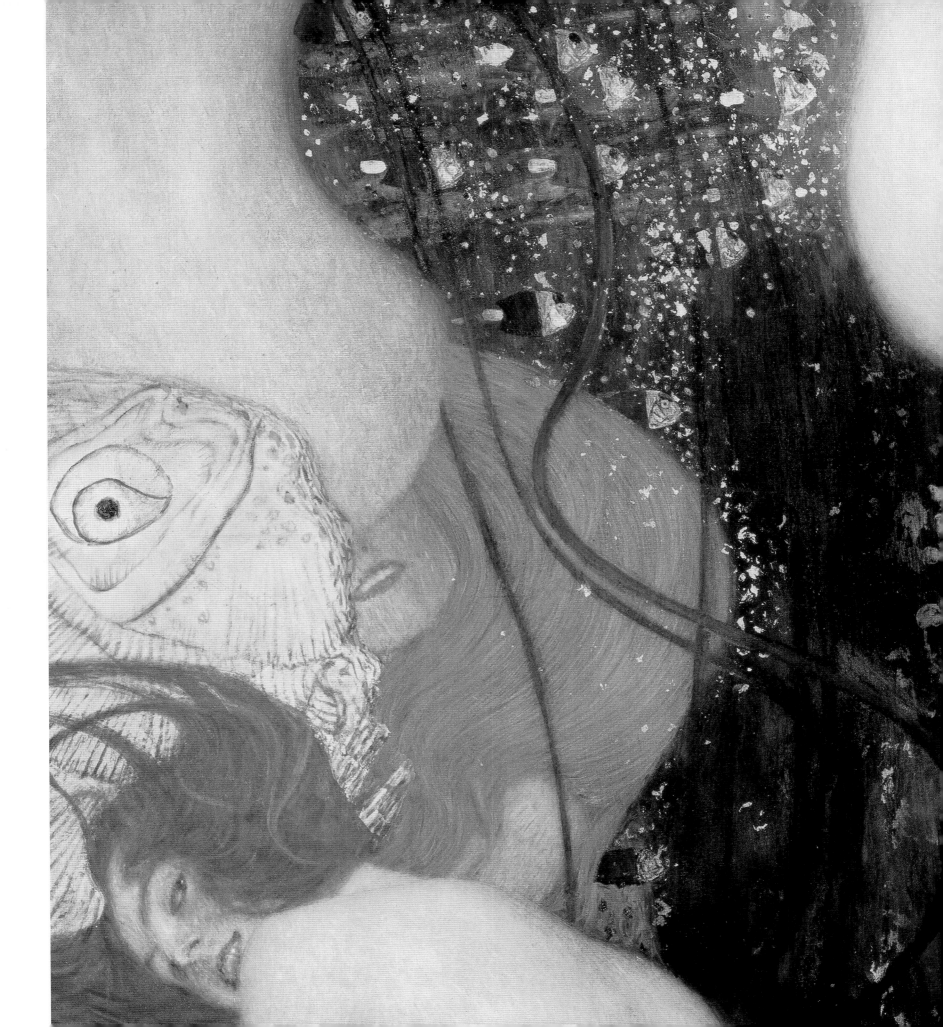

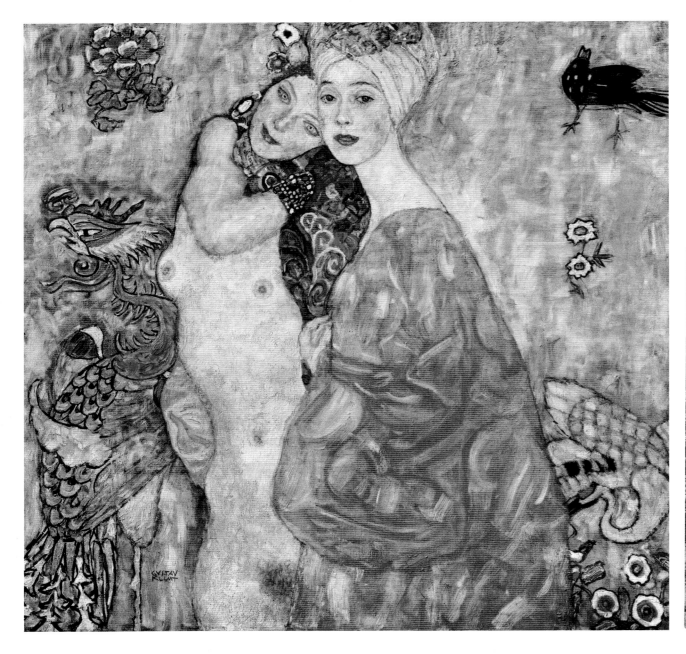

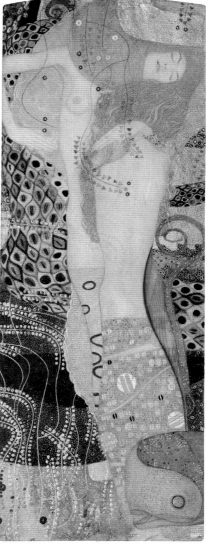

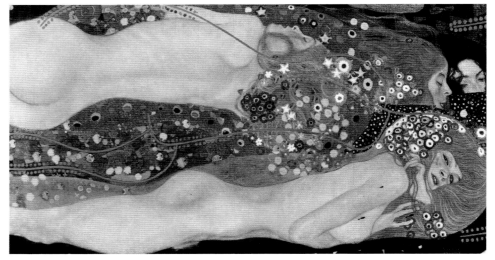

Above:
Friends, 1916–17; destroyed.

Top right:
Water Snakes I, 1904–07,
entire painting and detail
on the opposite page;
Vienna, Österreichische
Galerie Belvedere.

Right:
Water Snakes II, 1904–07,
entire painting and detail
on the following pages.

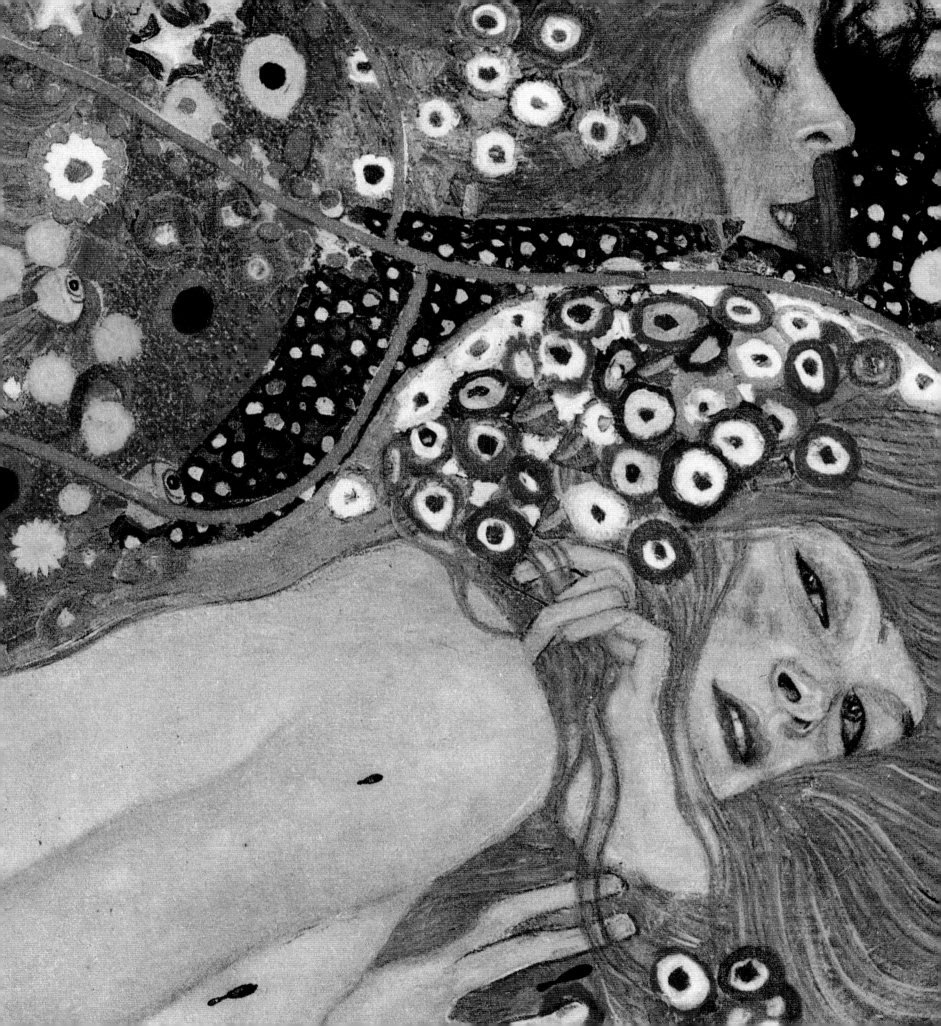

The play of ambiguity between figure and background, between the border of the veil and shape of the body, makes even the perception of the forms changeable to the eye. This is the triumph of the "additive" principle. Done in the rectangular format of Japanese prints favored by the artist along with the square, every centimeter of this painting is a dense concentration of decorative-symbolic microwriting, and resembles a cellular fabric seen through a microscope and then reworked by a jeweler. Regarding Klimt's painting as well as that of the entire Viennese decorative style, one scholar of the Secession, William Powell, recalled the contemporary research of the great anatomist Emil Zuckerkandl on the spontaneous artistic forms in sections of the epidermis or brain matter. It should be noted that, on Klimt's initiative, Zuckerkandl gave several lessons to a restricted artistic audience.

Love between women, a theme preferred by the decadent writers and poets (such as Baudelaire, Verlaine, Swinburne, and Louÿs), one already mentioned in an early work, *Two Girls with Oleander* (1890–91) and the motif of innumerable life drawings, finds its apology in the ecstatic sexual intimacy of *Water Snakes I* and returns without innuendo in a later work, *The Friends* (1916–17). Like Rodin, Klimt saw in lesbianism the possibility of grasping the enigma of female sexuality, reading in it above all the confirmation of the inessential quality of the male.

"The entire body of woman is an extension of her sexual organ…woman is a being that enters into coitus everywhere," wrote the Viennese theoretician of misogyny, Otto Weininger, in 1903 as a rationale for his contempt. Klimt seems to make this statement his own, especially in the formal concentration of *Danae* (1907–08), yet he reverses the negative meaning, as if the presumed erotic superiority of woman, representing the soft naturalness of being, were the only antidote to the alienation of a modernity that forces the individual into a one-way relationship with the world. Logocentric man is out of place in that inner bedroom, or perhaps this was the only refuge from the advance of insecurity in Viennese culture before the First World War. Thus the artist, who more than any other knew how to conjure up all the sweet and terrible feminine phantasms of the imagination between the two centuries, shifted the problem forward, showing in a woman's face the possibility of a different alchemy of life.

The *Danae* is no longer deadly, no longer a decapitator of heads. Curled into the ellipse of her rolled-up body, the reddened face, near liquid with pleasure, the hand still contracted from erotic tension, she expresses in her uterine sweetness the most extreme feminine essence. Where the golden rain of myth terminates, Klimt adds a symbol to represent the masculine principle: a black vertical rectangle, a mere angular, dissonant detail in the curvilinear harmony of the whole.

Above:
Study for "Danae," c. 1907.

Right:
Leda, 1917; destroyed.

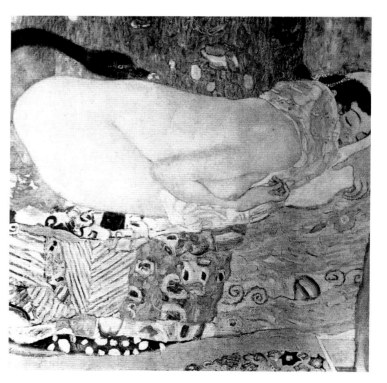

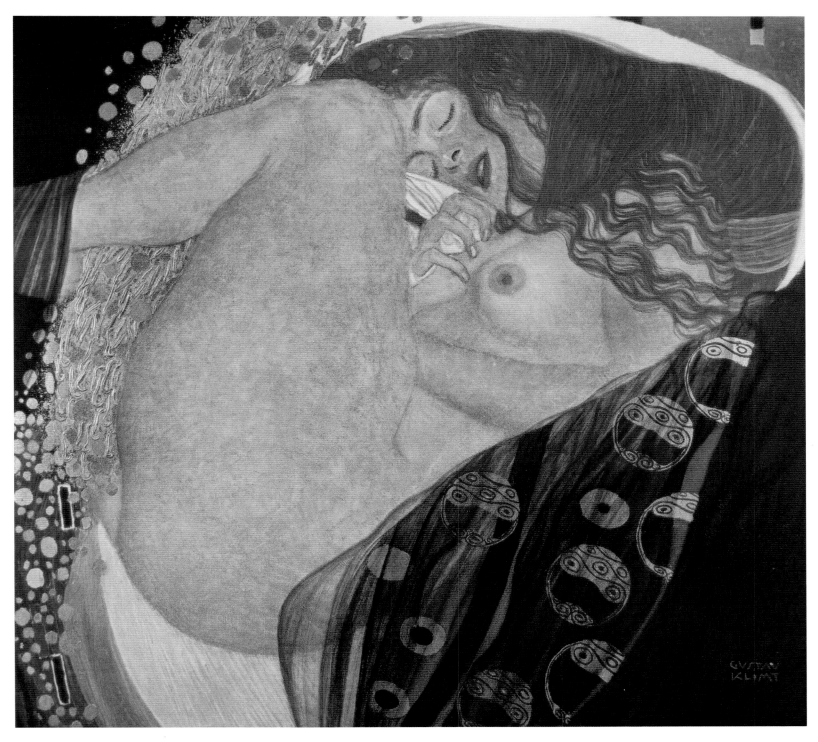

Danae, 1907–08.

Abandoned in sleep, the beautiful Danae forgets herself
and, having overcome the barriers of modesty, offers
herself up to the eye of her watcher, in all her sensuality.
The soft, circular development of the body, barely covered
by a veil with golden motifs, has no roughness and suggests
reaching an expansive erotic dimension. The black rectangle
below, lost among the golden disks, symbolically represents
the male principle, as seen in other Klimt paintings.

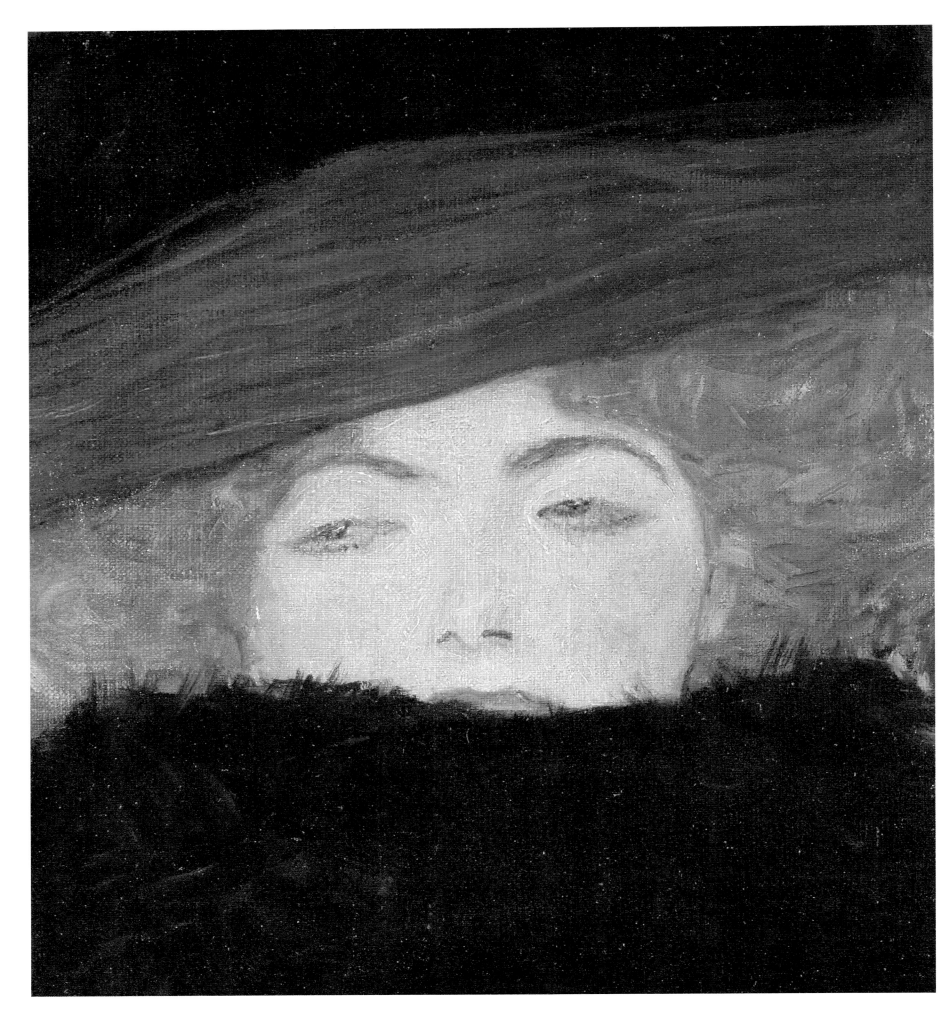

PORTRAITS OF LADIES

Portraits of beautiful ladies from the Viennese upper bourgeoisie made up at least a third of Klimt's modest pictorial production. Like Giovanni Boldini, but better, Klimt managed to capture on his canvases the indefinable aura that inseparably connects certain faces to a precise space and time.

The women in his portraits are the unmistakable prototype of feminine beauty in Vienna during the final years of Franz Joseph, not just in their clothes or hairstyle, but because of that secret, intangible aura emanating from them, the submissive melancholy throb hidden in their features. Fine, elegant figures inhabiting an abstract space, their presence at times is implied in the bright forest of decorations with which they mingle. While creatures of their city and time, they also share in the atemporal quality of idols.

In 1898, the portrait of *Sonia Knips,* with a post-Impressionist, Whistlerian flavor, already showed a compositional scheme the artist would take up again in subsequent portraits: decentralized and played on the diagonal, the woman seated in an armchair with evanescent outlines and a haloed head, her face turned frontally toward the observer and rendered with photographic naturalism. The red notebook, a chromatic touch that softens and ties together the contrast between the vaporous luminosity of the rose of the gown and the darkness of the background, is an album of sketches donated to the young lady by the artist. Klimt had around fifty of these that Knips had bound in red leather. After 1945, all but three examples were lost in a fire.

The works of James Whistler had been exhibited in Vienna in 1895. The influence of this American painter on Klimt

Right:
James Abbott McNeill Whistler,
Symphony in White, 1864;
London, Tate Gallery.

Far right:
Sonia Knips in a dress by the Wiener Werkstätte, photograph c. 1911.

Opposite page:
Sonia Knips, 1898; Vienna,
Österreichische Galerie Belvedere.

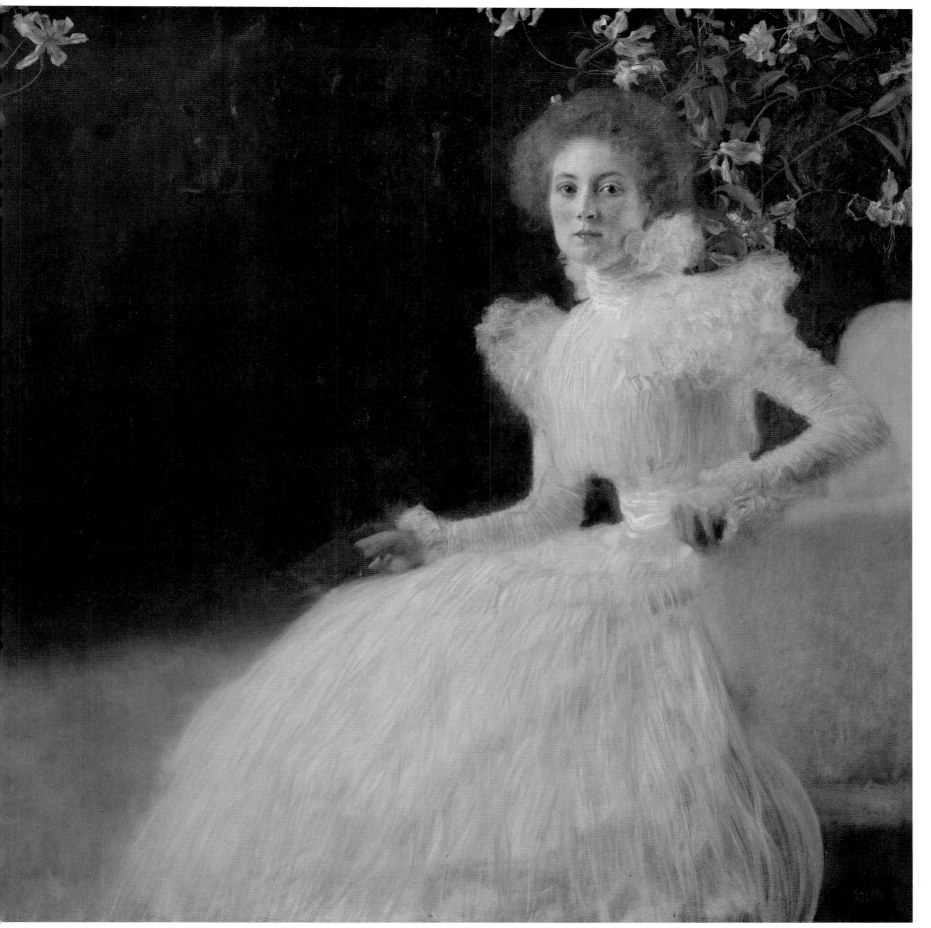

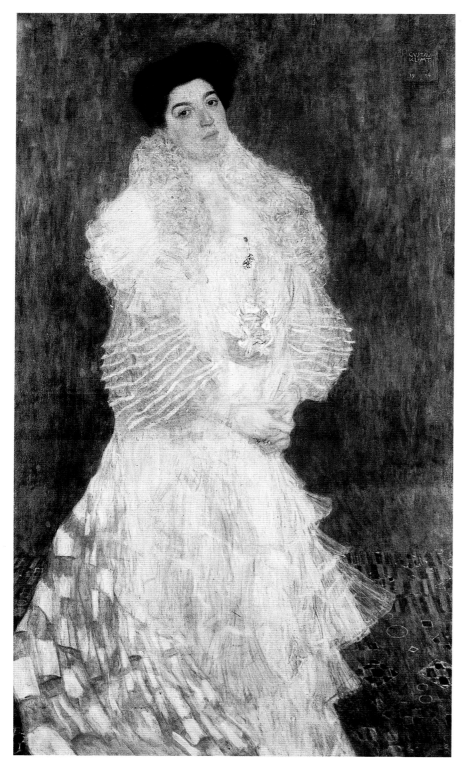

Herminie Gallia, 1904;
London, National Gallery.

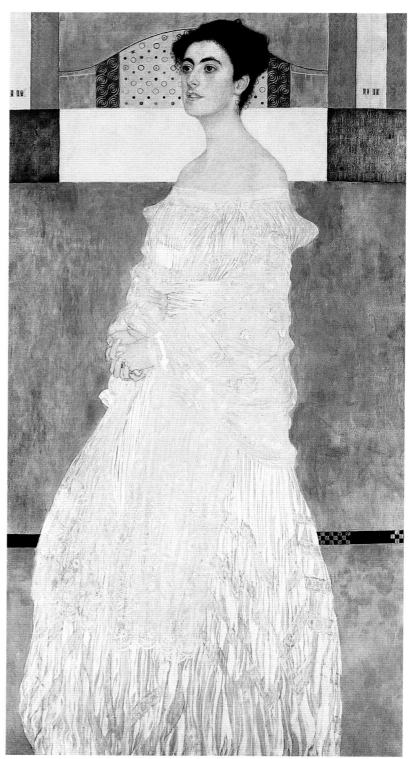

Margaret Stonborough-Wittgenstein,
1905; Munich, Neue Pinakothek.

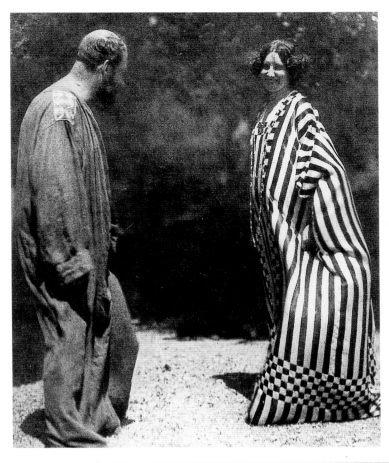

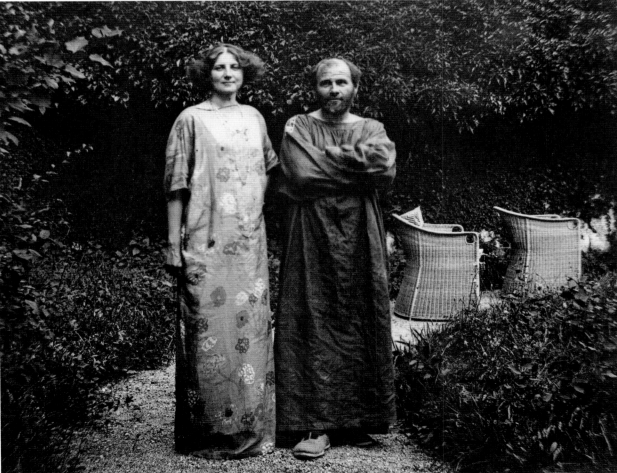

Above left:
Klimt and Emilie Flöge shown
in the garden facing the artist's
studio. They are wearing large,
oriental-style kaftans designed
by Klimt for Emilie's fashion
design studio in Vienna; Vienna,
Bildarchiv, Österreichische
Nationalbibliothek.

Above:
Sisters Emilie, Helene, and Paula
Flöge photographed c. 1910 during
a boat ride on the Attersee, east of
Salzburg, in the company of Klimt.

Left:
Klimt and Emilie Flöge in the
garden of the artist's studio in
a photograph from 1910.

Right:
Emilie Flöge on vacation on the Attersee c. 1910 in a gown designed by Klimt.

Far right:
Emilie Flöge, 1902, entire painting and detail on opposite page; Vienna, Wien Museum Karlsplatz.

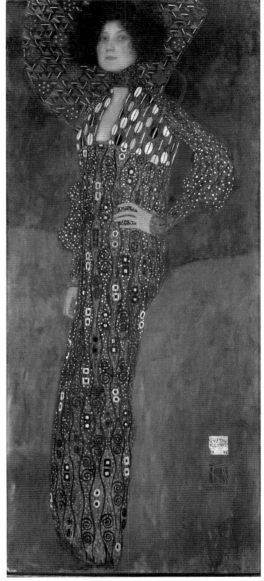

is noticeable in the delicate harmonies of gray that characterize several portraits, even after the artist abandoned the vaporous, atmospheric vagueness of his paintings done before 1900.

Beginning with the portrait of *Emilie Flöge* (1902), Klimt thickened the fabric of ornamental microstructures, shifting into midground the "blurred" effect that had until then characterized his portraits of women, and wrote his signature in a square that also became a decorative element. His companion for many years, Flöge had a fashion design studio in Vienna, for which the painter designed various dresses such as the one she is wear-

ing in the painting and the large, oriental-style kaftans he wore in his studio.

The "Secessionist" square would be the fundamental shape in the portrait of *Fritza Riedler* (1906). Here the environment of radical geometries, with its reticent sense of balance and refined simplified rhythm, recalls the Japanese prints Klimt collected. Even the armchair where Fritza Riedler is seated in her vaporous, Whistlerian gown is no more than a white and gray plane marked by a rhythm of lines and waves and vibrant, elliptical shapes of gold and silver. The arrangement of forms configures the arms, the folds in the cloth, and the fascinating

quality of the object. Behind her head, the elliptical shape composed of colored, geometric particles, as seen earlier in the pure, essential portrait of *Margaret Stonborough-Wittgenstein* (1905), is an elusive decoration that could be interpreted as stained glass or mosaic, or an ornament that turns her hairstyle into a halo evoking the women of Velázquez. But this is also endowed with its own autonomous life, like the square tile inserted into the black band of baseboard or the play of white and blue squares on the pink surface of the background, isolated notes on an imaginary musical staff that plays counterpoint to the band of intense azure below.

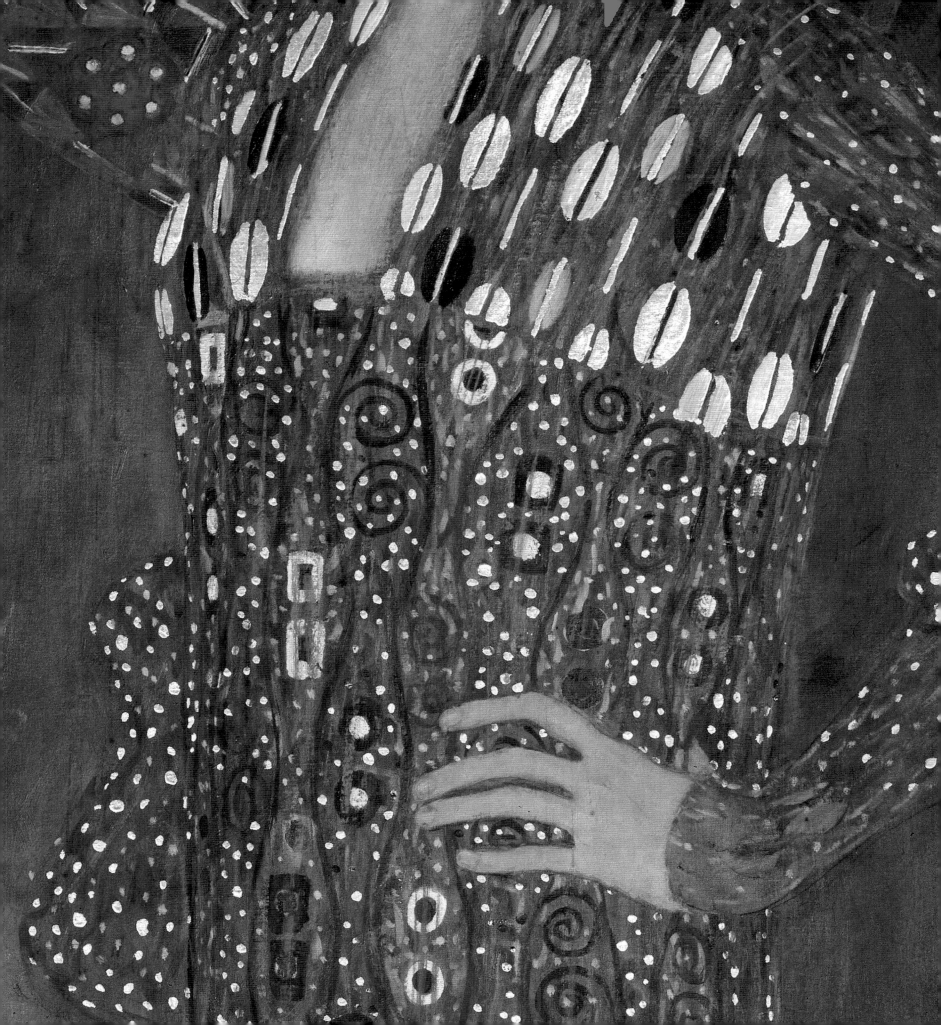

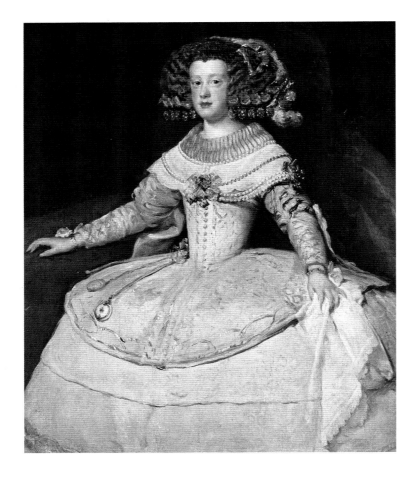

Diego Velázquez,
Maria Teresa of Spain,
c. 1652, detail; Vienna,
Kunsthistorisches
Museum.

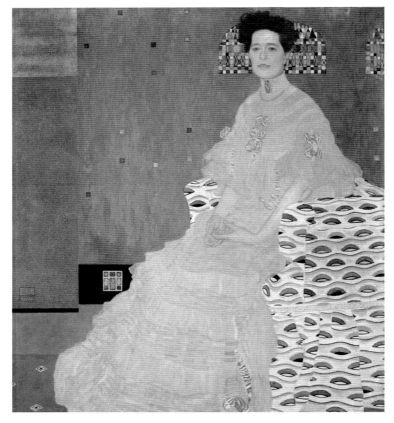

Fritza Riedler, 1906,
entire painting and
detail on opposite page;
Vienna, Österreichische
Galerie Belvedere.

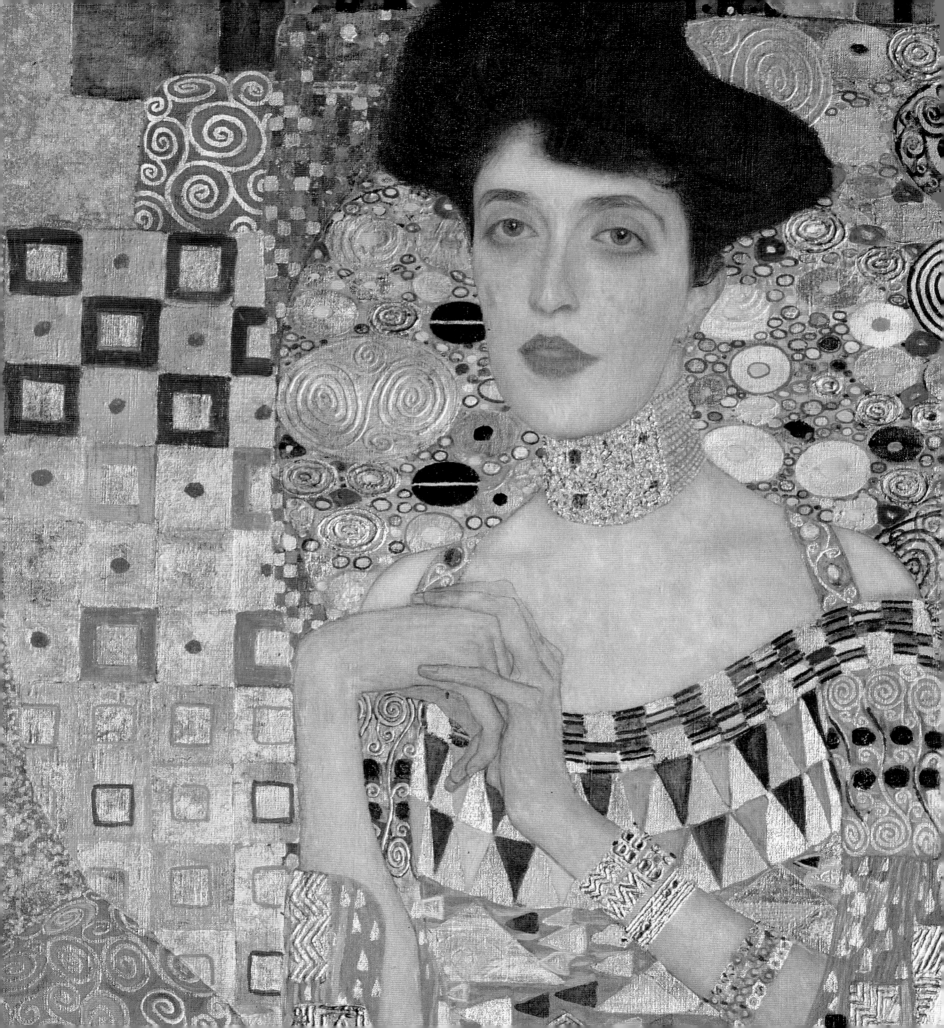

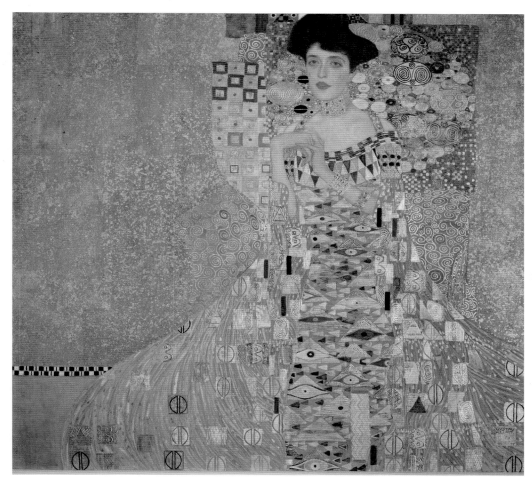

Adele Bloch-Bauer I,
1907, entire painting
and detail; New York,
Neue Galerie.

The peculiarity and modernity of Klimt's mature style consist precisely in the fact that the individual decorative elements, although they help integrate the harmonic whole, are at the same time small, autonomous, abstract, musical compositions, like "paintings within the painting." His "golden style" reached its peak in the portrait of *Adele Bloch-Bauer I* (1907).

The geometric precision and simple refinement of the previous composition have been replaced here with an opulent, patchwork space of ornaments, where Mycenaean gold mingles with Byzantium and the elegance of Jugendstil design. The silky gown that outlined the subject's soft anatomy has become a shining metal tunic of the same material as the armchair and background. In the glitter of the gold and dense vegetation of squares, spirals, triangles, ovoids, and eyes—ornamental motifs as well as secret erotic symbols—the contours of the bell-shaped figure remain ambiguous. Only the pearly face and nervously interlaced hands escape the "metallization" and appear as if cut out of the inlay work. Studded with precious metals, *Adele Bloch-Bauer* is the expression of the decadent, morbid passion for jewelry and the extreme homage to the femme fatale raised up to the throne like an enigmatic divinity. Yet the triumph of this goddess is also her prison, as if she were mounted in shining

metal, captured for eternity in her precious tapestries, sealed alive inside the flat wall of gems, as if the artist secretly wished to neutralize the threat hidden in that mother-of-pearl face. This painting, along with other works by Klimt (a second portrait from 1912 and three landscapes), was recently at the center of a lawsuit brought by the subject's heirs against the Austrian government for the restitution of goods expropriated from Jews during the Nazi period. Immediately after the Anschluss of 1938, unifying Austria with the German Reich, the Bloch-Bauer family was stripped of its considerable fortune and collections that, in addition to numerous paintings, included 400 valuable porcelain pieces. Some works, such as the Klimt paintings, ended up in museums; others were dispersed among art dealers. After sixty-six years, in part because of an Austrian law from 1998 that allowed for the repatriation (or return) of works plundered or extorted from their legitimate owners, the five Klimt works were returned to the family and left the Belvedere museum on February 6, 2006.

The portrait of Adele Bloch-Bauer, "the twentieth-century Mona Lisa," was acquired a few months later by cosmetics magnate Ronald S. Lauder for the sum of $135 million, making it the most expensive painting sold to date worldwide, and joined its new collection in New York at the Neue Galerie, the museum founded by Lauder and dedicated to Austrian and German art.

Opposite page:
Lady with Hat and Feather Boa, 1909; Vienna, Österreichische Galerie Belvedere.

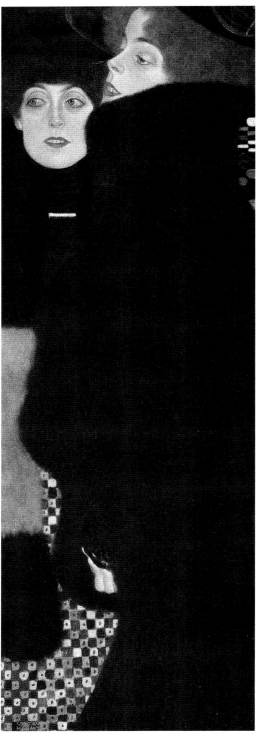

Right:
Klimt's studio with his collection of Japanese ceramics and paintings, in a photograph from c. 1915.

Far right:
The Sisters, 1907–08.

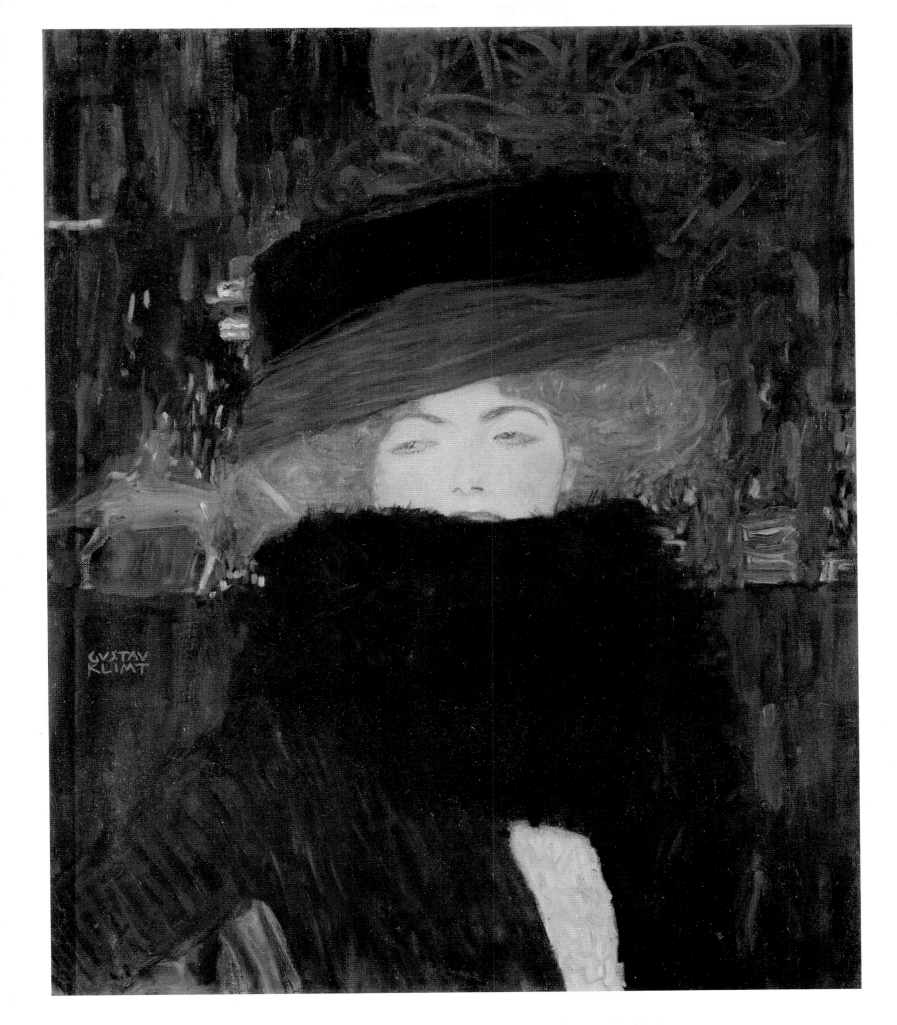

THE EROTIC SKETCHES

The Klimt catalogue, edited and revised by Johannes Dobai with Fritz Novotny in 1967, contains around 230 works, many of them lost at the end of World War II. Around a third of this production is made up of portraits of ladies from the Viennese upper bourgeoisie, less than a third are landscapes, and the rest allegorical subjects. These paintings required long preparation because of their frequent symbolic depth and richness of ornamental detail. Hence, Klimt was not a prolific painter. But he was a prolific sketch artist and did many preparatory drawings for his works, around a hundred in the case of the portrait *Adele Bloch-Bauer I.* He believed in the daily discipline of the pencil to keep his hand in practice. Every day, in an inexhaustible desire for mastery, he quickly captured on paper the movements and erotic poses of the models that camped out in his studio, as if he were writing his own catalogue of a Don Juan without Satanism. While in Spain, Leporello had earlier counted 1,003 women, the body of Klimt's drawings remaining, catalogued by Alice Strobl, amounts to more than 4,000 pages that bear witness to Klimt as one of the greatest masters of drawing in the twentieth century.

While paintings from the "golden style" translated into hieratic icons, his sketches became simultaneously more and more free and fluid. His graphic masterpieces belong to this period. Right from the academic period of the frescoes for the Burgtheater, Klimt possessed a very personal drawing style aimed at showing the plasticity and smoothness of bodies. After the founding of the Secession and throughout the graphic experimentation in *Ver Sacrum,* his style became linear, nourished by his study of Greek vase painting and Japanese printmaking. His deep assimilation of these sources, combined with the geometrizing and synthetic tension of the Secessionists, gave a definitely personal style to the Klimtian application of Jugendstil.

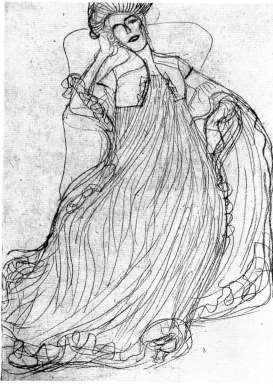

Far left:
Study [1] for the Portrait of "Adele Bloch-Bauer I," 1903; Vienna, Albertina.

Left:
Study [2] for the Portrait of "Adele Bloch-Bauer I," 1903.

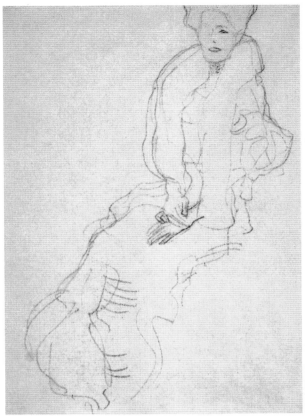

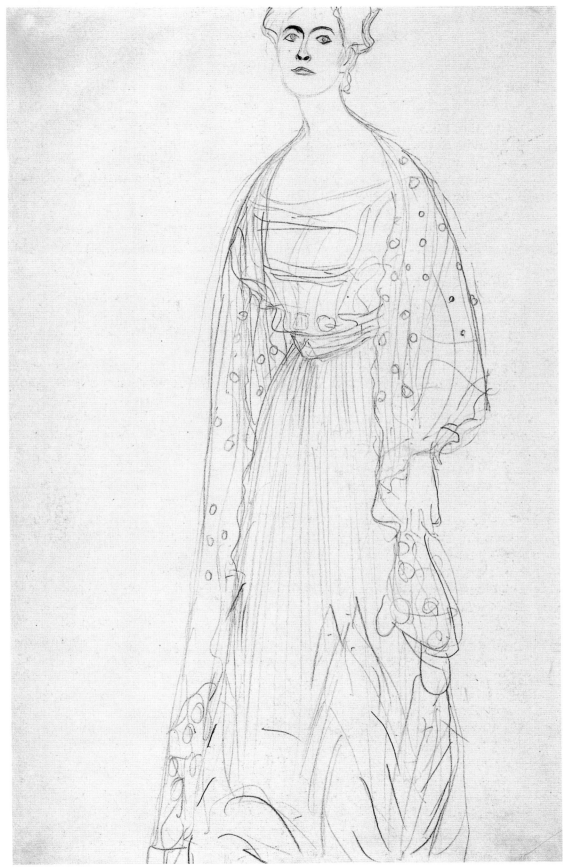

Above:
Study for the Portrait of "Margaret Stonborough-Wittgenstein," 1904–05.

Left:
Study for the Portrait of "Fritza Riedler," 1904–05.

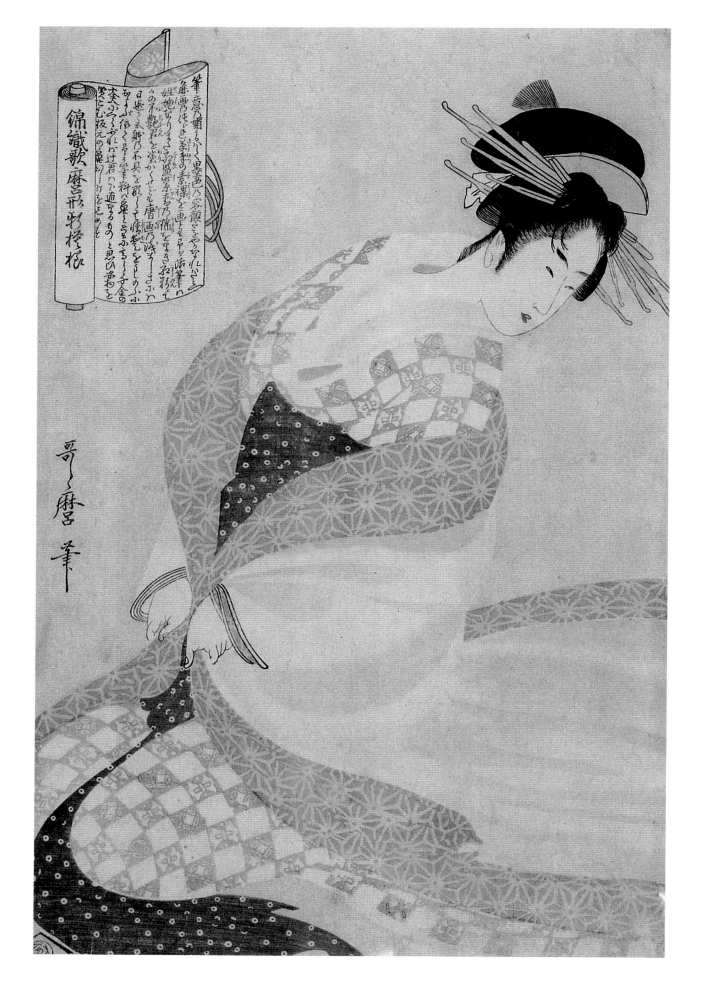

Kitagawa Utamaro,
Beauty with White Robe,
1796–97; New York
Public Library.

Study [3] for the Portrait of
"Adele Bloch-Bauer I,"
c. 1903; Vienna, Albertina.

The sharp arabesque of Beardsley and the serpentine line of Toorop became loose strokes, sensitive and sensual, that portrayed with incomparable lightness the curvilinear harmony of the body and its erotic vibrancy.

Klimt had earlier worked with rough paper and charcoal, but in 1903 began using pencils, occasionally colored, and smooth Japanese paper. While his painting shows a tension frozen in the ornamental opulence to which he entrusts the symbolic content, in his sketches, the artist lets this tension flow, ignoring detail and aiming instead at a pure linear dynamic. The contours become more and more subtle and rhythmic. The line runs from the curve to the corner without interrupting continuity, softly like a caress, at times merely whispered, that hints and summarizes instead of defining.

The centerpiece of these drawings is the female body, nude or partially undressed, in sleepwalking poses of uninhibited erotic abandon. The models curl up and stretch like the many cats that dozed and scampered around his studio. They masturbate or lovingly embrace a companion. They lose themselves in a fluid space with no history, offering their sleep and sex unveiled to the eye of the voyeur attempting to steal the soft secret of sensuality; there is no decorative masking, no literary or allegorical reference, no furnishings, only the cloth they lift to uncover the recesses of desire.

These thousands of drawings are the watermark of an occult, unconfessable thought, congealed in the decorative inlay, the elegant haloes, and nervous lines of the hands in the portraits of the beautiful women from good society. The pencil reveals the lewdness the painting conceals beneath the decorative shield; follows the mystery of a femininity that is vulnerable yet unhurt, possessed a thousand times yet never really possessed; explores the exhibited vulva that offers itself beyond all thresholds of modesty and remains the center of a radiating desire, fundamentally solipsistic.

Opposite page left:
Krater with Attic Columns and Red Figures, 500–480 BC; Vicenza, Palazzo Leoni Montanari.

Opposite page right:
Krater with Lucanian Volutes and Red Figures, 400–380 BC; Vicenza, Palazzo Leoni Montanari.

Left:
Egon Schiele, *Drawing a Nude Model before a Mirror,* 1910; Vienna, Albertina.

In every sketch, the gestures have such freedom and grace that the erotic obsession becomes melancholy hedonism and poetry, where sex still means privilege and not vice or sickness, as it would be portrayed in the audacious, neurotic drawings of Schiele.

A masterful group of similar drawings can be attributed to Rodin, who was charmed during his visit to Klimt's studio in 1902 and on leaving quoted Baudelaire, "Creative drawing is the prerogative of genius." But Klimt on the other hand considered it valuable mainly as study and relaxing exercise. He was never worried about the offensiveness of the subjects, precisely because he never intended his sketches for exhibition or the market. Instead, they would end up being sought after by his collectors.

In 1907, he chose several to illustrate an edition of Lucian's *Dialogues of the Hetaerae*, but his own carelessness no doubt caused the loss of most of this enormous production. Generally, visitors were amazed to see his sketches tossed here and there on the floor at the mercy of the cats. Arthur Roessler reported, "Once I visited Klimt's and rummaged through a pile of no less than 500 sheets, surrounded by eight or ten cats that meowed and purred and, in playing and chasing one another, scattered the rustling studies. Amazed, I asked him why he tolerated this running around that ruined hundreds of his most beautiful drawings. Klimt retorted, 'It's not important if they crumple up this sheet or that other sheet, that's nothing. That way they rub against one another and—You know? That is the best fixative!'"

Above:
Katsushika Hokusai,
Awabi Fisherwoman and Octopus
from *Pangs of Love*, 1814;
Cologne, Pulverer Collection.

Above:
Two Nudes Lying on Their Backs,
1905–06; Graz, Neue Galerie am
Landesmuseum Johanneum.

Far left:
The Friends, 1903–07; Vienna,
Wien Museum Karlsplatz.

Left:
Egon Schiele, *The Friends,* 1913.

THE EROTIC SKETCHES

Left:
*Semi-Nude Woman Lying
on Her Back, from the Right,*
1914–15; Vienna,
Wien Museum Karlsplatz.

Below left:
*Seated Woman with
Open Legs,* 1916–17.

Below right:
François-Auguste-René Rodin,
*Reclining Woman with One
Hand on Her Sex and a Bird on
the Right,* c. 1900–10; Paris,
Musée Rodin.

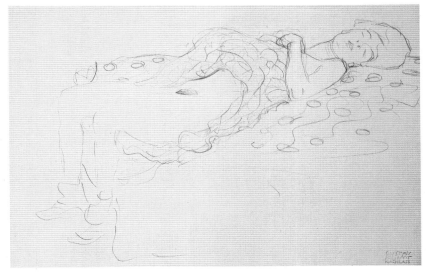

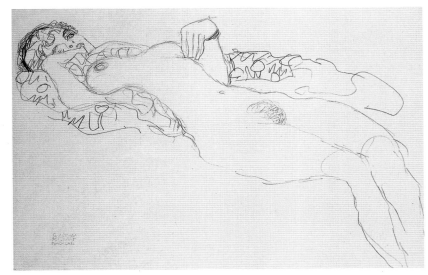

Above left:
Study [1] *for "Water Snakes II"*
and "The Friends," 1907.

Below left:
Woman Lying on Her Stomach, 1912–13;
Vienna, Wien Museum Karlsplatz.

Above right:
Study [1] *for "The Virgin,"* 1913.

Middle right:
Reclining Female Nude Turned to
the Left, 1914–15.

Right:
Study [2] *for "Water Snakes II"*
and "The Friends," 1907.

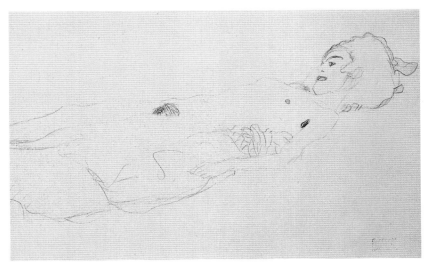

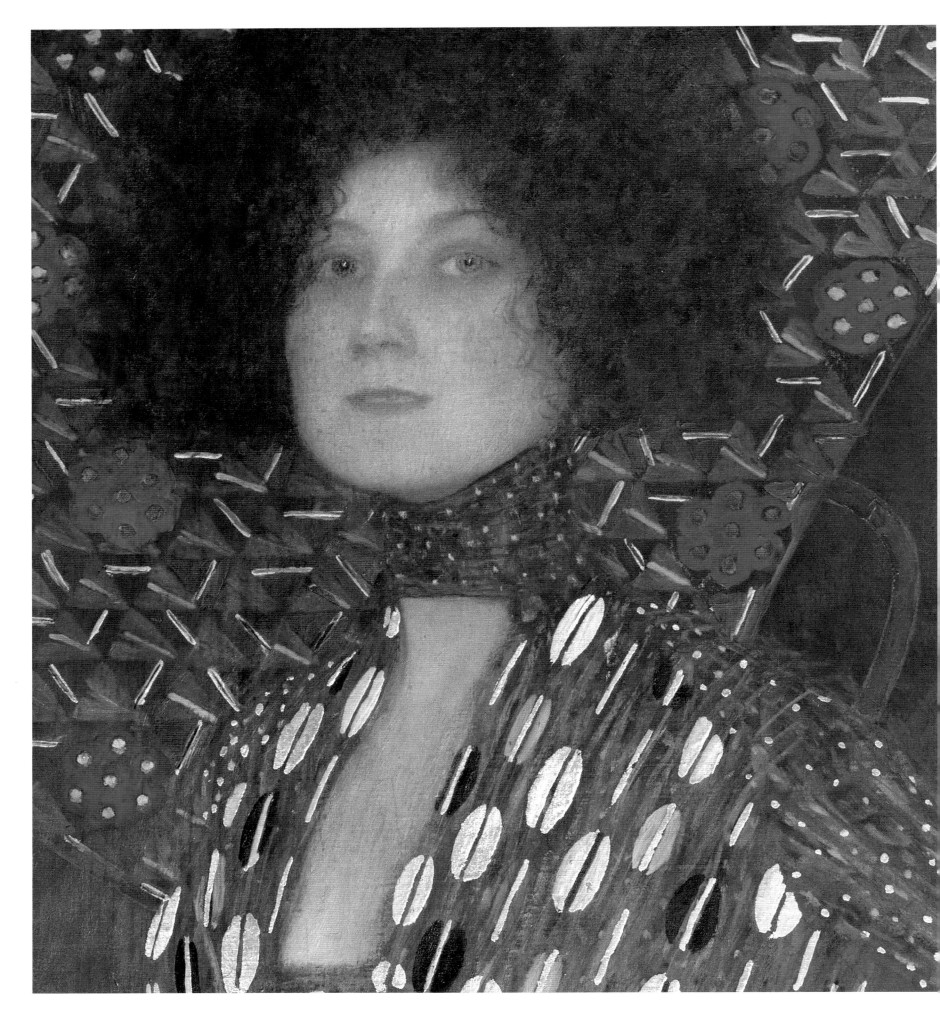

THE WOMEN IN
HIS LIFE

In his *Comedy of Seduction* (1924)—a play that unfolds in the days preceding the declaration of war in 1914—the Viennese writer and admirer of Klimt Arthur Schnitzler emphasized in the character of the painter Gysar several features that made Klimt legendary in Viennese society. Almost to the point of parody, Gysar is constantly on the hunt for beautiful women to paint, and every modeling session clearly coincides with an erotic encounter. His studio is a sort of free zone of desire, an island of Kythira. "My house stands alone. The garden is surrounded by high walls, like an island in the sea of the world." She who visits is irreparably compromised in the eyes of society and loses the right to become valued. Inside those walls, undressed young women are permanently stationed, as if in a harem, awaiting a sign from the master. Gysar paints two portraits of every lover, one official, the other in the splendor of intimacy, "Like Correggio painted Io at the very moment when the cloud is mounting her. And he is always the cloud."

His private portraits are so revealing they must be protected from the eyes of others and stored behind special panels. Being shown in the nude in a painting from the secret vault can even be fatal to the woman portrayed, generating in her an awareness and hysteria of desire that carries her beyond social norms and finally beyond life itself. Effectively, the garden of Klimt's studio, a bit beyond reach on Josefstädterstrasse, was surrounded by a wall, the vegetation growing wild, and on the couch of the studio numerous models stayed freely for entire days, chatting and playing erotic games, willing to strike any lascivious pose and, they insinuated in Vienna, offer the painter any possible distraction.

Remigius Geyling, a friend of the artist, was the author of an almost satirical watercolor from 1902 that shows Klimt on a scaffolding, concentrating on drawing the large panel of *Philosophy*, while below a nude woman offers him a snack on a platter and another plays with the ladder.

If the circumstances of Gysar's paintings kept under lock and key recall the storage in a cabinet at the Waerndorfer house of the scandalous *Hope I* by Klimt, then Schniztler's story of the double portrait seems to allude to the relationship between the artist and Adele Bloch-Bauer, daughter of a banker, wife of the owner of the largest sugar refinery in central Europe, and typical representative of that refined Jewish bourgeoisie, partially integrated into Viennese high society, who collected his works. Subject to headaches, fragile, elegant, and very cultured, Adele cultivated literature and art, collected porcelain and paintings, received in her luxurious home Alma Mahler, Richard Strauss, Arthur Schnitzler, and Stephan Zweig, among others, and was also politically inclined. She was a close friend, some said even lover, of the Social Democrat Karl Renner, who would become the first president of post-Nazi Austria at the end of the Second World War.

Gustav Mahler (standing), Max Reinhardt (facing away), Carl Moll, and Hans Pfitzner in the garden of Villa Moll in a photograph from c. 1905.

Far right:
Klimt in a painter's smock with one of his cats in front of his studio, c. 1910; Vienna, Bildarchiv, Österreichische Nationalbibliothek.

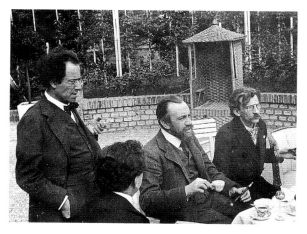

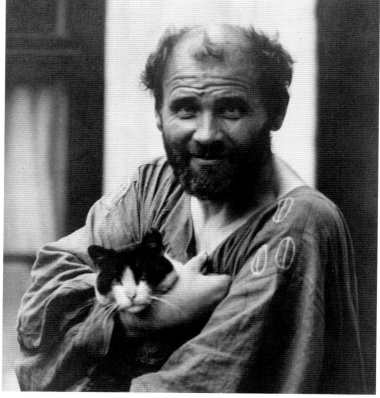

Chapter Opening (p. 146):
Emilie Flöge, 1902, detail;
Vienna, Wien Museum Karlsplatz.

Remigius Geyling,
*Klimt Transfers His Studies
for "Philosophy" to Canvas,*
1902.

Her love story with Klimt, supported by the American psychiatrist Salomon Grimberg and based on various accounts, till today has rested only on fascinating supposition. There was certainly a close personal relationship between the two, probably with some erotic overtones, and the artist was also her guest at the family castle near Prague.

Klimt would portray her in one of his most costly paintings, inlaid in a flat panel of gold and gems, and again in the final phase of his style, elegant against an oriental décor and the delicate dance of flowers between wall and floor. But in the second portrait, that pale lady with the nervously intertwined hands, who shines like an empress in her metal tunic, has a body that seems to have been reduced to an immaterial sheet inside the gown. According to Grimberg, this could also be the secret protagonist, bare-breasted and at the moment of orgasm, in another painting that carries the name *Judith I*. In the icon of the "decapitator of heads," Klimt would exhibit the intimate face of his own lover, the face in which the real woman joins with the imaginary woman.

"He had a hundred relationships: women, children, sisters who became enemies to each other for his love." In her autobiography, Alma Mahler contributes to Klimt's fame as an unrepentant womanizer and tells the story of a courtship that culminated in a kiss in Piazza San Marco in Venice, immediately discovered and punished by her tutor Carl Moll, when she was still quite young and had not yet married the famous composer.

This episode dates back to 1899 and is also documented in a long letter the artist himself, overcoming his own aversion to the pen, wrote to his colleague Moll, urging him not to abandon their friendship, reducing the affair to a girlish action brought on by one drink too many. He was careful not to propose, thus removing himself from the future succession of geniuses married by the lovely Alma, who would later confess her regret. "I owe Gustav Klimt many tears and at the same time my reawakening… ours remained, for many years, a strange relationship…He himself affirmed, many years later, that we had searched for each other all our lives, without ever finding each other. He loved to play with human feelings. Nevertheless, as a man, he was everything that I at the time, erroneously, sought."

The "man who loved women" never loved them enough to choose one from among his "hundred relationships," and all his life lived a regular, middle-class existence with his mother and two sisters, reserving the haven of his studio for his passions, above all his painting. He never willingly broke his habits, such as his daily walk to Schönbrunn for breakfast at Tivoli, where he also dispatched his correspondence. He entrusted others with his affairs and practical tasks. He did not like to travel and never led a worldly nightlife. He preferred good food and the occasional evening at Prater, where he would offer champagne to his company of friends and young female strangers. He was always generous with his lover-models, who worshipped him and told him all their troubles.

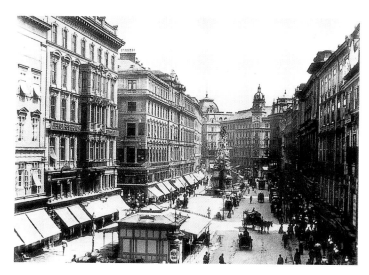

In a period photograph, an urban scene from fin-de-siècle Vienna characterized by intense life in cafés, theaters, and sumptuous golden salons, between waltzes and Sachertorte, or in the Prater for long walks or carriage rides.

Leisurely moments in the Prater in a photograph from the period.

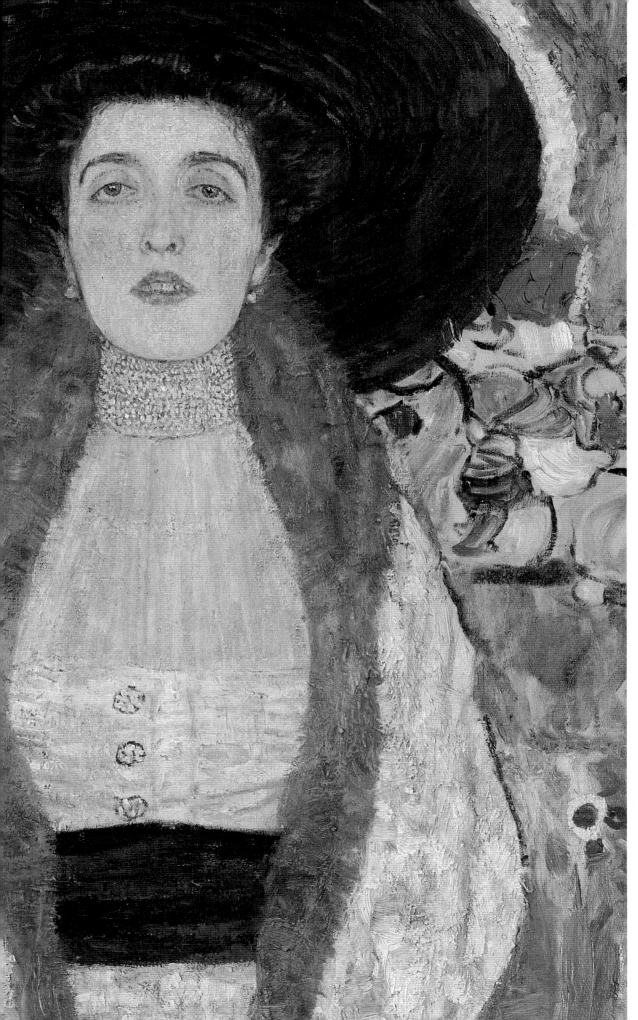

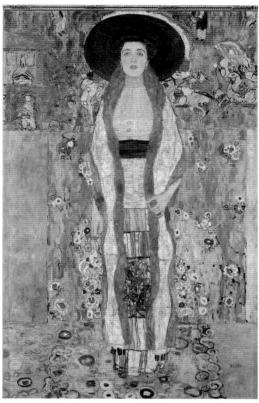

Adele Bloch-Bauer II,
1912, entire painting and
detail; work returned in 2006
by Austria to her heir Maria
Altmann in California.

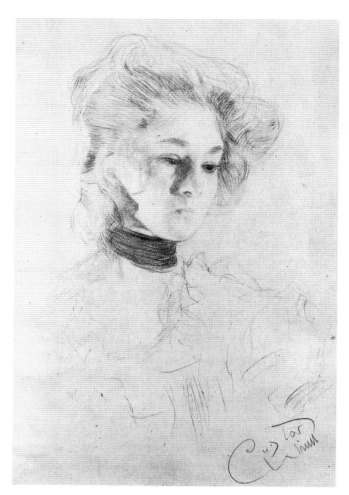 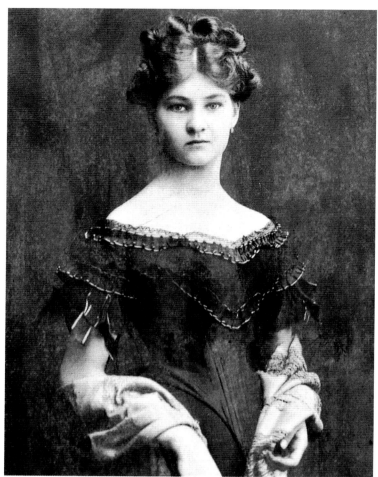

"There was something in him like a scar that kept him from abandoning himself to life," wrote art historian Hans Tietze in 1919, suggesting a deep melancholy, perhaps a neurosis. Certainly, Klimt shared the common idea of the era that every exclusive relationship was an enemy to art and every woman basically an attack against creativity, sucking out one's vital energy and weighing down the spirit with inconvenient appeals to daily matters. From Moreau to Rodin, Khnopff to Munch, the artists most obsessed with the feminine would remain obstinately unmarried so as not to undermine their dream, as well as not to become prey to the dread that suffused their cult images, that of being subjugated.

We can only conjecture that other rich portrait customers, such as Sonja Knips, who bound for Klimt a series of red leather-bound notebooks, or Serena Lederer, who owned the largest collection of his paintings and after the death of the painter acquired 200 drawings at one time without asking the price, may have also had a closer relationship with him. But those suppositions remain speculative in the case of Bloch-Bauer. The man Klimt was reserved regarding his private life, frugal in his correspondence and expressions. In any case, his catalogue of female lovers served no other function than to intensify the feeling of the era the artist used to display the type of Viennese beauty seen in slender ladies from high society. Like a jewel set against a Secessionist décor or a flower against a colored Oriental backdrop, as well as suburban nymphets to whom he gave the sirens' magic, all were near and distant at the same time, as becomes the phantasms of the imagination.

But the gentle Mizzi Zimmermann was no phantasm. The young, dreamy blonde figure in the background of *Schubert at the Piano II* (1899) for years looked after him in the shadows, too real and simple to inhabit his subsequent paintings, even though she may have given him two children (fourteen would attempt to claim their hereditary rights after the painter's death) and suggested the portrayal of pregnant women (although the face of *Hope I* is not hers). Klimt supported her, followed the progress of the children, sketched the early death of little Otto, and always wrote her brief affectionate letters when he was away, some of which also contain interesting information about the progress of his painting.

Neither was the independent Emilie Flöge a phantasm; she was his lifetime friend and companion, the only one Klimt wanted beside him on his deathbed. He had always known her. She was actually the young sister-in-law of his brother Ernst, also a painter, with whom he worked in the early years, a collaboration interrupted by his brother's sudden death. While completing a painting Ernst had left unfinished, he inserted a portrait of

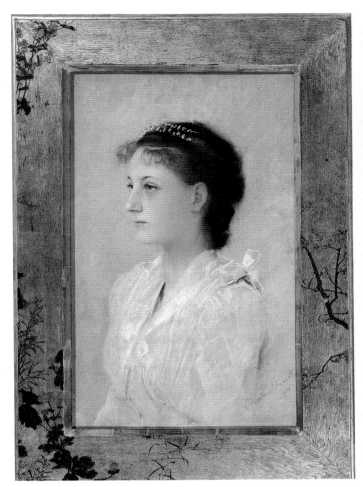

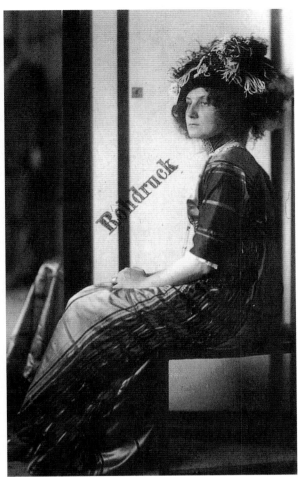

Emilie at seventeen that shows her strong-willed temperament, as she would be depicted in her subsequent portrait in 1902, where the direct gaze and hand on her side give the slender figure confidence and determination. If contrasted with the sublime, swooning decapitator, Emilie indicates the opposite possibility of a joint relationship in her proud yet never threatening distance.

Her gown with its Secessionist decorative motifs was an example of the clothes Klimt designed for the fashion studio Flöge opened in Vienna in 1904, one that would serve the most prominent ladies of the city until 1938, when it closed upon the arrival of the Nazis. The Wiener Werkstätte furnished the fashion studio in the Secessionist style with furniture designed by Hoffmann and Moser. The great artist and the great dressmaker maintained a solid, constant relationship. Although it never led to living together, small daily messages and many photos show them together at their customary annual vacation on the Attersee, where he always wore a kaftan, his usual uniform for work and relaxation, and she wore the flowing, diaphanous dresses with checkerboard motifs, in which the graphic geometry of the Secession combined with the progressive needs of "dress reform."

In the photo, the couple almost seems to put on display, like an advertisement, their adherence to the contemporary dress reform that started in England around 1880 along with the movement for the emancipation of women. This reform proposed abolishing the torture of the corset and the "wasp waist" in favor of greater comfort in women's clothing, calling for the rights of the body and the abolition of cages, as well as the possibility of informal, less uniform, men's clothing.

This avant-garde fashion would spread only after the First World War and at the time was recognizable in the uniform of the utopian communities during the era that came to Ascona, Switzerland, where on Monte Verità, the "Mount of Truth," followers in tunics held communal property and practiced free love in the name of the primacy of Eros and the possibility of a new matriarchy.

These libertarian gowns point to the same themes Gustav Klimt concealed in his iridescent paintings. His existence conformed to these themes but without theories, excesses, or rebellious gestures. Then again, the artist never needed them because his Monte Verità was already contained in his painting. In the end, beyond any collection of anecdotes, the painting is the only thing that shows the unambiguous direction of his yearning for the maternal dream. In one of his rare public statements, he said, "Everything there is to know about me is in my paintings."

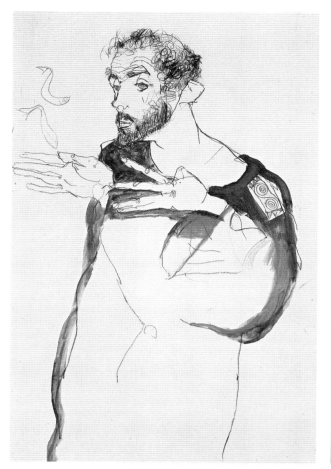

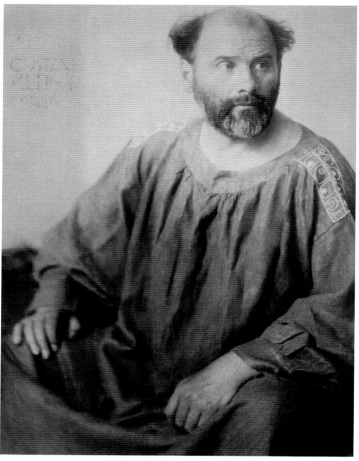

Above left:
Egon Schiele, *Gustav Klimt*
in *Work Smock*, c. 1912.

Above:
The artist in his self-designed,
kaftan work smock.

Left:
Klimt and Emilie Flöge in a
boat on the Attersee.

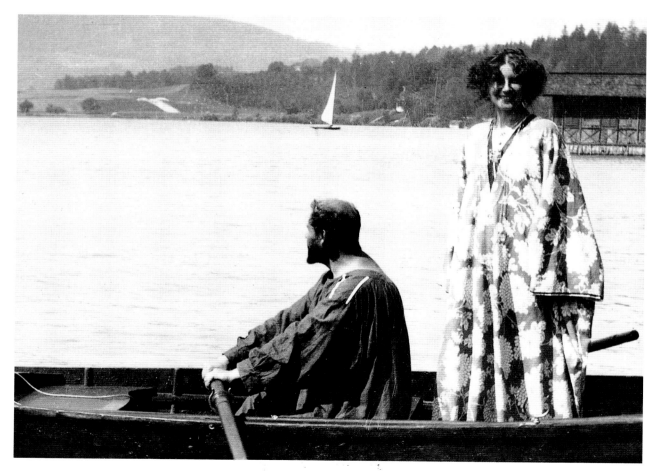

Postcard by the Wiener Werkstätte,
signed by Gustav Klimt and sent to
Emilie Flöge, dated July 7, 1908, on
which the artist writes, "How can
one justify the lack of flowers?
Tomorrow evening I leave [for
Munich] and will stop at 4
Jahreszeiten. Sincerely yours,
Gustav."

Emilie Flöge, photographed by Klimt in 1907,
wearing a soft gown designed by the artist with
inlaid geometric motifs in the Secessionist style.

Emilie had known Gustav since she was a child,
as she was the sister-in-law of Ernst, the artist's
brother. Strong-willed and independent, she was
Klimt's companion and lifelong friend, the only one
he wanted by his side on his deathbed.

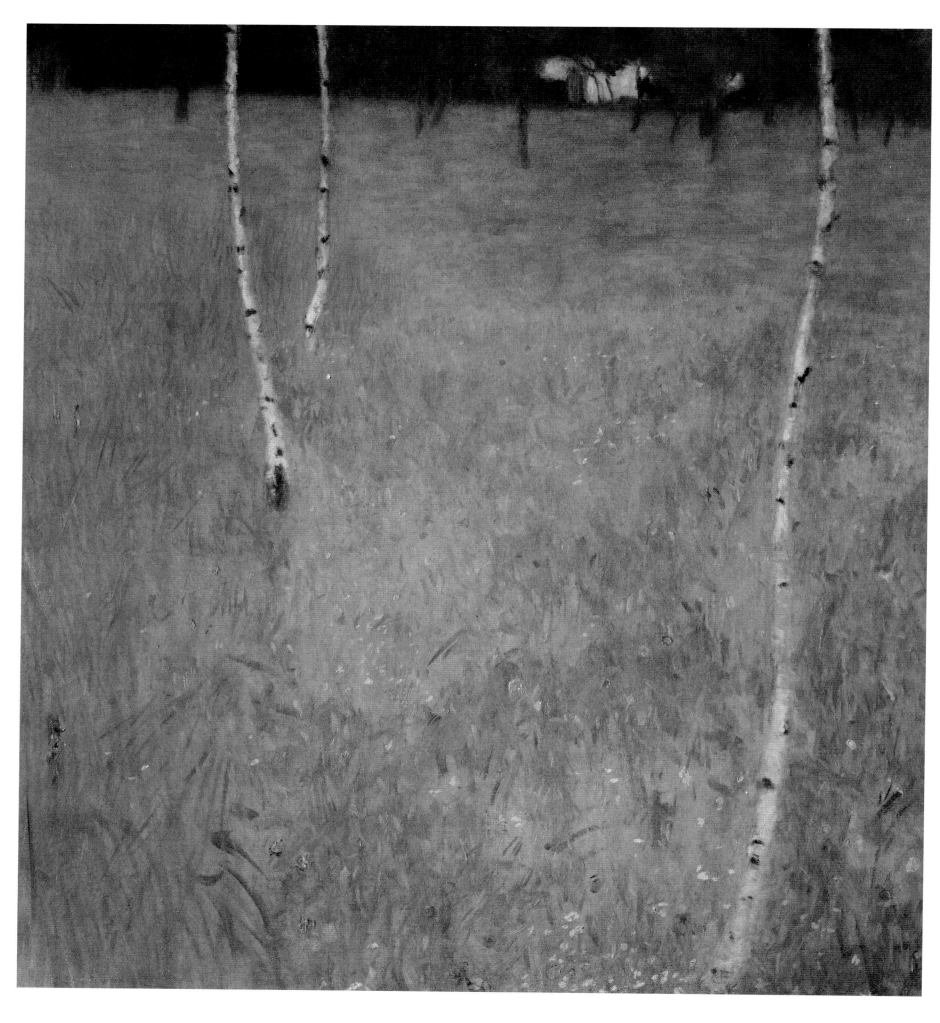

THE LANDSCAPES

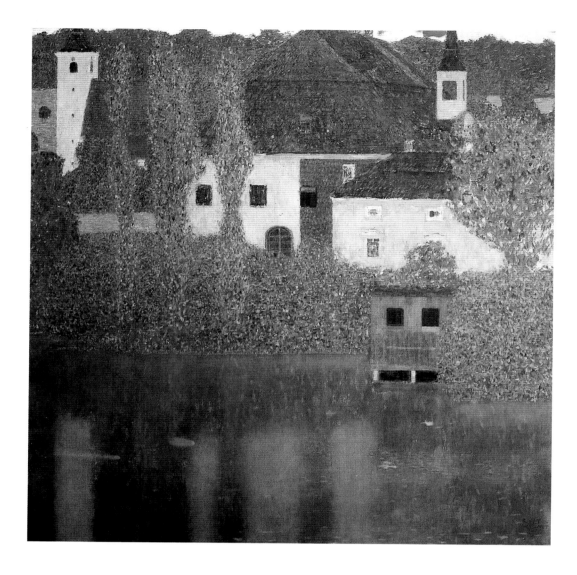

Klimt began painting landscapes only in his mature years, during the summers between 1900 and 1916 spent in the quiet lakeshore landscape of the Attersee in the company of Emilie Flöge. A stylistic shift had already occurred, replacing the rhythmic partition of the surfaces with an atmospheric fluidity, and ambiguous two-dimensional definition with enigmatic depths.

Klimt worked en plein air, planting his easel among the trees or on a boat and finishing the paintings later in his Viennese studio. These paintings are far removed from early impressionist sketches. They celebrate neither nature, nor fleeting light effects, nor the mutating spontaneity of growth. On the contrary, Klimt tended to effect a sort of indefinite suspension of time. The foreground expands until it fills up the painting, patterned by reflections of light on immobile water or the vertical lines of trees, with the line of the horizon very high. Even the square format imposes suggestions of tranquility. The landscapes exclude human presence; instead, they become inaccessible hidden places where the eye cannot move beyond the horizon that almost meets the margin. Vision is restricted to a fragment as if through a spyglass blocked at one point; the eye exclusively brings into focus the detail, intensifies it until it becomes a magic moment, an object of meditation, a curtain of noninvolvement and solitude.

As he mentioned in a letter to Mizzi Zimmermann in August 1903, the artist used to verify the pictorial subject by observing the landscape through a square opening in a small tablet of ivory he carried with him. "In the early days of my stay here, I did not immediately start to work and got a bit lazy, leafing through books, studying some Japanese art, searching for motifs for my landscapes with my 'sight,' but I found few, in fact none."

During the day, he worked on several paintings, depending on the hour and weather, as he mentions in another letter from the same period to his beloved Mizzi.

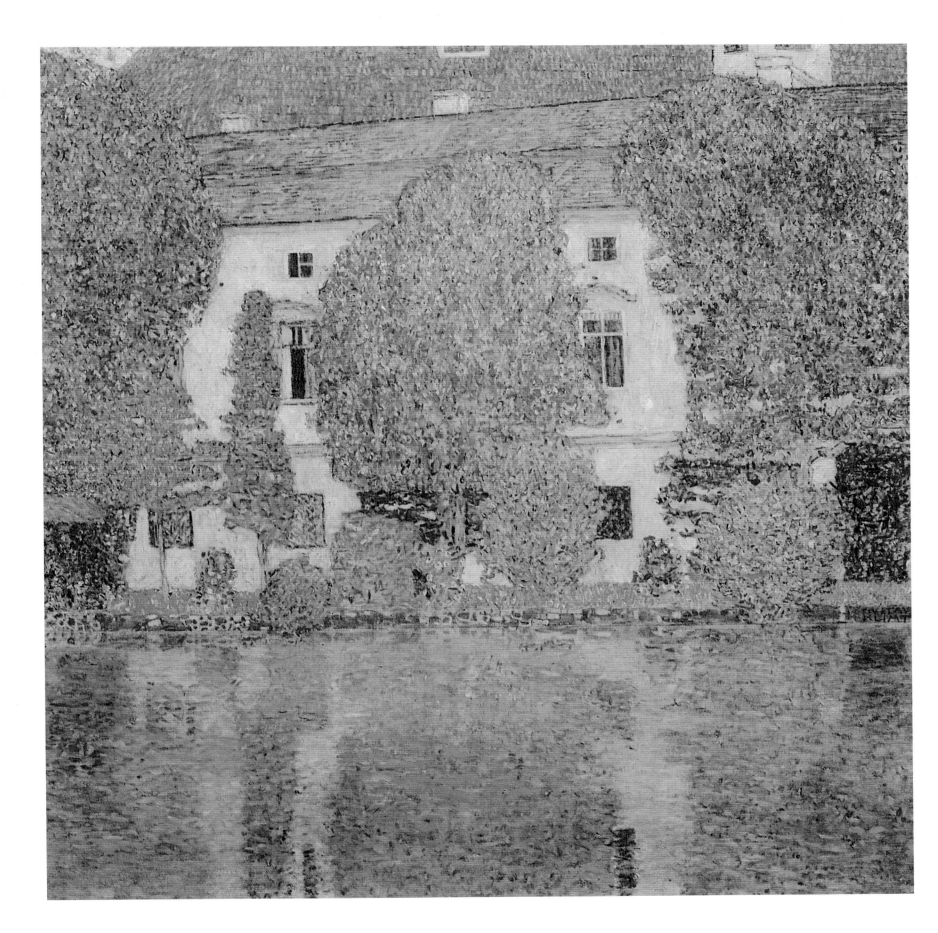

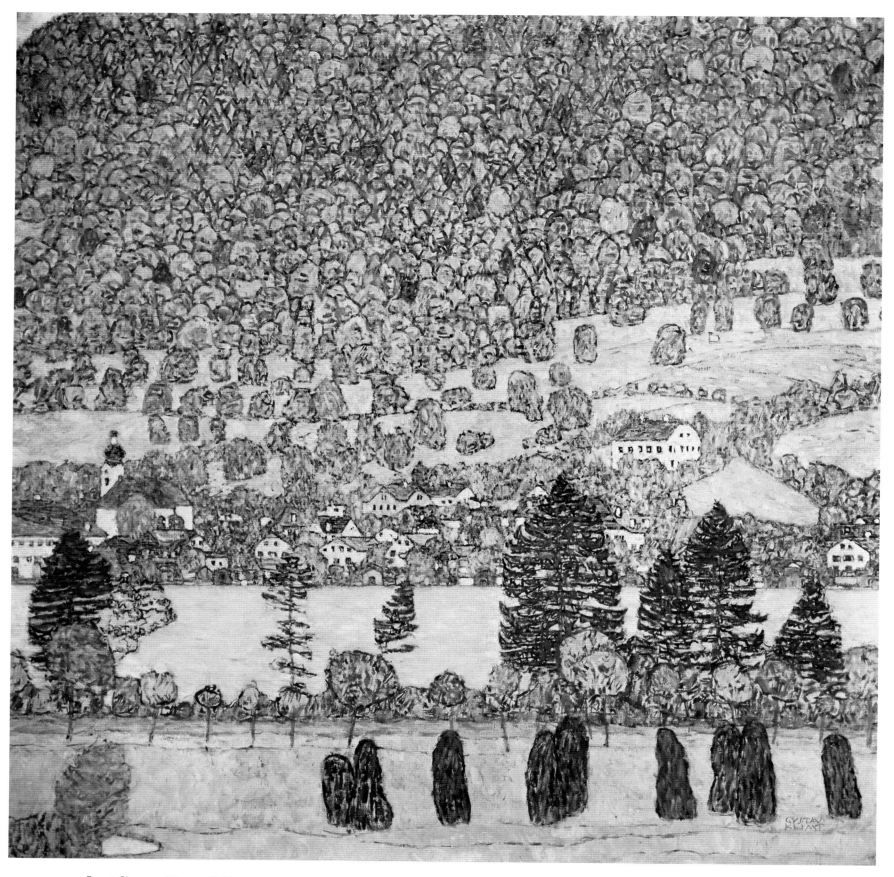

Forest Slope on Attersee, 1917.

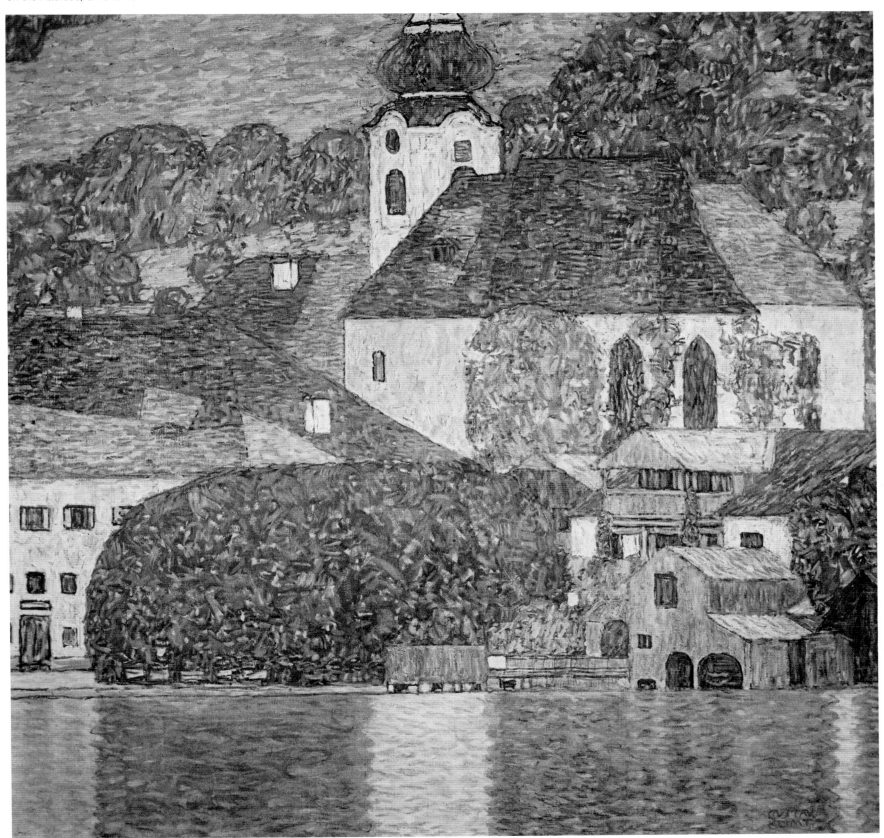

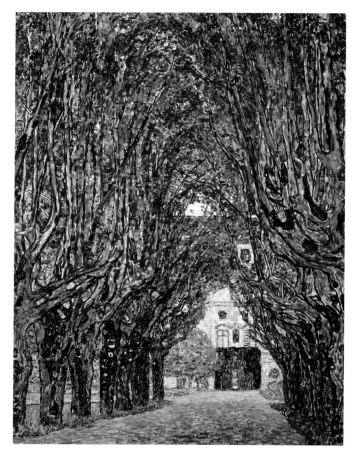

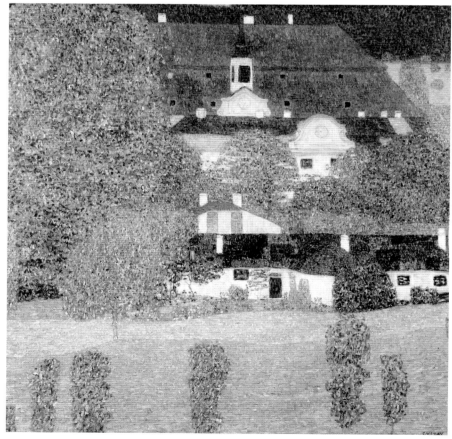

Above:
Avenue in Schloss
Kammer Park, 1912, detail;
Vienna, Österreichische Galerie
Belvedere.

Above right:
The Forester's House in
Waeissenbach at Attersee, 1912.

Right:
Schloss Kammer at Attersee III,
c. 1909, entire painting and
detail on opposite page.

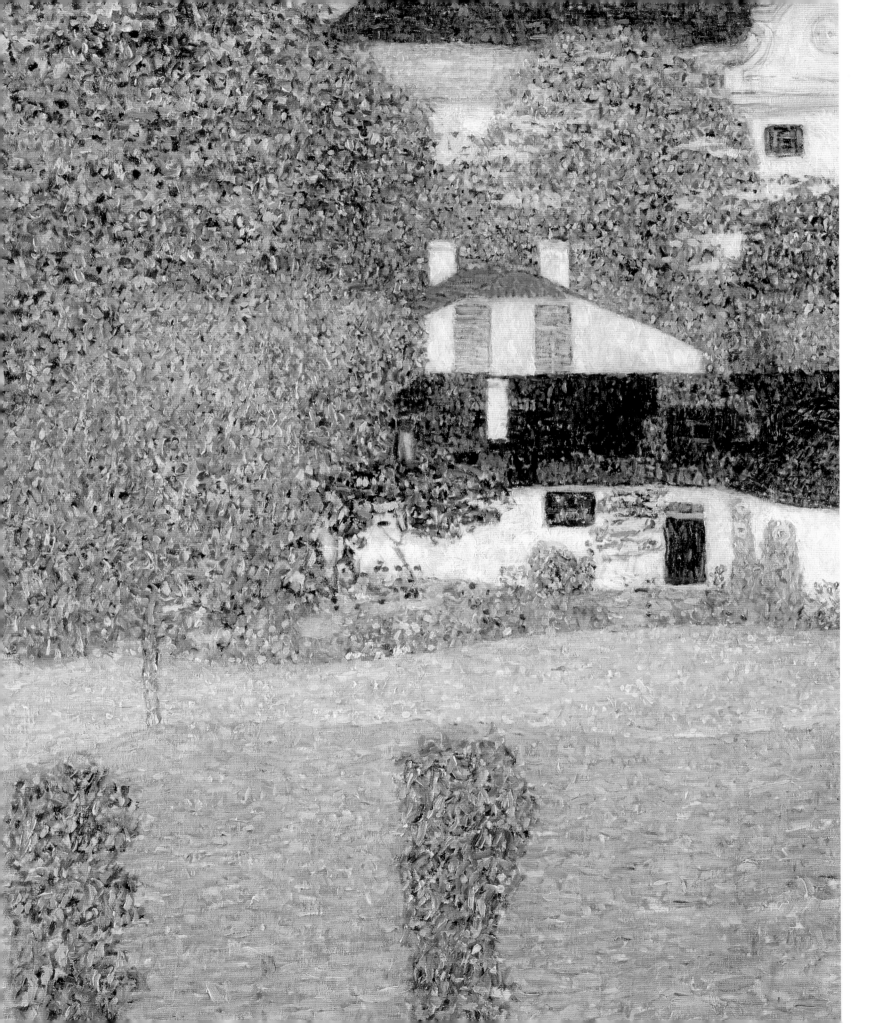

Right:
Georges Seurat, *A Sunday Afternoon on the Island of La Grande Jatte,* 1886; Chicago, Art Institute.

Below:
Théo van Rysselberghe, *Sailboats and Estuary,* c. 1892–93; Paris, Musée d'Orsay.

Below right:
Georges Seurat, *The Lighthouse at Honfleur,* 1886; Washington, National Gallery of Art.

Opposite page:
Island in the Attersee, c. 1901.

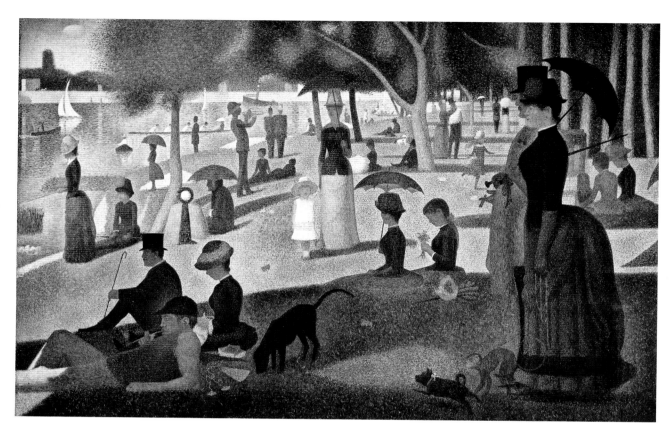

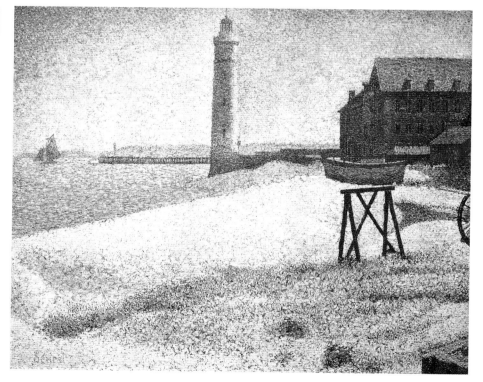

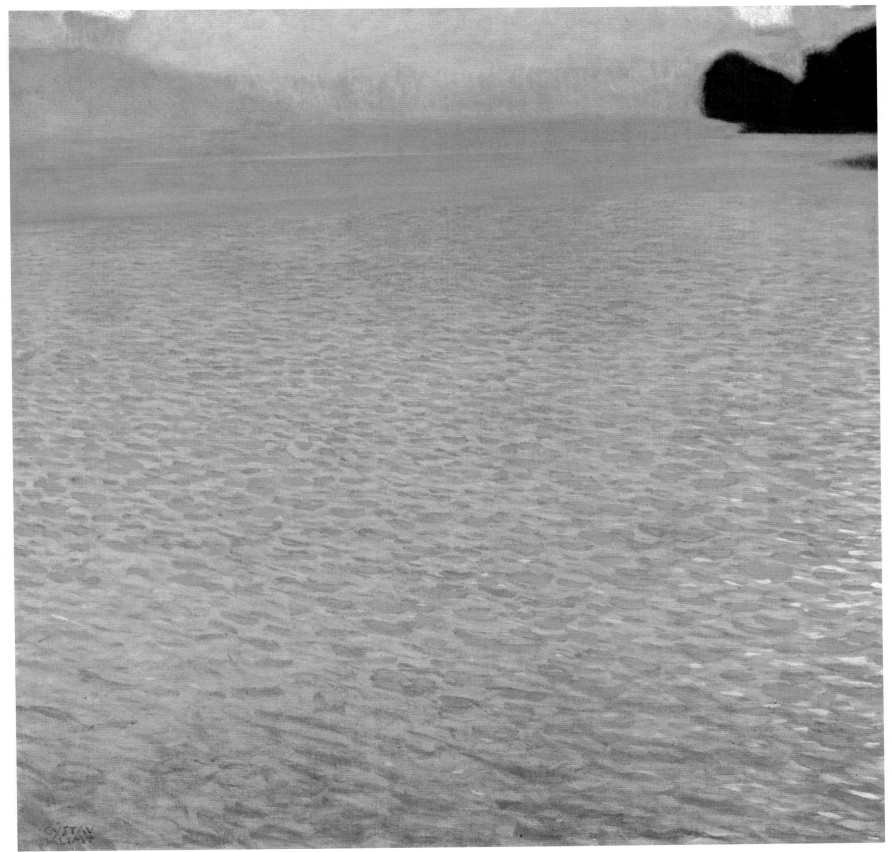

Birch Forest, 1903,
entire painting and detail;
returned by Austria to
the heirs.

A forest of dense, naked
trunks with no tops,
similar yet at the same
time different in color, size,
and movement. Like sinuous
and sensual female figures,
the vertical and dark lines
of the slender trees in
terweave and contrast with
the luminous line of the flat
horizon, seeming to wave
almost hypnotically.

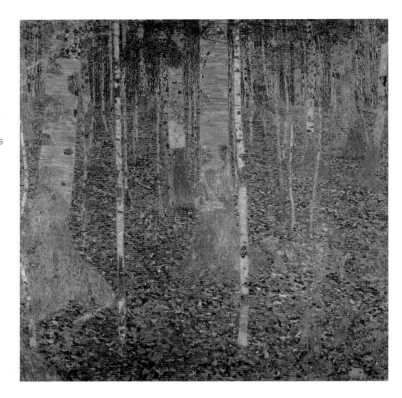

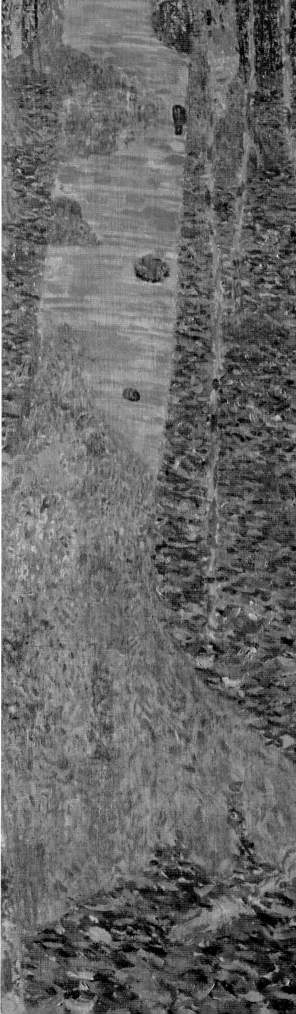

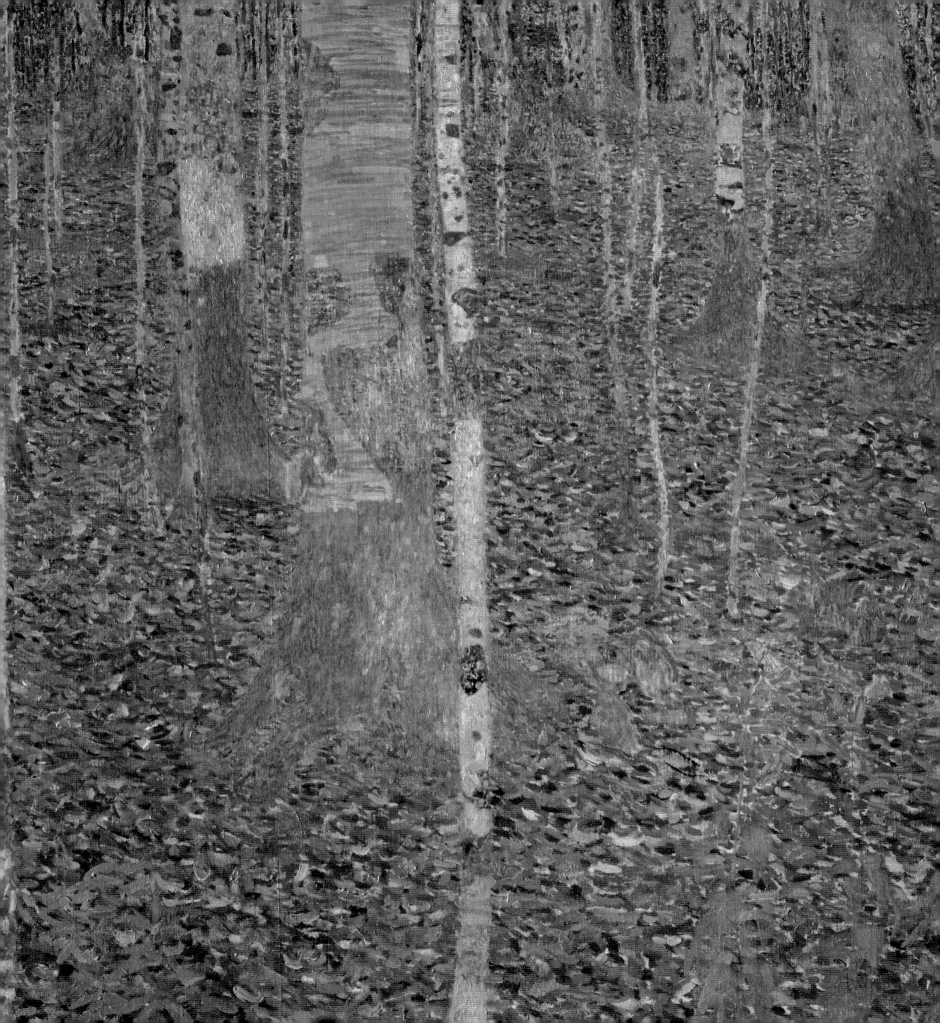

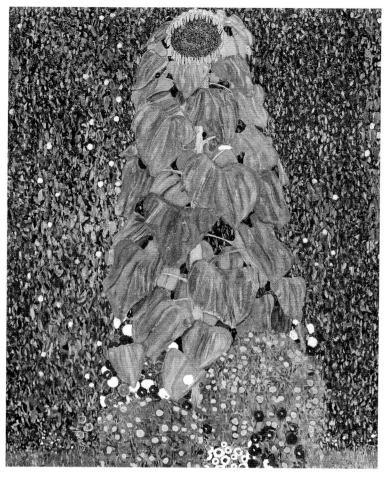

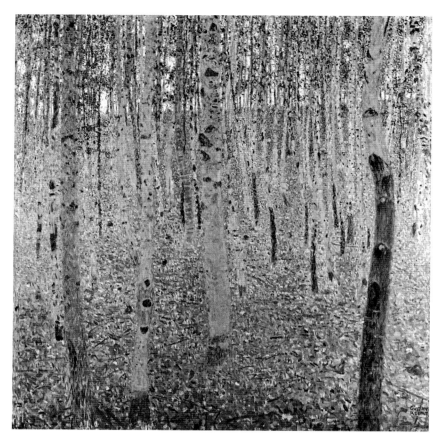

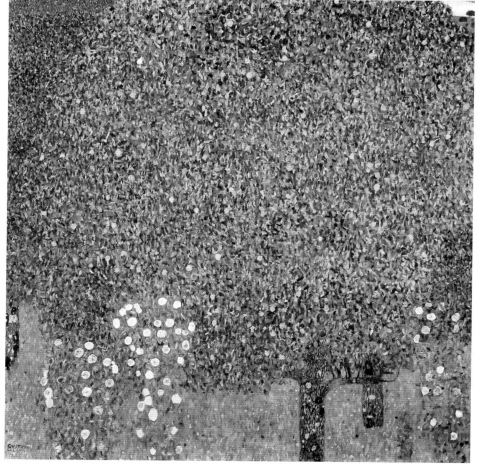

Above:
Sunflower, c. 1906–07.

Above right:
Beechwood I, 1902; Dresden,
Galerie Neue Meister.

Right:
Rosebushes under the Trees,
c. 1905. Paris, Musée d`Orsay.

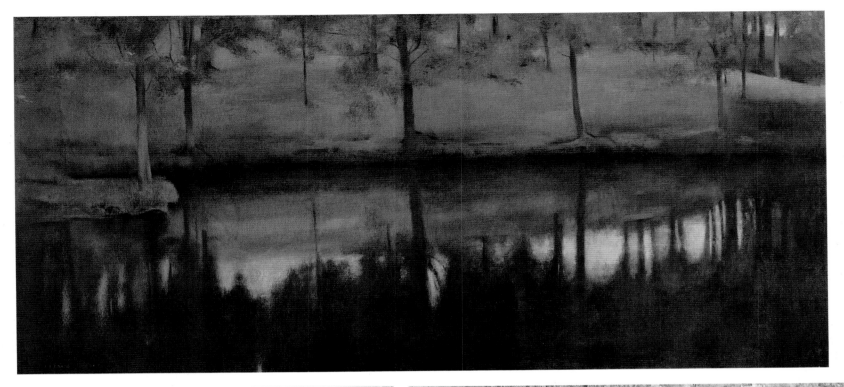

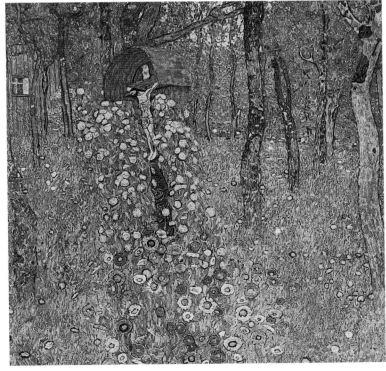

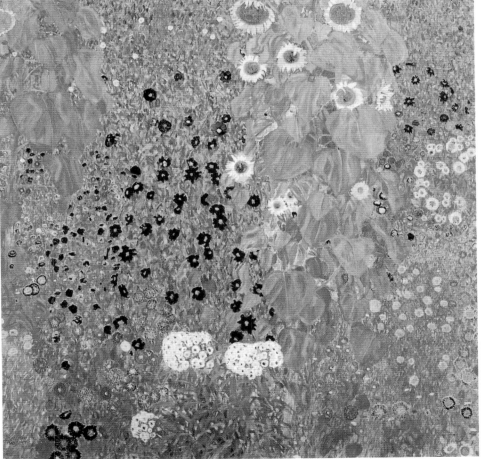

Top:
Fernand Khnopff, *The Motionless Water,*
1894; Vienna, Österreichische Galerie Belvedere.

Above:
Country Garden with Crucifix, 1911–12; destroyed.

Right:
Country Garden with Sunflowers, 1905–06;
Vienna, Österreichische Galerie Belvedere.

"In the morning, I get up early, around six. If the weather is nice, I go into the woods near here and paint a small beechwood in the sun interspersed with firs. I carry on this way until eight, time for breakfast, then I go to the lake where I have a swim, with all due caution, and paint a little bit more: a view of the lake if there is sun, a landscape seen from my room if the sky is overcast; some mornings I do not paint, and study my Japanese books in the open, instead. Then it is noon. After eating, a nap and some reading until it is time for a snack, before or after which I have another swim in the lake, not always, but fairly frequently. After the snack, I continue painting, a great poplar at twilight, while a storm is on its way."

While the artist suggests the importance of Japanese art as a source of inspiration, the compositional style and close point of view recall several paintings by Khnopff. The result is a harmony so esoteric it seems to remove itself from the play of light and shadow, the passing of the seasons, and conceal an enigma behind the dense curtain of brushstrokes. Nearby seems as distant as far away; the frontality is so exclusive it attracts one like a magnet. The technique is additive, a texture of small touches of color, not pure in the pointillistic manner but already mixed in infinite shades. Customary for Klimt's works, the method is similar to a mosaic, but reduced further into smaller particles. There is also an echo of Seurat (*A Sunday Afternoon on the Island of La Grande Jatte* was exhibited at the Secession in 1903), but perhaps above all the self-assured, Symbolist "Pointillism" of Théo van Rysselberghe and the maniacal *horror vacui* of the decorative painter from Munich Carl Strathmann.

The themes here are water, as in *Island in the Attersee* (1902); the woods as a place of the interiority of nature and the soul, cathedral of silence and the indivisible, where the parallel repetition of trunks removes the space from the control of the eye in *Beech Forest I* (1902); the "Japonisme" of those trunks cut at the upper margin of the painting and vegetation as a virtually infinite proliferation in *Poppy Field* (1907); the almost anthropomorphic pyramid in *The Sunflower* (1907); and the thick chromatic weave of *The Park* (1910).

The poet Peter Altenberg, an admirer of Klimt, identified here in these landscapes, more than in the allegorical paintings, that perfect balance of image, idea, and feeling he felt were the mark of true Viennese modernity, made up of melancholy, elegance, intimacy, and decadence. He wrote in 1917, "Gustav Klimt, as a contemplative painter, you are also a modern philosopher, a very modern poet! Through painting, you suddenly transform yourself, almost incredibly, into that very modern man who you may not actually be in the real existence of that day and time! Your rural landscapes with a hundred thousand flowers and one gigantic sunflower constitute an ideal connection between idealism and romanticism! Yes, the theoretically practical solution of this problem! Your dark cottages, your sylvan lakes are melancholy and very modern songs and poems! Your beechwoods could make sweet-tempered souls cry, they are so lonely—exquisite—dark!"

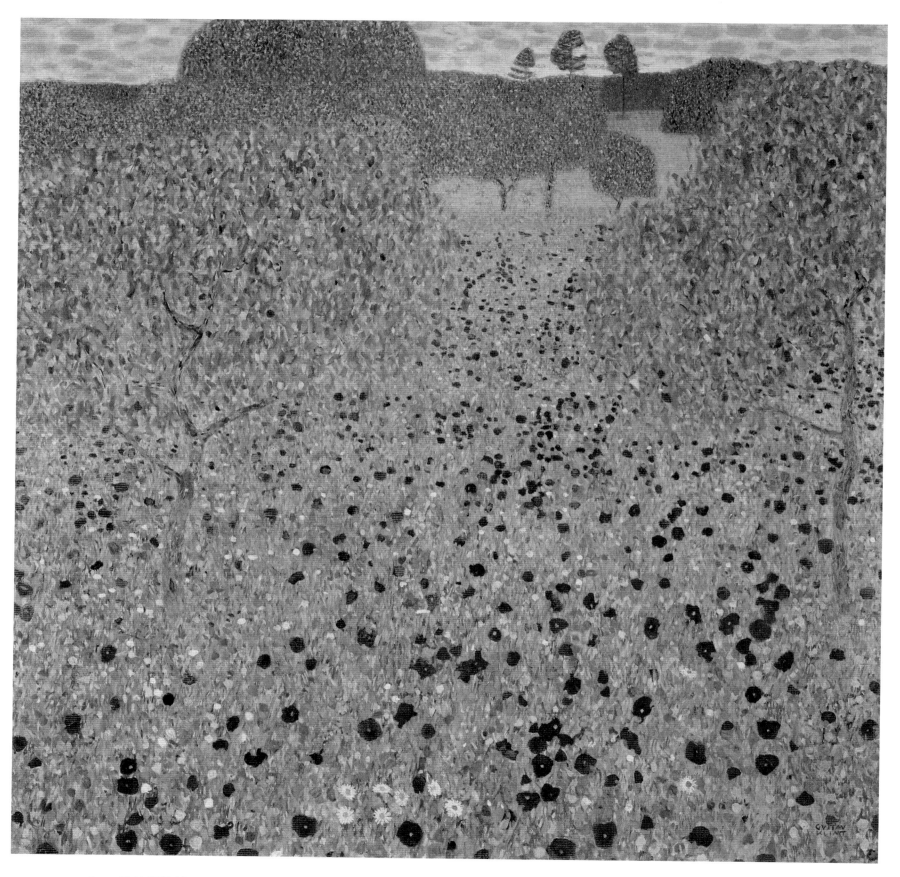

Poppy Field, 1907; Vienna,
Österreichische Galerie Belvedere.

The Park, 1910; New York,
Museum of Modern Art (MoMA).

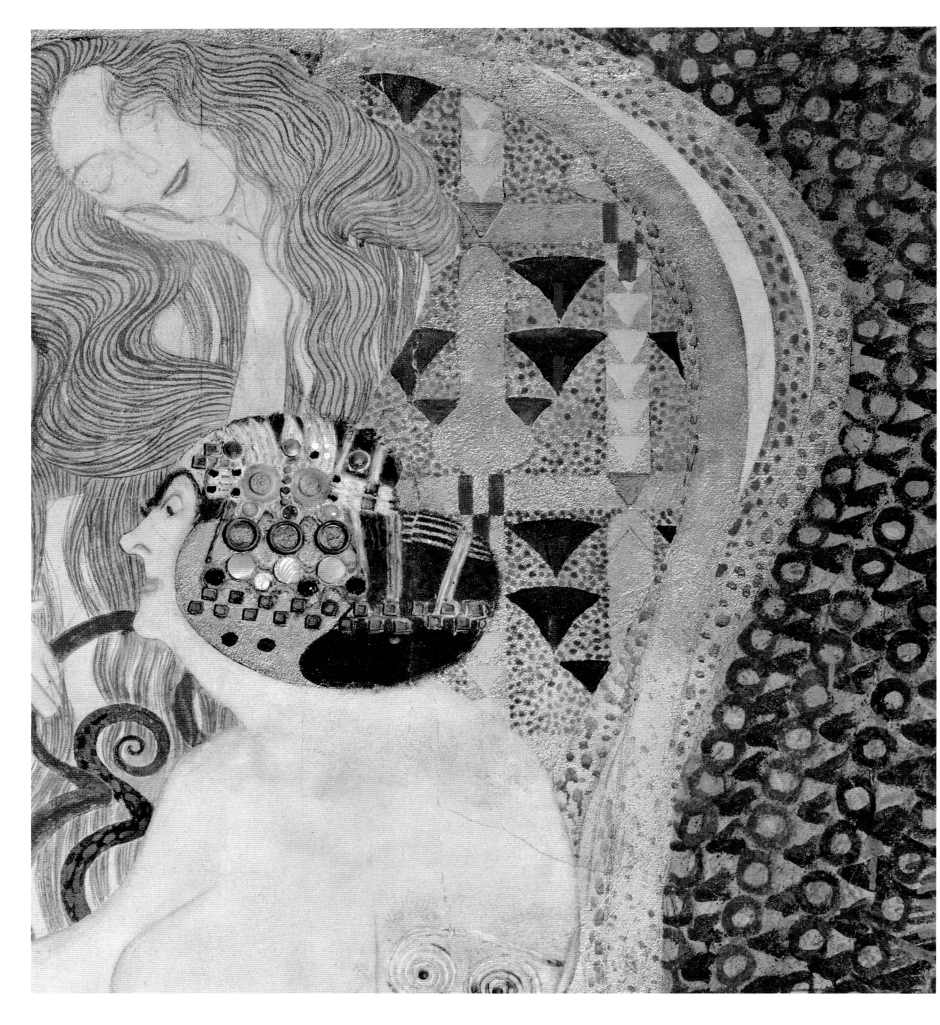

THE ALLEGORICAL
FRIEZES

Chapter Opening (p. 174):
The Hostile Forces (Wantonness and Intemperance), 1902, detail from the *Beethoven Frieze*; Vienna, Secession Building.

View of Hall A of the Fourteenth Viennese Secession Exhibition (1902) with the *Beethoven Frieze* in a photograph from the period. The sculpture of Beethoven by Max Klinger can be seen in the adjacent central hall.

Between 1901 and 1909, the "golden style" took the form of allegory par excellence. In the *Beethoven Frieze*, done in 1902, Klimt completely showed for the first time the concept that stylization and the use of decorative symbols are the most suitable instruments for allegory and the elements of a new way of conceiving monumental painting.

The *Frieze* was 24 meters long, produced on three panels painted with casein paint on plaster applied to lattice-work and inlayed with precious stones and mother-of-pearl; it was constructed for the Sixteenth Secession Exhibition dedicated to the great Max Klinger

sculpture, done in multicolored marble, depicting the apotheosis of Beethoven. The exhibition was conceived as a total work of art, with themed works by Secessionist artists arranged by Hoffmann in a maze of spaces from which Klinger's sculpture could be seen in the white main hall, open to musical performances and the ritualistic dances of Isadora Duncan.

Klimt mixed various influences with fascinating eclecticism, an updated version of initial historicism. From Greek vase painting and Egyptian painting, he took the concept of the wall as a strip where figures and events were aligned in

View of the last wall of the *Beethoven Frieze,* after the restoration, and the
environment designed by Josef Hoffmann for the Fourteenth Viennese Secession
Exhibition (1902) in the reconstruction done by the studio of architect Hans Hollein
for the 1985 Vienna Exhibition, *Traum und Wirklichkeit. Wien 1870–1930,* dedicated
to Austrian art.

The *Frieze* is 24 meters long and develops across three panels painted with
casein paint on plaster applied to latticework and inlaid with precious stones and
mother-of-pearl. Although intended to be destroyed after the exhibition, it was
purchased by the industrialist Carl Reininghaus and later by the collector Erich Lederer
who, in 1973, sold it to the Republic of Austria. Ruined by humidity and improper
storage, it underwent a difficult restoration beginning in 1970 and was finally
returned to the Secession Building in 1986.

Above:
Max Klinger, *Beethoven Monument*,
1902, exhibited at the Fourteenth
Secession Exhibition; Leipzig,
Museum der Bildenden Künste.

Right:
*Study for "The Yearning for Happiness,"
from the "Beethoven Frieze,"* 1902.

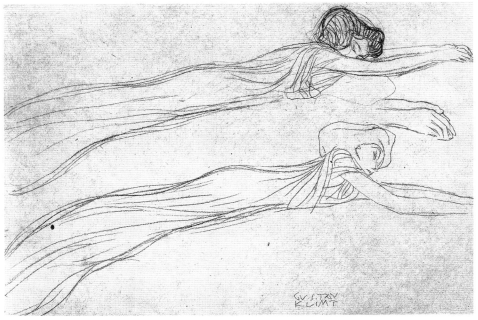

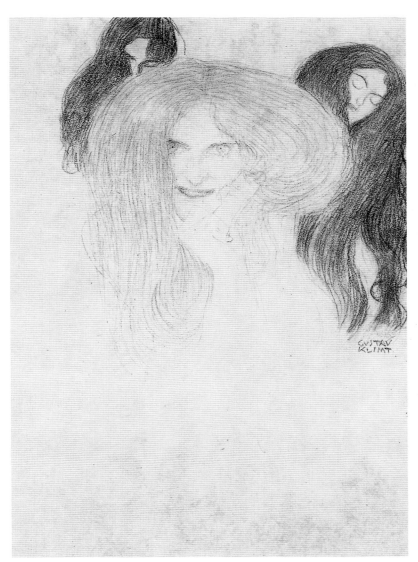

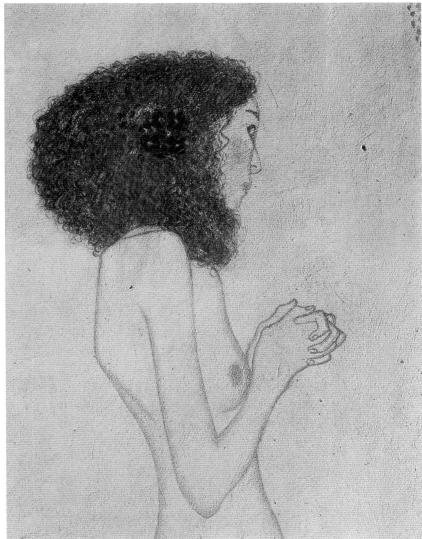

sequence. The incisive marks came from prints by Katsushika Hokusai and Kitigawa Utamaro. Klimt had begun to collect African sculpture at the time, and this suggested the horrid masks that inhabit the kingdom of evil. Those spirals repeated around the figure of Poetry are Mycenaean. The figures show mixed echoes of Minne, Beardsley, Mackintosh, Toorop, and Hodler—the entire Jugendstil culture of the line is lyrically condensed in the *Beethoven Frieze*.

The narrative theme was an interpretation of Beethoven's *Ninth Symphony* (the inauguration featured a performance of the *Ode to Joy* conducted by Gustav Mahler) and was briefly presented in the exhibition catalogue.

"**First wall**: The Yearning for Happiness—Suffering Humanity—Their Pleas to the Knight in Shining Armor—Compassion and Ambition as Internal Motivation Moving Him to Take Up the Fight for Happiness.

"**Second wall**: The Hostile Forces—The Giant Typhoeus against Whom Even the Gods Battle in Vain, His Daughters, The Three Gorgons—Sickness, Madness, and Death—Lasciviousness, Wantonness, Intemperance—Gnawing Grief—The Yearnings and Desires of Humankind Fly Past.

"**Third wall**: The Yearning for Happiness Finds Appeasement in Poetry—The Arts Lead Us into an Ideal Realm, the Only Place We Can Find Pure Joy, Pure

Above left:
Study for "Three Female Heads" from the "Beethoven Frieze," 1901–02.

Above right:
Suffering Humanity, 1902, detail from the *Beethoven Frieze;* Vienna, Secession Building.

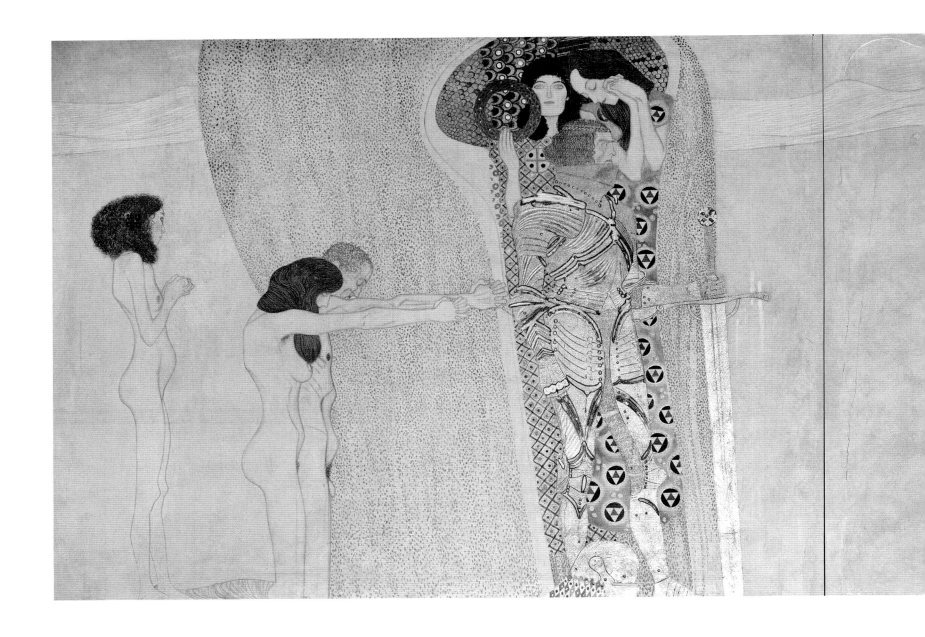

Happiness, Pure Love—Choir of Angels in Paradise 'Freude, schöner Gotterfunken—Diesen Kuss der ganzen Welt!'"

Klimtian literature shows the agreement between the content of the *Frieze* and Wagner's interpretation of the *Ninth Symphony*, and the harmony with Nietzsche's theory of the genius and his suffering. One inspiration may have been Mahler himself, a good friend of Klimt, whose features seem to have inspired those of the Knight, the male protagonist of the *Frieze*. Moreover, in 1910, Klimt contributed precisely this figure for reproduction in a publication in Munich in honor of the musician.

Support for the Wagnerian thesis also comes from the fact Klimt later entitled the last panel of the *Frieze* with a biblical quote, "My kingdom is not of this world," the same quote that occurs in Wagner's 1846 article on Beethoven to emphasize the liberating quality of music and art in general as opposed to the corruption of the earthly world.

The *Frieze* contains a further symbolic level since Klimt interprets the timeless conflict between good and evil, and the longing for ideal liberation through art, from the point of view of the male-female relationship. The moment of liberation in the work is identified with

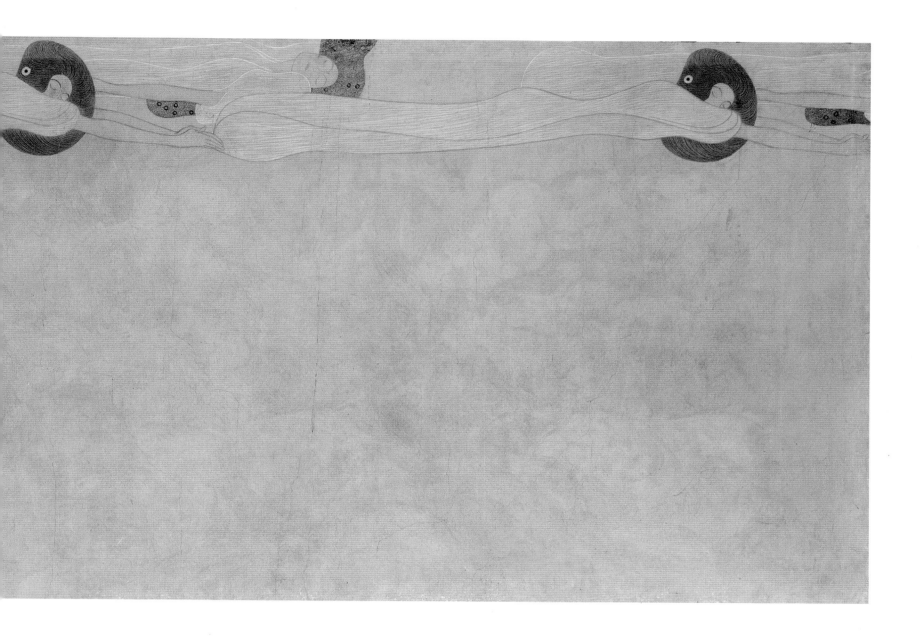

reaching amorous ecstasy, and the ideal kingdom identified with the embrace of a woman. The masculine element, the powerful Knight, corresponds to a feminine figure on the opposite wall, Poetry. Her head is bowed in passive expectation and she plays a lyre. The "feminine" curvilinearity of her instrument corresponds to the "masculine" angularity of his armor.

In order to reach the woman and join with her, the Knight must undertake a sort of voyage through the underworld, confront and conquer the powers of evil, and resist the seduction of the wicked, lascivious sirens.

The Yearning for Happiness, first wall of the *Beethoven Frieze,* 1902; Vienna, The Secession Building.

From the left:
Suffering Humanity—Pleas to the Knight in Shining Armor—Compassion and Ambition as Internal Motivation Moving Him to Take Up the Fight for Happiness—The Yearning for Happiness.

Compassion and Ambition Moving the Knight in Shining Armor to Take Up the Fight for Happiness, 1902, detail from the first wall of the *Beethoven Frieze*; Vienna, Secession Building.

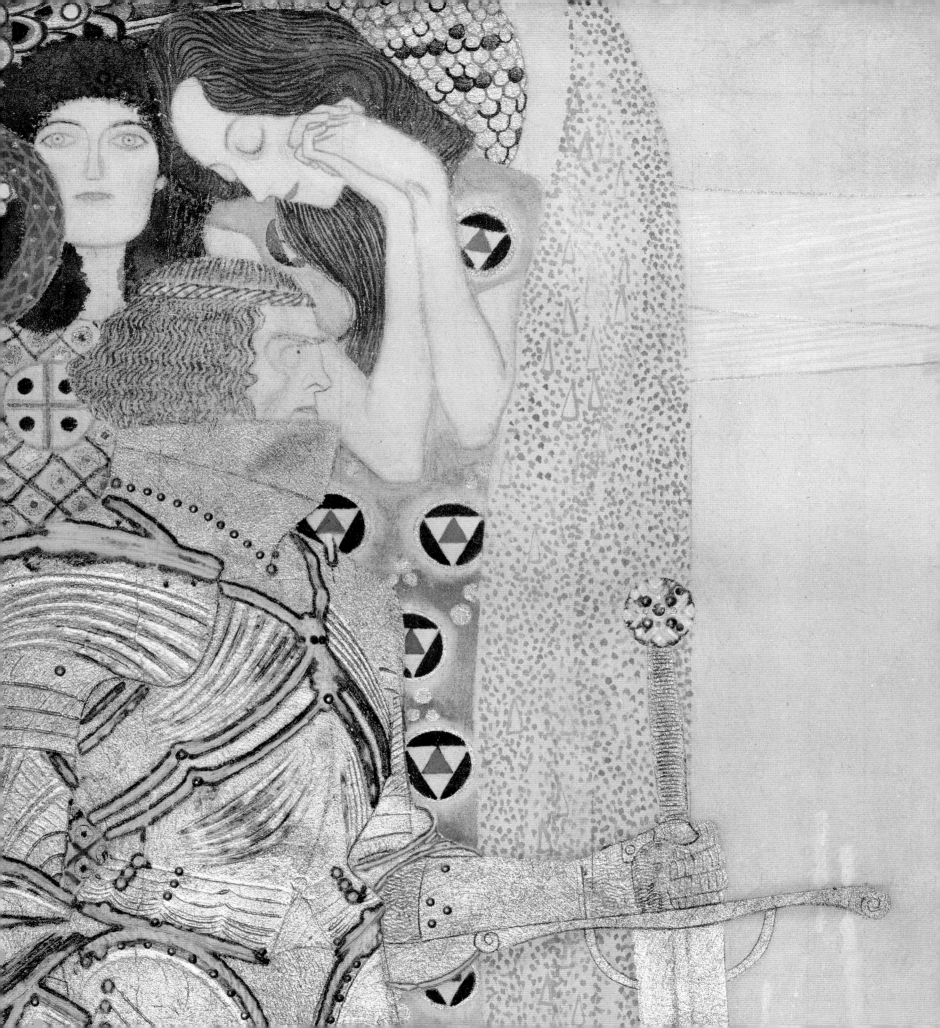

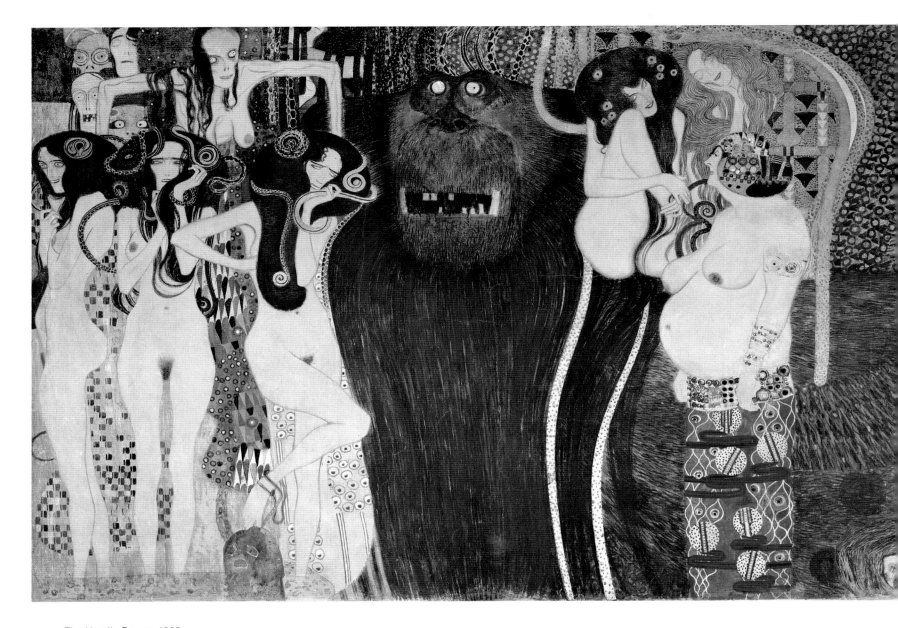

The Hostile Forces, 1902,
second wall of the *Beethoven Frieze;*
Vienna, Secession Building.

From the left:
The Three Gorgons—Sickness, Madness,
and Death—The Giant Typhoeus against
Whom Even the Gods Battle in Vain, His
Daughters—Lasciviousness, Wantonness,
and Intemperance—Gnawing Grief—
The Yearnings and Desires of Humankind
Fly Above the Hostile Forces.

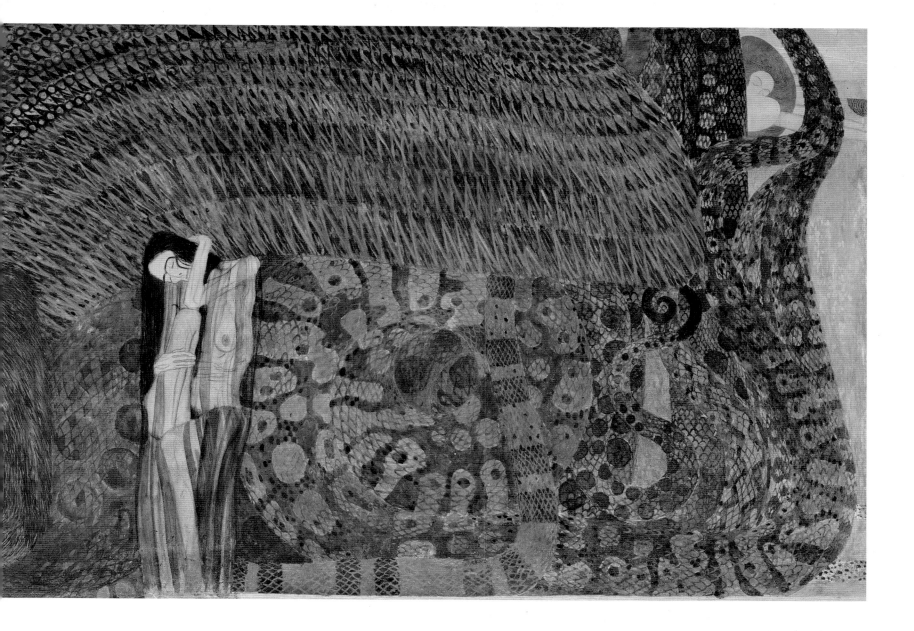

Though the two appeasing figures are feminine, as is the fluctuating current of bodies that guides him along the dangerous path he must complete, the evil universe is feminine as well, inhabited by the Gorgons, a parody of the theme of the Three Graces, and their indecent or terrifying companions. Above these reigns the monster Typhoeus, a hybrid beast with the head of a monkey and the body of a dragon, which represents materialistic ignorance against which the Knight, a personification of the Artist, must fight to assert the rule of Art, just as Theseus defeated the Minotaur at the First Secession Exhibition.

In Greek mythology, Typhoeus is the rival of Athena, already encountered in the guise of the tutelary deity of the new art, and was born out of Hera's revenge on Zeus. In the form of a dragon that inhabits the dark cavities of volcanoes, Typhoeus is one of the personifications of the threatening, voracious aspect of the Earth Goddess, the primordial maternal deity whose cult goes back to the origins of Mediterranean civilization.

Therefore, the task of the Knight-Artist, his obstructed marriage with Poetry, appears rich in multiple meanings, similar to the recurring battle with a dragon in myths and legends.

The tales of trials and heroes, the exploits of Jason, Heracles, Saint Michael, and Saint George, have been interpreted in psychoanalytical studies as symbolic

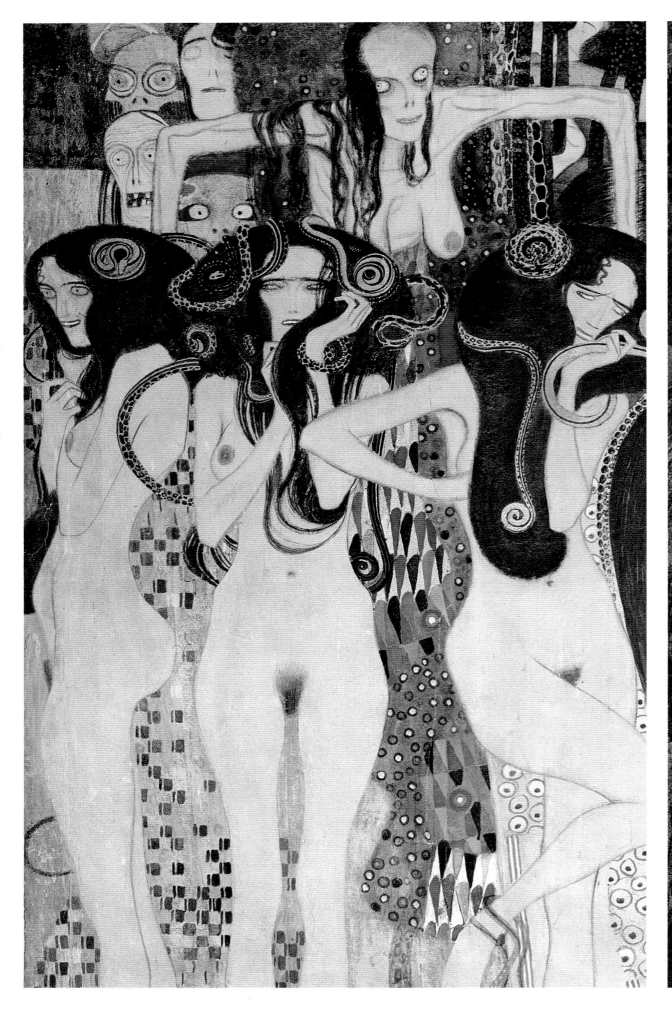

Right:
The Three Gorgons, Sickness, Madness, and Death, 1902, detail from the second wall of the *Beethoven Frieze;* Vienna, Secession Building.

Far right:
The Giant Typhoeus and Lasciviousness, 1902, detail from the second wall of the *Beethoven Frieze;* Vienna, Secession Building.

Typhoeus, threatening adversary of the gods and personification of the voracious aspect of the Earth Goddess, is a hybrid beast with the horrible head of a monkey and the body of a dragon with wings and a serpent's tail. He inhabits the dark cavities of volcanoes and represents the materialistic ignorance against which the Knight-Artist must struggle to affirm the rule of Art.

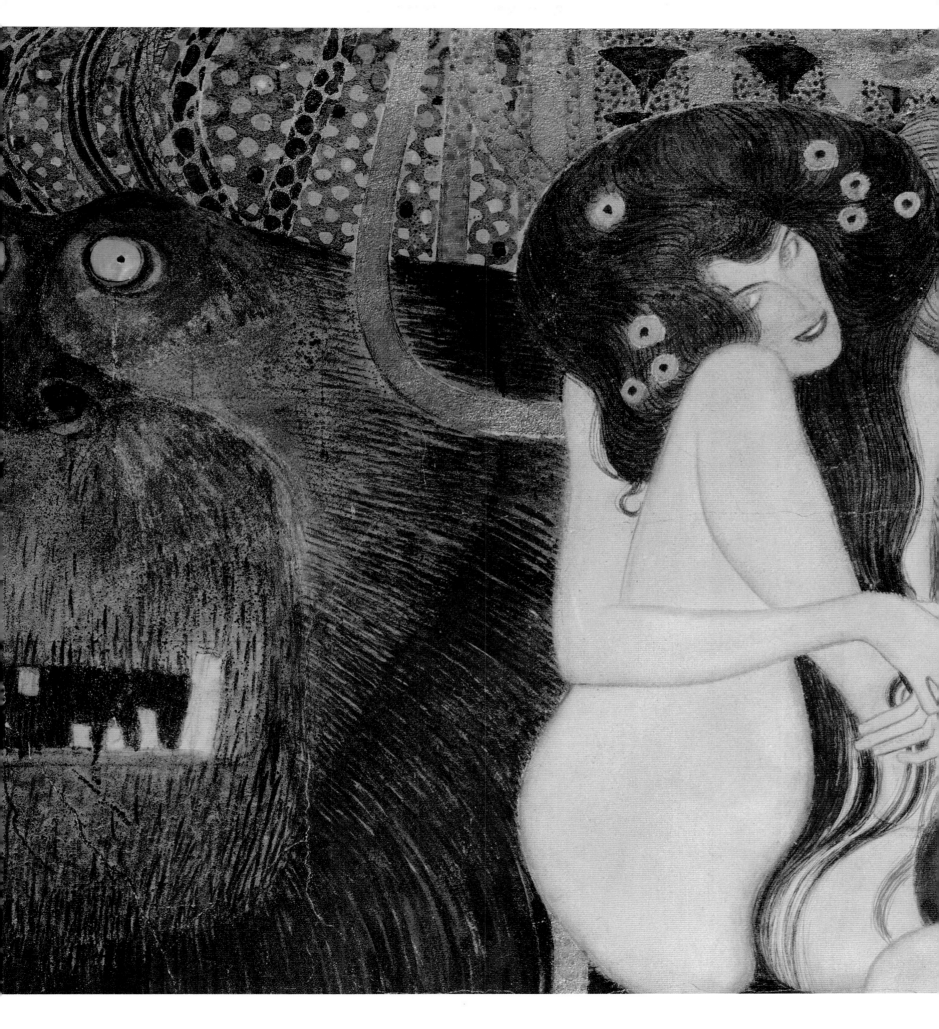

The Yearning for Happiness Finds Appeasement in Poetry, 1902, third wall of the *Beethoven Frieze*; Vienna, Secession Building.

In a delicate mix of gold, white, and brown, a woman playing the lyre, a recurring image in Klimt's work, portrays Poetry. Ethereal figures float above, almost tying together the various episodes with light, transparent gowns.

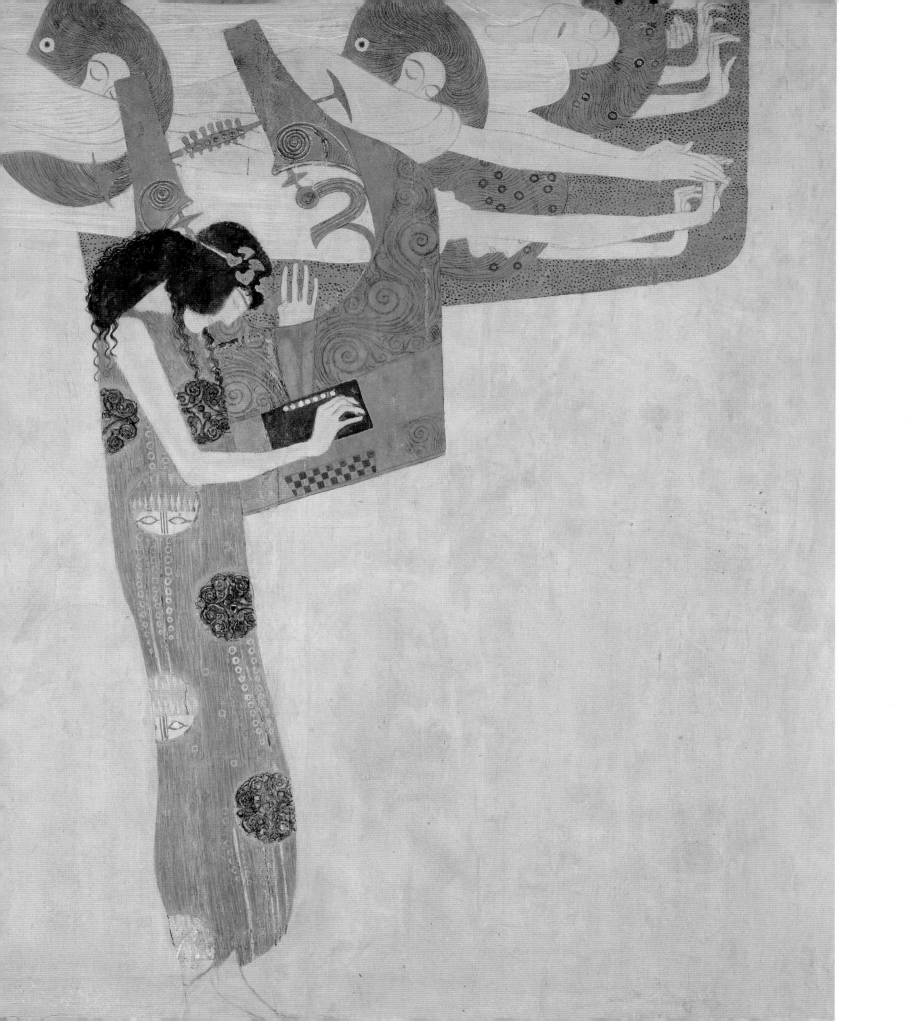

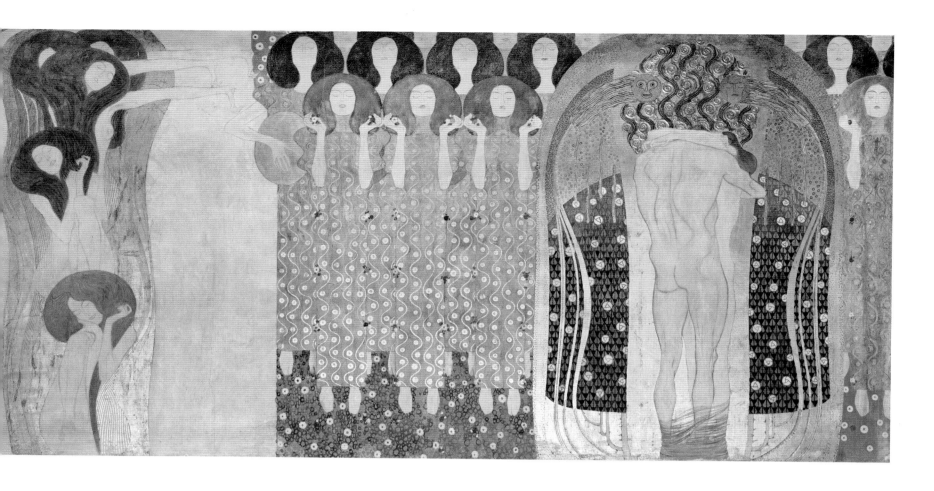

events of initiation into virility through
the defeat of the aggressive, earthy pow-
ers of femininity.

In the final scene, in an enchanted
garden strewn with small roses, myriad
symbols of the female sex, a choir of girls
sing Schiller's *Ode to Joy.* These are the
vestals of a positive feminine universe,
accessible only by passing unharmed
through the troubled universe of the
Gorgons that, despite everything, remains
the focal point of the frieze. Undressed
of his armor and seen from behind, the
protagonist is immersed in the embrace
but seems more like a subdued lover than
a victorious hero. So, although the image
apparently celebrates the liberation and
triumph of the hero over hostile forces,
it is in reality also the image of his sur-
render to a feminine power identical to
Eros, the victory of the universe of the
senses over that of fear and the rational,
daylight instruments of defense. Consistent
with his poetics, the apotheosis of the

arabesque art of Klimt on the walls of the
Secessionist temple could not help but
once again express the connection between
erotic and aesthetic.

The artist would return to this argument,
glorifying every narrative remnant in a
second frieze designed between 1907 and
1908 for the dining room of the Stoclet
Palace in Brussels. The metaphysical
malaise that inspired the panels for the
university seems to have subsided here.
The malevolent specters, which had
undermined the fragile, healing utopia in
the *Beethoven Frieze,* have here vanished.
In the Brussels frieze, the ecstatic face
of Eros prevails over the deadly, fatal
face, and passion is exalted in an ever more
elegant, ever more yearning arabesque.
There is no room for hostile forces in this
house where the Secessionist dream of
a total work of art is finally realized. The
Belgian financier Adolphe Stoclet com-
missioned the architect Hoffmann and the
Wiener Werkstätte to build his residence

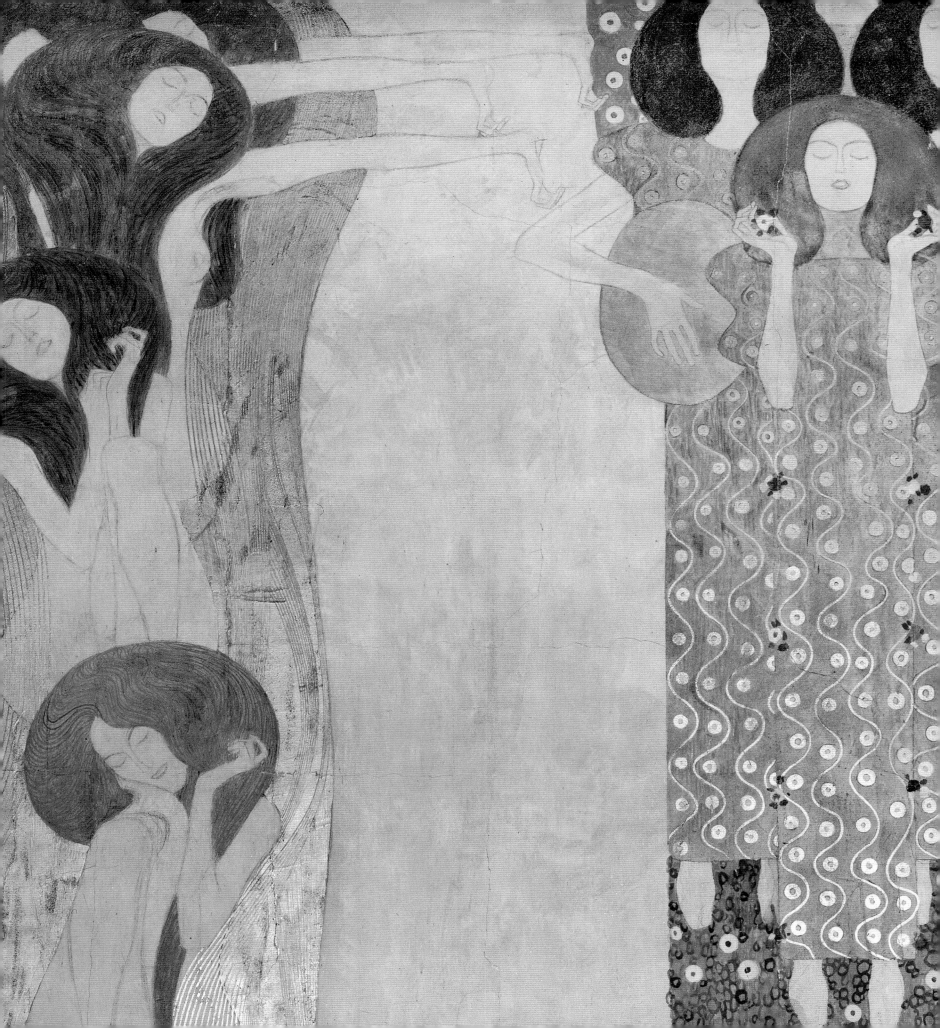

with no limits on expense, giving them the chance to achieve this dream in a permanent form. Completed between 1905 and 1911, with its marble coverings, decorations, furnishings, statues, and paintings, the palace is a house of art that adorns the everyday with ceremony like a sacred site. Here shapes lose their functional origins, and objects for use become instead scenic props for a social ritual that resembles an elect aesthetic priesthood.

All physicality or remaining naturalism vanishes in the *Stoclet Frieze*. Created by the Wiener Werkstätte as a mosaic of precious materials on sheets of marble (11 different qualities of gold, inserts of mother-of-pearl and various metals, the cost of materials alone was 100,000 crowns, equal to the annual income of 45 working-class families or 12 families of high-level employees). The *Frieze* runs along the two long walls in the rectangular dining room and is linked to one of the shorter walls by a decorative panel with a vaguely anthropomorphic, abstract checkerboard motif. In its splendid archaic spirals, the *Frieze* resolves the Klimtian hybridism of representation and abstraction, organic and inorganic, using the modulation of metals to create those chromatic and

Below:
The dining room of the Stoclet Palace in Brussels, designed by the architect Josef Hoffmann, 1905–11. On the walls, the frieze of mosaics superimposed on cartoons by Gustav Klimt.

Right:
The Knight, cartoon for the short wall of the *Stoclet Frieze*, 1908–10, entire painting and detail on opposite page; Vienna, Österreichisches Museum für Angewandte Kunst.

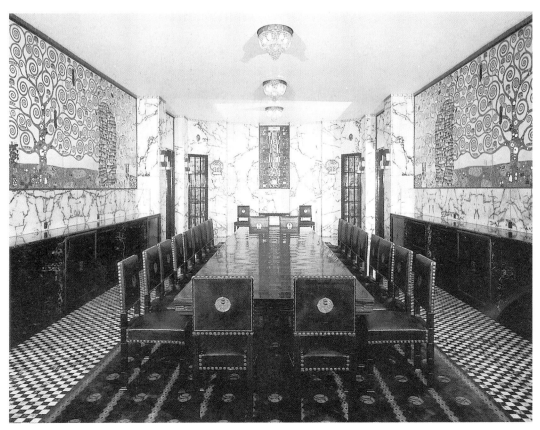

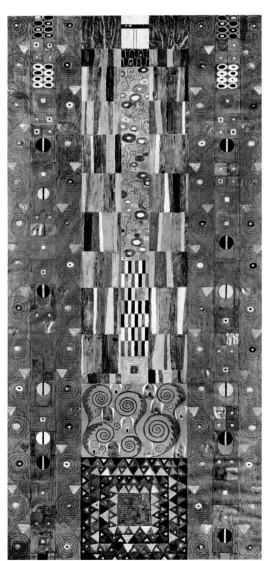

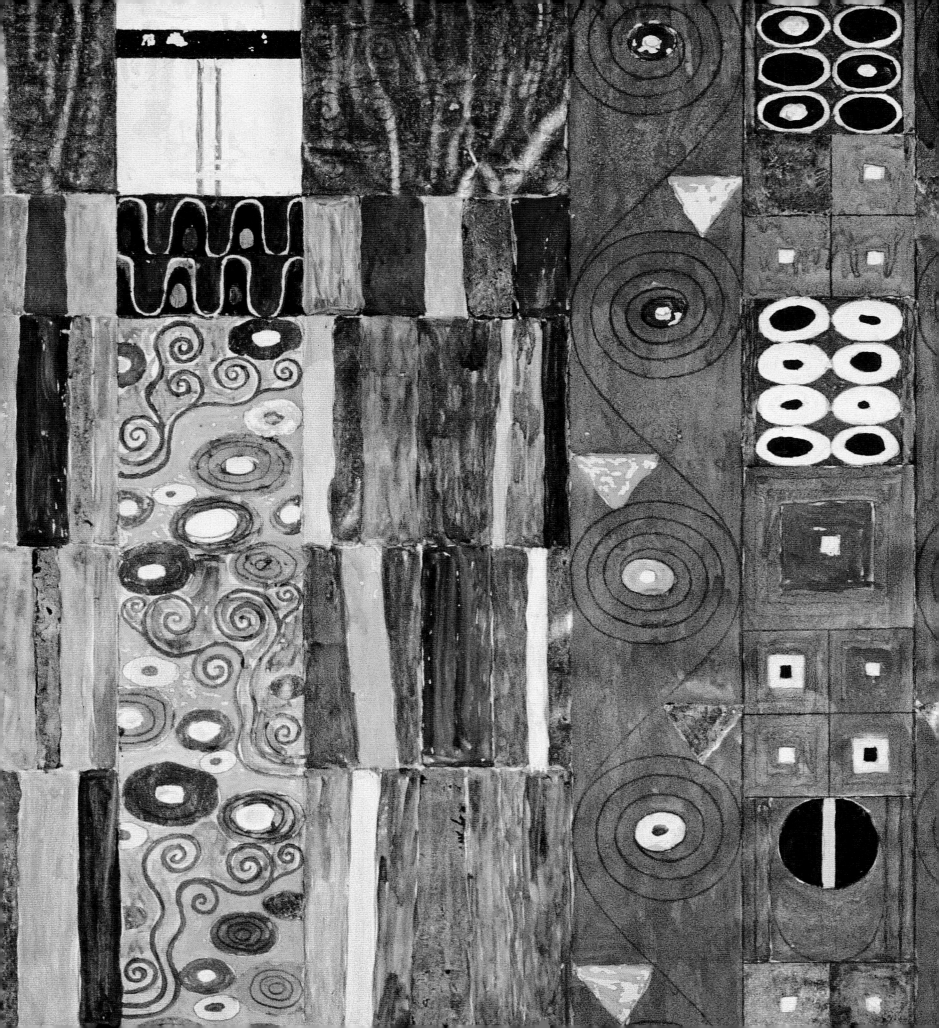

decorative effects he had until then attempted mainly with the instruments of painting.

The artist did not limit himself to drawing the preparatory cartoons, but collaborated intensely with the artisans at the Wiener Werkstätte. Keeping notes on every detail, once the design was engraved into the marble with a drill he went back over the outlines by hand. He decided not to show it to the Viennese public before its completed installation in Belgium, stating he wanted to protect this piece, which had cost years of hard work and involved the total commitment of many artisans and artists, from sneers and derision.

The central motif is *The Tree of Life* containing the inlayed forms of *Expectation*, a dancer with an Egyptian-like gesture and horizontal hairstyle, and *The Embrace*, in which the placement of the stylized figure, the man seen bent over his companion from behind, recalls the final scene in the *Beethoven Frieze*, but the accent this time is placed on the cloak, an assemblage of elementary decorative motifs aimed at evoking the primary symbolism of the masculine and feminine, spirit and matter, conscious and subconscious. Only an enamel rosebush and a few birds of prey, the divine falcons of Horus, animate the spiral branches of the golden tree where the eye-shaped flowers are also an Egyptian motif.

The panel on the short wall acts as a link between the two long lateral sequences and was for a long time seen as a simple abstract decorative motif. But a postcard from Klimt to Emilie Flöge on May 18, 1914 (published by Alice Strobl in 1989), indicates this is a very stylized version of the *Knight*, this time wearing a white helmet and multicolored cloak, and placed on a checkerboard platform. This esoteric figure, whose identity remains a secret concealed in the decoration, is also hieratic in its rectangular rigidity (the rectangle in Klimt's graphic lexicon indicates the masculine element) and watches over the garden of art and love where the *Knight-Artist* is finally the guardian Templar, the high priest. Strobl writes, "With the *Knight*, as with the *Beethoven Frieze*, Klimt referred to an elevation of life into a work of art or an artist that is revealed as the creator, so to speak, of an earthly paradise indicated by the two Trees of Life with the representation of Expectation and Fulfillment, but not without a hint of impermanence represented by the birds of prey."

With intensity, even lyrical-decorative excess, the theme of loving fusion and the healing power of Eros and art return in *The Kiss* (1907–08), high point of the "golden style" and ideal centerpiece of the great Kunstschau exhibition, at the same time the apotheosis and swan song of Viennese modernism.

Sketch for "Expectation" from the Stoclet Frieze and for "The Dancer," c. 1908; Vienna, Österreichisches Museum für Angewandte Kunst.

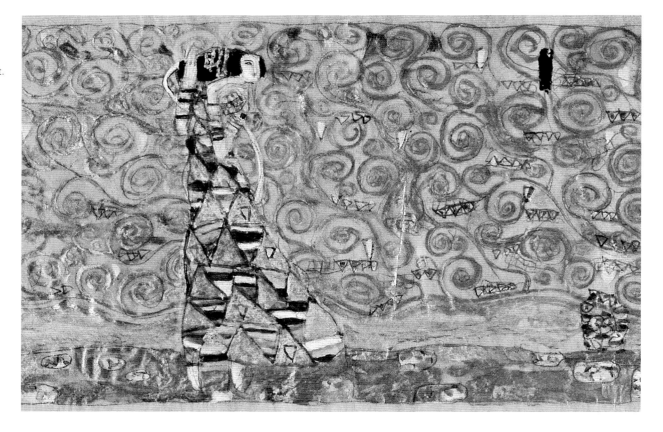

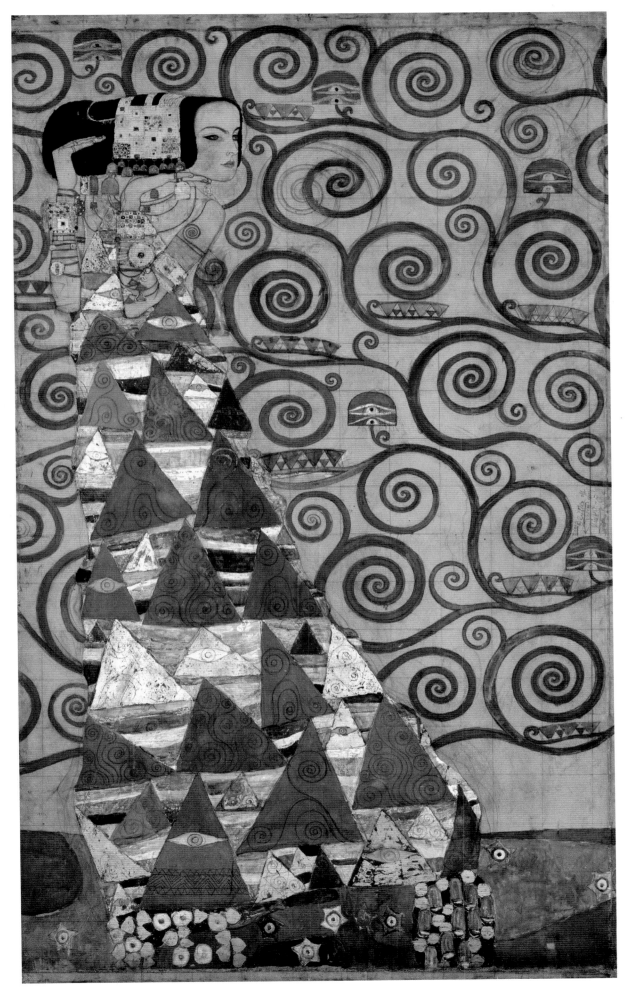

Expectation, cartoon for the *Stoclet Frieze,* (long wall), 1905–09; Vienna, Österreichisches Museum für Angewandte Kunst.

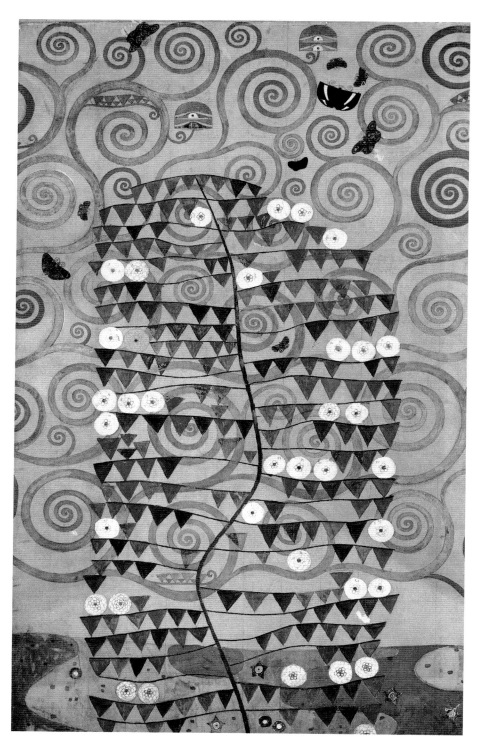

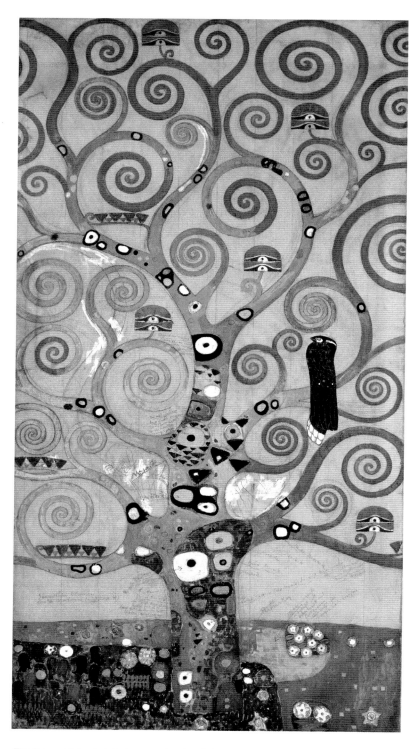

Rosebush, cartoon for the long
wall of the *Stoclet Frieze*, 1905–09;
Vienna, Österreichisches Museum
für Angewandte Kunst.

The Tree of Life, detail above and right of the
cartoon for the long central section of the
Stoclet Frieze, 1905–09; Vienna, Österreichisches
Museum für Angewandte Kunst.

The Tree of Life is embellished by tiny,
ornamental elements, spreads its spiraling
branches across the entire space of the wall, ani-
mated by multicolored butterflies and birds of
prey (the falcons of Horus), an enamel
rosebush, and flowers shaped like eyes, with
an Egyptian aspect.

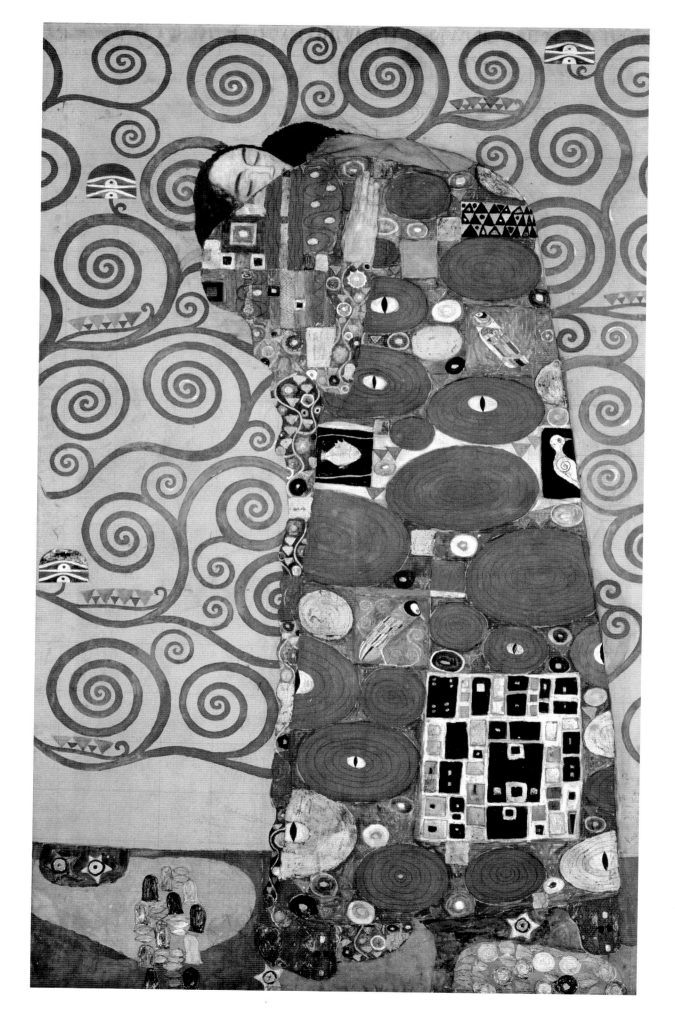

The Embrace, cartoon for the long wall of the *Stoclet Frieze,* 1905–09; Vienna, Österreichisches Museum für Angewandte Kunst.

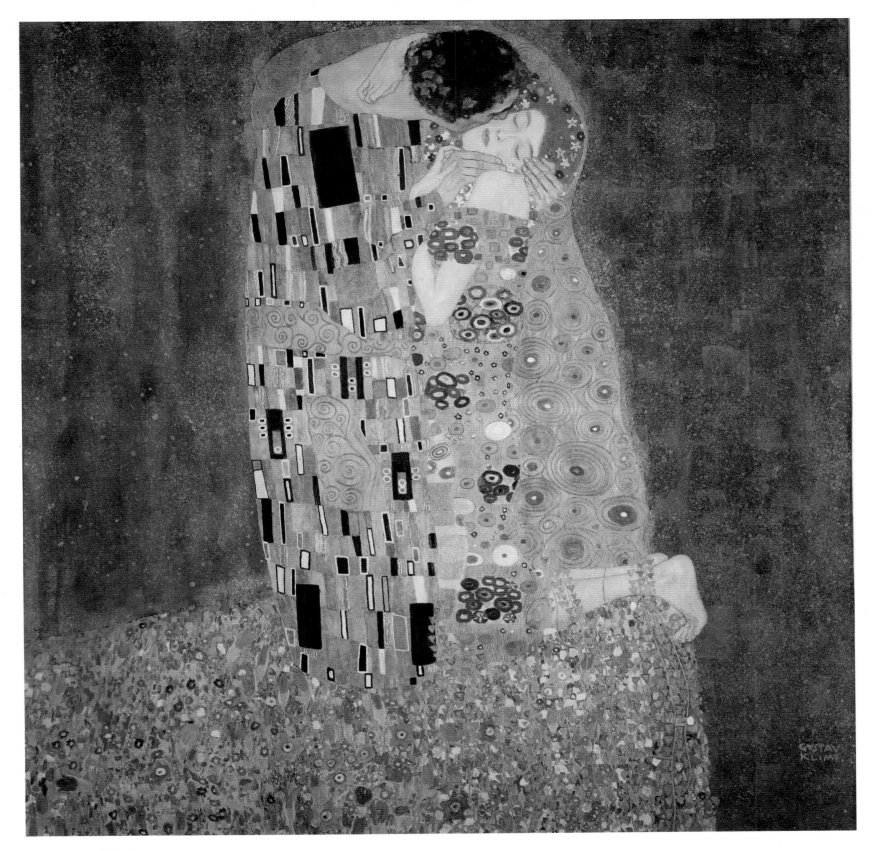

The Kiss, 1907–08; Vienna,
Österreichisches Galerie Belvedere.

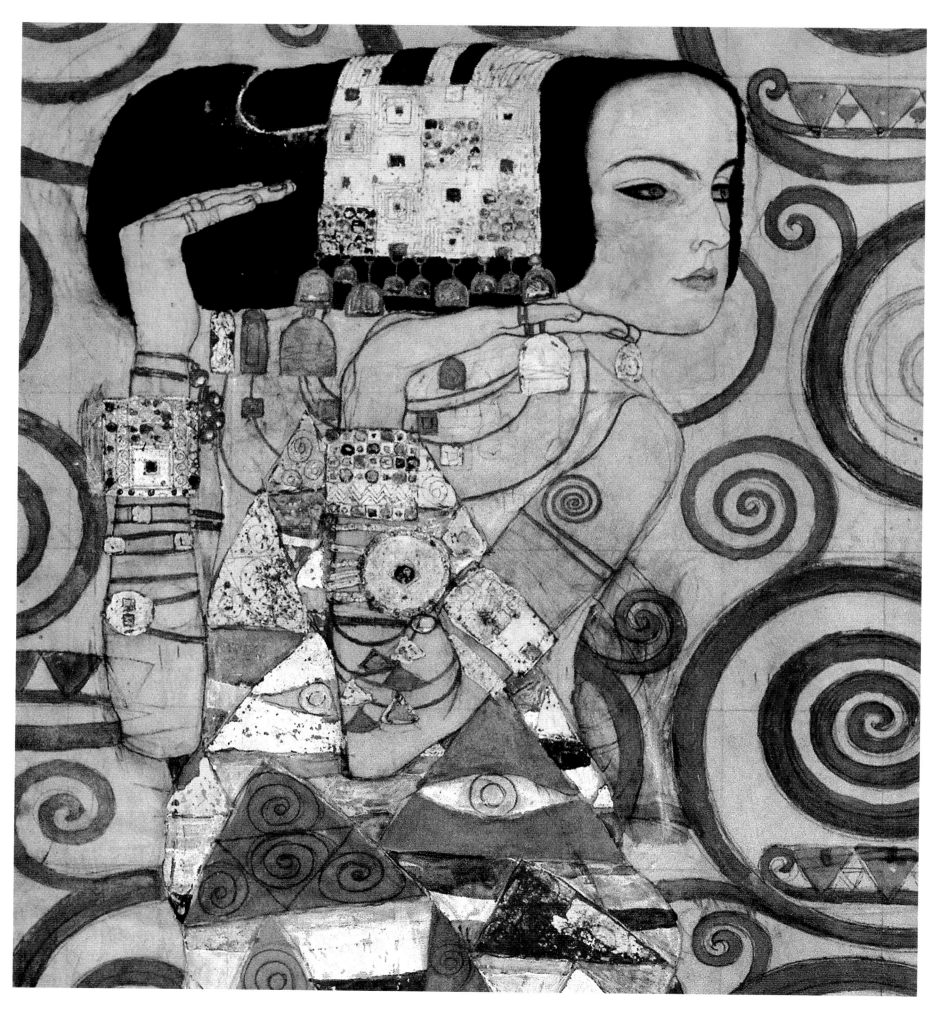

THE KUNSTSCHAU
AND THE CRISIS
IN THE SECESSION

In 1905, dissension within the Secession became irreconcilable between the minority group, who had given life to the new "Style," and the naturalist and late Impressionist painters, who did not appreciate the importance given to the applied arts, and led to the departure from the association of the innovators, who once again gathered around Klimt. From that moment on, although the Secessionist style would find other spaces to express an ever more all-encompassing artistic dream, it no longer belonged to the association with the Secession name that, although it continued its activity, no longer had much importance.

The collective labor of the ambitious Stoclet Palace project begun at that time did not in fact impede the departing group from finding new funds, searching for an available site, constructing a new, temporary exhibition pavilion designed by Hoffmann, and organizing the 1908 Kunstschau, a great exhibition of Austrian art coinciding with the magnificent celebrations for the emperor's jubilee, followed the next year with a second event that was also open to the international scene.

"We wanted to show how life could be totally permeated with art....No sector is so small and insignificant as to not offer space to artistic aspirations," declared Klimt in his inaugural speech, concluding that "the aspiration of the Kunstschau is one of creating an artistic community." This showcase of the "beautiful" thus became a spiritual place where visitors were also an element in the collective work and, as in Wagnerian drama, art was realized through the tension between its creators and its audience to reach unity. Again Klimt said, "We define an artist not only as one who creates but also one who knows how to enjoy what has been created, reliving the creative act with his sensitivity and thus giving the work of art new dignity."

The largest exhibition ever organized in Austria (179 artists in 54 rooms) revealed its all-embracing style by harmonizing each environment with the same formal language, the same chromatic sensibility, and the same elegance. Not only paintings and drawings were on exhibit but also architecture, furniture, cases, fans, jewelry, glasswork, ceramics, posters, theatrical costumes, fashions, art for children, art for

Left:
The poster room at the
Kunstschau in Vienna, 1908.

Below:
The Wiener Werkstätte Pavilion
(destroyed), architectural design
by Josef Hoffmann for the
Kunstschau in Vienna, 1908.

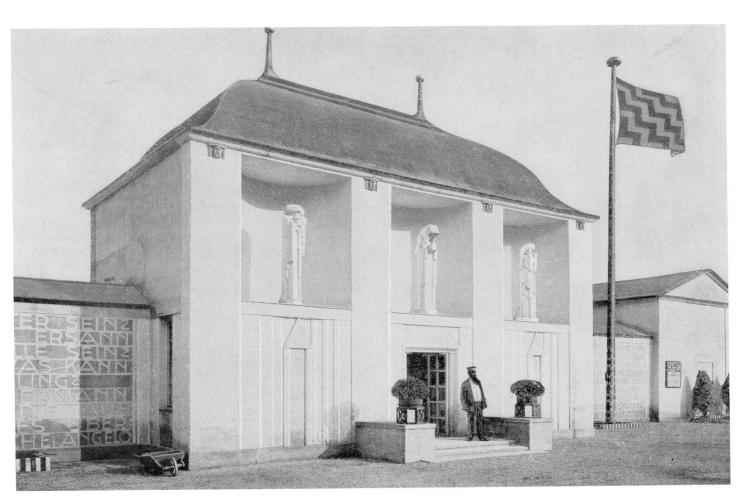

From the left:
Gustav Klimt, Egon Schiele,
Oskar Kokoschka, c. 1908.

gardens, graveyard art, the complete design of a model house by Hoffmann, a theater, and a café. Art critics of the day called it a "joyous mantle" the Wiener Werkstätte had wrapped around a central room where Klimt exhibited 16 paintings, including *The Kiss*. This was the artist's last great retrospective. He would be present with only seven works the following year. This was also the exhibition that most struck the young Schiele, changing the course of his future.

As in the portrait *Adele Bloch-Bauer I*, the only moments of plastic naturalism in *The Kiss* are the faces and hands engraved into the golden landscape and the hangings that cover the couple. After the abstract statement of the *Stoclet Frieze*, originating from the need to properly relate to the architectural environment and craftsmanship, Klimt returned to establish his characteristic tension between naturalism and decorative abstraction, to reformulate his idea of painting as a harmonious measure, the subtle yet unbreakable balance between heterogeneous sections of surface.

Edvard Munch's *The Kiss* (1897) also shows lovers, whose faces seem melded into one, joined in the shape of a bell. But this is a tragic, dark-colored bell that tolls the bitter sound of perdition and guilt. Instead, the golden bell in Klimt's painting gives visual form to a utopia of love. Its elongated form joins the protective quality of the womb with the vertical dream of ascent, simultaneously bell and column, uterus and phallus. The mandorla (almond-shaped enclosure) of light protects the harmony between masculine and feminine, consciousness and unconsciousness, in a dimension beyond the confines of space and time, infinitely distant from all suffering and danger. With the years of struggle at this point behind him, at the peak of his success and creativity, the artist Klimt created an unforgettable work for a public that would grow greater and greater over time, sealing within the gold the near-mystic splendor of the amorous experience that redeems the world.

But times were changing quickly. Perhaps the intensity of that flowering contained the writing on the wall foreseeing the end of the world along the

Danube. Historians such as Fernand Braudel, and before him Jacob Burckhardt, observed that historically, the most splendid explosions of artistic energy frequently come just before political disintegration. Perhaps this is what happened in Vienna, where "the precise sensation of greatness, of immutability, of enclosing everything" felt by visitors in the environments of the Kunstschau created by Hoffmann was no more than a shield against that foundation on a "terrain filled with cracks" seen by Kraus, Loos, and Wittgenstein, as well as aesthetes like Hofmannsthal.

Furthermore, the utopia of the "sacred spring" had tended more and more toward an elite stylization of taste and ended up turning its back on the future and becoming the obstinate makeup on the face of a world in decline. Adolf Loos had seen this for some time and, with the Savonarola slogan "ornament is crime," did not spare his polemical darts against the Secessionist style, stigmatizing the decorative sublimation of functionality and the aesthetic of ecstasy at all costs.

In addition, elements of angst had already undermined the successful structure of the Kunstschau. Among the other collaborators from the Wiener Werkstätte was a young artist named Oskar Kokoschka. In addition to his small illustrated book *The Dreaming Youths* with an angular style that had already hardened Secessionist compositional structure, he also exhibited six cartoons for tapestries, *The Messengers of the Dream*, where "a tendency toward the cruel and twisted," as one critic stated, created a scandal as a perceived outrage against the general harmony. He was called the "great savage" and his painting

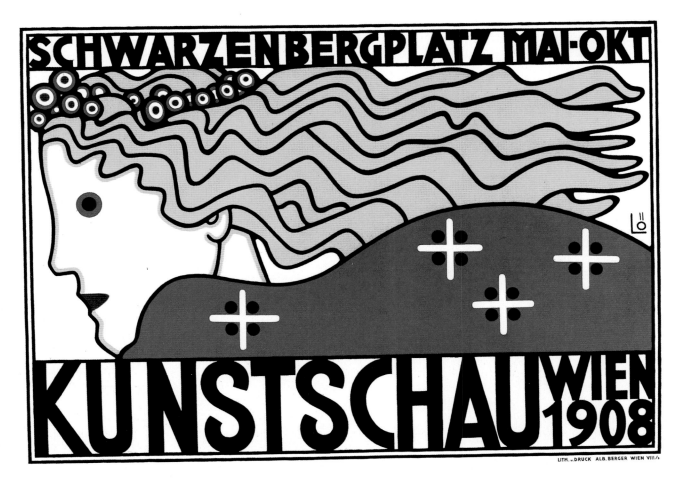

Bertold Löffler, *Lithograph Advertising the Kunstschau* (art exhibition) in Vienna, 1908, printed by Albert Berger.

was considered tantamount to "hurling the soul in the face." It would be Klimt who defended him against censorship, foreseeing perhaps that the value of intensity was on the verge of ousting the aspiration toward universality and beauty. At the same time, he encouraged the precocious talent of Schiele and his dramatic and expressive stylization.

In 1909, the theater-garden annex to the Kunstschau hosted the performance of a play by Kokoschka, *Murderer, the Hope of Women,* a ferocious, cannibalistic tale of a love conflict that culminates in violence and destruction. The young artist created a dramatic poster for his play with abrupt brushstrokes that break up the layers of color, where the woman is a specter and the man a bloody larva.

Nothing could have possibly been further from the ecstatic fusion of Klimt's *The Kiss.* The city of dreams was rapidly changing into the city of nightmares.

For Klimt as well, something was happening to darken the shining image of his new Byzantium. Perhaps he noticed that the times were to change radically, the fracture between ego and world was to become terrible, irreparable. Perhaps he dimly realized that formal harmony could no longer deal with that disruptive "truth" about to show itself on the horizon. Or perhaps his style had reached such completeness that he was forced into an artistic impasse. With the exception of the landscapes, belonging to a more intimate dimension, the last major work from this period was *Judith II* from 1909, with its extreme decorativism. With this, he closed the phase of his "golden style" and entered into a creative crisis that would last several years.

Above:
Max Klinger, *Triton and Nereid,* detail, 1895; Florence, Villa Romana.

Left:
François-Auguste-René Rodin, *Circle of Lovers,* c. 1880; Paris, Musée Rodin.

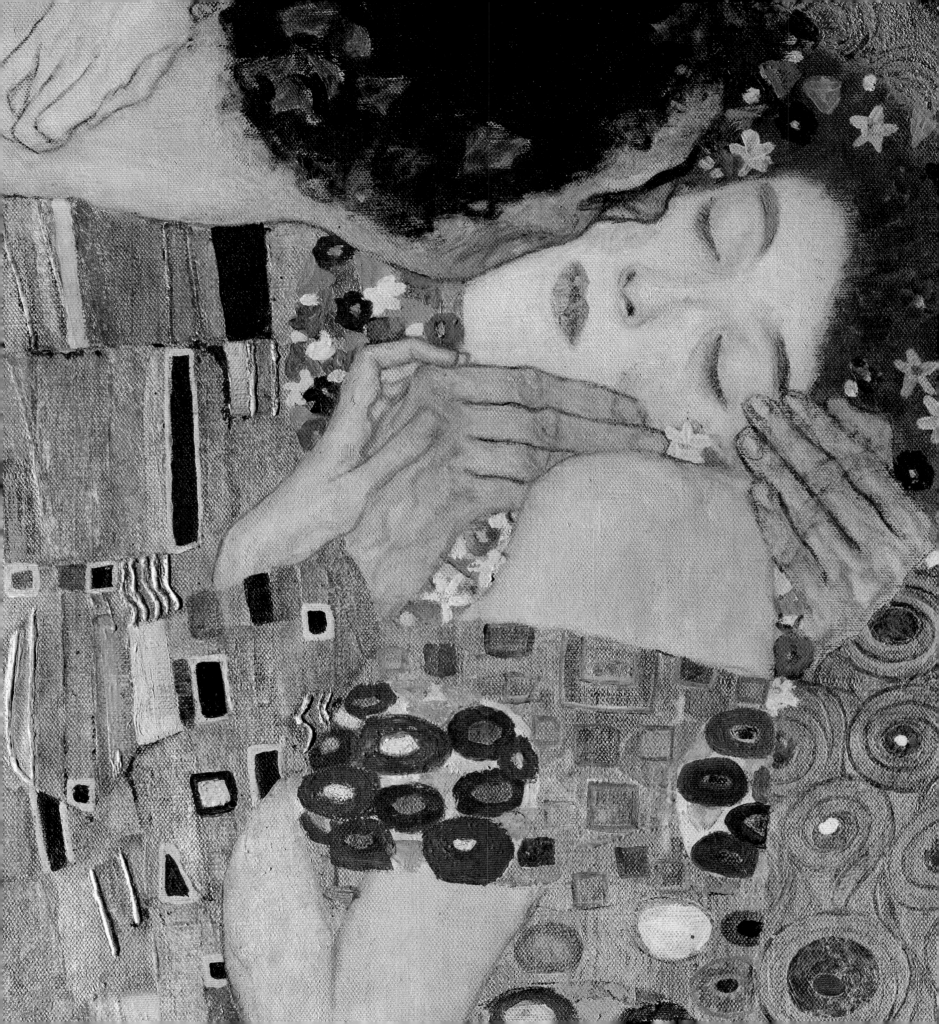

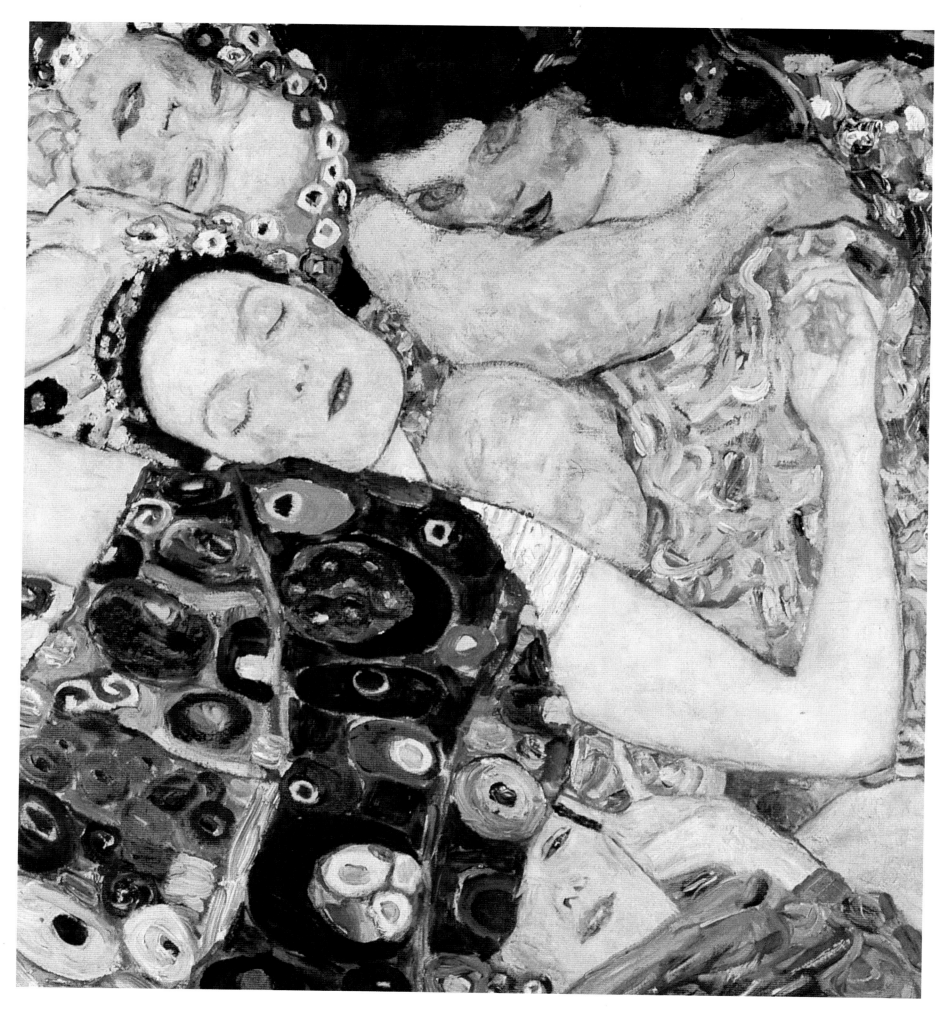

THE FLORID STYLE

Despite the great investment of resources and public success, the two Kunstschau exhibitions in 1908 and 1909 proved to be an economic failure. Klimt's activity as project promoter and unifying element in Viennese artistic life was interrupted. At the same time, his activities as a painter became less frequent. The few works created testify to a sudden turn away from the decorative style, the search, not without anxiety, for a new emotional formula, a black cloud that seemed to thicken and occlude the glowing surfaces with its oppressive mass. Dark tones dominated along with the reduction to a rough, quasi-expressionistic essentiality. Consider *Old Woman* (1909) or *Mother with Children* (1910), where only the heads emerge from the bare, nocturnal tangle of the heavy cloak, or the intensity of a simple portrait

like *The Black Hat* (1910), with its dimmed chromatism. But the absence of any deformation in those faces, the absolute necessity for formally brightening things up, tells us how much Klimt, despite the disturbance created by the works of young Schiele and Kokoschka, remained connected to the great humanistic era of Western realism, powerless to make that leap to the edge of eruption required by the times.

In order to understand the generational distance, compare his works with those of 1909–10 by Oskar Kokoschka that already cruelly fragment Secessionist language into a vision of panic. The pathos of angst and terrible directness of destruction had by then clouded the era of enigmas and the subtle ambivalence of the psyche. A short while later, Schiele began repainting

Klimt's themes, in works such as *The Pregnant Woman and Death* (1911) or that desperate caricature of *The Kiss, The Cardinal and the Nun* (1912), translating the sharp, sensitive Klimtian linearism into pointed, angular dryness. The geometry, the weave, the rhythmic cadence of that modern Byzantine here became red-hot in an unsustainable, expressive tension.

In 1908, Richard Gerstl had committed suicide. The impetuous, restless painter had refused to exhibit with Klimt and, before anyone else, had angrily upset the harmony of the "Style" and inserted violence into the pictorial gesture. The soft melancholy of Vienna had clearly given way to an unhappy logic. A long series of suicides by Viennese intellectuals had begun that would conclude only with the end of the Second World War.

Right:
Egon Schiele, *The Scornful Woman (Gertrud Schiele)*, 1910.

Opposite page:
The Black Feather Hat, 1910.

Chapter Opening (p. 208):
The Virgin, 1912–13, detail;
Prague, Národní Galerie.

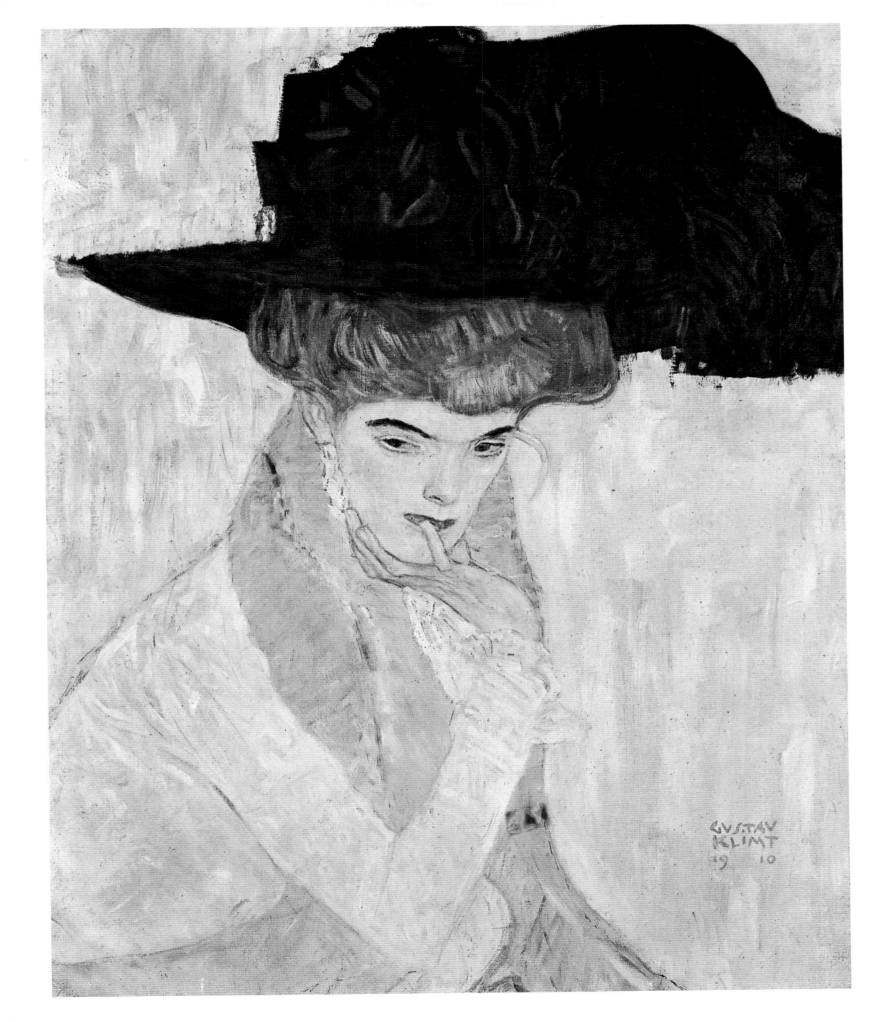

Klimt's artistic stagnation lasted until 1912. These were years of depression, frequent spa cures, and sporadic trips: Paris and Madrid in 1909, Venice in 1910 for the Ninth Biennale where *Judith II* was acquired by the Gallery of Modern Art in Rome in 1911 for the International Art Exhibition, after which the National Gallery of Modern Art would acquire *The Three Ages of Woman*.

The 1912 commission of a new portrait of *Adele Bloch-Bauer II*, the beautiful pale lady who may have secretly been his captivating Judith and was later portrayed enthroned like a Byzantine empress, opened a new decorative phase, the so-called "florid style." After years of crisis, Klimt seemed to be once again reconciled with himself and his own inclination toward the paradigm of beauty and conciliatory synthesis.

While in his new sketches, the pencil no longer traces on the page the fluid continuity of the line, but instead it cracks and shatters the outlines, allowing the bodies to assume ever more unusual poses and accentuating the expressive intensity of their faces. In his painting the color freely expands across the surfaces, liberating that rigid "Byzantine" frame. Without abandoning the field of symbolic ornament, this new happy medium now transformed the mosaic from another period into a multicolored carpet with a weave no longer dictated exclusively by abstract geometric order but arranged and combined with a new vitalistic spontaneity. That essential yet refined rhythm, which modulated the canvas into sections of surface, remained unchanged, only now his definition appeared more malleable

and permeable. The same surface grew thin to the point of transparency, and the touch of the brush was lighter, like a breath across the canvas. The ornament become biomorphic, a mobile flowering and irregular, spiral curling. The figures becomes more concise, cut out with archaic frontal simplicity on a background with which they mingle. The artist's love for "Japonisme" grew and he no longer limited himself to allusions through format, style, or the eccentric modulation of the image. Instead, as already done in the past with Greek vase painting, he appropriated figurative motifs from engravings or vases, actually Korean, directly into the background strips and clothed them in a lively chromaticism discovered in Slavic folklore. Perhaps mysticism or sensuality, something had always drawn Klimt's gaze

Egon Schiele,
The Pregnant Woman and Death,
1911; Prague, Národní Galerie.

Egon Schiele,
The Cardinal and the Nun, 1912;
Vienna, Leopold Museum.

Opposite page:
Mother with Children,
1910, detail.

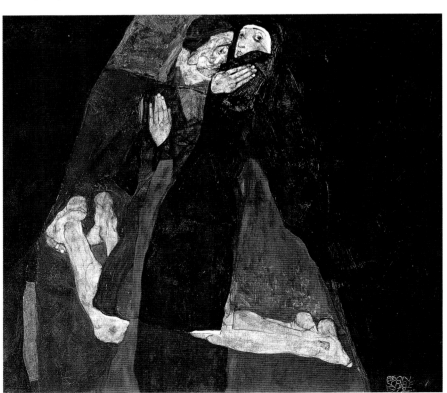

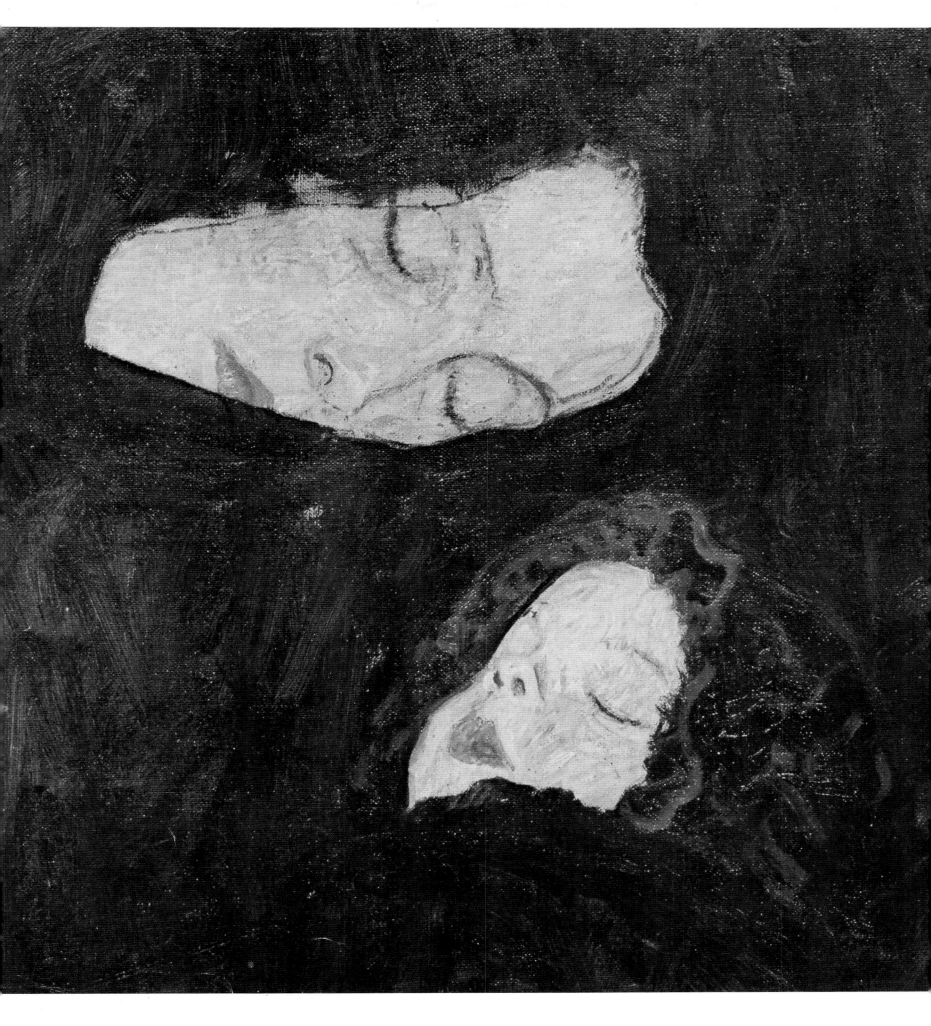

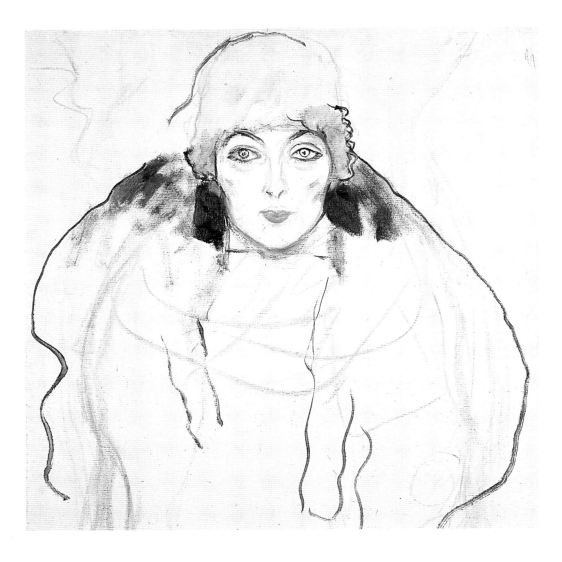

Head of a Woman, 1917–18;
Linz, Lentos Kunstmuseum.

toward the East. First it was Byzantium and now the Orient that fed his visionary symbolism, the evocation of a world inaccessible to the wear and tear of history. He moved constantly further away from European contemporaneity, absorbing only the chromatic suggestions of Matisse in whom he recognized the same faith in the self-sufficiency of art, the same striving for harmony, the same eclectic attention to artisanal decorative stylistic elements, and the same rootedness in tradition.

While the language of art in Vienna became more and more apocalyptic, the artist once again raised his shining shield against this danger. In his landscapes, the fabric remains tight-knit with no empty spaces, as if leaving no openings for specters, and although he may seem to take on the humoral graphic elements

of a van Gogh (*Avenue in Schloss Kammer Park,* 1912), or echo the younger Schiele (*The Forester's House,* 1912) in the nervous inlay of planes, there is always something like a quiet calming of the emotional temperature, at the most an enigmatic, imperceptible oscillation of space.

Not even the war seemed to damage the heart of his harmony. Only the portrait of *Friederike Maria Beer* (1916) alludes to it with chromatic dissonances and the oriental battle scenes in the background. On the contrary, his decorative tension regained its vigor and crystallized around the figure, as in the portrait *The Baroness Elisabeth Bachofen-Echt* (1914–16), or became a sumptuous phantasmagoria from *A Thousand and One Nights,* as in *The Friends* (1916–17), where Klimt again takes up the Sapphic theme. But his was not

simply a comforting escape or voluntary reclusion in the last ivory tower, but rather the conviction that art cannot intervene between history and its victims, and that the principle of hope must after all prevail over the pathos of destruction. Klimt was not so much a prisoner of his elegance as he was of his visionary tension, which appeals not to the forces of reason but to those darker powers of amorous energy.

Fritz Novotny and other scholars have seen this "flowery style," freer with respect to the decorative rigidity of the previous compositions, as a point of arrival where Klimt wonderfully achieved a balance between pictorial values and the density of mystery.

However, some works, such as the portrait of *Johanna Staude* (1917–18) with its ornamental simplification on a

Left:
Studies for the Portrait of
"Friederike Maria Beer," 1916.

Below:
Study of a Dancer Standing
of with Her Head Turned
to the Left, c. 1916.

Above:
Study for the Portrait of
"Mäda Primavesi," c. 1912–13;
Vienna, Wien Museum Karlsplatz.

Left:
Study for the Portrait of "Baroness
Elisabeth Bachofen-Echt," 1916.

Baroness Elisabeth Bachofen-Echt, 1914–16.

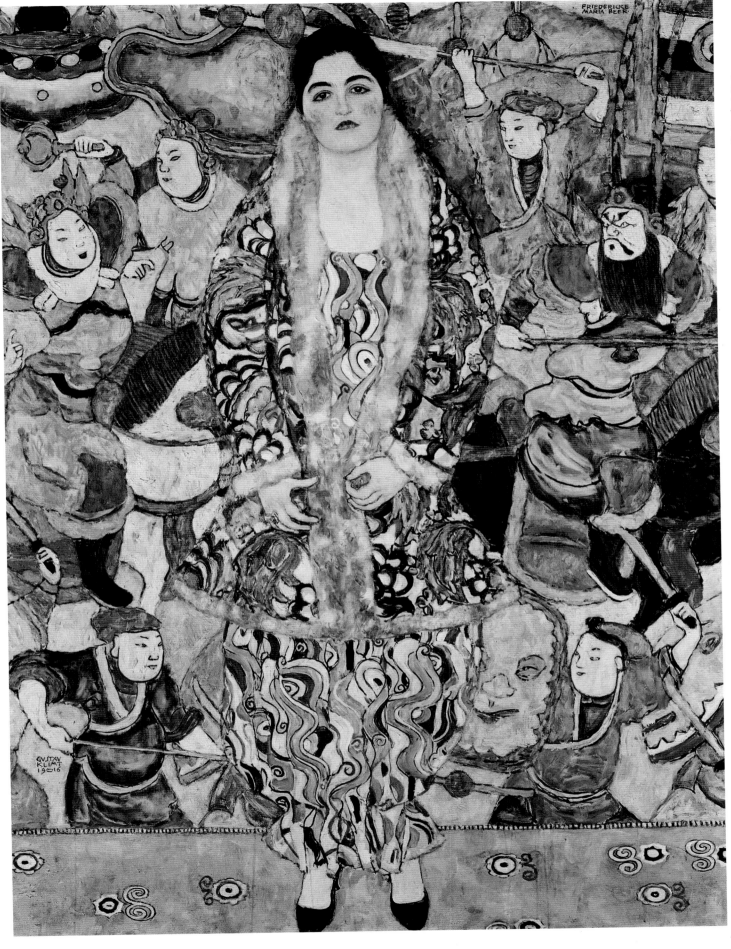

Friederike Maria Beer, 1916; Israel, Tel Aviv Museum of Art.

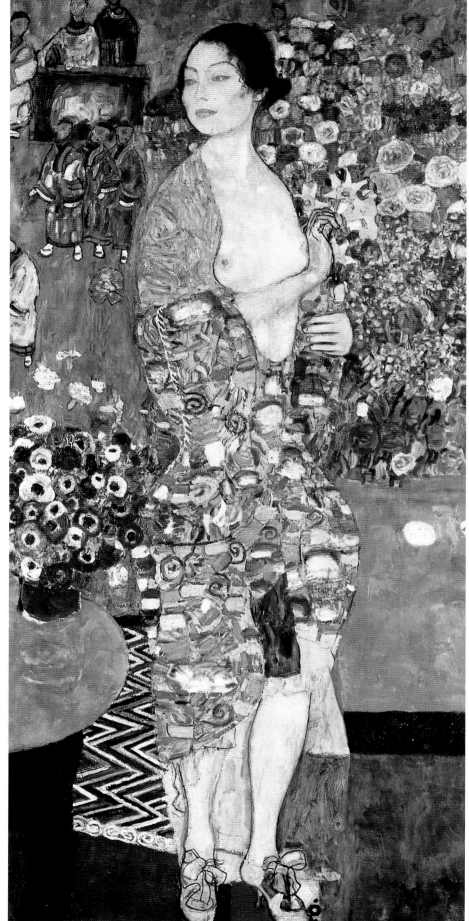

Left:
The Dancer, 1916–18.

Above:
Adam and Eve, 1917–18,
unfinished; Vienna,
Österreichische Galerie
Belvedere.

Opposite page:
The Friends, 1916–17,
detail; destroyed.

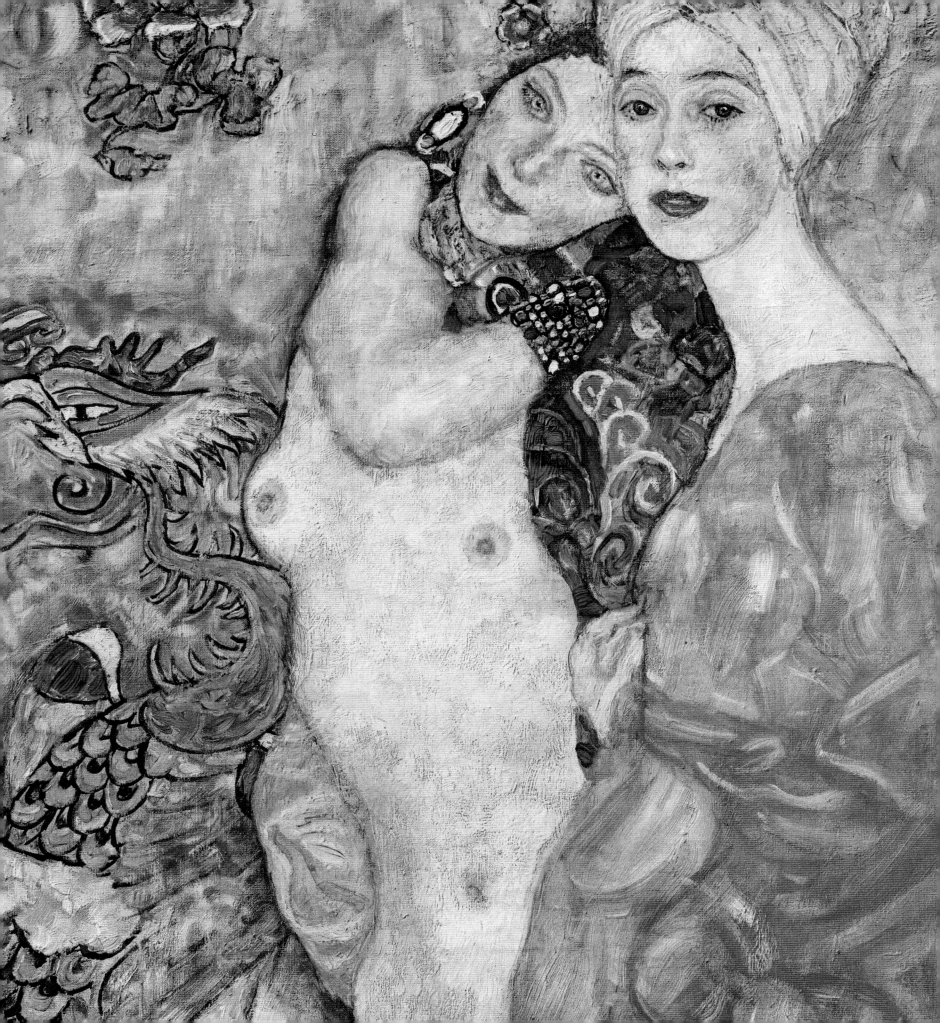

Mäda Primavesi, c. 1912; New York, Metropolitan Museum of Art.

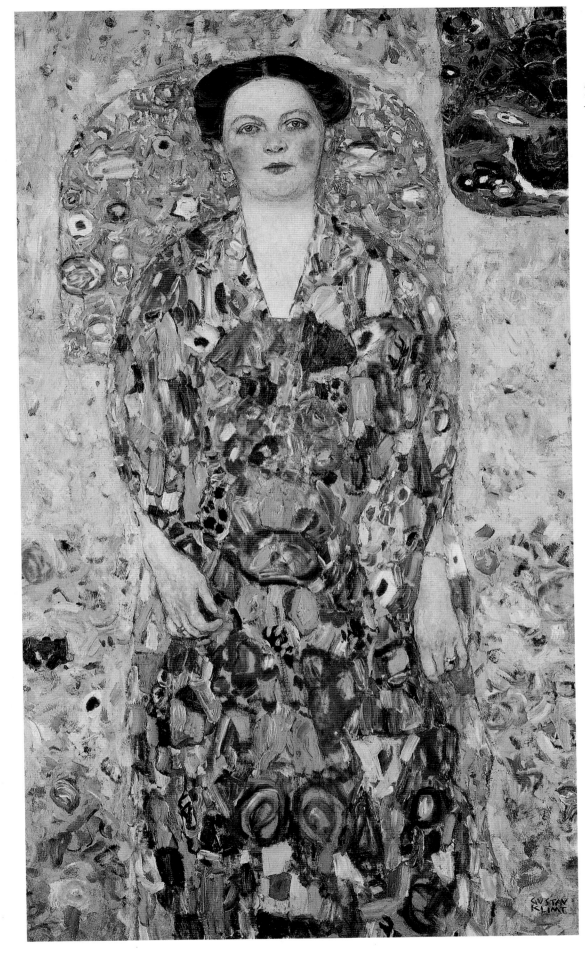

Eugenia Primavesi,
1913–14; Toyota, Japan,
Toyota City Museum.

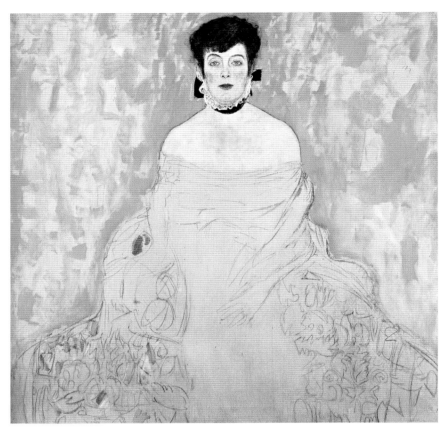

Above:
Amalie Zuckerkandl, 1917–18.

Right:
Maria Munk III,
1917–18, unfinished; Linz,
Neue Galerie der Stadt,
Linz-Wolfgang Gurlitt Museum.

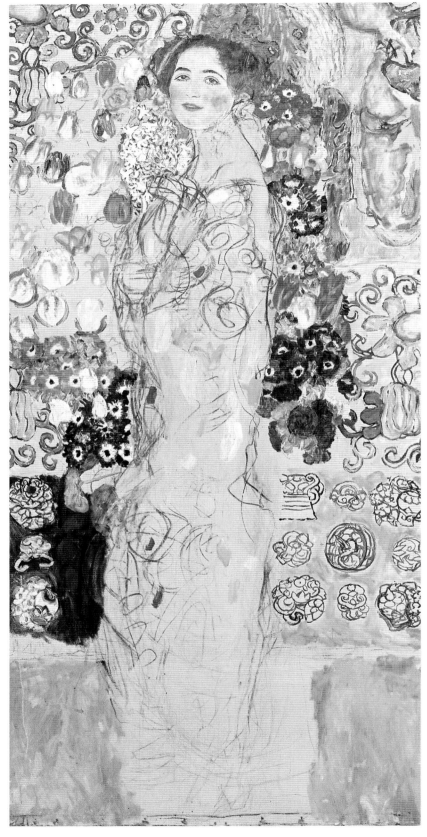

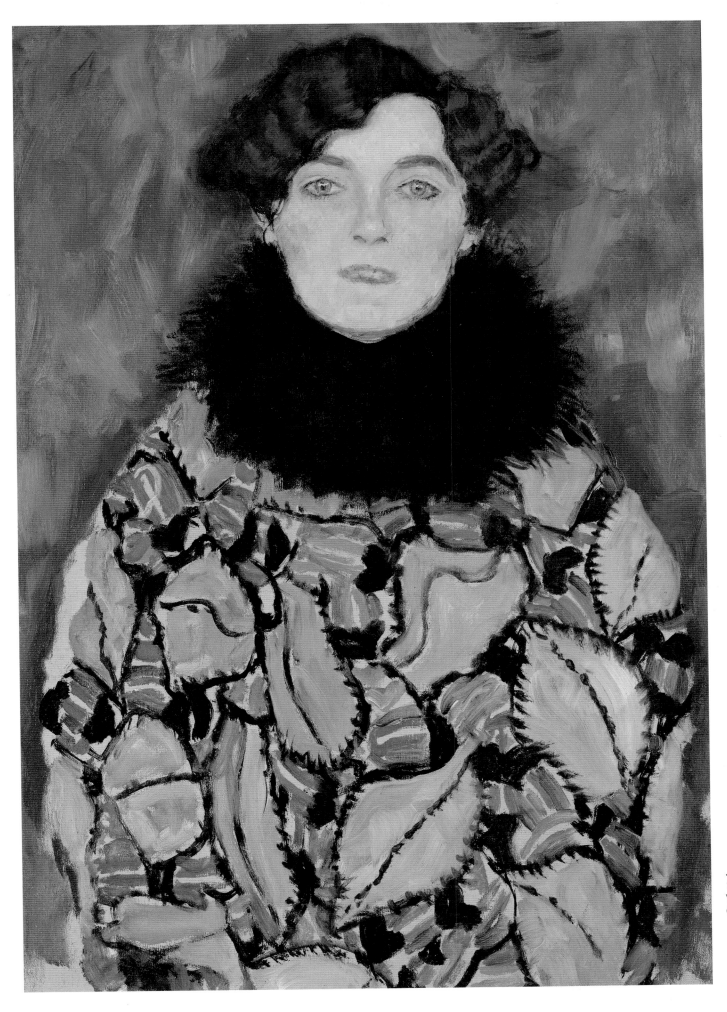

Johanna Staude,
1917–18, unfinished;
Vienna, Österreichische
Galerie Belvedere.

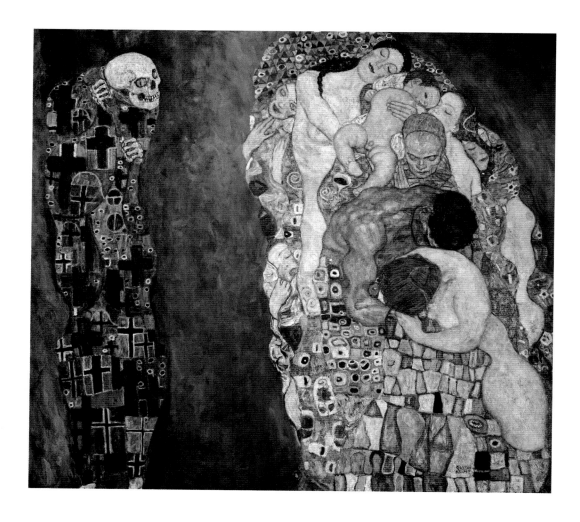

broader background and the unfinished idealization of the face with its wide-open eyes, leave us to intuit the possibility of further research into expressive intensity.

Eros continued to be the central theme in his allegories. In *The Virgin* (1912–13), the double movement of the rotating spiral toward the center and the universe opens and closes like a mandala, the densely metamorphic image of a feminine dreamlike universe symbolizing the psychic state of expectation and recalling the cosmic symbolism of the moon, the aquatic symbolism of the shell, and the erotic symbolism of the vulva. With the colors of popular fable, Klimt again introduces the motif of autoeroticism, the girl sleeping on a bed formed by a circular tangle of female bodies that

seems to levitate in space. In a preparatory study, he instead had her gown raised to uncover her sex. The sketch makes clear the parallels between this ecstatic image and the *Danae* from 1907–08. Like Klimt's other women, like the damnable woman of the misogynous philosopher Weininger and the Great Hetaera imagined by the theoretician of matriarchy Elisabeth Bachofen, *The Virgin* is the essence itself of Eros. Future faces, the languor of sensual pleasure, and the Luciferian gaze of seduction already inhabit its dreamy circular cocoon. Man is exiled from her fantasies. As if in a hall of mirrors, she sees only her own image infinitely multiplied. She dreams not of the Other, the "dark bridegroom," but of herself facing her companions.

Just before he died in 1918, Klimt worked on the theme of the couple, *Adam and Eve,* in which the female figure in the foreground shows an unusual, triumphal Rubenesque carnality, illuminated by an enigmatic smile. The painting remained unfinished, like *The Bride,* a painting that constitutes the narrative companion to *The Virgin.*

Now, finally rising from her bed of dreams, the girl goes toward her wedding night, advancing with closed eyes and the cape wrapped around her shoulders, as if in a trance. The tangle of bodies she leaves behind includes the figure of a man, the bridegroom dressed in red, and below that a child, the fantasized object of future maternity.

As if divided and dispersed among the Sapphic hallucinations, the painting

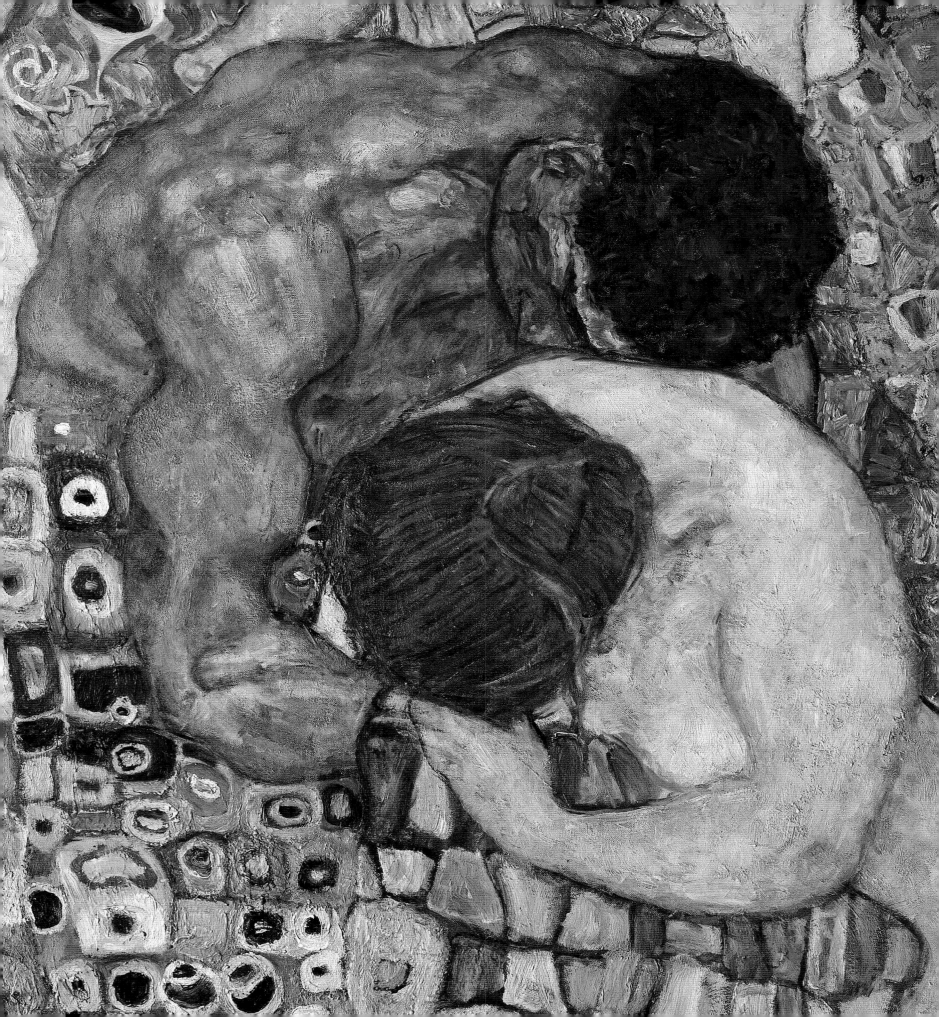

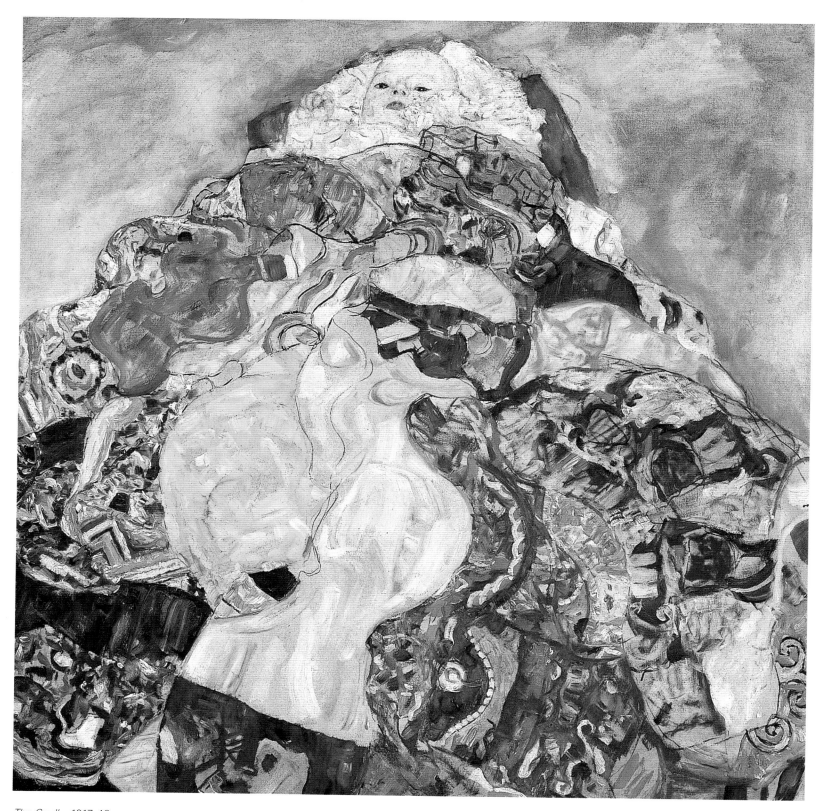

The Cradle, 1917–18,
unfinished; Washington,
National Gallery of Art.

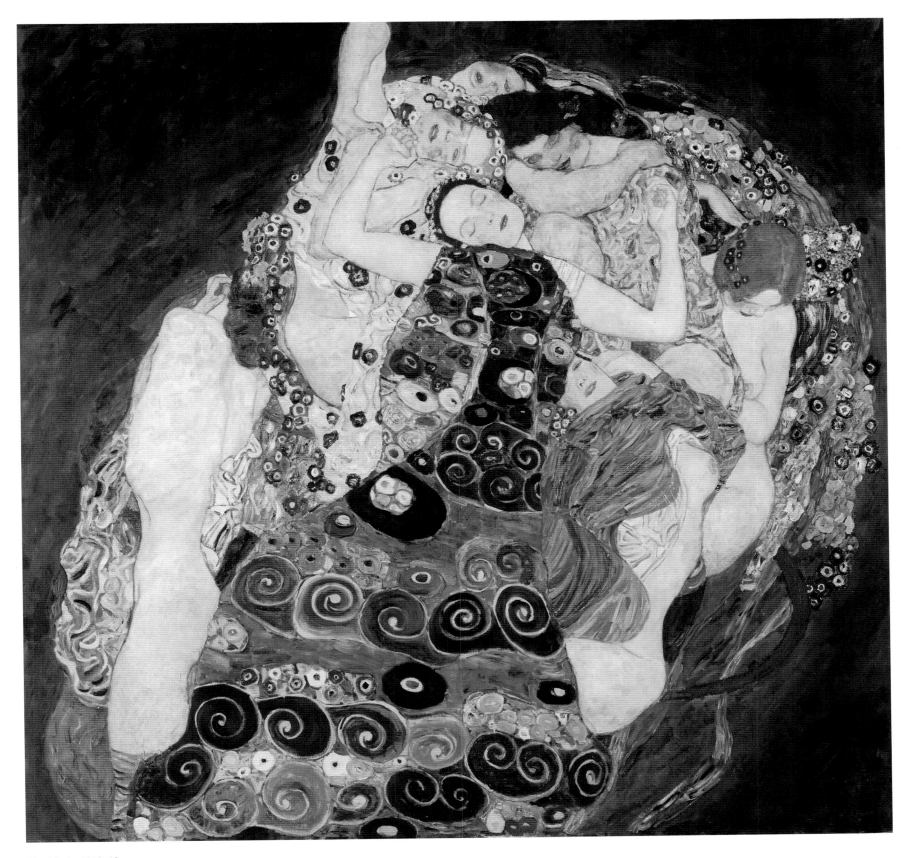

The Virgin, 1912–13;
Prague, Národní Galerie.

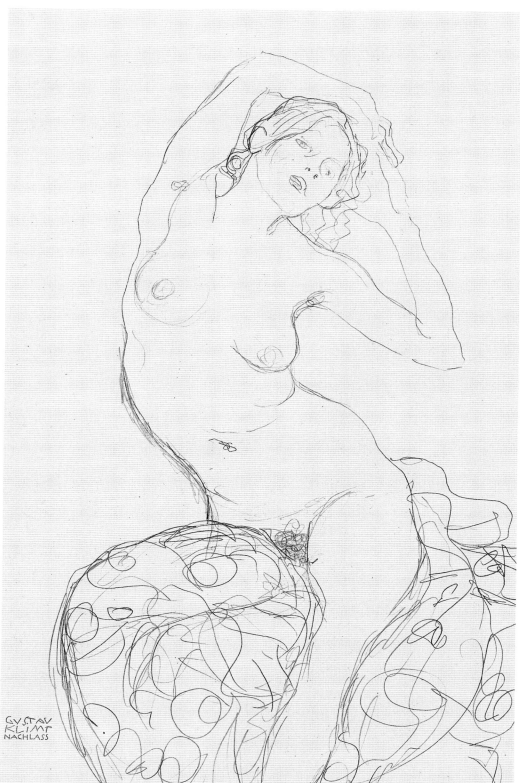

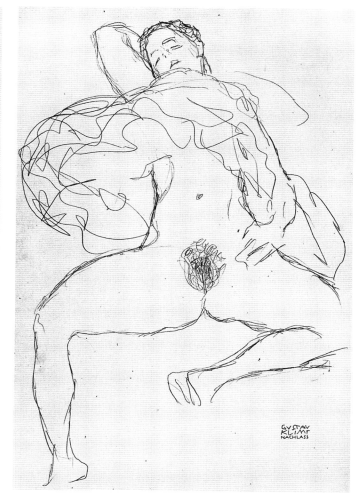

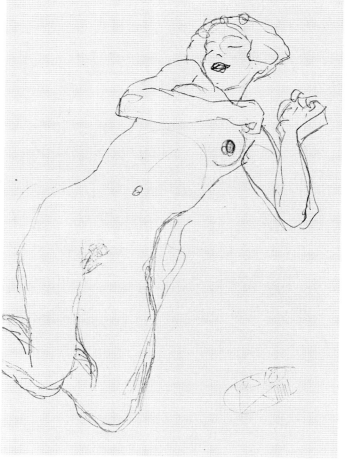

Above:
Study [2] for "The Virgin," 1913;
Zurich, graphic arts collection of
the Eidgenössische Technische
Hochschule.

Above right:
Study for "The Bride," 1917–18.

Right:
Study [3] for "The Virgin," 1913.

THE FLORID STYLE

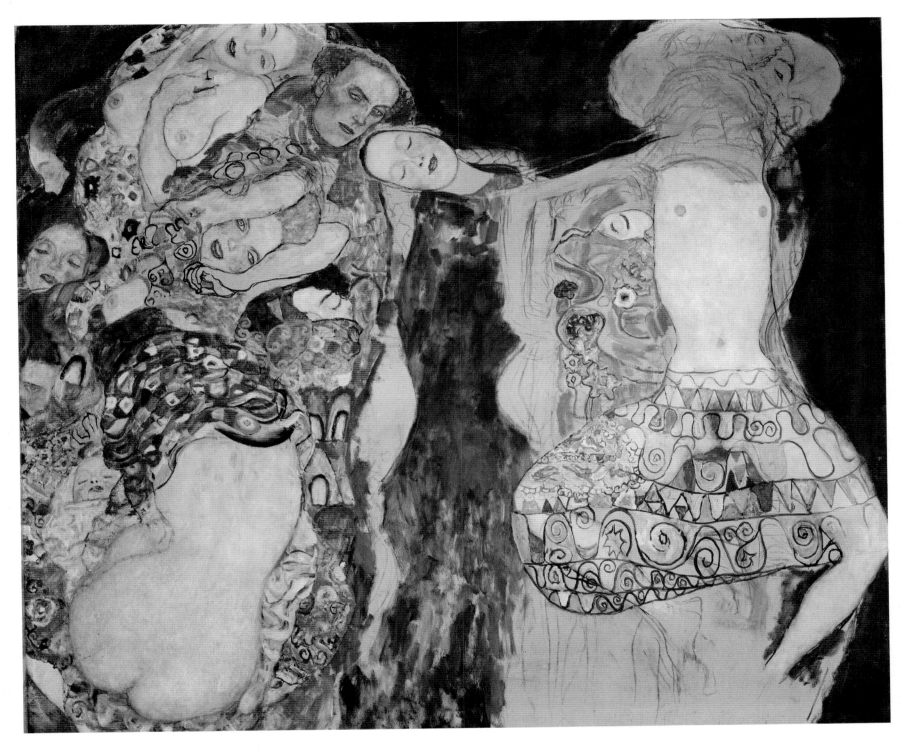

The Bride, 1917–18,
entire painting and detail on
the following page, unfinished;
Vienna, Österreichische Galerie
Belvedere.

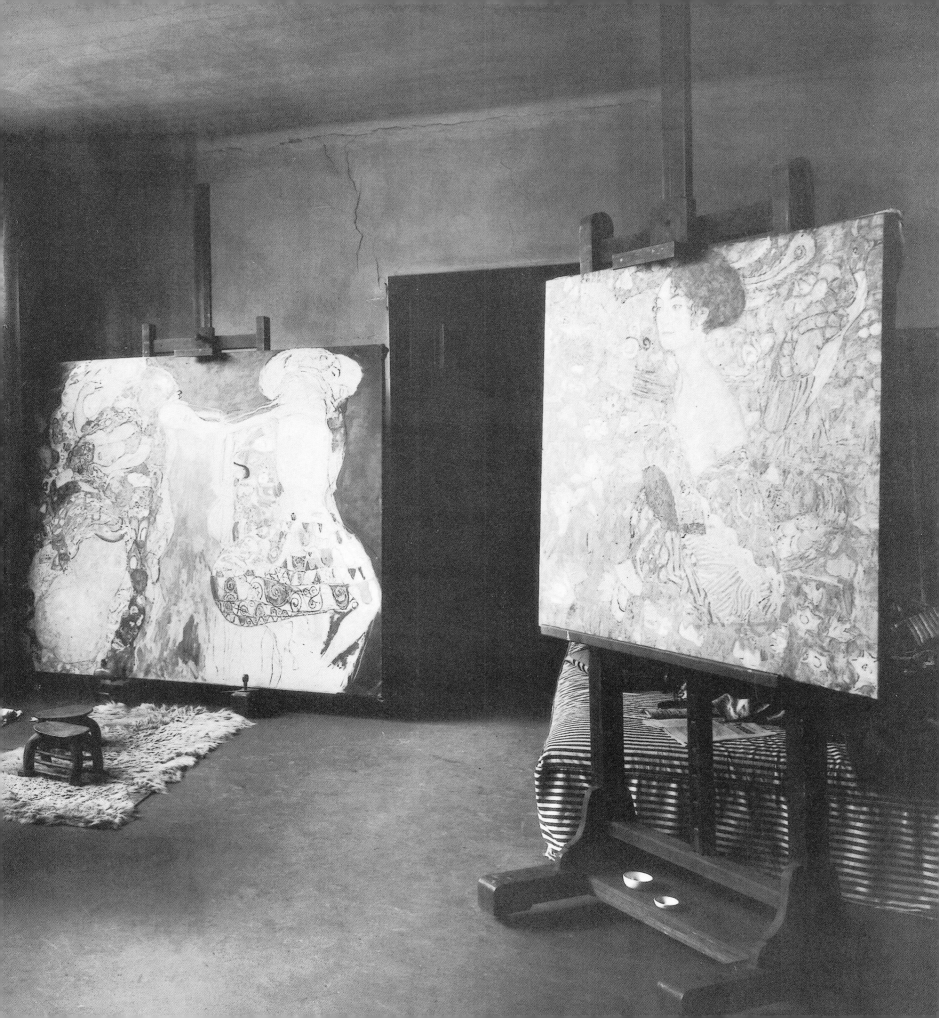

features all three characters from the Holy Family, even dressed in traditional colors (the man in brick red, the virgin in light blue). Though the masculine presence seems to indicate that the Virgin/Bride has finally given her fantasies the face of the Other, the strange semi-nude figure on the right (which remains faceless and seems to guide the sleepwalker like Hermes guides Eurydice toward the exit of the subterranean world) is once again the representation she makes of herself, of her own body stripped naked at the moment of erotic initiation.

A preparatory study seems to show Klimt initially wanted to portray a hermaphrodite. His first intention may well have been to illustrate the epiphany of a mythical, totalizing Eros, that original unity, as yet unmutilated by the division of the sexes and the diaspora of desire, a remote myth emphasized during the Symbolist era and later paradoxically inherited by twentieth-century art, running underneath it. At another point, the artist preferred to move toward a more hermetic representation: an androgynous yet feminine figure with its legs symmetrically spread apart to reveal the sex, barely covered by a transparent veil with ornamental phallic motifs, in an "obstetric" pose of offering itself that coincides with the demonstrative act of the Gorgon as she appears in ancient reliefs, once again perhaps an unconscious reference to the terrible Great Mother. Therefore, the nocturnal desire of the bride does not assume the features of the Other, who remains behind, and once again the absolute expansion of the identical appears where the "dark bridegroom" has no other reality except that of being the "phantasmic" double of the bride and therefore, more generally, a Dionysian personification of the soul.

A photo from the period shows his now deserted studio with the painting—in which the gentle flowers already appear to begin to disintegrate in view of hallucinatory intensification—on which Klimt was working when he suffered a stroke on January 11, 1918. He passed away on February 6, at the age of 56. Schiele would do his deathbed portrait and write his obituary: "Gustav Klimt / an artist of incredible completeness / man of rare depth / his work a sanctuary." Schiele died the same year from the Spanish flu, as did Secession figures Wagner and Moser. The "Style," in which Viennese culture had managed to condense Apollonian rigor and Dionysian disorder, would not survive the end of the empire.

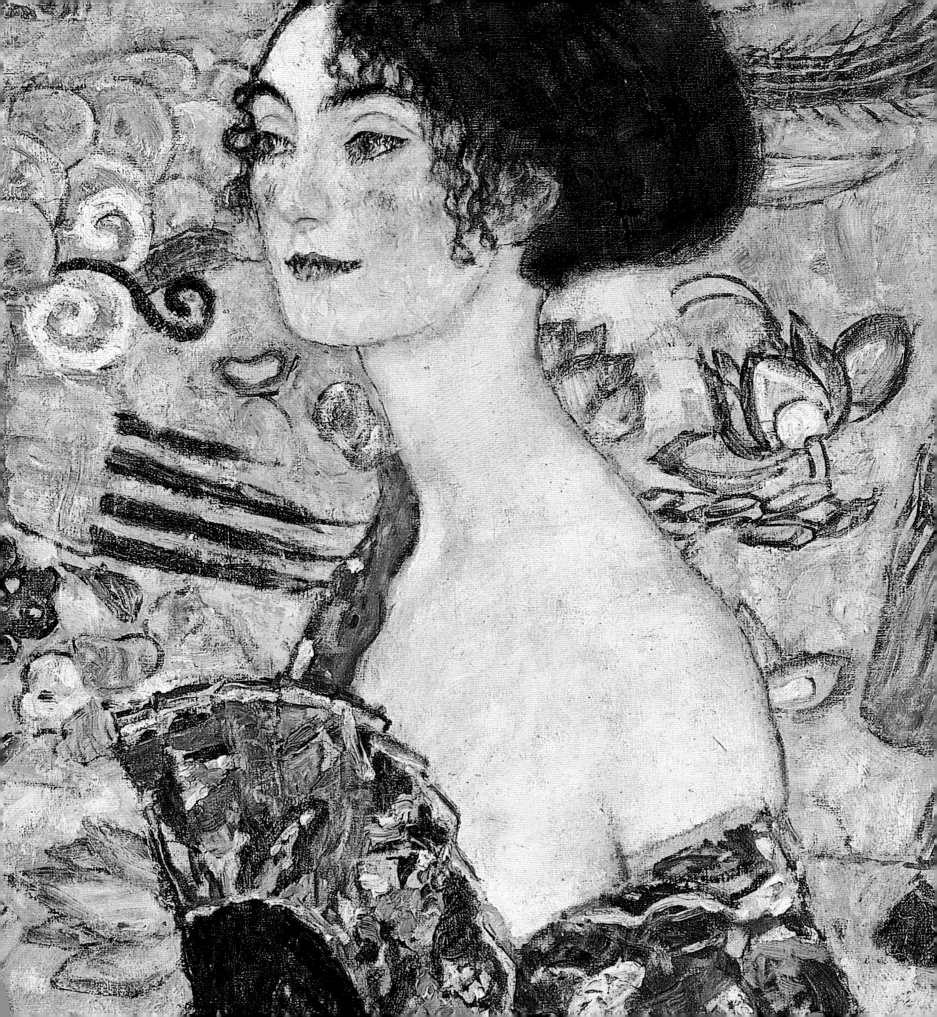

APPENDIX

BIBLIOGRAPHY

GENERAL WORKS
Art and Culture in Vienna

Le Arti a Vienna. Dalla Secessione alla Caduta dell'Impero Asburgico, exhibition catalogue (Venice Biennale, 1984), Milan 1984.

M. BISANZ-PRAKKEN, *Das Quadrat in der Flachenkunst der Wiener Secession*, Vienna 1982.

F. BORSI and E. GODOLI, *Wiener Bauten der Jahrhundertwende*, Stuttgart 1985.

O. BREICHA and G. FRITSCH, *Finale und Auftakt: Wien 1898–1914*, Salzburg 1964.

H. BROCH, *Hofmannsthal e il Suo Tempo*, in ID., *Poesia e Conoscenza*, It. trans., Milan 1965.

M. CACCIARI, *Dallo Steinhof. Prospettive Viennesi del Primo Novecento*, Milan 1980.

J. CLAIR (editor), *Vienne. L'Apocalypse Joyeuse*, exhibition catalogue, Paris 1986.

M. FRESCHI, *La Vienna di Fine Secolo*, Rome 1997.

L. HEVESI, *Acht Jahre Secession*, 1906, edited by O. Breicha, Klagenfurt 1984.

W. HOFMANN (editor), *Experiment Weltuntergang. Wien um 1900*, exhibition catalogue, Hamburg 1981.

W. HOLZBAUER, F. KURRENT, and S. SPALT, *L'Architettura a Vienna Intorno al 1900*, Rome 1971.

A. JANIK and S. TOULMIN, *La Grande Vienna*, It. trans., Milan 1975.

J. KALLIR (editor), *Klimt, Schiele, Kokoschka. Dall'Art Nouveau all'Espressionismo*, exhibition catalogue, Milan 2001.

F. KURRENT and A. STROBL, *Das Palais Stoclet in Brüssel*, Salzburg 1991.

C. MAGRIS, *Il Mito Asburgico nella Letteratura Austriaca*, Turin 1963.

W. MRAZEK, *Die Wiener Werkstätte. Modernes Kunsthandwerk 1903–1932*, Vienna 1967.

D. MULLER, *Klassiker des Modernen Möbeldesign: Otto Wagner, Adolf Loos, Josef Hoffmann, Koloman Moser*, Munich 1980.

T. NATTER, *Die Welt von Klimt, Schiele, Kokoschka. Sammler und Mäzene*, Cologne 2003.

T. G. NATTER and M. HOLLEIN (editors), *Die Nachkte Wahrheit. Klimt, Schiele, Kokoschka und Andere Skandale*, exhibition catalogue, Munich 2005.

C. M. NEBEHAY, *Die Wiener Werkstätte und die Kunst um 1900*, Vienna 1965.

Ibid., *Ver Sacrum 1898–1903*, Vienna 1975.

W. PIRCHER (editor), *Début eines Jahrhunderts. Essays zur Wiener Moderne*, Vienna 1985.

Ibid., *Traum und Wirklichkeit. Wien 1870–1930*, exhibition catalogue, Vienna 1985.

N. POWELL, *The Sacred Spring. The Arts in Vienna 1898–1918*, London 1974.

J. RIEDL, *Das Geniale, Das Gemeine. Versuch uber Wien*, Munich 1992.

J. LE RIDER, *Mitteleuropa. Storia di un Mito*, It. trans., Bologna 1995.

Ibid., *Modernité Viennoise et Crises de l'Identité*, Paris 1990.

C. E. SCHORSKE, *Vienna Fin de Siècle*, It. trans., Milan 1981.

W. J. SCHWEIGER, *Wiener Werkstätte. Arte a Artigianato a Vienna 1903–1932*, It. trans., Milan 1983.

J. SHEDEL, *Art and Society. The New Art Movement in Vienna 1897–1914*, Palo Alto, California, 1981.

K. VARNEDOE (editor), *Vienna 1900. Art, Architecture & Design*, exhibition catalogue, New York 1986.

P. VERGO, *Art in Vienna. Klimt, Kokoschka, Schiele and Their Contemporaries*, Oxford 1975.

N. WAGNER, *Geist und Geschlecht. Karl Kraus und die Erotik der Wiener Moderne*, Frankfurt 1982.

R. WAISSENBERGER, *Die Wiener Secession*, Vienna-Munich 1971.

F. WERFEL, *Nel Crepuscolo di un Mondo. Storie Borghesi nella Vecchia Austria*, 1952, It. trans., Milan 1980.

S. ZWEIG, *Il Mondo di Ieri. Ricordi di un Europeo*, 1944, It. trans., Milan 1994.

Nineteenth and Twentieth Century Images of Women

P. BADE, *Femme Fatale*, New York 1979.

BRAM DIJKSTRA, *Idoli di Perversità*, Milan 1988.

M. DOTTIN-ORSINI, *Cette Femme qu'Ils Disent Fatale: Textes et Images de la Mysoginie Fin-de-Siècle*, Paris 1993.

B. ESCHENBURG and H. FRIEDEL, *Das Kampf der Geschlechter. Der Neue Mythos in der Kunst 1850–1930*, exhibition catalogue, Munich-Cologne 1995.

C. HILMES, *Die femme fatale*, Stuttgart 1990.

W. HOFMANN, *Nanà, Mythos und Wirklichkeit*, Cologne 1973.

Ibid. (editor), *Eva und die Zukunft*, exhibition catalogue (Hamburger Kunsthalle, 1986), Munich 1986.

H. KREUZER (editor), *Don Juan und Femme Fatale*, Munich 1994.

G. MARMORI, *Le Vergini Funeste*, Milan 1966.

L. NOCHLIN, *Representing Woman*, London 1999.

M. PRAZ, *La Carne, la Morte e il Diavolo nella Letteratura Romantica*, Florence 1966.

C. QUIGUER, *Femmes et Machines de 1900*, Paris 1979.

G. SCARAFFIA, *La Donna Fatale*, Palermo 1987.

S. SINISI (editor), *Cantami o Diva. Ipercorsi del Femminile nell'Immaginario di Fine Secolo*, Cava dei Tirreni 1999.

J. THOMPSON, *The Role of Woman in the Iconography of Art Nouveau*, in *Art Journal* XXXI, 2, 1971–72.

E. WITSCHNIGG, *Das Rätsel Weib. Das Bild der Frau in Wien um 1900*, Berlin 2001.

General Catalogues of Klimt's Work

F. NOVOTNY and J. DOBAI, *Gustav Klimt*, Salzburg 1967.

A. STROBL, *Gustav Klimt. Die Zeichnungen 1878–1918*, 4 vols., Salzburg 1980–89.

Documents and Writings by the Artist

H. BAHR, *Gegen Klimt*, Vienna 1903.

G. KLIMT, *Lettere a Emilie Flöge*, edited by L. Lombardi, Pistoia, 1998.

G. KLIMT, *Lettere e Testimonianze*, edited by E. Pontiggia, Milan 2005.

C. M. NEBEHAY, *Gustav Klimt. Dokumentation*, Vienna 1969.

Monographs and Exhibition Catalogues

A. BAUMER, *Gustav Klimt. Donne*, Trento 1985.

G. BELLI, *Gustav Klimt. I Capolavori*, Trento 1988.

M. BISANZ-PRAKKEN, *Der Beethovenfries*, Salzburg 1977.

Ibid. (editor), *Gustav Klimt e le origini della Secessione Viennese*, exhibition catalogue, Milan 1999.

P. BOUILLON, *Klimt: Beethoven*, Geneva 1986.

C. BRANDSTATTER, *Klimt und die Frauen*, Vienna 1994.

O. BREICHA, *Gustav Klimt*, Milan 1981.

A. COMINI, *Gustav Klimt. Eros und Ethos*, Salzburg 1975.

J. CLAIR, *Le Nu et la Norme. Klimt e Picasso en 1907*, Paris 1988.

H. CZERNIN, *Die Fälschung: Der Fall Bloch-Bauer und das Werk Gustav Klimts*, Vienna 1999.

C. DEAN, *Gustav Klimt*, London 1996.

J. DOBAI, *Gustav Klimt. Die Landschaften*, Salzburg 1981.

J. DOBAI and S. CORADESCHI, *L'Opera Completa di Klimt*, Milan 1978.

E. DI STEFANO, *Il Complesso di Salomè. La Donna, l'Amore e la Morte nella Pittura di Klimt*, Palermo 1985.

W. G. FISCHER, *Gustav Klimt und Emilie Flöge. Genie und Talent, Freundschaft und Besessenheit*, Vienna 1987.

G. FLIEDL, *Gustav Klimt 1862–1918*, It. ed., Cologne 1989.

G. FRODL, *Il Fregio di Beethoven*, It. ed., Salzburg 1997.

Gustav Klimt. Disegni Proibiti, exhibition catalogue, Milan 2005.

W. HOFMANN, *Gustav Klimt und die Wiener Jahrhundertwende*, Salzburg 1970.

Ibid. *Klimt e la Secessione Viennese*, in F. RUSSOLI (editor), *L'Arte Moderna*, vol. III, Milan 1975.

H. H. HOFSTATTER, *Gustav Klimt. Erotische Zeichnungen*, Cologne 1979 (It. trans., Milan 1980).

H. KREJCI, *Der Klimt-Streit*, Vienna 2005.

R. METZNER, *Gustav Klimt. Das Graphische Werk*, Vienna 2005.

J. NAGEL and S. OHLBAUM, *Zu Gast bei Gustav Klimt*, Munich 2003.

T. NATTER and G. FRODL, *Klimt und die Frauen*, exhibition catalogue, Vienna 2000.

C. M. NEBEHAY, *Gustav Klimt. Dal Disegno al Quadro*, Milan 1996 (2nd ed., 2000).

S. PARTSCH, *Gustav Klimt, Maler der Frauen*, Munich 1994.
Ibid., *Klimt. Leben und Werk*, Munich 1990.

B. STERNTAL, *Diesen Kuss der Ganzen Welt. Leben und Kunst des Gustav Klimt*, Graz 2005.

T. STOOSS and C. DOSWALD (editors), *Gustav Klimt*, exhibition catalogue, Zurich 1992.

R. WELSER and C. RAHL, *Der Fall Klimt. Die Rechtliche Problematik der Klimt-Bilder im Belvedere*, Vienna 2005.

F. WHITFORD, *Klimt*, London 1993.

T. ZAUNSCHIRM, *Gustav Klimt, Margaret Stonborough-Wittgenstein*, Frankfurt 1987.

F. ZERI, *Klimt: Giuditta I*, Richmond Hill (Canada) 2000.

Review Articles

M. BISANZ-PRAKKEN, *Die Fernliegenden Sphären des Allweiblichen. Jan Toorop und Gustav Klimt*, in "Belvedere," 2001, 1.

Ibid., *Zur Gemälde "Pallas Athena" von Gustav Klimt*, in *Alte und Moderne Kunst*, 147, 1976.

J. DOBAI, *Zur Gustav Klimt's Gemälde "Der Kuss,"* in *Mitteilungen der Österreichischen Galerie*, XII, 1968, no. 56.
Ibid. *Gustav Klimt's "Hope I,"* in *Bulletin. The National Gallery of Canada*, Ottawa, 17, 1971.

S. GRIMBERG, *Adele—Private Love and Public Betrayal*, in *Art and Antiques*, summer 1986.

Klimt Studien, in *Mitteilungen der Österreichischen Galerie*, 22/23, 1978–79, nos. 66–67.

U. KULTERMANN, *Gustav Klimt, Emilie Flöge und die Modereform in Wien um 1900*, in *Alte und Moderne Kunst*, VII, 1962.

J. LESHKO, *Klimt, Kokoschka und die Mykenischen Funde*, in *Mitteilungen der Österreichischen Galerie*, XIII, 1969, no. 57.

M. V. MILLER, *Symphonie in Rosa. Das Bildnis Sonya Knips*, in *Belvedere*, 2001, 1.

F. NOVOTNY, *Zu Gustav Klimts "Schubert am Klavier,"* in *Mitteilungen der Österreichischen Galerie*, VII, 1963, no. 51.

F. OTTMANN, *Klimt's Medizin*, in *Die Bildenden Künste*, II, 1919.

A. STROBL, *Zu den Fakultätsbildern von Gustav Klimt*, in *Albertina Studien*, 1964, no. 2.

P. VERGO, *Gustav Klimt's Beethovenfrieze*, in *The Burlington Magazine*, CXV, 1973.

M. E. WARLICK, *Mythic Rebirth in Gustav Klimt's Stoclet Frieze: New Considerations of Its Egyptianising Form and Content*, in *The Art Bulletin*, 74, March 1992.

A

Alma-Tadema, Laurens, 20, **22**, 23
Alt, Rudolf von, 54
Altenberg, Peter, 170
Altmann, Maria, 151
Amiet, Cuno, 108
"Arts and Crafts," 68, 70

B

Bacher, Rudolf, 54, 56, **56**
Bachofen-Echt, Elisabeth, 214, 215, 216
Bachofen, family, 224
Bahr, Hermann, 8, 42, 50, 54, 68, 77
Baudelaire, Charles, 118, 142
Beardsley, Aubrey, 89, **89**, 93, **93**, 94, 106, 140, 179
Beer, Friederike Maria, 214, 215, 216
Beethoven, Ludwig van, 55, 58, 176, 178–180
Bellini, Jacopo, 26
Berger, Albert, 205
Berger, Julius Victor, 20
Bernhardt, Sarah, 93, 95
Billroth, Theodor, 22
Bloch-Bauer, Adele, 131, 132, 136, 139, 148, 151, 152, 204, 212
Bloch-Bauer, family, 132
Böcklin, Arnold, 58, 108, **110**, 111
Boldini, Giovanni, 122
Bonnard, Pierre, 62
Botticelli, Sandro (Filipepi), 26
Brahms, Johannes, 22
Braudel, Fernand, 205
Broch, Hermann, 8
Burckhard, Max, 50
Burckhardt, Jacob, 205
Burne-Jones, Edward Coley, 108

C

Carrière, Eugène, 58
Catherine II, the Great, of Russia, 52
Christiansen, Hans, 108
Constable, John, 62
Cornaro, Catherine, 21
Corot, Jean-Baptiste-Camille, 62
Correggio, Antonio Allegri da, 148
Crane, Walter, 58

D

Debussy, Claude, 108
Delacroix, Eugène, 62
Della Robbia, Luca, 26

Denis, Maurice, 62
Dhurmer, Lévy, 94
di Samosata, Luciano, 142
Diveky, Josef von, 73, 73
Dobai, Johannes, 106, 136
Donatello (Donato di Bardi), 26
Duncan, Isadora, 58, 176

E

Elizabeth I of Russia, 62
Engelhart, Josef, 50

F

Feure, Georges de, 94
Flaubert, Gustave, 92
Flöge, Emilie, 106, 125, 126, 148, 152–155, 158, 194
Flöge, Helene, 125, 153
Flöge, Paula, 125, 153
Franz Joseph I, Emperor of Austria, 8, 14, 22, 52, 56, 58, 122
Freud, Sigmund, 14, 16, 46, 80

G

Gallia, Herminie, 124
Gauguin, Paul, 62
Gentile da Fabriano, 84, **84**
George, Stefan, 108
Gerlach & Schenk, Viennese Editor, 34
Gérôme, Jean-Léon, 20
Gerstl, Richard, 210
Geyling, Remigius, 148, 149, **149**
Girardi, Alexander, 22
Gogh, Vincent van, 58, 62, 214
Goya y Lucientes, Francisco, 62
Grasset, Eugène, 58
Greco, El (Domenico Theotokópoulos), 62
Grimberg, Salomon, 150

H

Hasenauer, Karl von, 22
Heine, Heinrich, 92
Heinze, Richard, 42
Hevesi, Ludwig, 50, 76, 88, 96, 106
Hodler, Ferdinand, 58, 179
Hoffmann, Josef, 50, 52, 55, 66, **66**, 68, 70–73, **70–73**, 153, 176, **192**, 192, 202, **203**, 203–205
Hofmann, Hans von, 108
Hofmannsthal, Hugo von, 14, 32, 46, 55, 68, 205
Hokusai, Katsushika, 61, **61**, 142, **142**, 179

Holz, Arno, 68
Huysmans, Joris-Karl, 89, 92

J

Jodl, Friedrich, 42
"Jugend," Munich Magazine, 66, 67
Jugendstil, 26, 34, 36, 58, 70, 110, 132, 136, 179
Jung, Carl Gustav, 106

K

Kafka, Franz, 14
Kandinsky, Wassily, 76
Khnopff, Fernand, 26, 58, 62, **62**, 68, 77, 80, **80**, 152, 169, **169**, 170
Klimt, Ernst, 13, **13**, 20, 22, 26, 152, 153, 155
Klimt, Georg, 110
Klimt, Gustav, **20, 58, 125, 148, 154, 170, 204**
 Adam and Eve, 218, **218**, 224
 Adele Bloch-Bauer I, **130**, 131, **131**, 132, 136, 204
 Adele Bloch-Bauer II, 151, **151**, 212
 Allegory of Music I, **18**, 20, 36, 37, **37**, 84
 Allegory of Music II, 36, **36**, 84
 Allegory of Sculpture, 33, **33**
 The Altar of Apollo, 22
 The Altar of Dionysus, 22, 24, **24**
 Amalie Zuckerkandl, 222, **222**
 Avenue in Schloss Kammer Park, 162, **162**, 214
 Baroness Elisabeth Bachofen-Echt, 214, 216, **216**
 Beechwood I, 168, **168**, 170
 Beethoven Frieze, 16, 58, 61, 176–190, **176–190**, 194
 – *Choir of Angels and Embracing Couple*, 16, **17**
 – *Compassion and Ambition Moving the Knight in Shining Armor to Take Up the Fight for Happiness*, 182, **182–183**
 – *The Giant Typhoeus and Lasciviousness*, 186, **187**
 – *Gnawing Grief*, 58, **59**, **60–61**, 61
 – *The Hostile Forces*, 184, **184–185**
 – *The Hostile Forces (Wantonness and Intemperance)*, **174**, 176

 – *Ode to Joy*, 190, **190–191**
 – *Suffering Humanity*, 179, **179**
 – *The Three Gorgons and Sickness, Madness, and Death*, 186, **186**
 – *The Yearning for Happiness*, **180–181**, 181
 – *The Yearning for Happiness Finds Appeasement in Poetry*, 188, **188–189**
 Birch Forest, 166, **166–167**
 The Black Feather Hat, 210, **211**
 The Blood of Fish, **64**, 66, 68
 The Bride, 224, 229, **229**, **230**, 232
 The Cart of Thespis, 22, 26, **27**
 Church at Unterach on the Attersee, 161, **161**
 Comic Actors Improvise a Performance in Rothenburg, 13, **13**
 Compositional Studies of Movement for "Medicine," 46, **46**
 Country Garden with Crucifix, 169, **169**
 Country Garden with Sunflowers, 169, **169**
 The Cradle, 226, **226**
 Danae, **100**, 102, 118, 119, **119**, 224
 The Dancer, 218, **218**
 Death and Life, 224, **224**, **225**
 The Death of "Romeo and Juliet," 22, 26, **27**
 Drawing for "Ver Sacrum," 53, **53**
 Drawing for the Magazine "Jugend," 66, **66**
 Egyptian Antiquity, **28**, 29
 Emilie Flöge, 126, **126**, **127**, **146**, 148, 153, **153**
 Envy, 68, 69, **69**
 Eugenia (Mäda) Primavesi, 221, **221**
 Ex Libris, 77
 Fable, 23, **23**
 Farmhouse with Birch Trees, **156**, 158
 Forest Slope on Attersee, 160, **160**
 The Forester's House, 162, **162**, 214
 Friederike Maria Beer, 214, 216, **217**
 Friends, 114, **114**, 118, 214, 218, **219**
 The Friends, 143, **143**
 Fritza Riedler, 126, 128, **128**, **129**
 Girl from Tanagra, 26, 28, **28**, 36

Girl with Oleander, 23, **23**, 26, 118

Goldfish (or Undines), 110, 112, **112, 113**

Greek Antiquity II, 28, **28**

Head of a Girl, 38, **38**

Head of a Woman, 214, **214**

Herminie Gallia, 124, **124**

Hope I, 102, **102–104**, 108, 148, 152

Hope II, 105, **105**, 108

Hygeia, 44

Idyll, 21, **21**

Illustration for the Month of January [1901] of *"Ver Sacrum,"* 67, **67**

The Interior of the Old Burgtheater in Vienna, 14, **15**

Island in the Attersee, 164, **165**, 170

Johanna Staude, 223, **223**, 224

Judith I, **82**, 84, **85**, 88, 92, 96, **96, 97**, 108, 150

Judith II (Salomé), 84, **90**, 92, 98, **98, 99**, 206, 212

Jurisprudence, 34, 42, 44, 46, **47**, 62, 88

The Kiss, 34, 194, 199, **199**, 204, 206, **207**

Lady with Fan, 232, **232, 233**

Lady with Hat and Feather Boa, **120**, 122, 132, **133**

Leda, 118, **118**

Life Is a Struggle (or The Golden Knight), **48**, 50

Love, 30, **30**, 32, 84, **86**, 87

Mäda Primavesi, 220, **221**

Margaret Stonborough-Wittgenstein, 124, **124**, 126

Maria Munk III, 222, **222**

Medicine, 34, **40**, 42, 44, 45, **45**, 46, 68, 77

Mother with Children, 108, 210, 212, **213**

Moving Water, 110, 111, **111**

Music, 36, **36**

Nuda Veritas, 68, 69, **69**, 77, 80, **80, 81**, 106

The Organ Player, 11, **11**

Pallas Athena, **74**, 76–78, **77, 79**

The Park, 170, 173, **173**

Philosophy, 34, 42, 43, **43**, 44, 46, 48

Poppy Field, 170, **171–172**

Portrait of the Actor Josef Lewinsky, 84, 87, **87**

Portrait of the Pianist Josef Pembaur, 26, 30, **31**

Portrait of Serena Lederer, 38, **38**

Portrait of a Woman, 38, **39**

Portrait of a Woman in a Gold Dress, 26, **26**

Poster for the Eighteenth Secession Exhibition, 55, **55**

Reclining Female Nude Turned to the Left, 145, **145**

Reclining Semi-Nude, **134**, 136

Rose Bushes under the Trees, 168, **168**

Schloss Kammer at Attersee I, 158, **158**

Schloss Kammer at Attersee II, 162, **162**, 163

Schloss Kammer at Attersee III, 158, 159

Schubert at the Piano I, 36, 153

Schubert at the Piano II, 8, **8–10**, 152

The Scornful Woman, 210

Seated Woman with Open Legs, 144, **144**

Semi-Nude Woman Lying on Her Back, from the Right, 144, **144**

Serenade, 66, **66**

Silver Fish (or Undines), 110, 112, **112**

The Sisters, 132, **132**

Sketch [1] of the Secession Building, 57, **57**

Sketch [2] of the Secession Building, 57, **57**

Sketch for "Expectation" from the Stoclet Frieze and for "The Dancer," 194, **194**

Sketch for "Medicine," 45, **45**

Sketch for "Schubert at the Piano II," 11, **11**, 152

Sonja Knips, 36, 122, **123**

Stoclet Frieze, 4, 190–199, **192–200**, 202, 204, 206, **207**
— *The Embrace*, 194, 198, **198**
— *Expectation*, 194, 195, **195**, **200**, 202
— *The Knight*, 192, **192–193**, 194

— *Rosebush*, 196, **196**
— *The Tree of Life*, **2**, 4, 194, 196, **196–197**

Studies for the compositions "Hygeia" and "Couple" for "Medicine," 44, **44**

Studies for the Portrait "Friederike Maria Beer," 215, **215**

Study [1] for "Medicine," 32, **32**

Study [1] for the Portrait "Adele Bloch-Bauer I," 136, **136**

Study [1] for "The Virgin," 145, **145**

Study [1] for "Water Snakes II" and "The Friends," 145, **145**

Study [2] for "Medicine," 43, **43**

Study [2] for the Portrait "Adele Bloch-Bauer I," 136, **136**

Study [2] for "The Virgin," 228, **228**

Study [2] for "Water Snakes II" and "The Friends," 145, **145**

Study [3] for the Portrait "Adele Bloch-Bauer I," 139, **139**

Study [3] for "The Virgin," 228, **228**

Study for "Allegory of Sculpture," 33, **33**, 34

Study for "Allegory of Tragedy," 34, **35**

Study for "The Bride," 228, **228**

Study for "Danae," 118, **118**

Study for "Greek Antiquity II," 28, **28**

Study for "Philosophy," 32, **32**

Study for "Schubert at the Piano I," 11, **11**

Study for "Three Female Heads" from the "Beethoven Frieze," 179, **179**

Study for "The Yearning for Happiness," from "The Beethoven Frieze," 178, **178**

Study for the Portrait "Baroness Elisabeth Bachofen-Echt," 215, **215**

Study for the Portrait "Fritza Riedler," 137, **137**

Study for the Portrait "Mäda Primavesi," 215, **215**

Study for the Portrait "Margaret Stonborough-Wittgenstein," 137, **137**

Study of a Dancer Standing with Her Head Turned to the Left, 215, **215**

Study of a Girl (Marie Zimmermann) for the Painting "Schubert at the Piano I," 153, **153**

Sunflower, 168, **168**, 170

The Theater at Taormina, 22, 24, **24**, 25

Theseus and the Minotaur (censored), 76, **76**

Theseus and the Minotaur (original), 76, **76**

The Three Ages of Woman, 106, **106**, 108, **108–109**, 212

Tragedy, 34

Two Nudes Lying on Their Backs, 143, **143**

The Virgin, **208**, 210, 224, 227, **227**

Water Snakes I, 110, 114, **114**, 118

Water Snakes II, 110, 114, **114**, **115**, **116–117**

Woman Lying on Her Stomach, 145, **145**

Klimt, Otto, 152

Klinger, Max, 58, **58**, 80, **80**, 93, 94, **94**, 176, **176**, 178, **178**, 206, **206**

Knips, Sonja, 36, 122, 152

Kokoschka, Oskar, 14, 102, 204–206, 210

Krämer, Johann Viktor, 53, **53**

Kraus, Karl, 14, 42, 205

Kubin, Alfred, 14, 108

Kurzweil, Maximilian (Max), 52, 55, **55**

L

Laforgue, Jules, 93

Lauder, Ronald S., 132

Laufberger, Ferdinand, 20

Lederer, August, 44

Lederer, Erich, 177

Lederer, Serena, 38, 152

Lehár, Franz, 16

Löffler, Bertold, 73, **73**, 205, **205**

Loos, Adolf, 14, 68, 205

Lorrain, Claude (Claude Gellée), 93, 118

Louys, Pierre, 118

Lueger, Karl, 22, 52

M

Mach, Ernst, 14

Mackintosh, Charles Rennie, 58, 70, 71, **71**, 179

Maeterlinck, Maurice, 68

Mahler, Alma, 148, 150

Mahler, Gustav, 14, 50, 58, 148, 179, 180

Maillol, Aristide, 108

Makart, Hans, 20–22, **21**, 84

Mallarmé, Stéphane, 93

Maria Theresa of Hapsburg, 22

Maria Theresa of Spain, 128

Matisse, Henri, 214

Matsch, Franz, 20, 22, 26, 34

Melozzo da Forlì, (Melozzo degli Ambrosi), 26

Minne, George, 58, 179

Moll, Carl, 50, 52, 55, **55**, 58, 148, 150

Moreau, Gustave, 88, **88**, 89, 92–94, **92, 93**, 152

Moreau, Sarah, 93

Morris, William, 68, 70, 71, 71

Moser, Koloman (Kolo), 52, 54, **54**, 58, 62, 68, **68**, 71, **71**, 106, 153, 232

Mucha, Alphonse, 58

Munch, Edvard, 58, 94, 96, 108, 152, 204

Munk, Maria, 222

Musil, Robert, 8, 14

N

Nadar, pseudonym for Gaspard-Félix Tournachon, 95, **95**

Nahr, Moritz, 58

Neumann, Erich, 106

Nietzsche, Friedrich Immanuel, 34, 44, 46, 55, 180

Novotny, Fritz, 136, 214

O

Olbrich, Joseph Maria, 36, 50, 52–55, **53**, 57, **57**

P

Péladan, Joseph, 93

Pembaur, Josef, 26, 30

Pfitzner, Hans, 148

Picasso, Pablo, 94

Potemkin, Grigori Aleksandrovich, 52

Powell, William, 118

Primavesi, Eugenia (Mäda), 215, 221

R

Redon, Odilon, 62

Reinhardt, Max, 148

Reininghaus, Carl, 177

Renner, Karl, 148

Riedler, Fritza, 126, 128, 137

Rilke, Rainer Maria, 68, 108

Rodin, François-Auguste-René, 58, 108, **110**, 111, 118, 142, 144, **144**, 152, 206, **206**

Roessler, Arthur, 142

Roller, Alfred, 52, 54, **54**, 55, **55**, 57, 63, 63, 66

Rops, Félicien, 93, **93**, 94

Roth, Joseph, 14

Rubens, Pieter Paul, 224

Rysselberghe, Théo van, 164, **164**, 170

S

Sacher-Masoch, Leopold von, 92

Sappho, 110

Samain, Albert, 93

Savonarola, Girolamo, 205

Schefer, Jean Louis, 69, 77

Schiele, Egon, 102, **102**, 106, 141–143, **141**, 143, **154**, 154, 204, 206, 210, **210**, 212, **212**, 214, 232

Schiele, Gertrud, 210

Schiller, Friedrich von, 77, 190

Schnitzler, Arthur, 8, 14, 16, 148

Schönberg, Arnold, 14, 16

Schopenhauer, Arthur, 44

Schorske, Carl E., 46, 62

Schwob, Marcel, 93

Segantini, Giovanni, 58, 68, 106, **106**, 108

Semper, Gottfried, 22

Seurat, Georges, 62, 164, **164**, 170

Sissi, Elisabeth of Bavaria, Empress of Austria, Queen of Hungary, 22

Staude, Johanna, 223

Stoclet, Adolphe, 70, 72, 73, 190, 191, 202

Stonborough-Wittgenstein, Margaret, 124, 126, 137

Strathmann, Carl, 92, 170

Strauss, Richard, 89, 93, 94, 148

Strobl, Alice, 136, 194

Stuck, Franz von, 50, 50, 58, 76, 77, 88, **88**, 92, 94, **94**

Swinburne, Algernon Charles, 118

Symons, Arthur, 93

T

Theodora, Empress of Byzantium, 84, 94

Tietze, Hans, 152

Toorop, Jan Theodore, 34, **34**, 58, 61, **61**, 78, **78**, 140, 179

Toulouse-Lautrec, Henri de, 58, 62

Turner, Joseph Mallord William, 62

U

Uhland, Ludwig, 66

Utamaro, Kitagawa, 63, **63**, 138, **138**, 179

V

Vallotton, Félix, 62

van Gogh, Vincent; *see* Gogh, Vincent van

Veith, Gustav, 51, **51**

Velázquez, Diego Rodríguez de Silva y, 62, 126, 128, **128**

Verhaeren, Émile, 68

Verlaine, Paul-Marie, 118

Ver Sacrum, Viennese magazine, 36, 42, 44, 46, 52, 53, 65–73, 77, 136

Vigeland, Emanuel, 62

Vogeler, Heinrich, 108

Vuillard, Édouard, 62

W

Waerndorfer, Fritz, 68, 106, 148

Wagner, Otto, 50, 52–54, **52**, **53**, 56, **56**, 232

Wagner, Richard, 180

Weininger, Otto, 16, 118, 224

Weiss, H., 67, **67**

Werfel, Franz, 8

Whistler, James Abbott McNeill, 122, **122**, 126

Wickhoff, Franz, 42, 44

Wiener Werkstätte, 65–73, 122, 153, 155, 192, 194, 203–205

Wilde, Oscar, 80, 89, 92, 93

Wittgenstein, Ludwig, 14, 108, 205

Wolfdel, T., 12, **12**

Wratislaw, Theodor, 93

Z

Zimmermann, Marie (Mizzi), 152, **152**, 153, 158

Zuckerkandl, Amalie, 222

Zuckerkandl, Berta, 50

Zuckerkandl, Emil, 118

Zweig, Stephan, 8, 148